Compositions Book 7

Missa Unitas: A Mass For Unity for Chorus and Brass

by Ken Langer

Compositions Book 7

Missa Unitas:
A Mass For Unity
for Chorus and Brass

by
Ken Langer

Compositions Book 7
Missa Unitas: A Mass For Unity
Music for Chorus and Brass
by Ken Langer

Klangermuzik
http://www.klangermuzik.com

First Edition (Softcover)

Copyright © 2013, Ken Langer

ISBN: 978-1-300-76574-5

All rights reserved. No Part of this book may be reproduced or transmitted in any form or by any means, electronic or mechanical, including photocopying, recording or by any information storage and retrieval system, without written permission from the author, except for the inclusion of brief quotations with proper annotation.

Produced in the United States of America

The author may be contacted at ken@kenlanger.com.

Table of Contents

Part One: To Life

1	Reading No. 1	solo trumpet and narrator	9
2	Introit	brass choir	10
3	Prelude	brass choir and chorus	17
4	Kyrie Call	brass choir	25
5	Kyrie Response	chorus	31
6	Canticle To Life	solo voice and brass quartet	34
7	Gloria Call	brass choir	36
8	Gloria Response	chorus	60
9	Alleluia	brass choir and chorus	64

Part Two: To Love

10	Reading No. 2	brass duet and narrator	73
11	Credo Call	brass choir	74
12	Credo Response	chorus	85
13	Canticle To Love	vocal duet and brass quartet	88
14	Sanctus Call	brass choir and chorus	92
15	Sanctus Response	chorus	99
16	Benedictus	brass choir and chorus	103

Part Three: To Light

17	Reading No. 3	brass trio	115
18	Canticle To Light	(missing)	
19	Agnus Dei Call	brass choir and chorus	116
20	Agnus Dei Response	chorus	128
21	Finale	brass choir and chorus	133

Introduction

Missa Unitas is a single work in 21 movements for brass choir and SATB chorus.

I have always felt that if we could see how the basic premises of religions are actually more similar than different, then maybe we could seize upon those similarities and develop ways of working together. I have studied many religious texts and commentaries and have read the works of many philosophers of comparative religion. I have combined that interest with my life work as a composer. The result has become a full length mass for brass ensemble (trumpets, horns, trombones, baritones, and tubas) and full choir and will include vocal and instrumental solos, duets, and ensembles as well as full brass, choir, and combined pieces. The texts include quotes from authors such as William James, Vaclav Havel, Robert Fulghum, Bhagavan Das, and Evelyn Underhill and also include original texts based on the text of the original mass.

 The work is divided into three sections: To Life, To Love, and To Light. Each section contains pieces for brass ensemble alone, unaccompanied choir, small group pieces, and combined sections. The whole work is about an hour in length.

This work is published by Yelton Rhodes. Performance copies should be purchased from them.

Recordings of all the works can be found on my website: http://kenlanger.com. Some of the recordings are live while others are MIDI transcriptions which may help you become familiar with each work.

Missa Unitas
Reading No. 1

Ken Langer

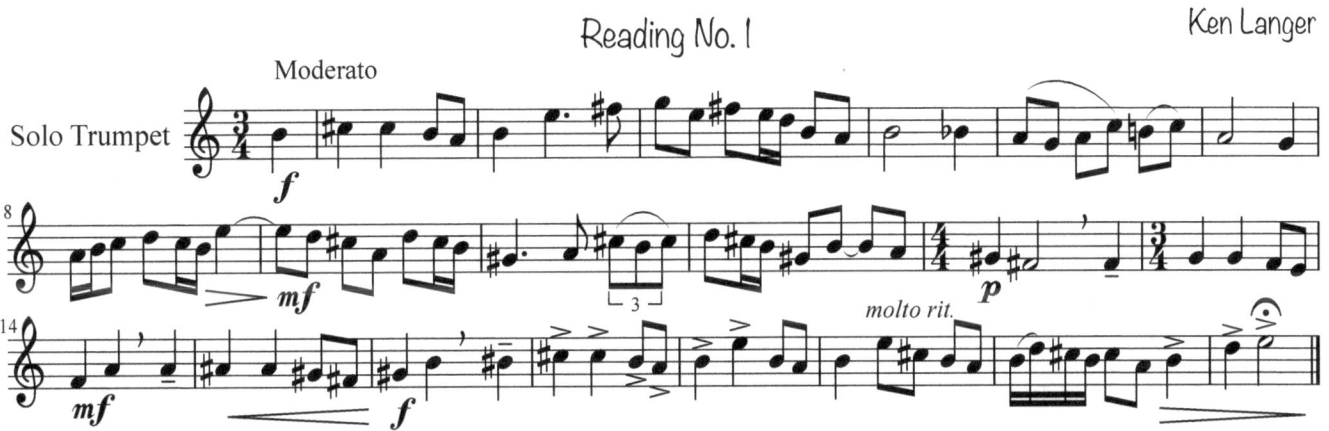

Narrator: Is the existence of so many religious types and sects and creeds regrettable? To [this] question I answer 'no' emphatically. And my reason is that I do not see how it is possible that creatures in such different positions and with such different powers as human individuals are, should have exactly the same functions and the same duties... If an Emerson were forced to be a Wesley, or a Moody forced to be a Whitman, the total human consciousness of the divine would suffer. The divine can mean no single quality, it must mean a group of qualities, by being champions of which in alternation, different (people) may all find worthy missions. Each attitude being a syllable in human nature's total message, it takes the whole of us to spell the meaning out completely.

William James
The Varieties of Religious Experience

Missa Unitas
Introit

Ken Langer

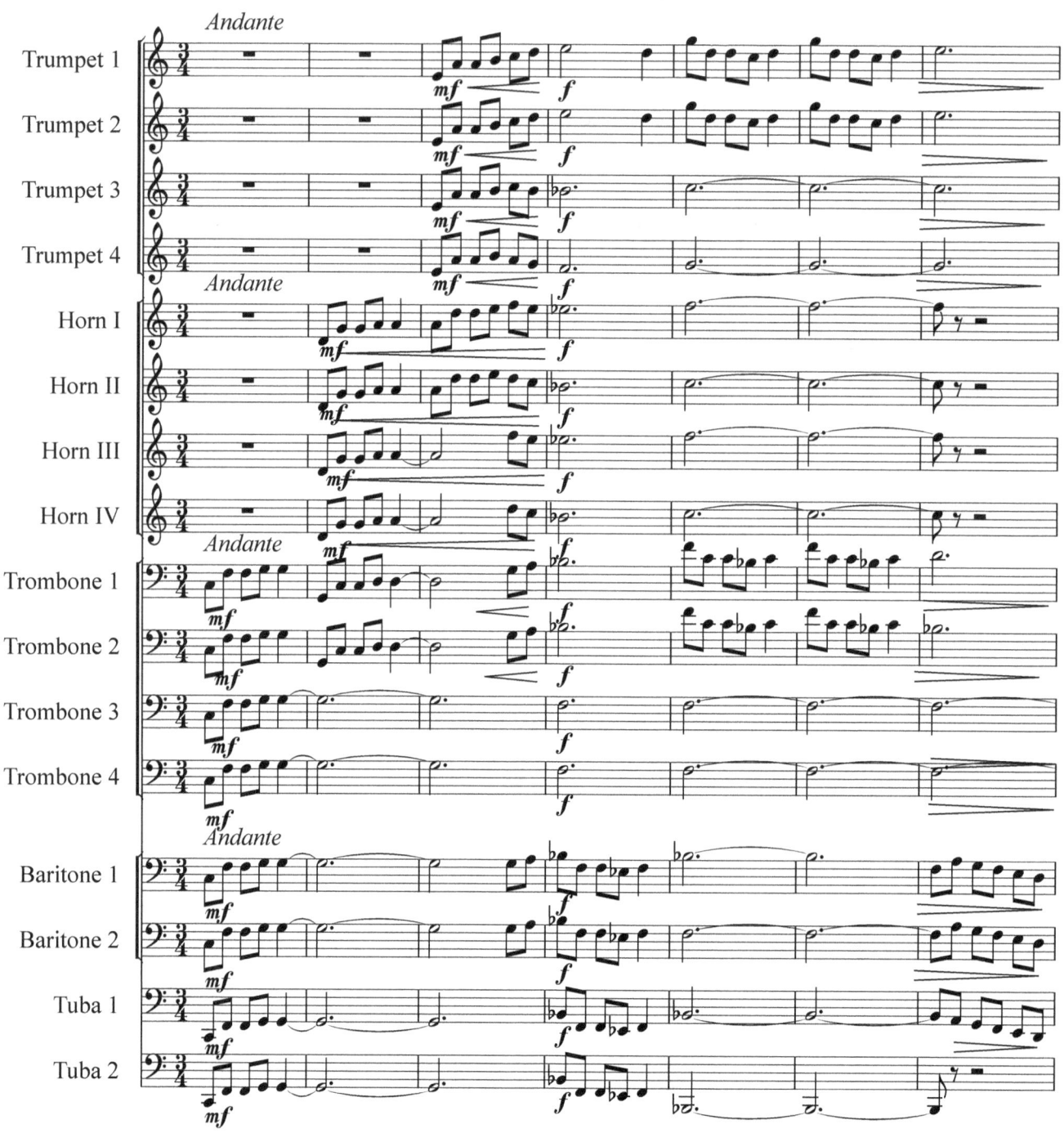

10

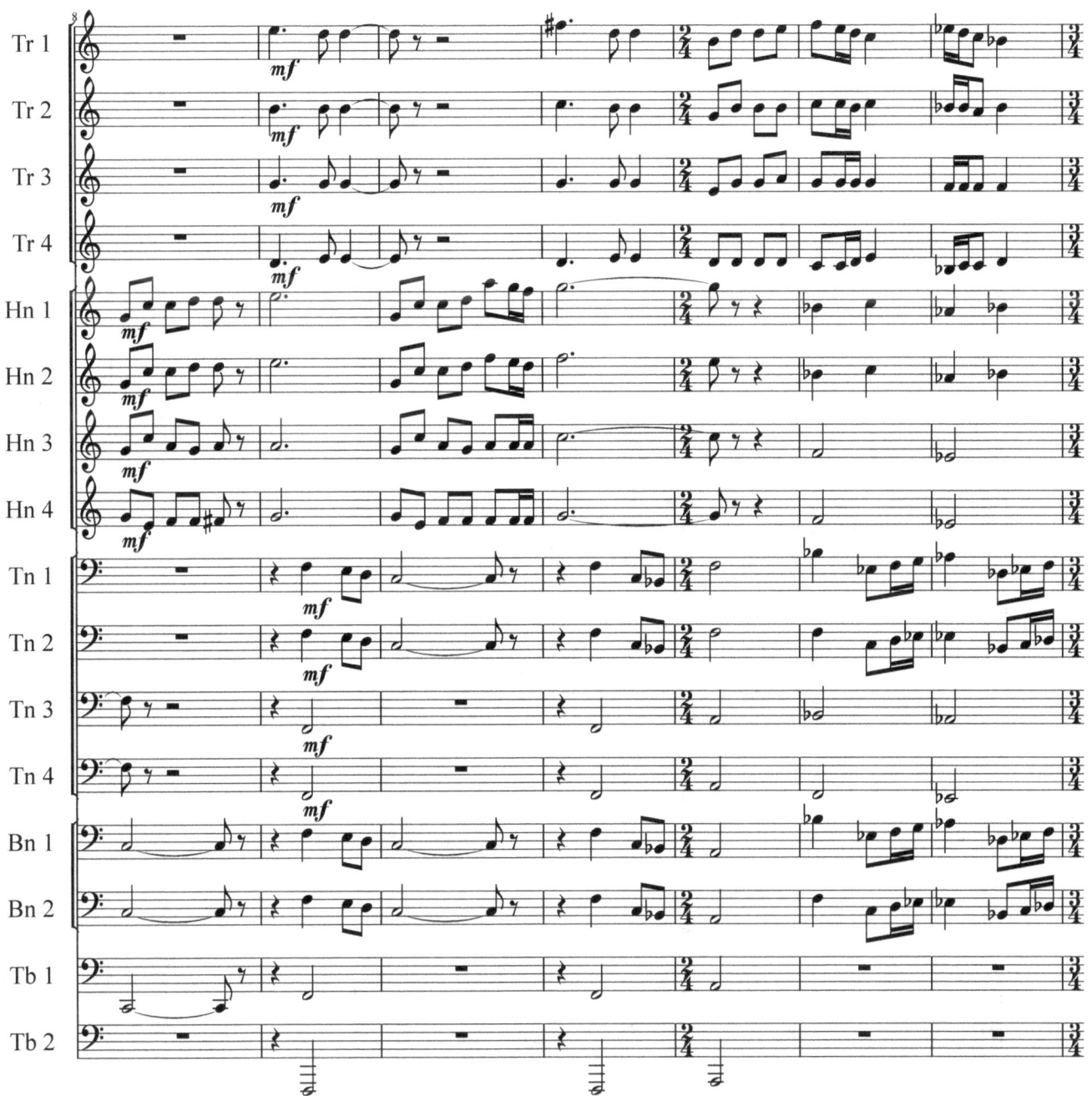

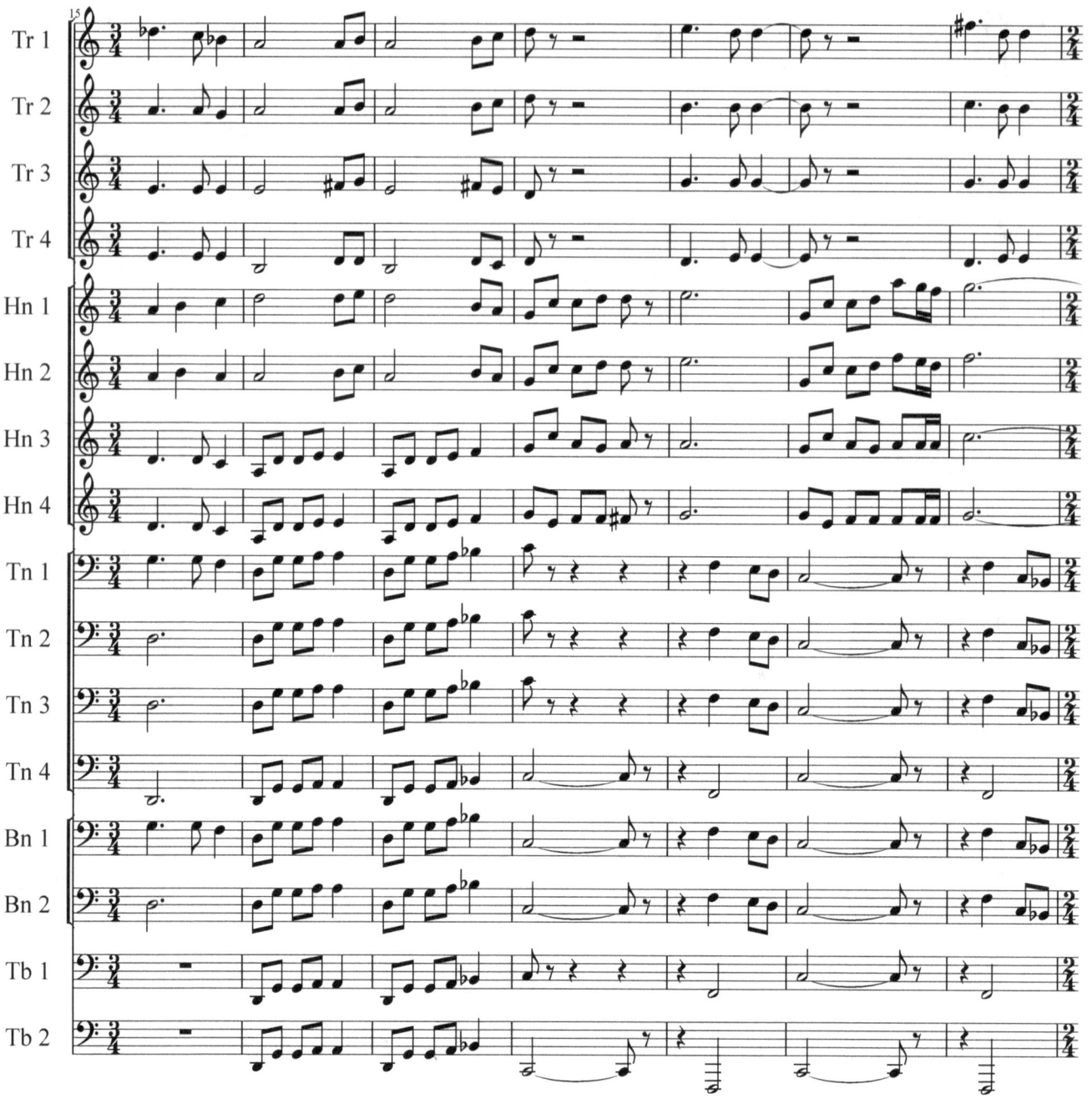

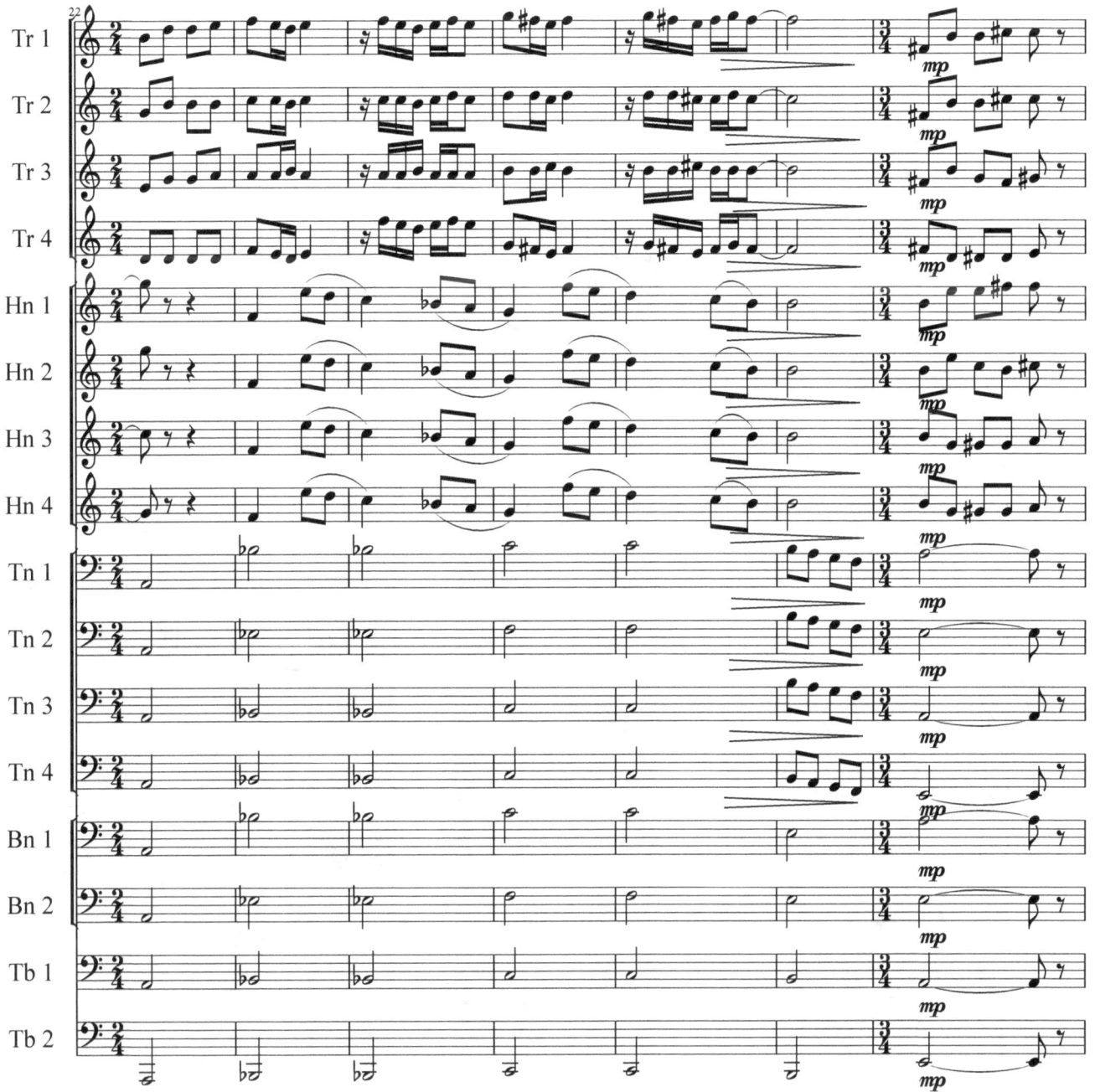

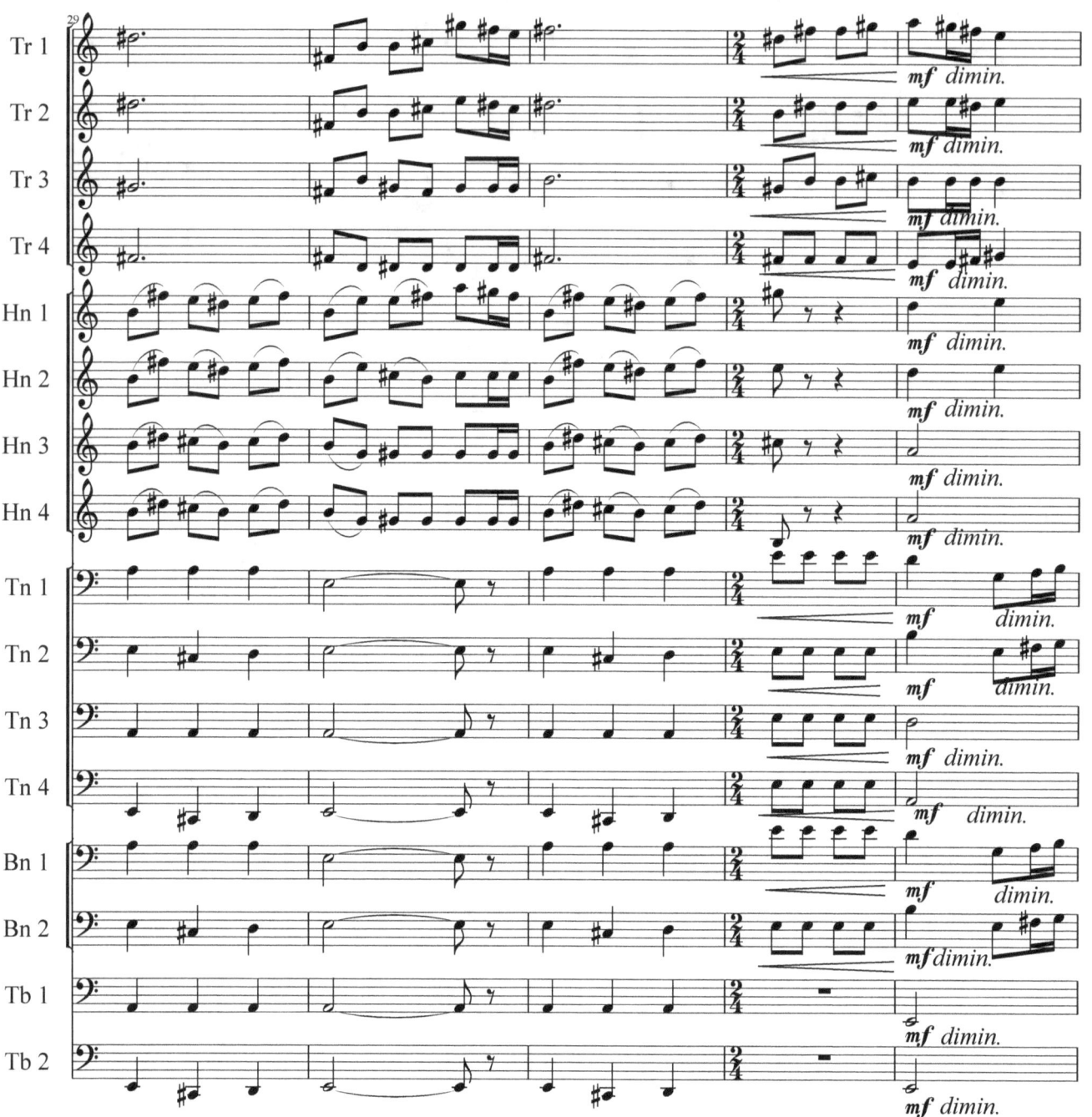

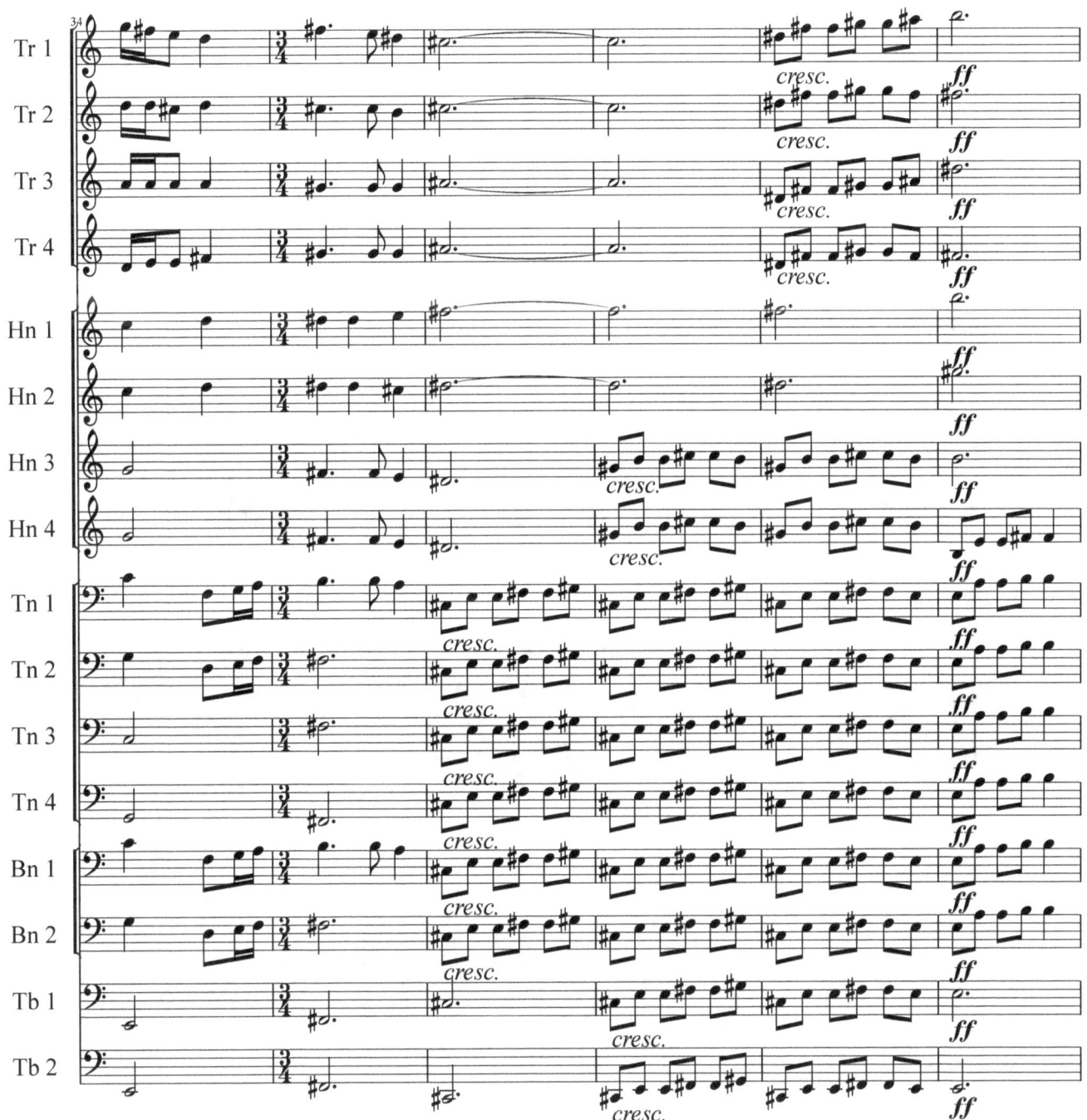

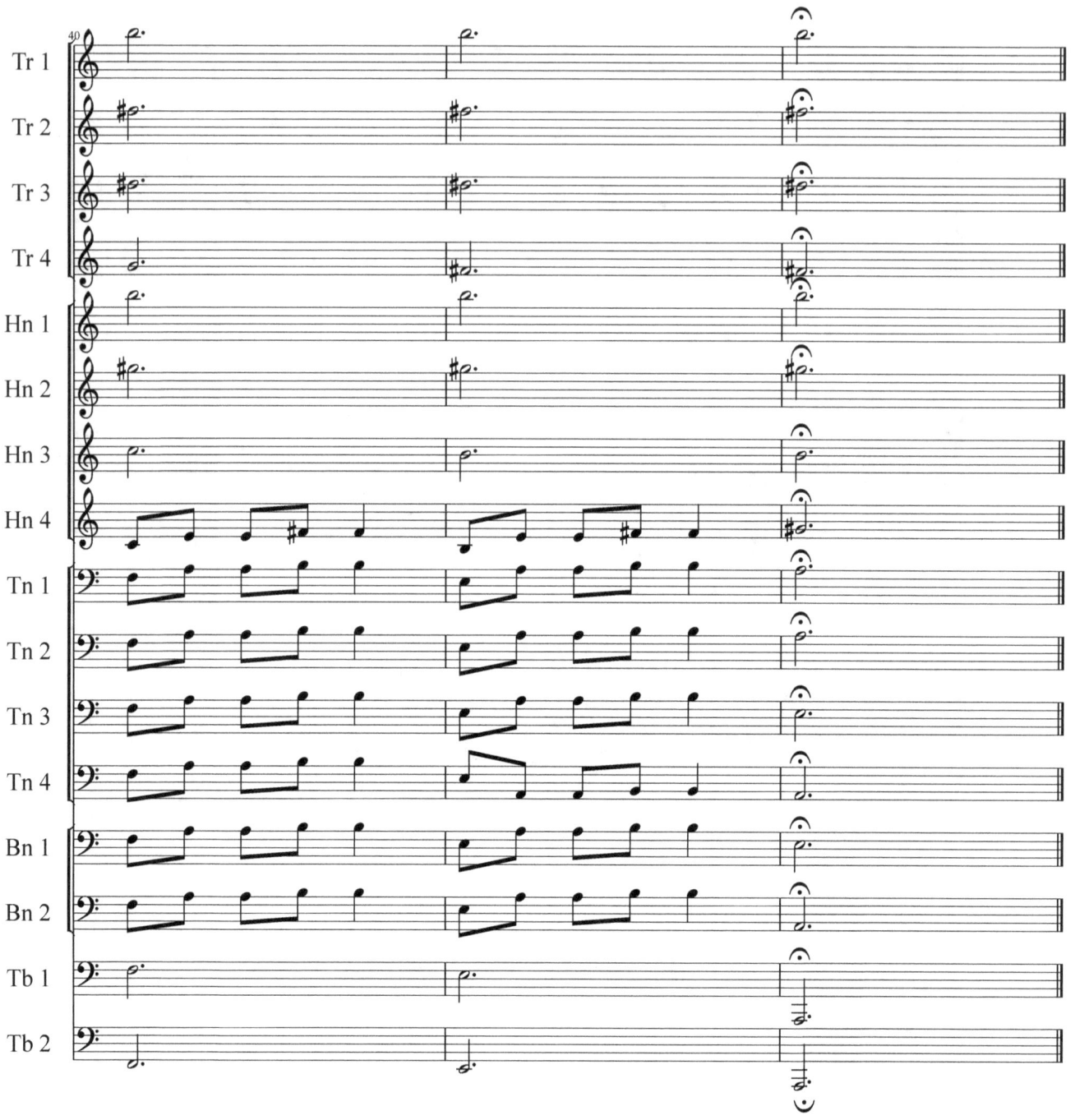

Missa Unitas
Prelude

Ken Langer

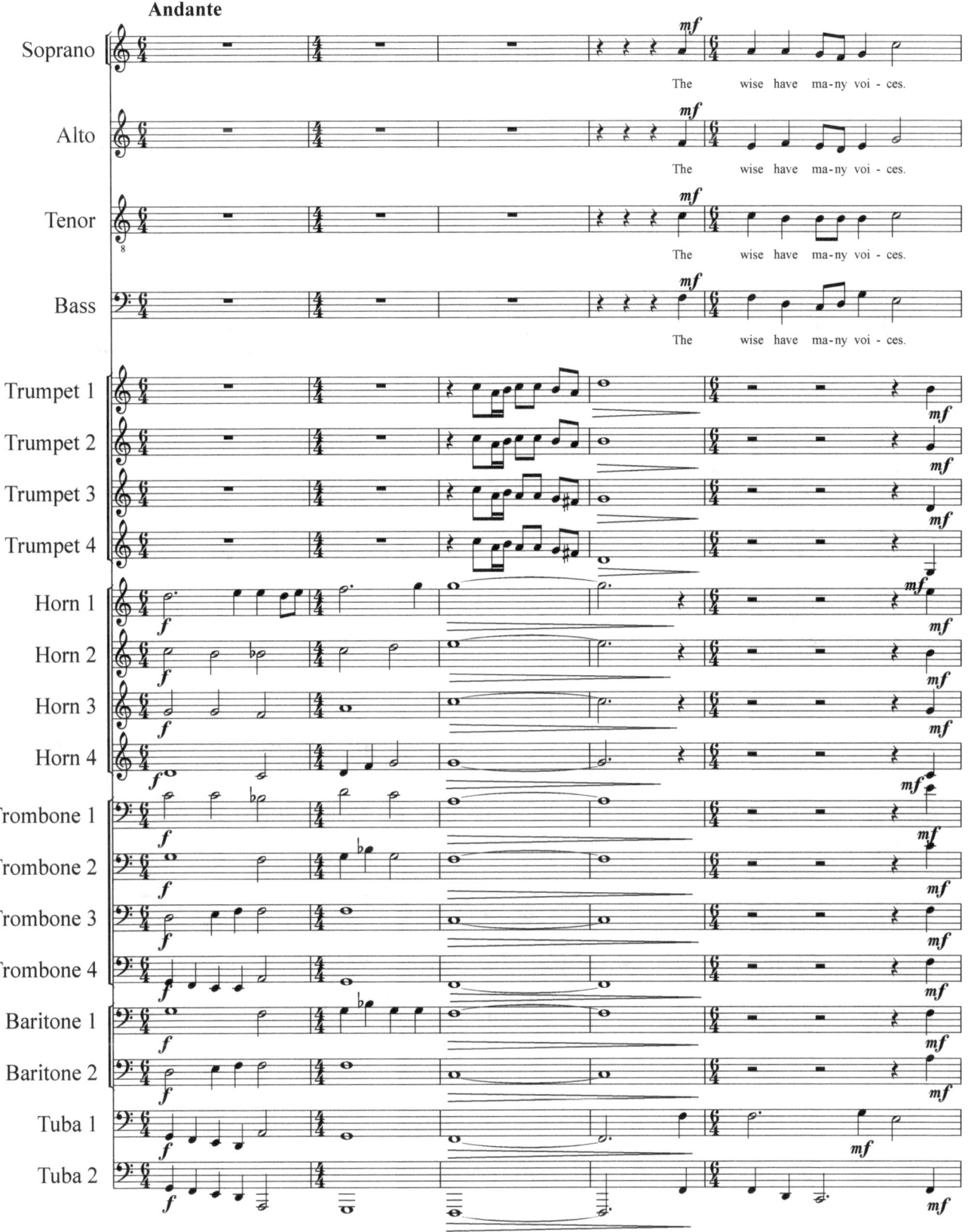

17

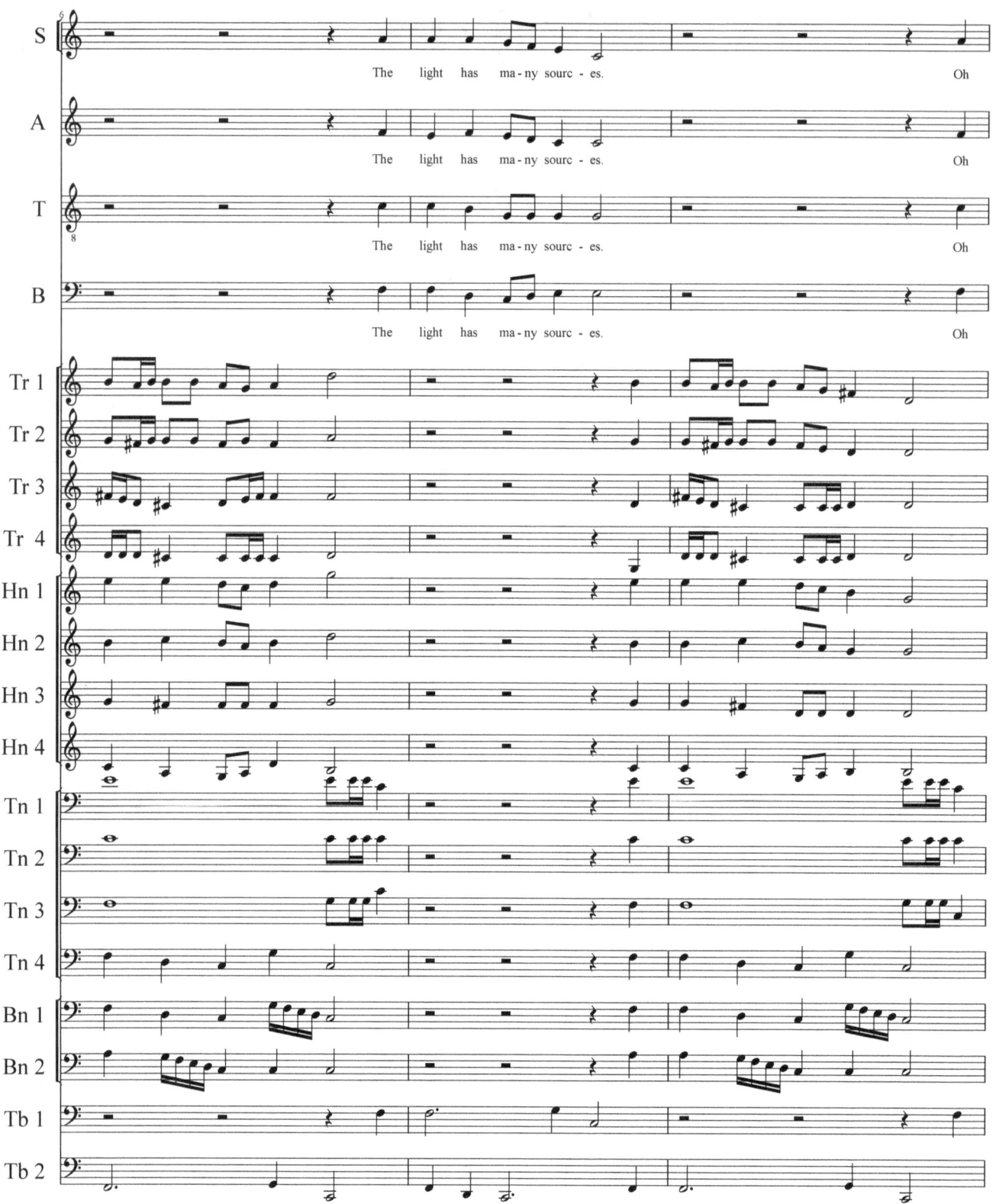

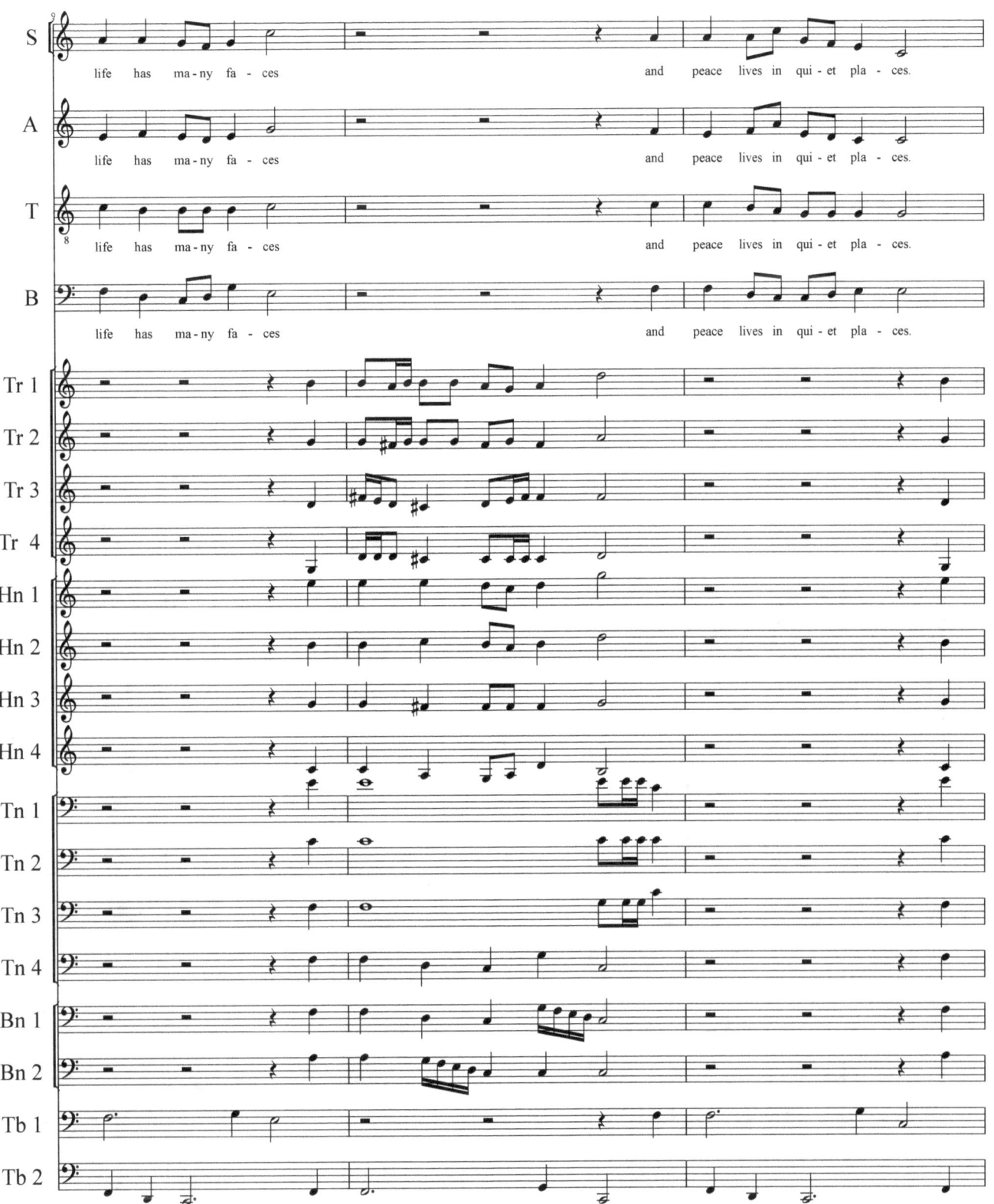

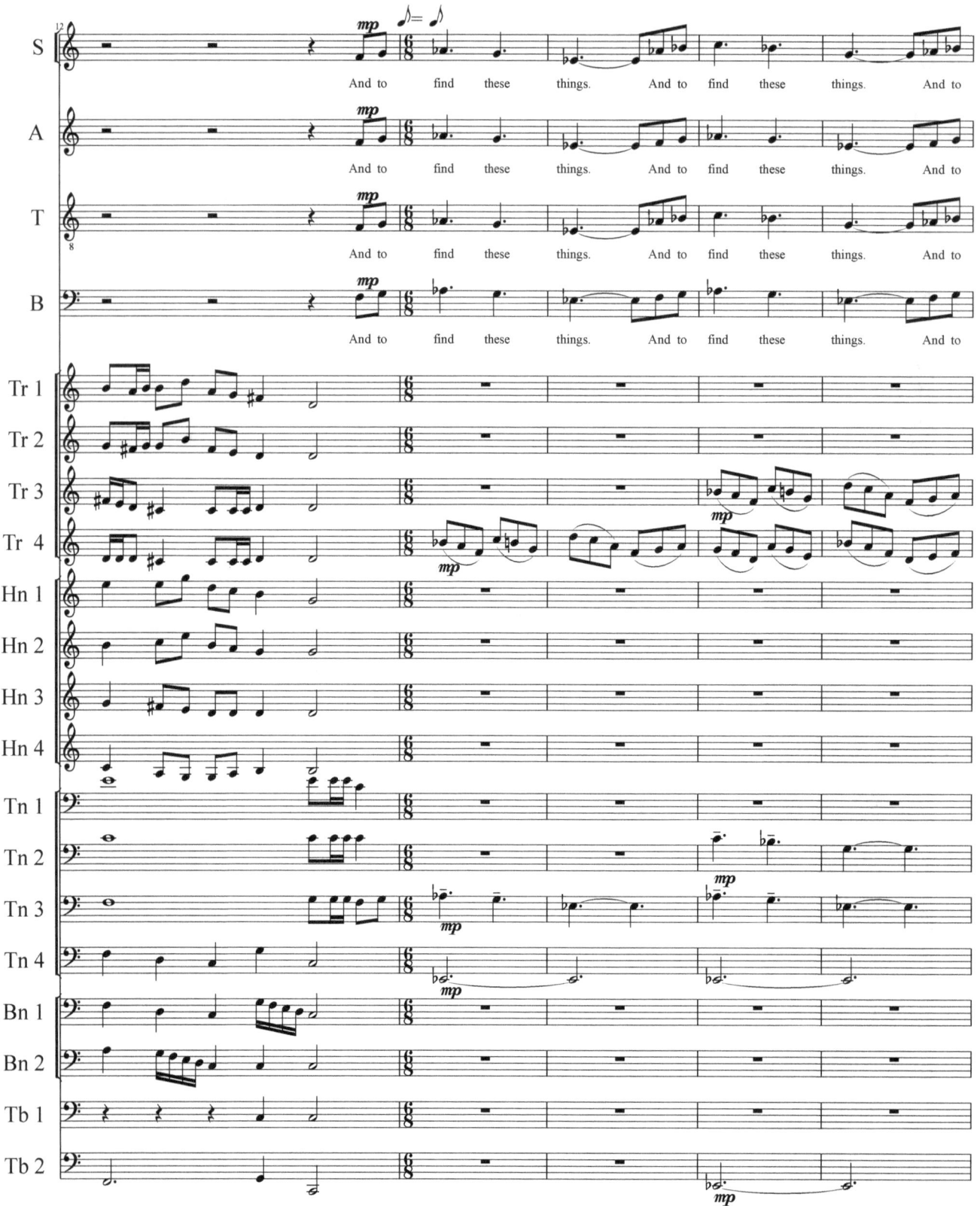

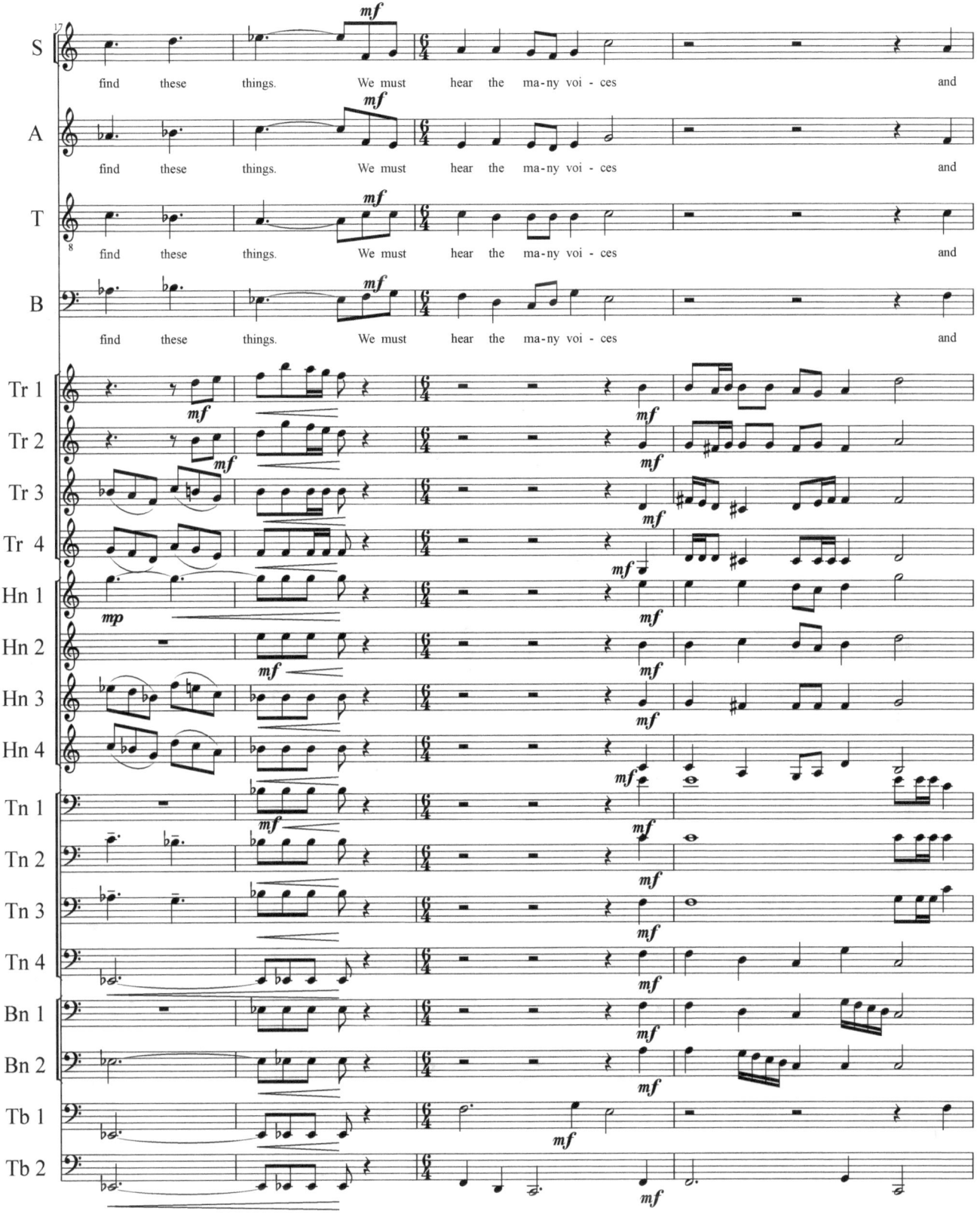

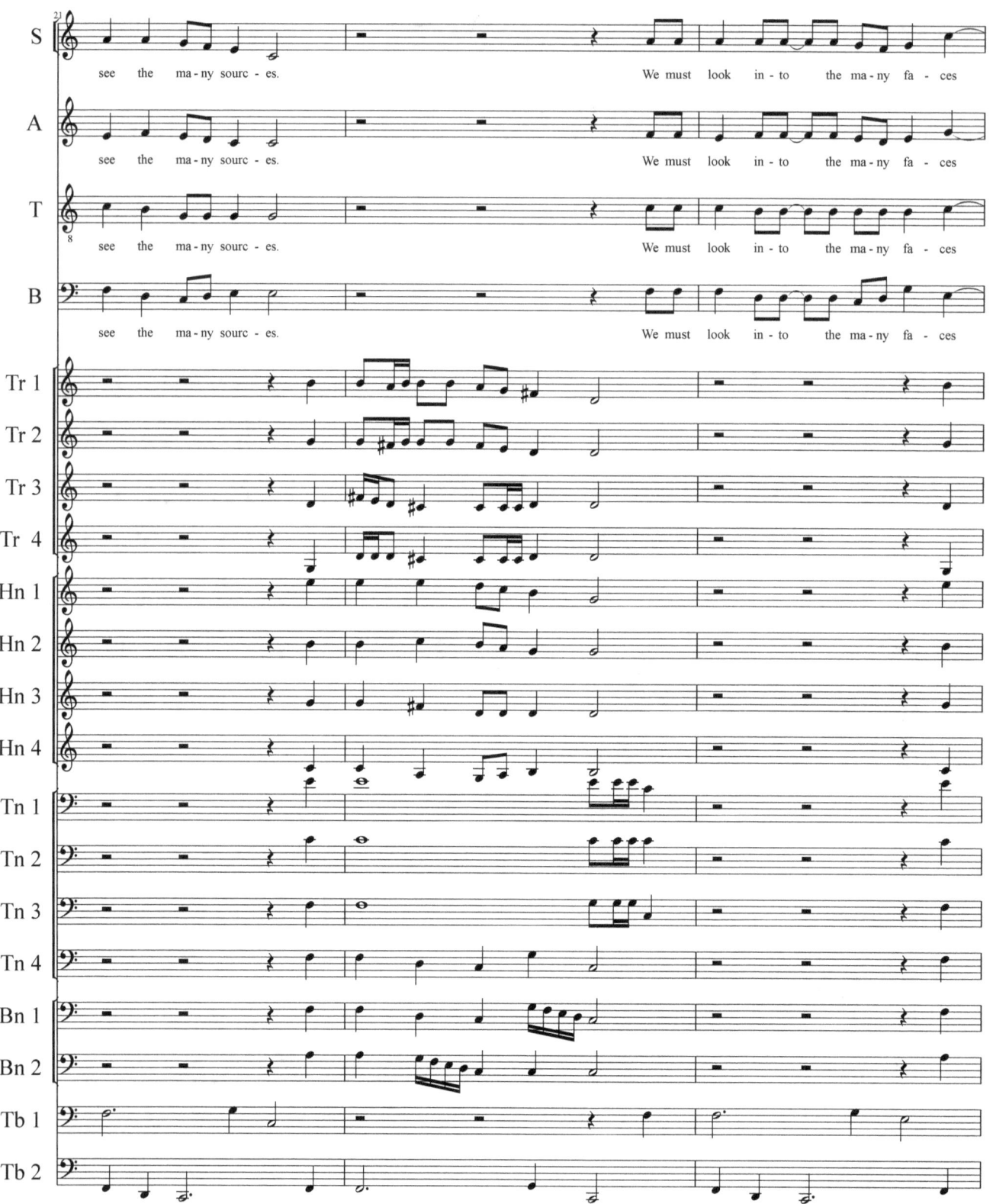

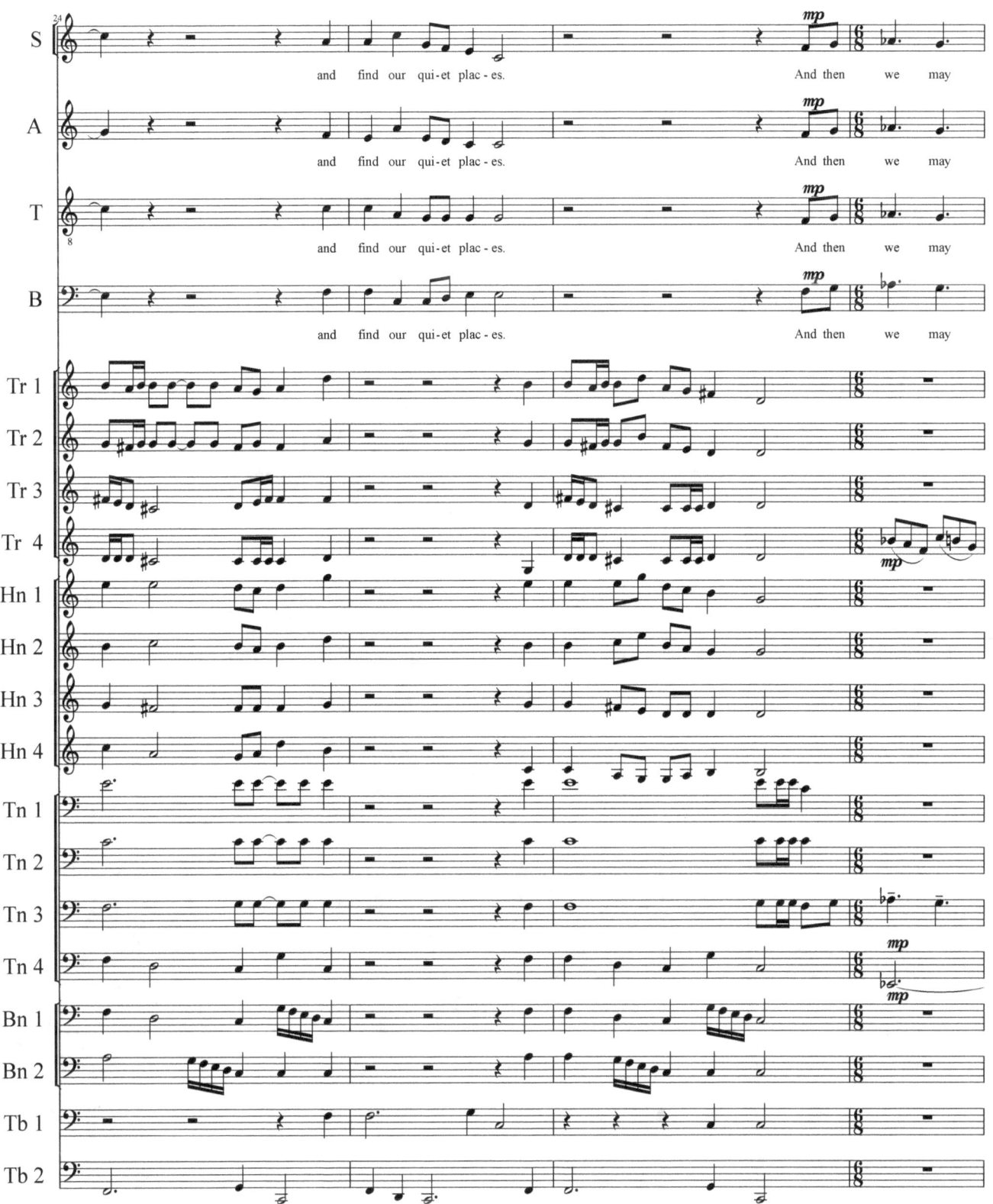

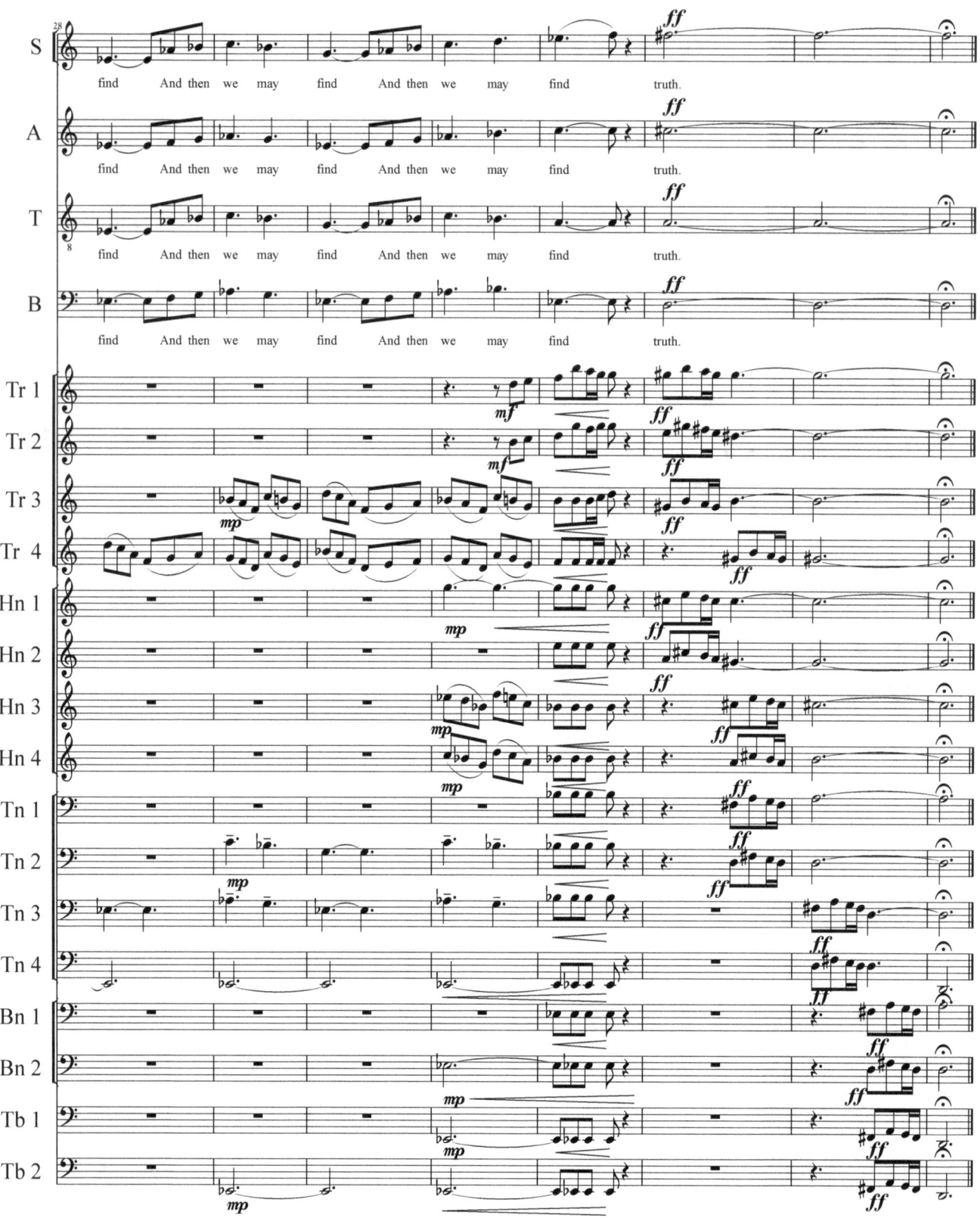

Missa Unitas
Kyrie Call

Ken Langer

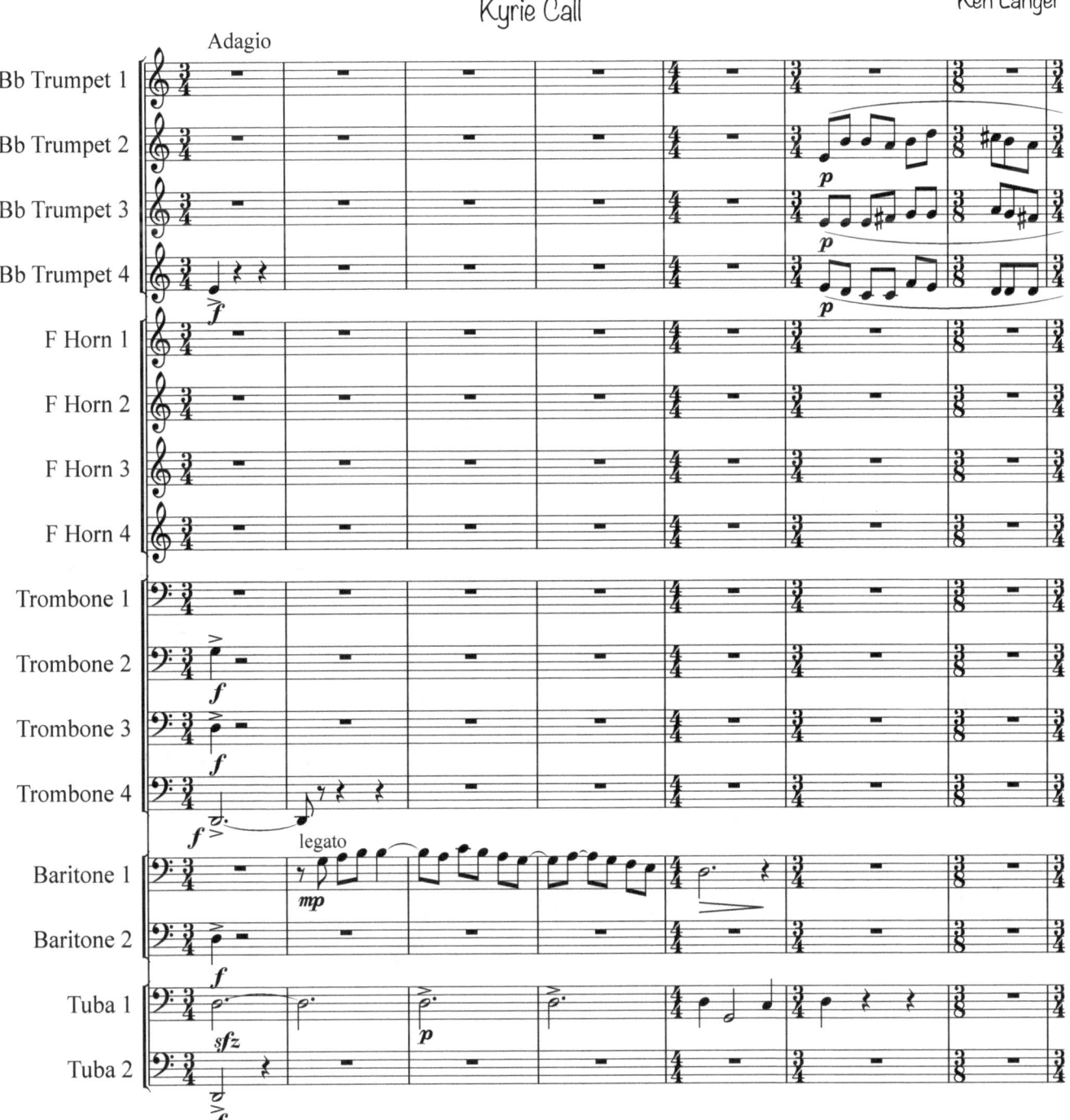

25

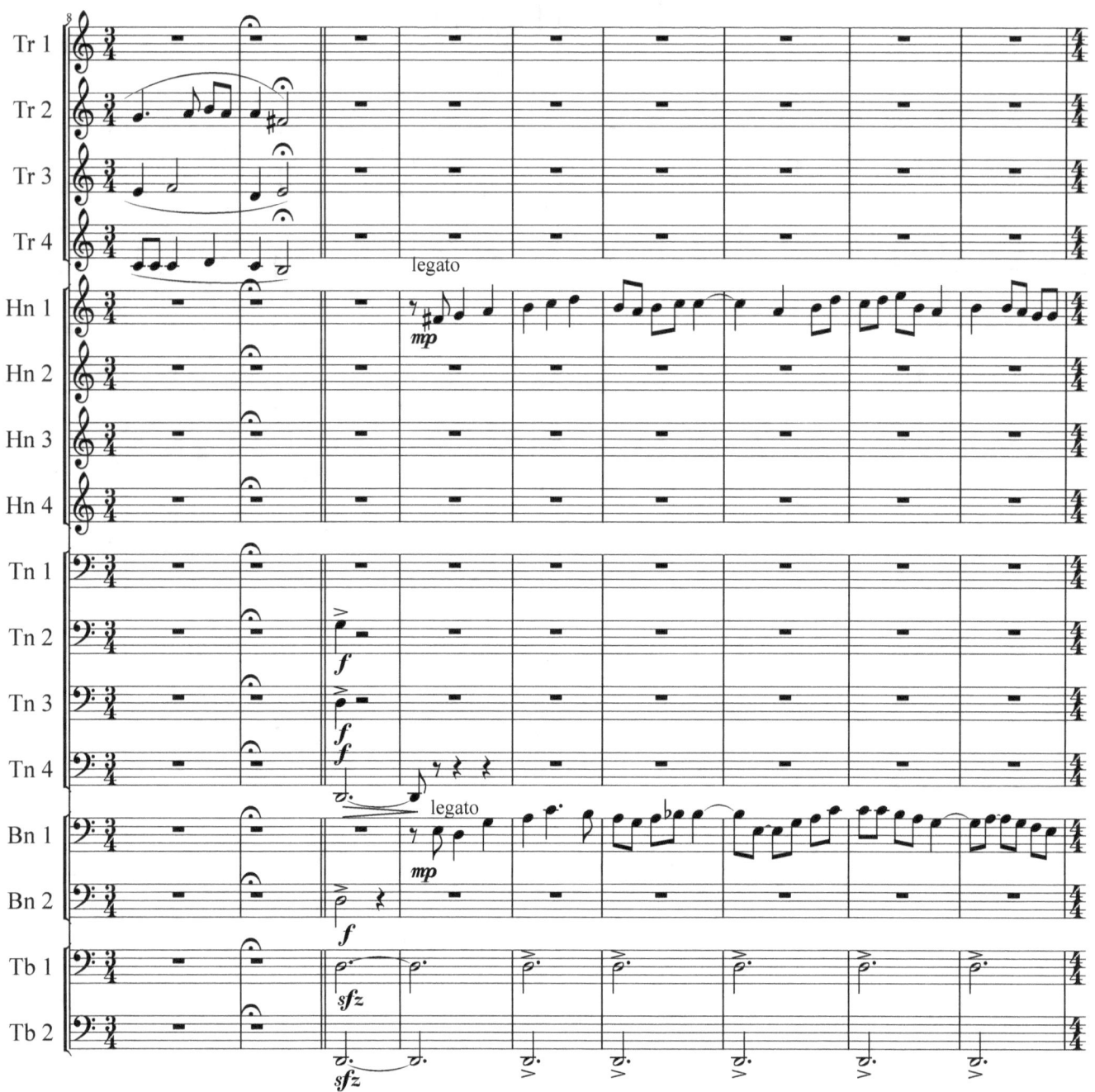

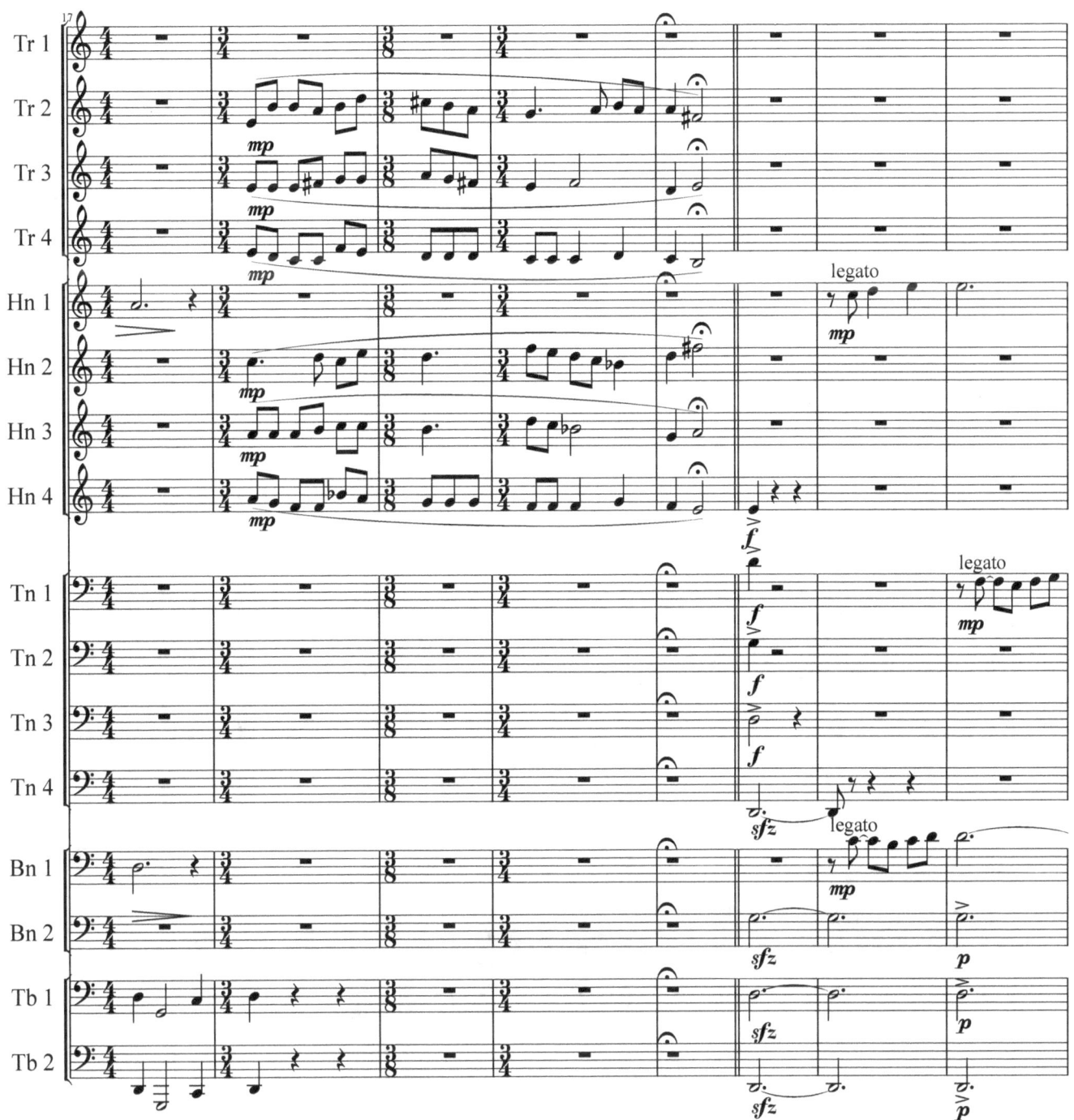

27

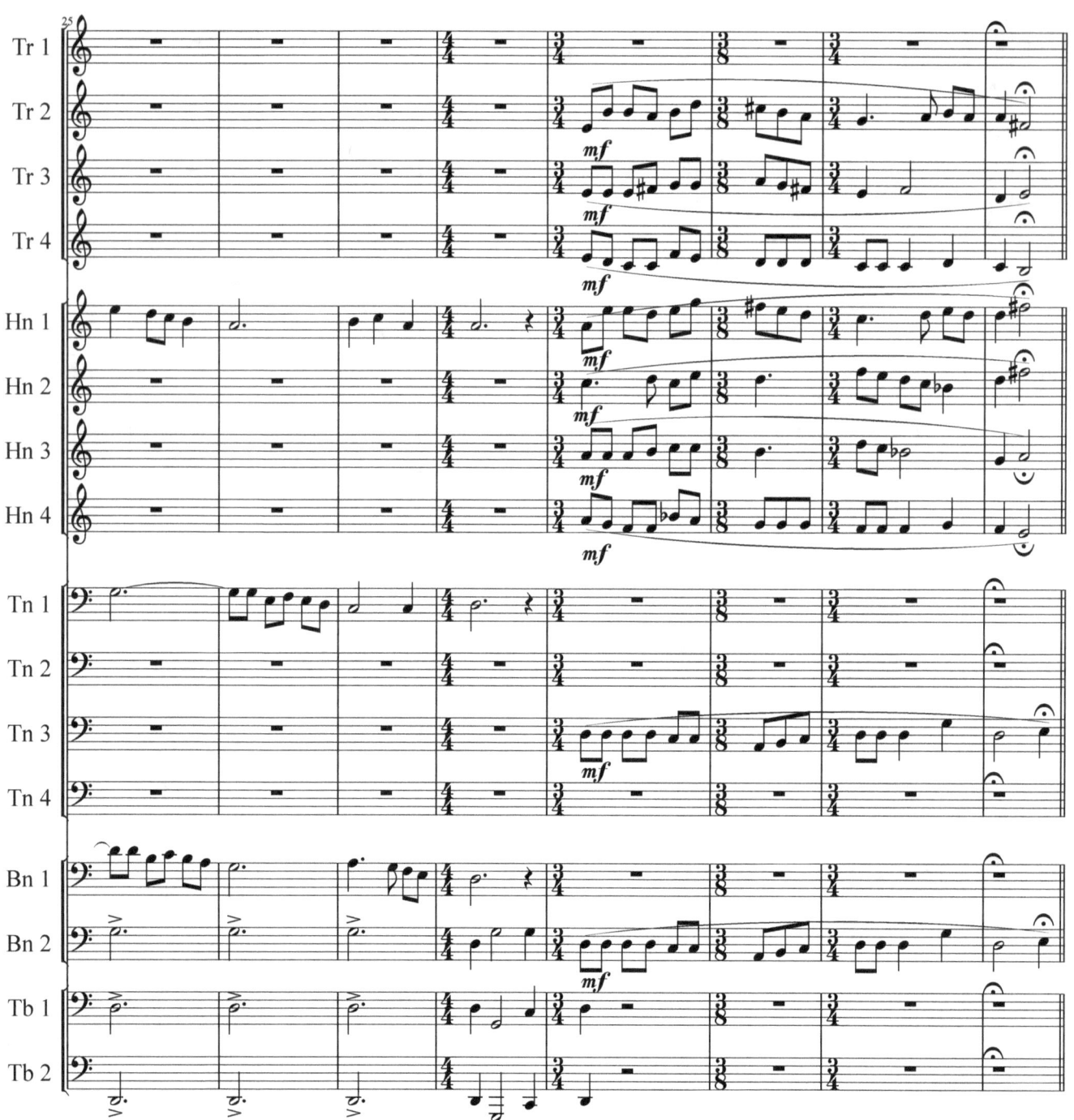

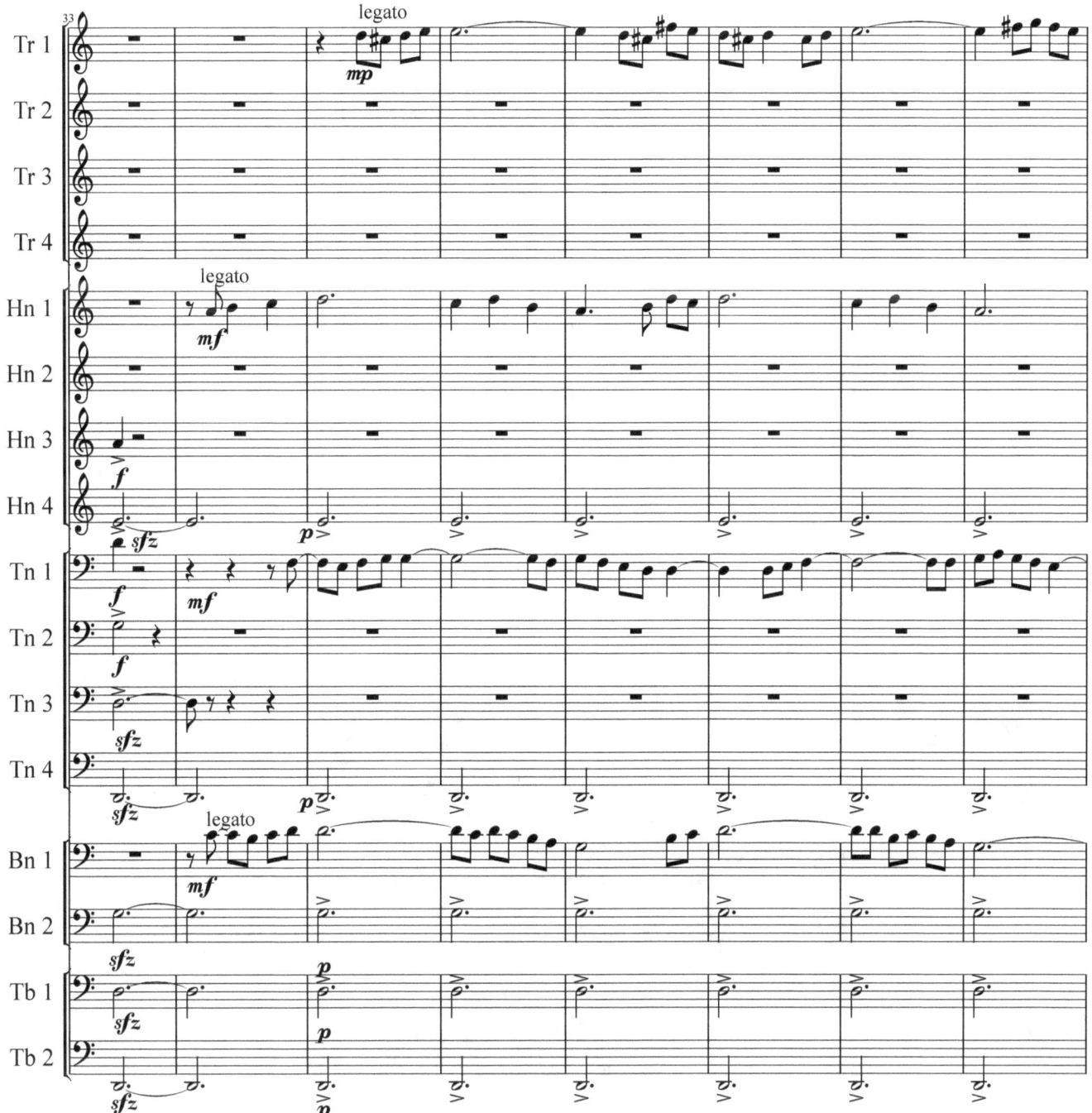

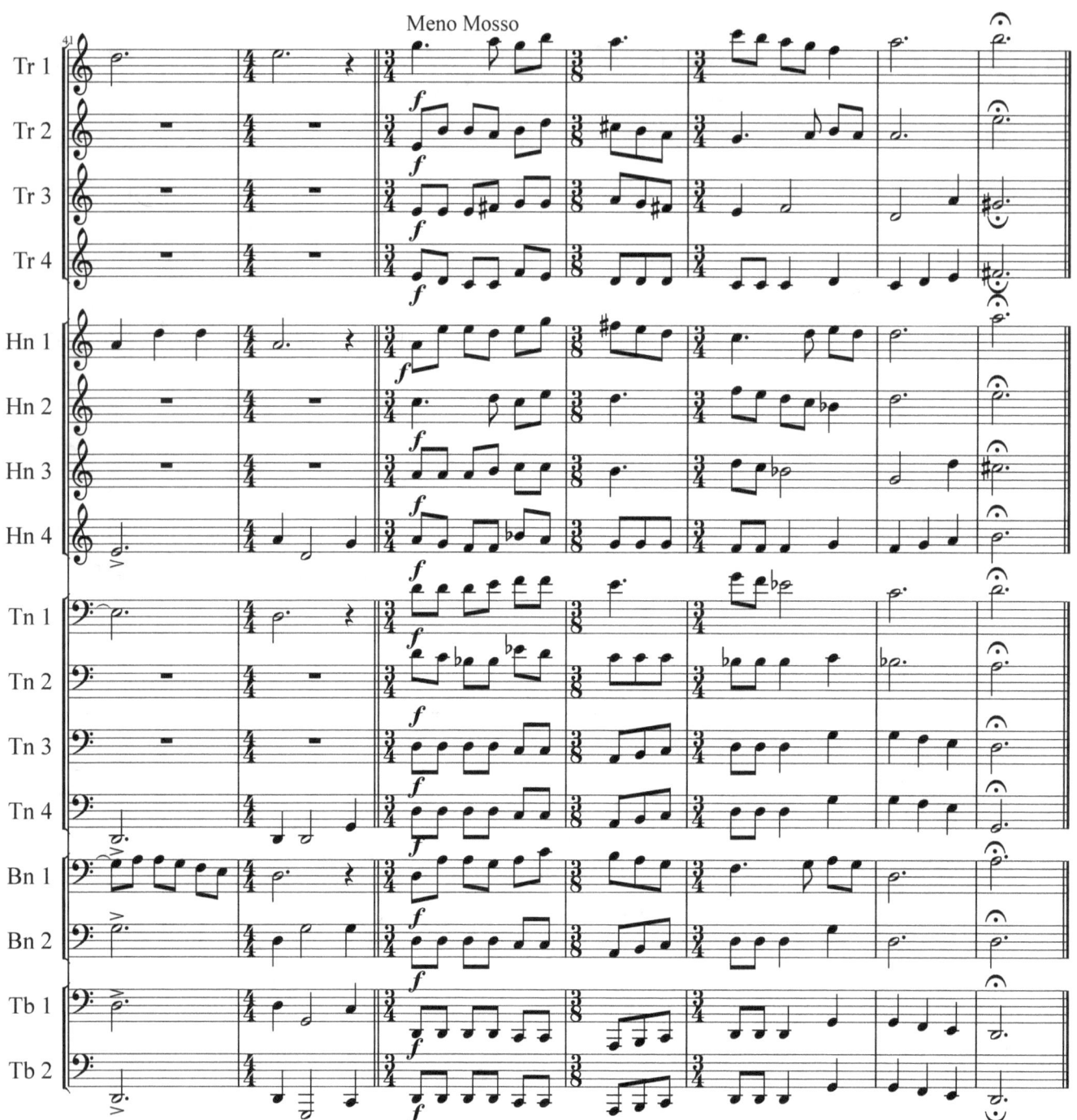

Missa Unitas

Kyrie Response

Ken Langer

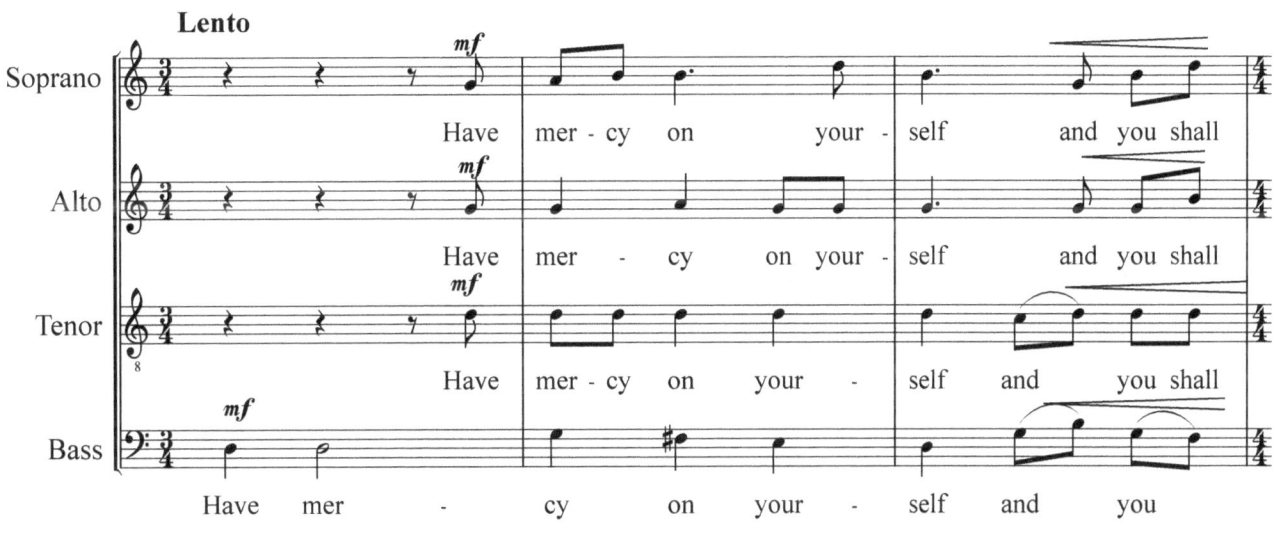
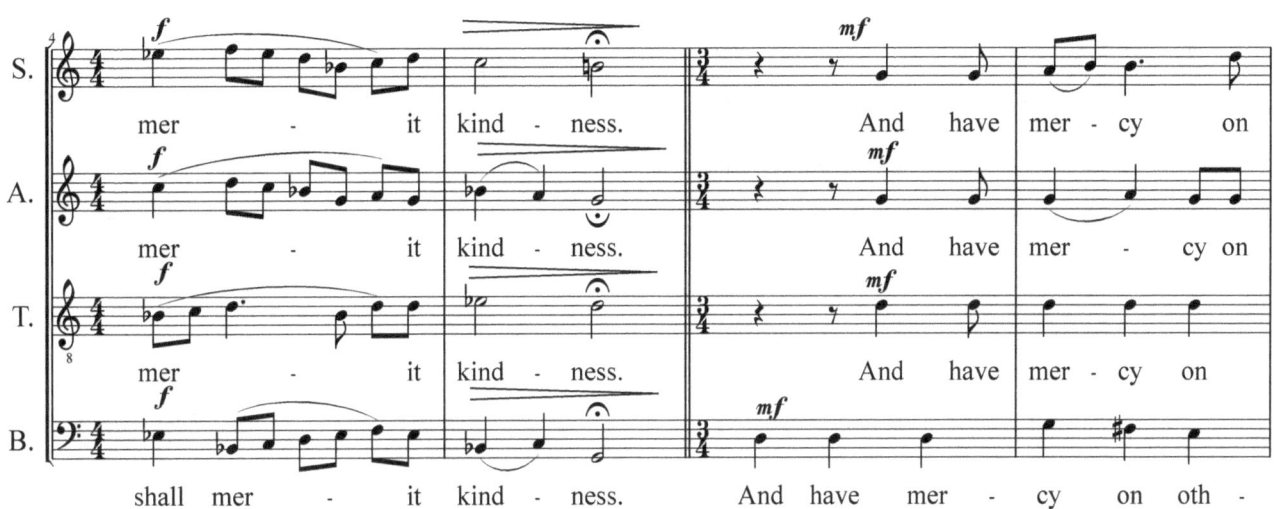
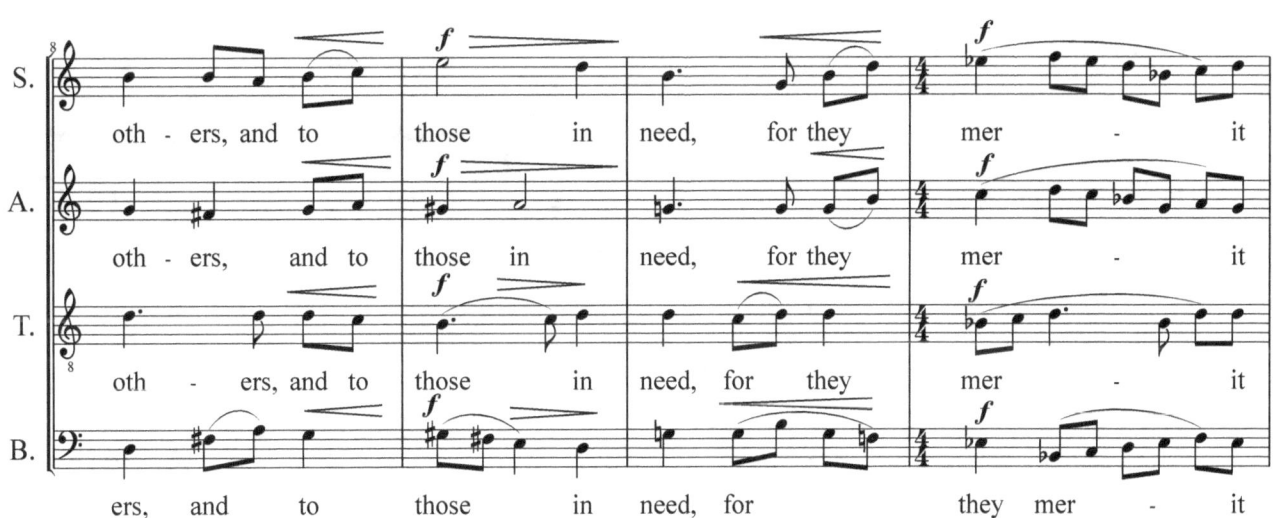

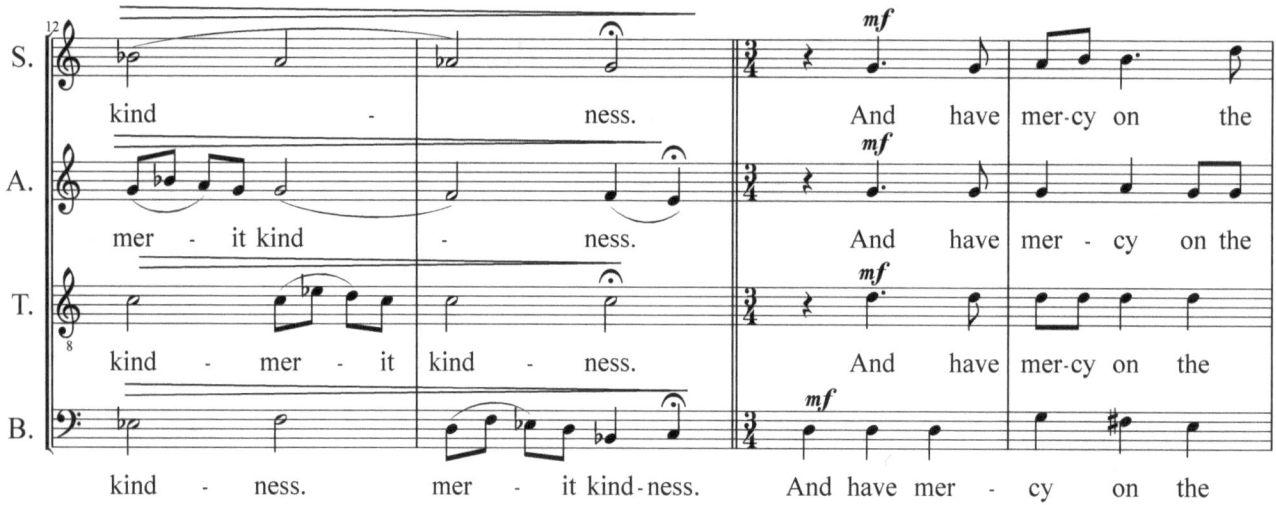
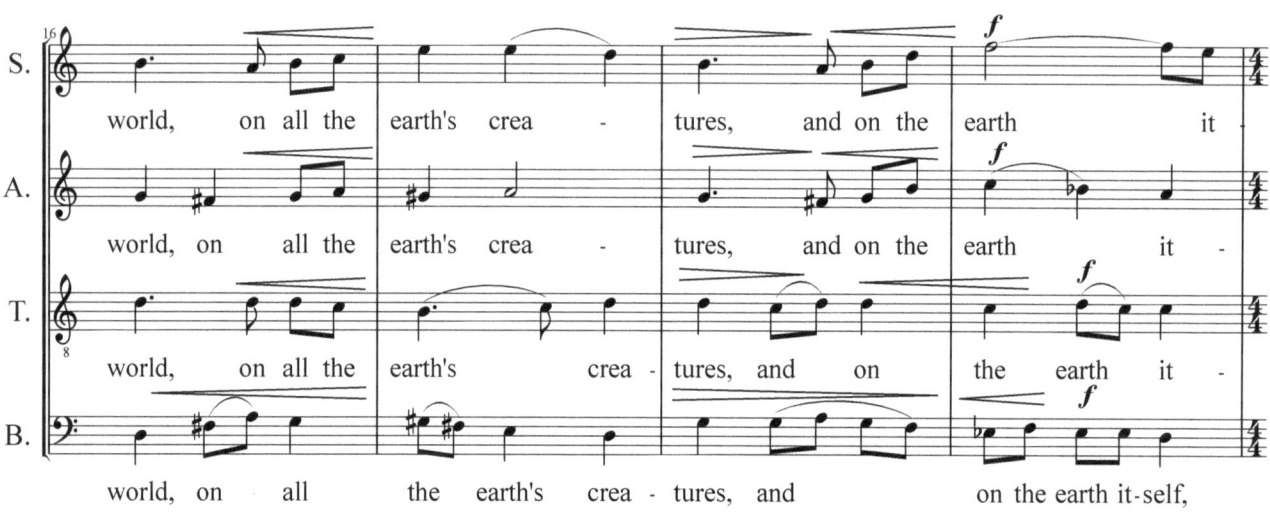
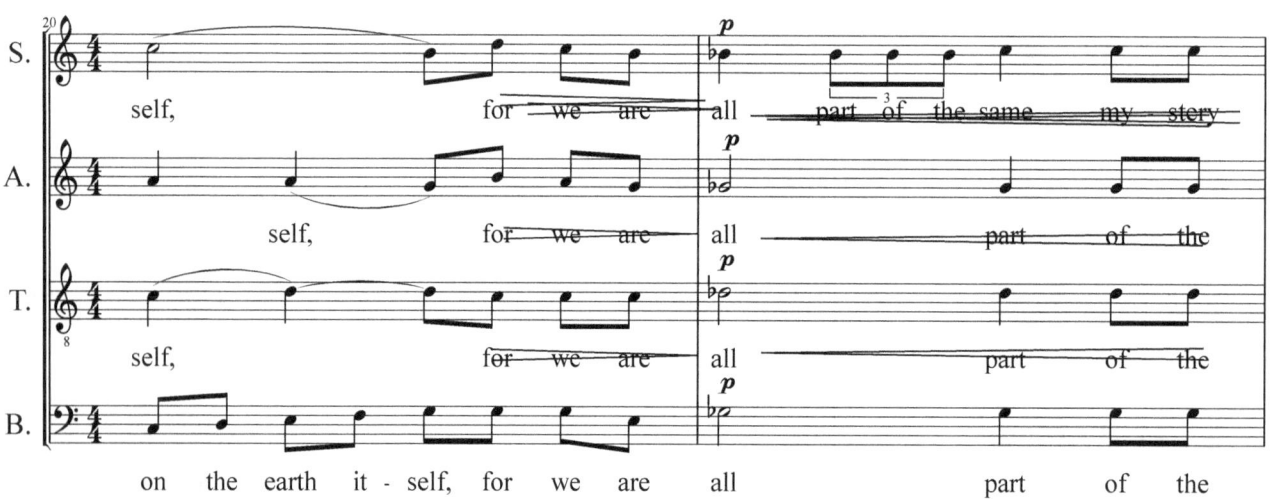

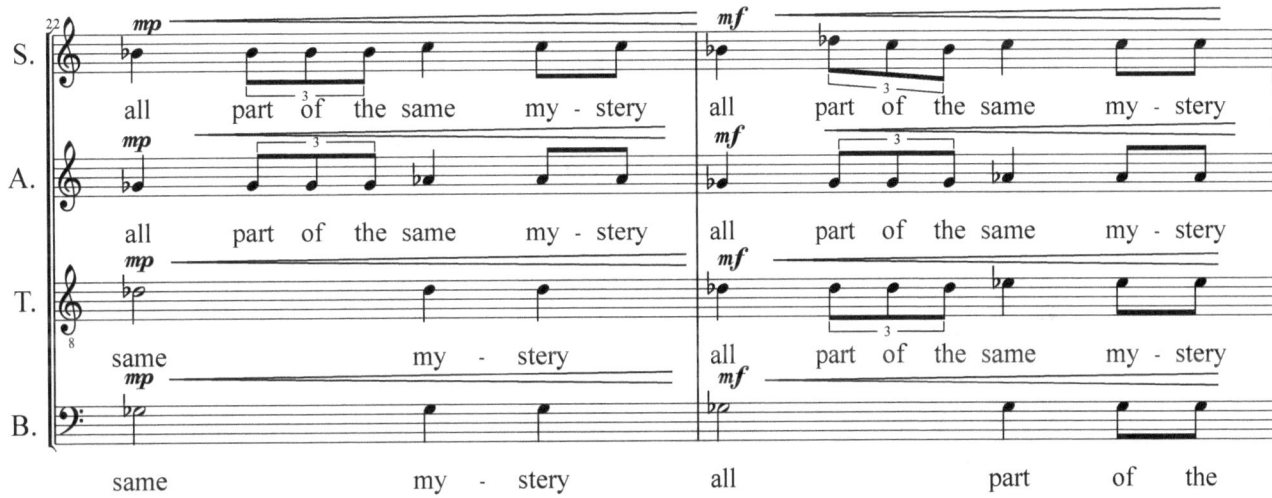
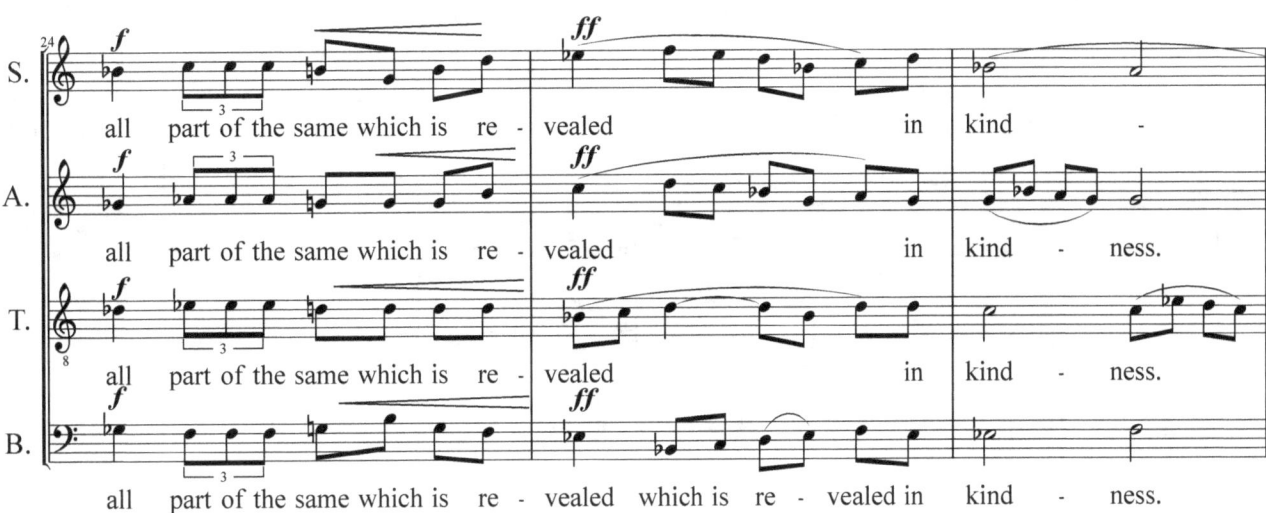
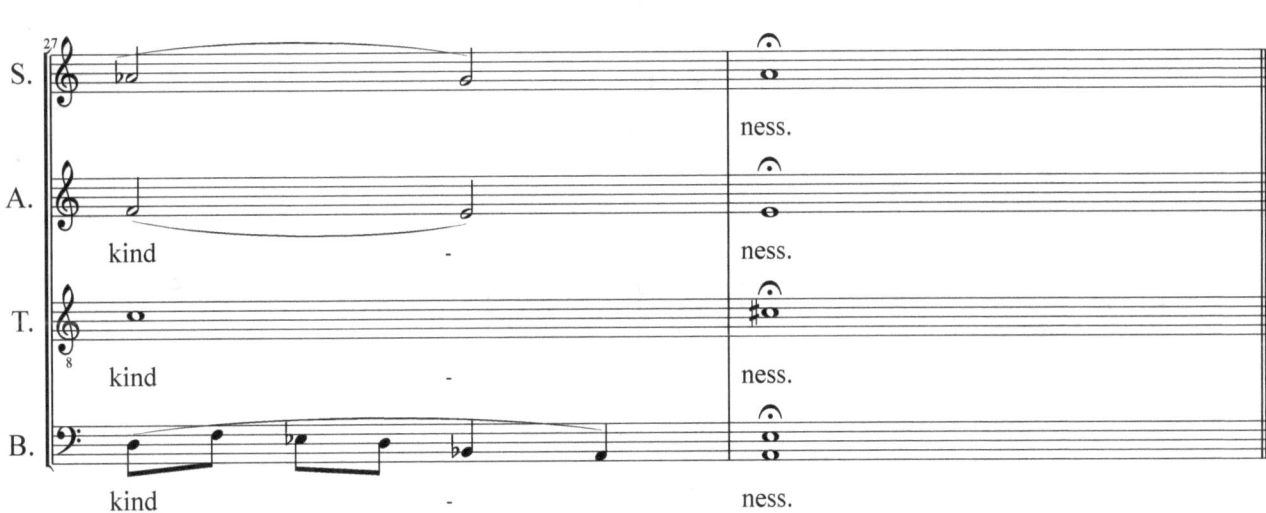

Missa Unitas
Canticle To Life

Ken Langer

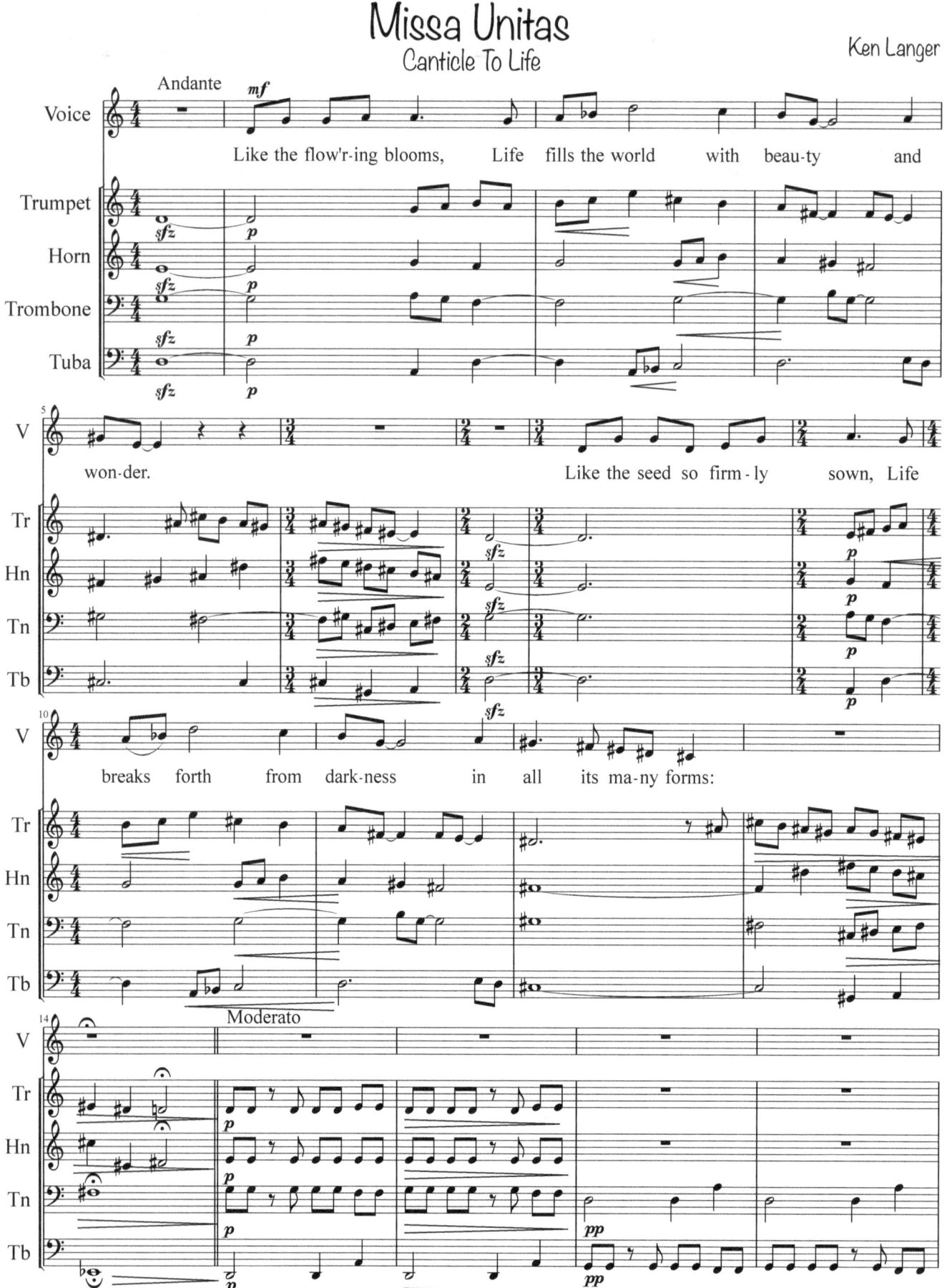

34

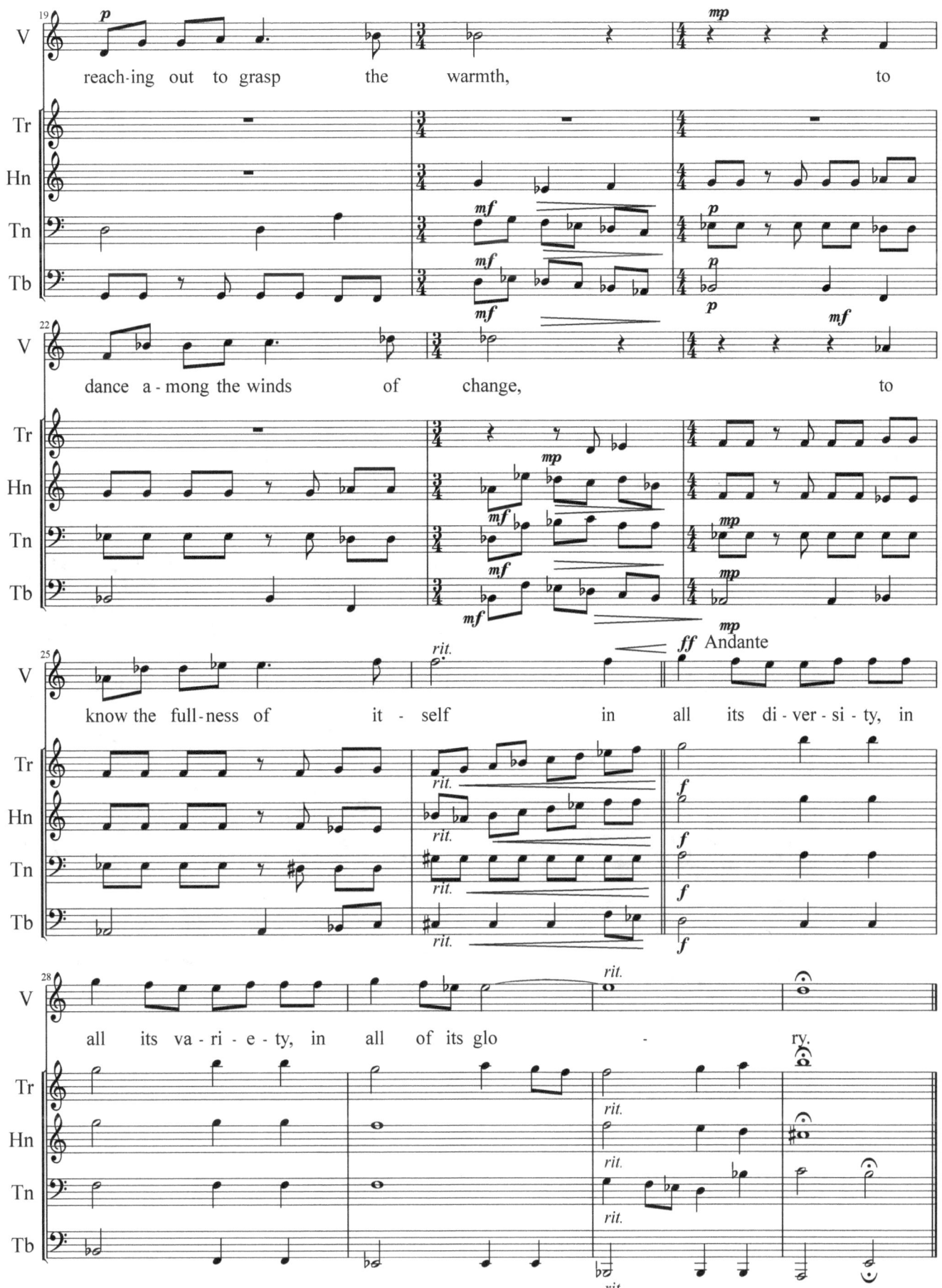

Missa Unitas
Gloria Call

Ken Langer

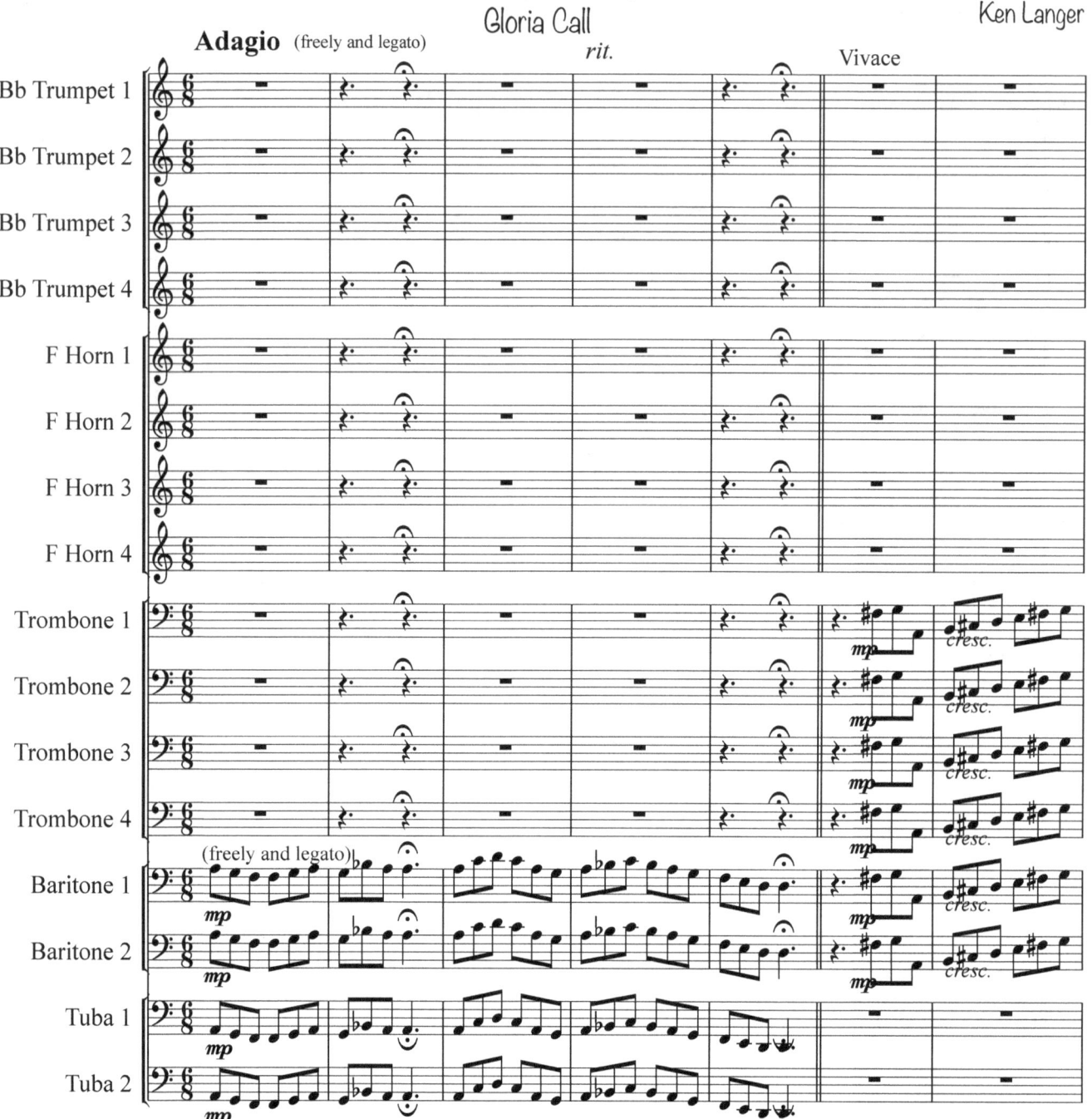

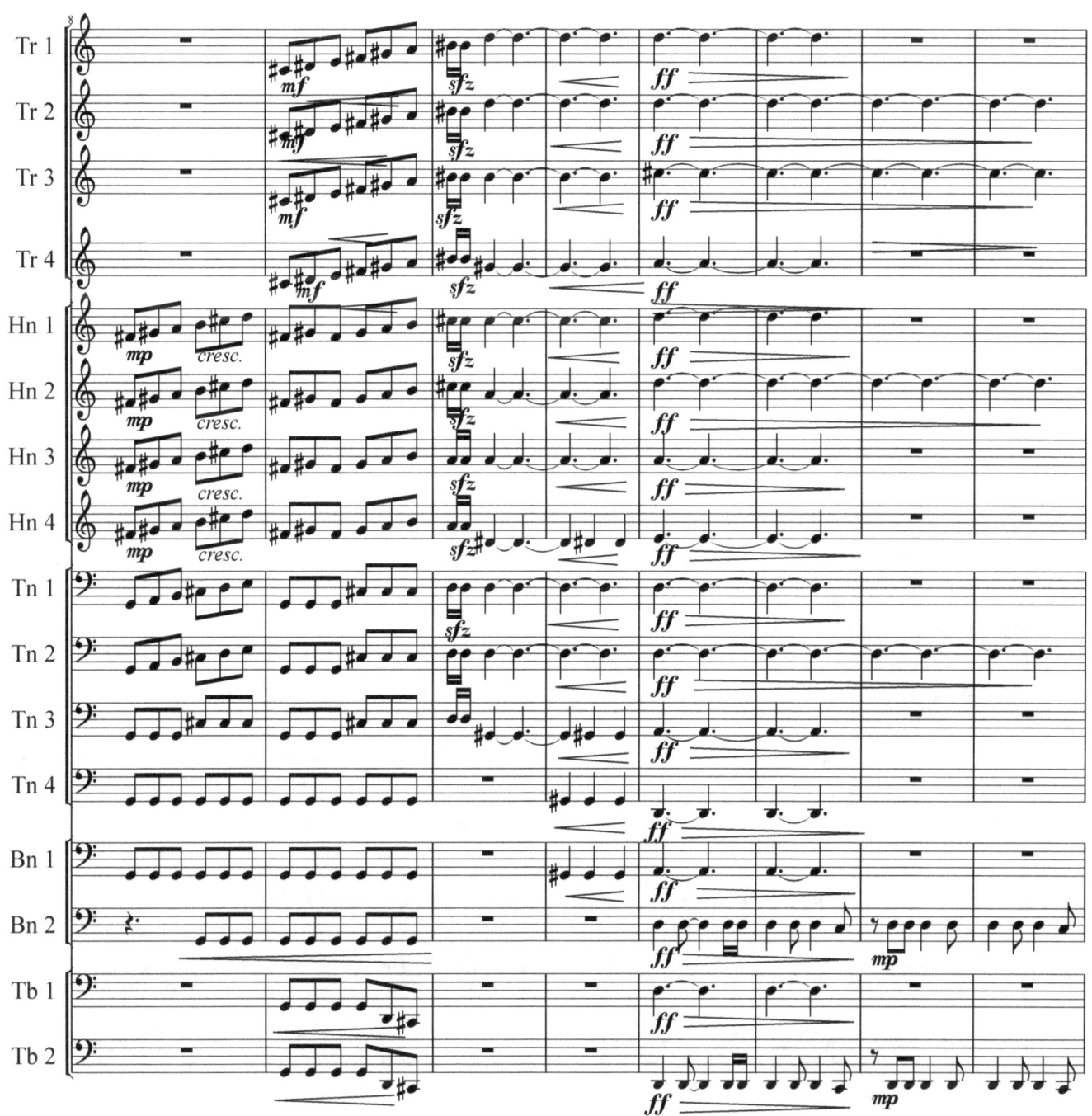

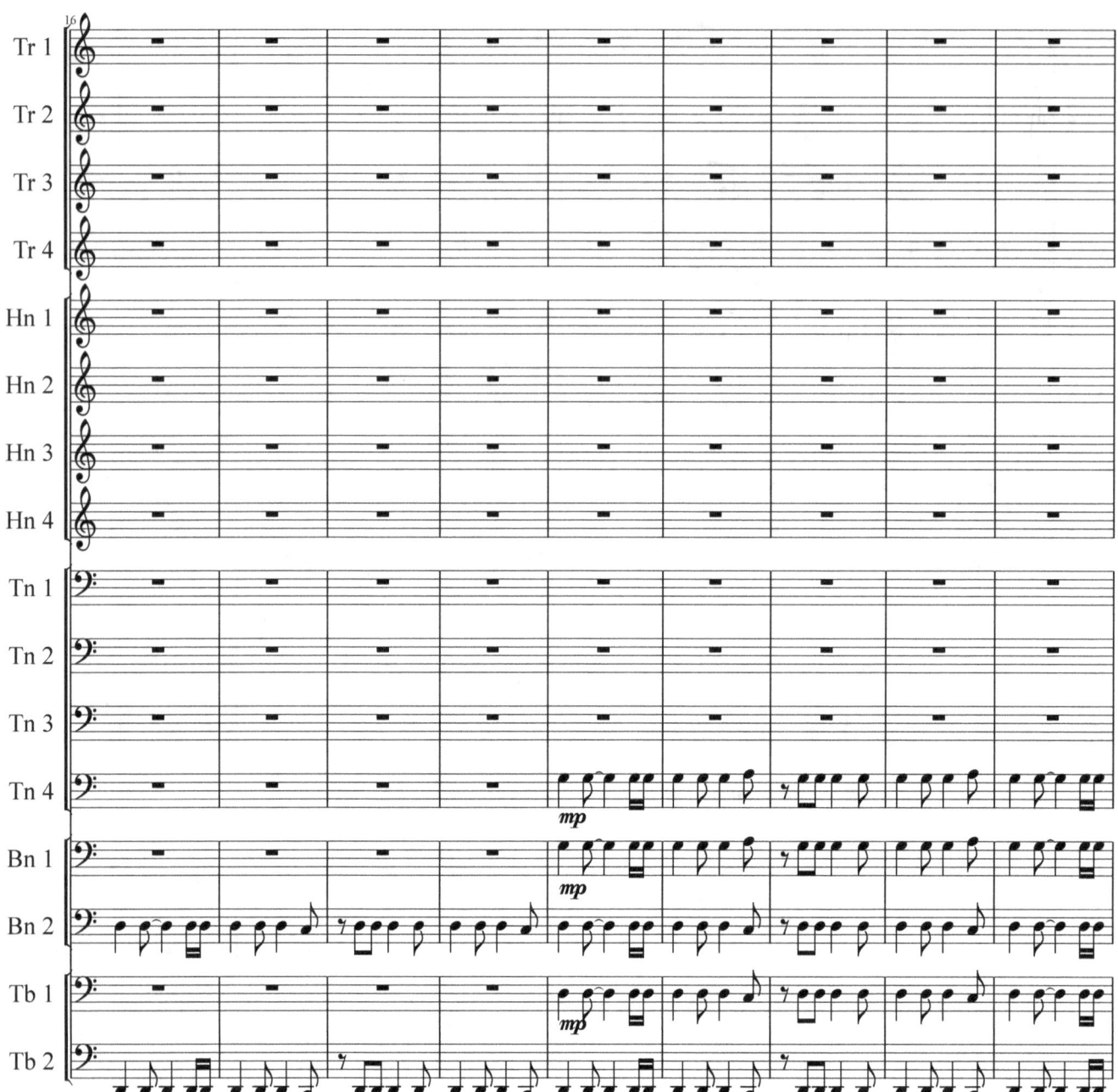

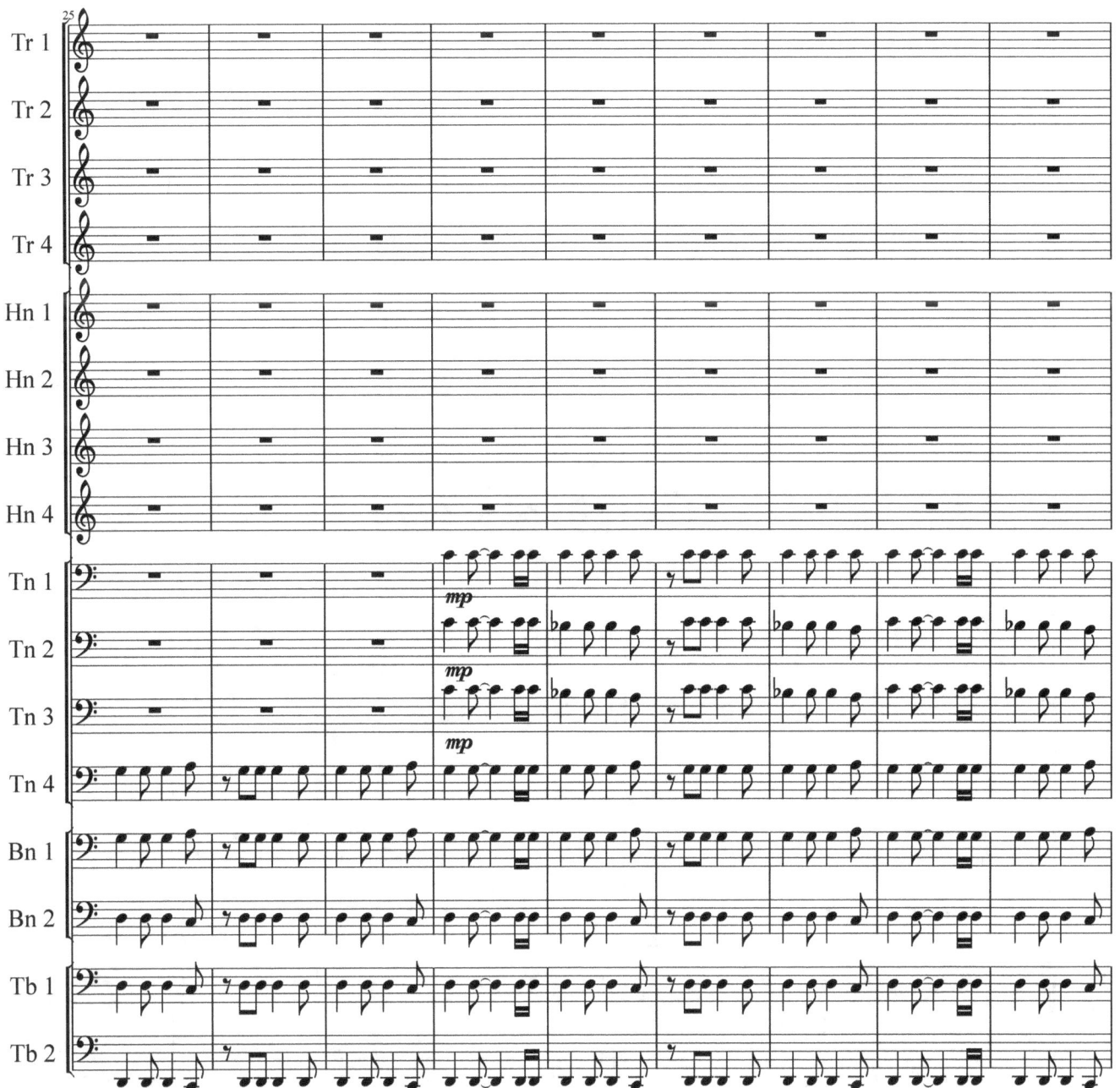

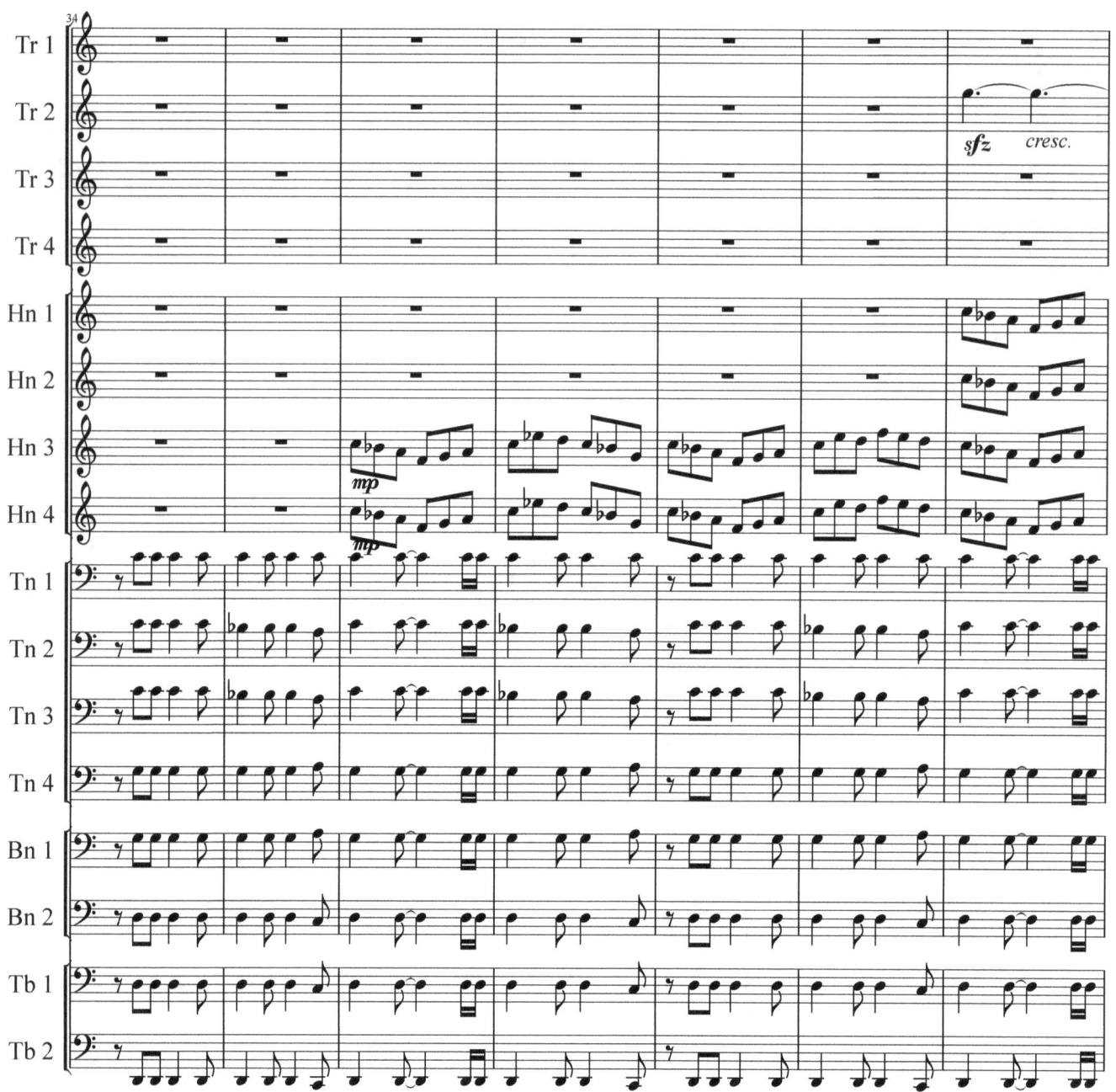

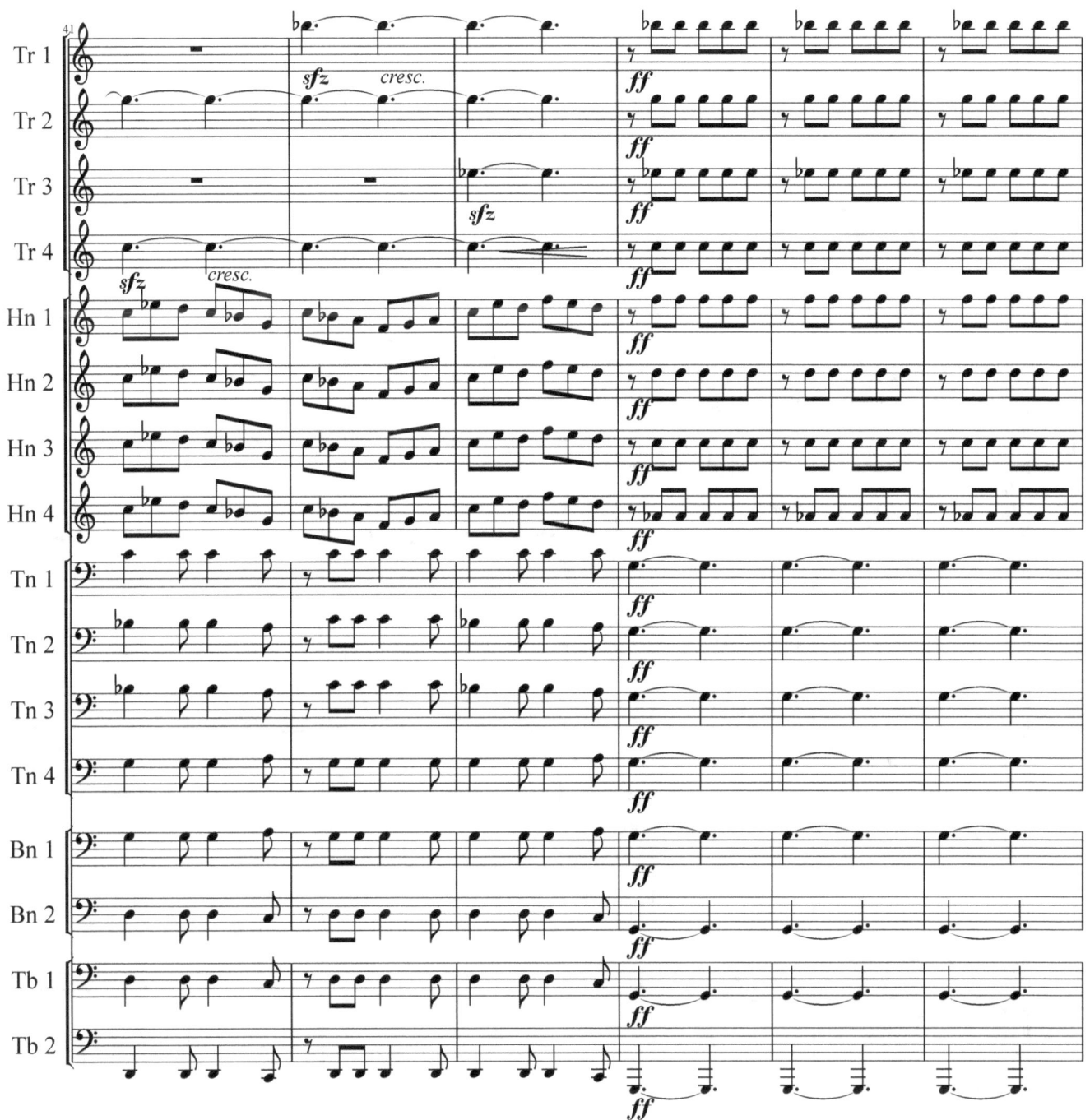

41

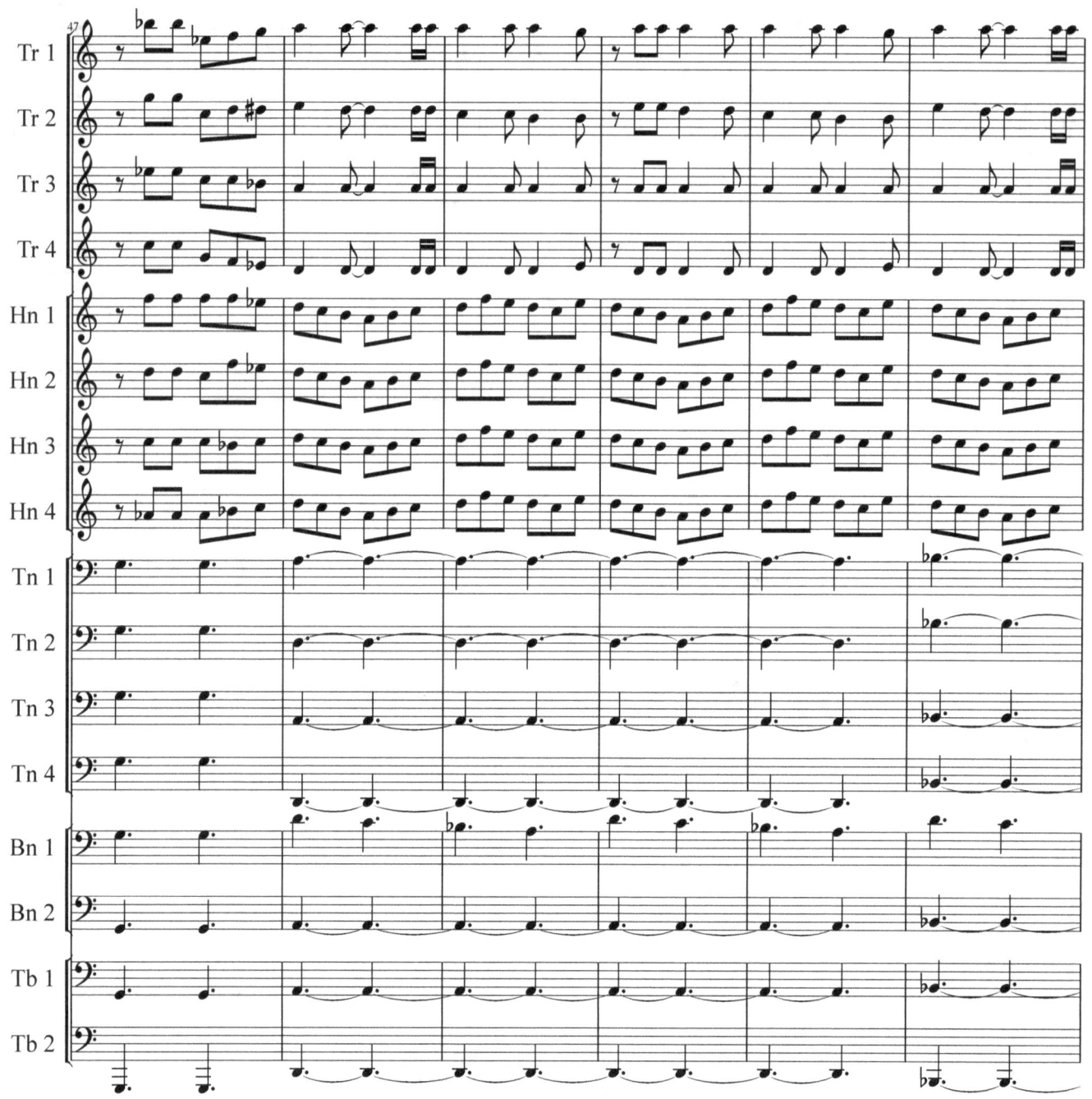

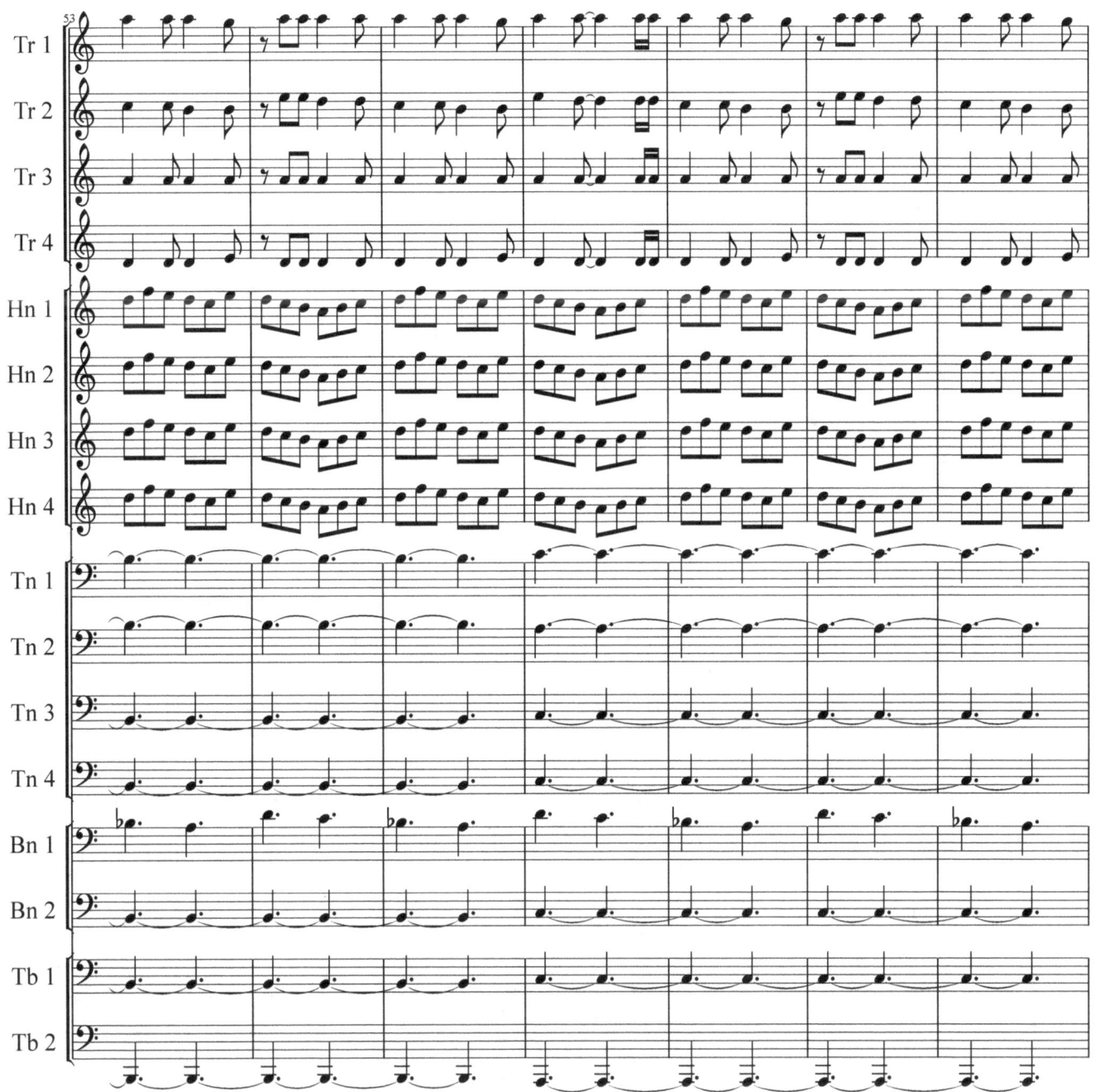

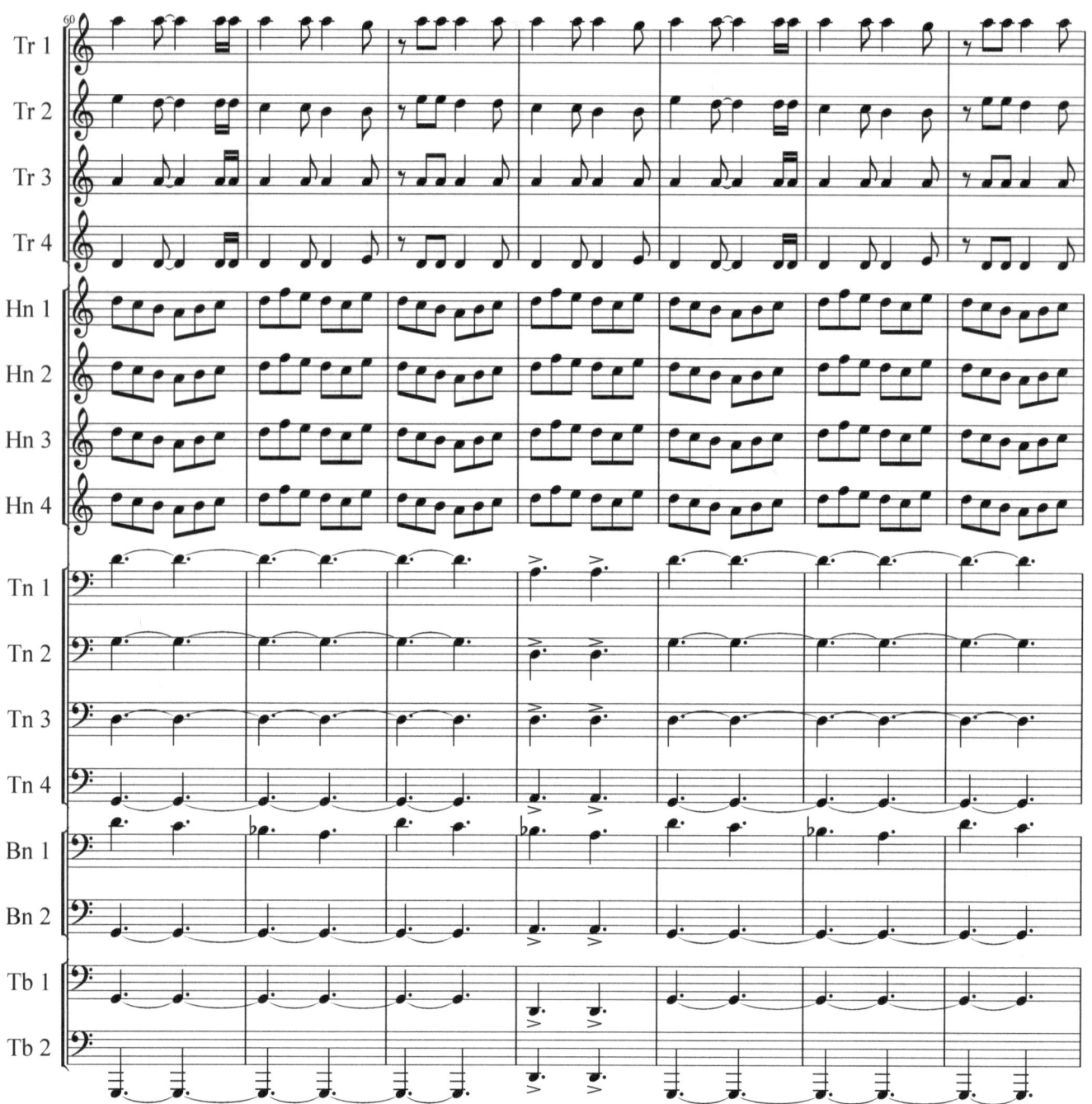

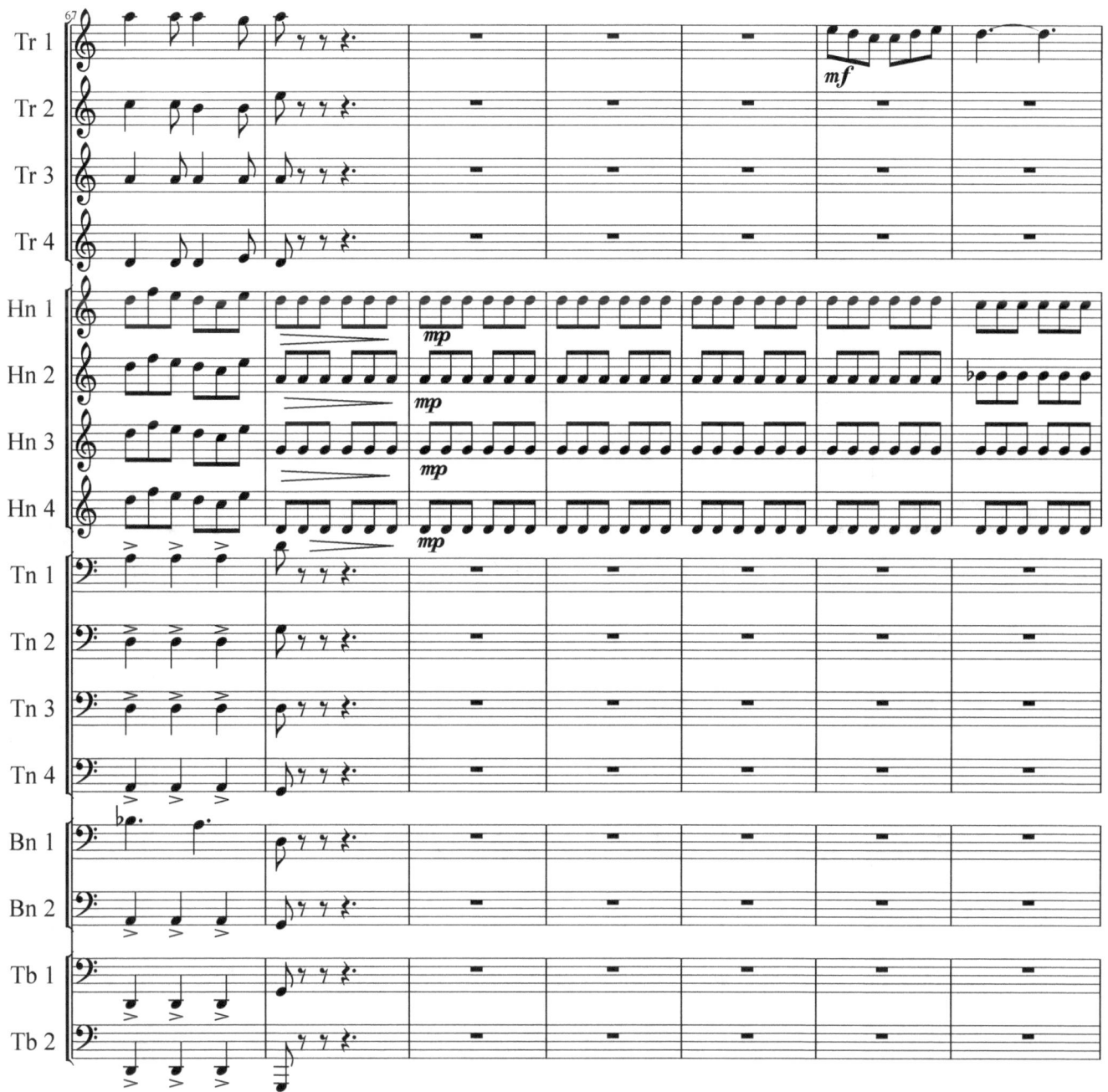

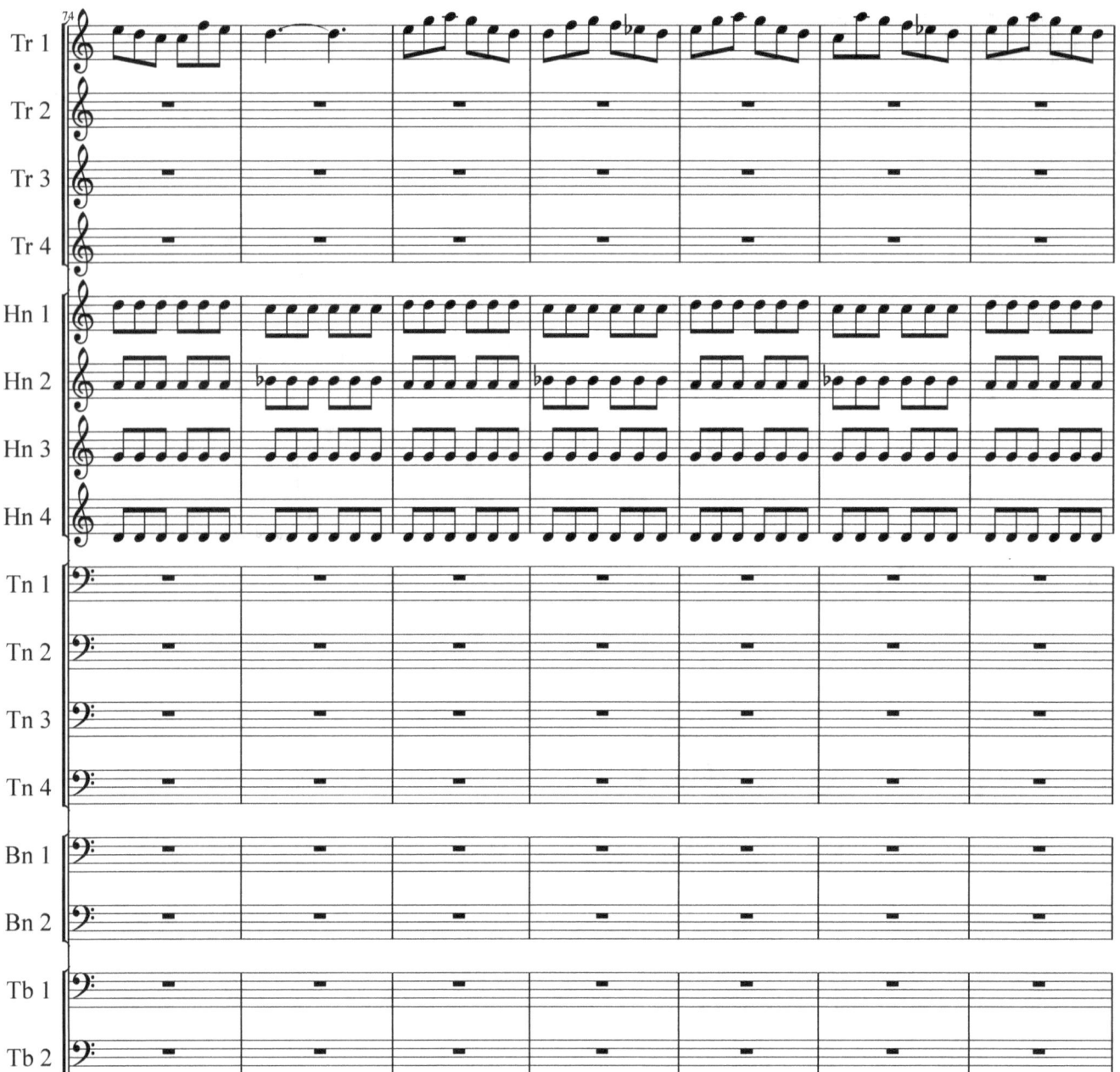

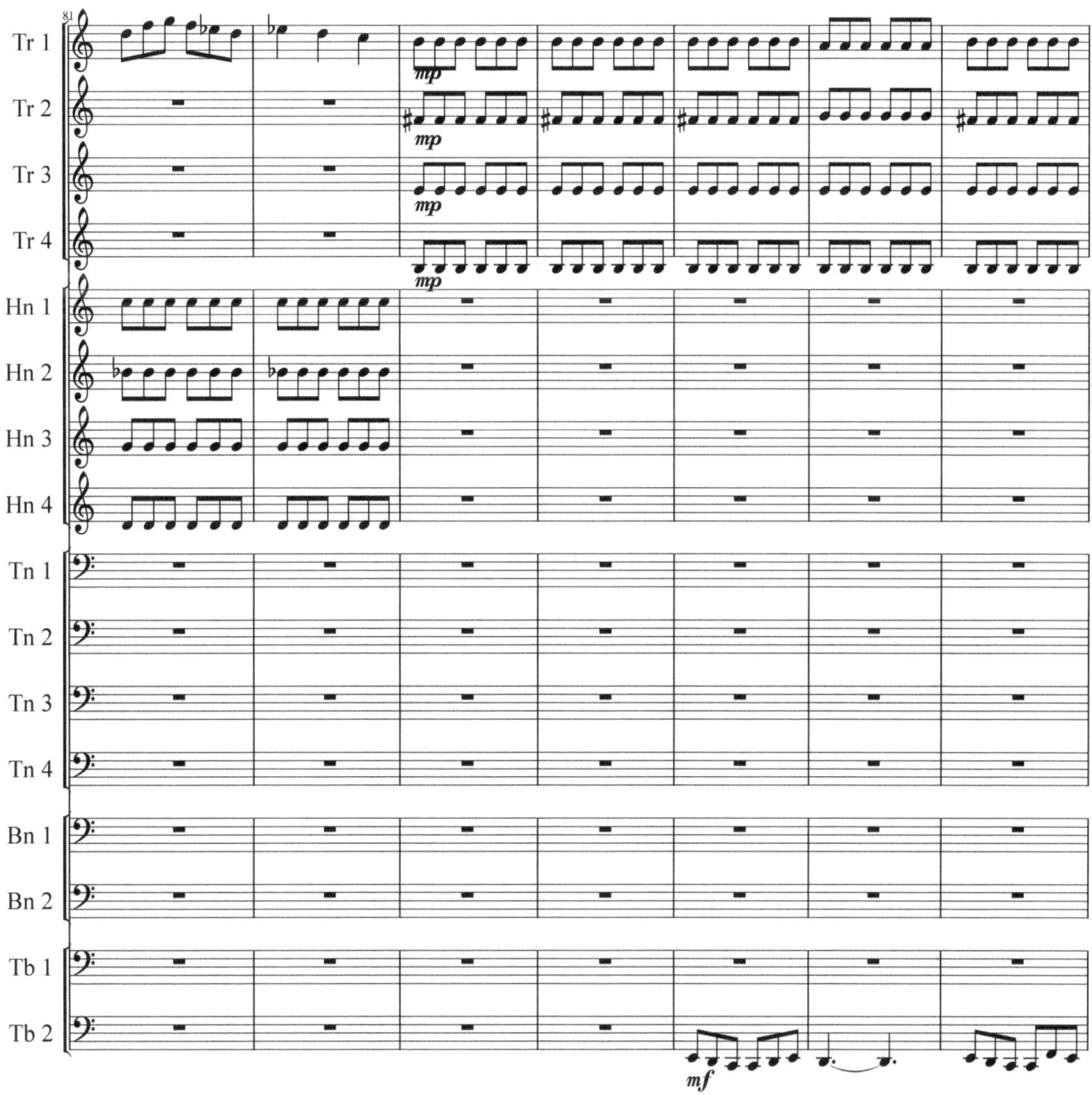

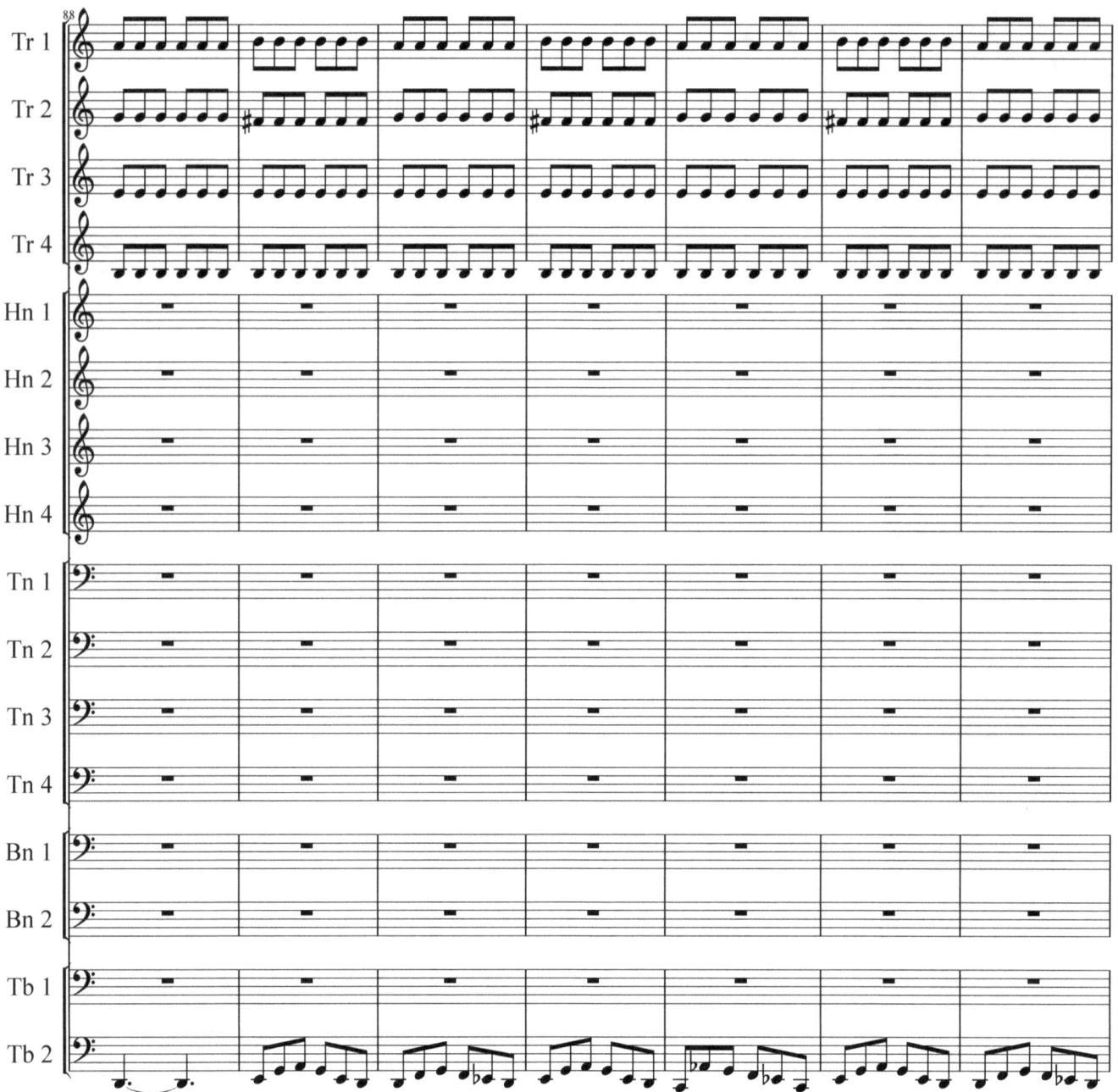

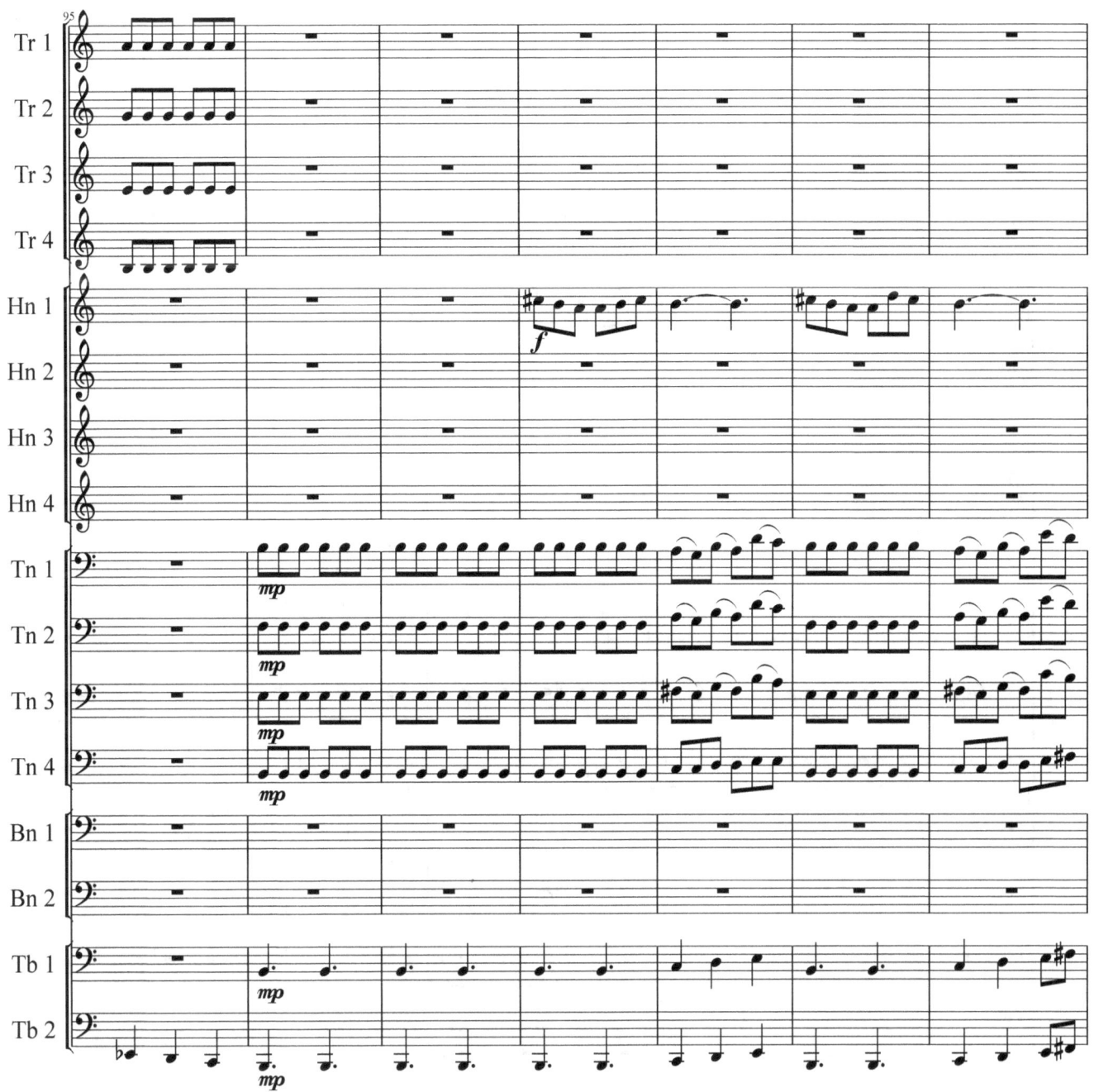

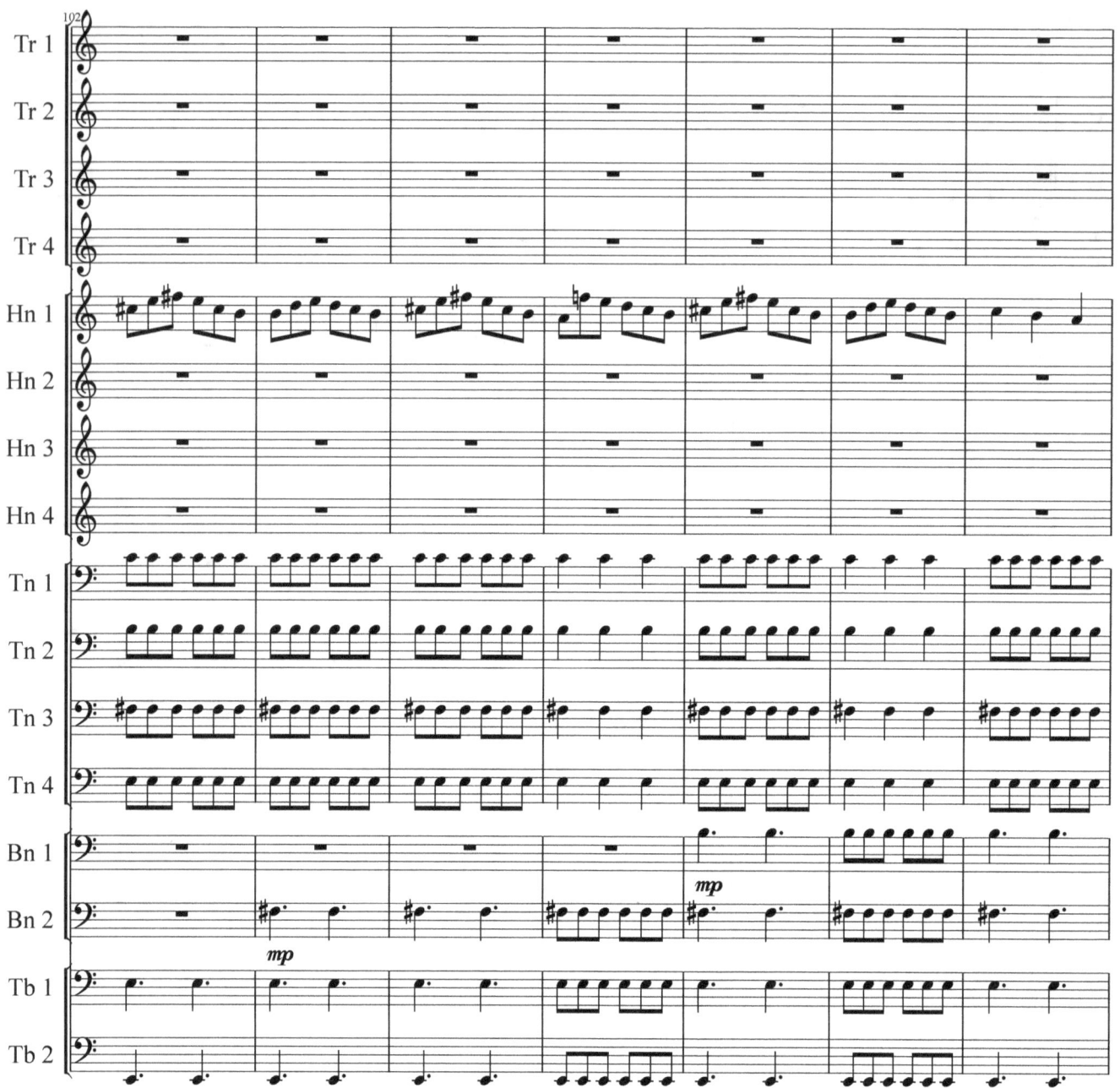

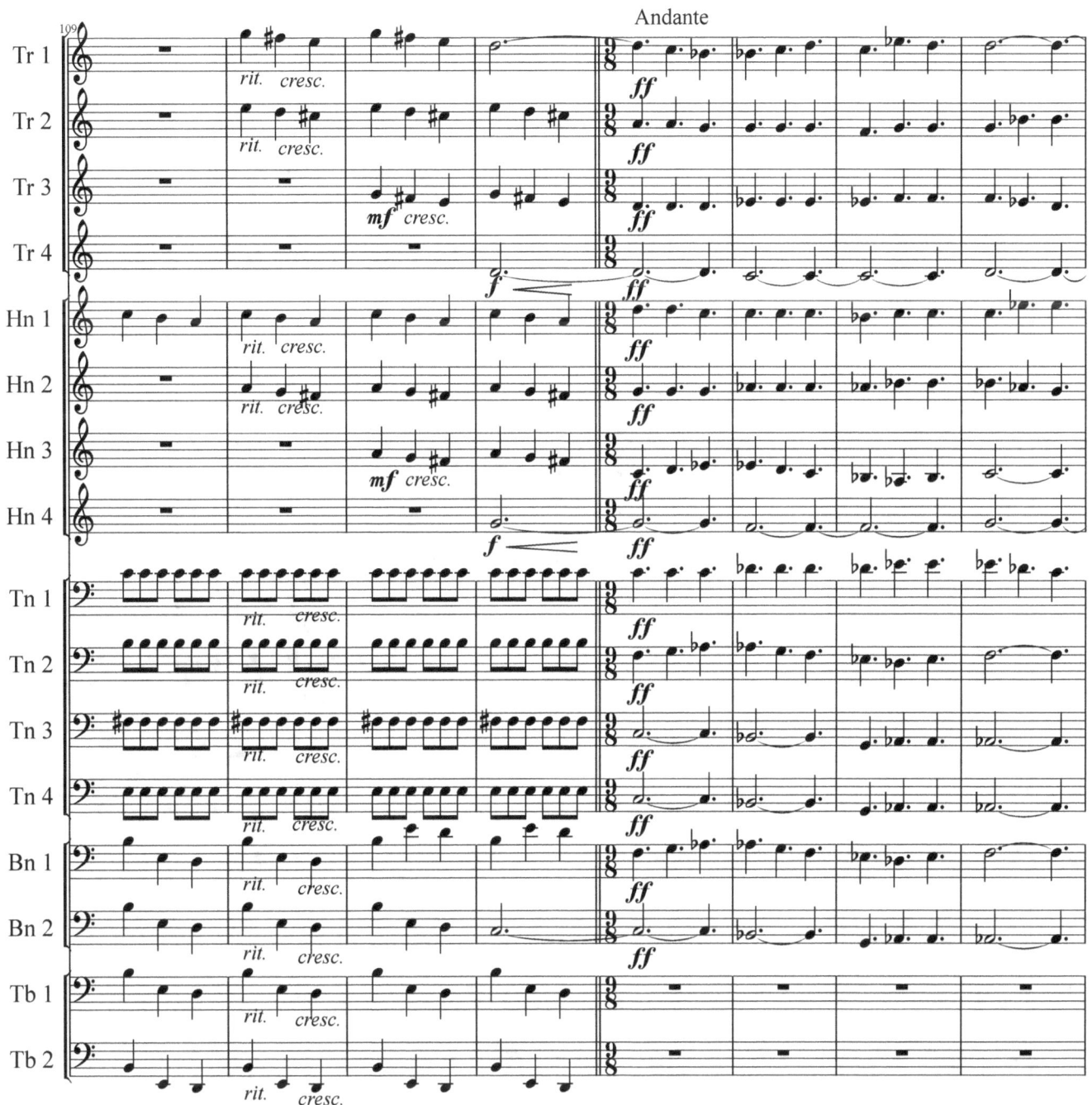

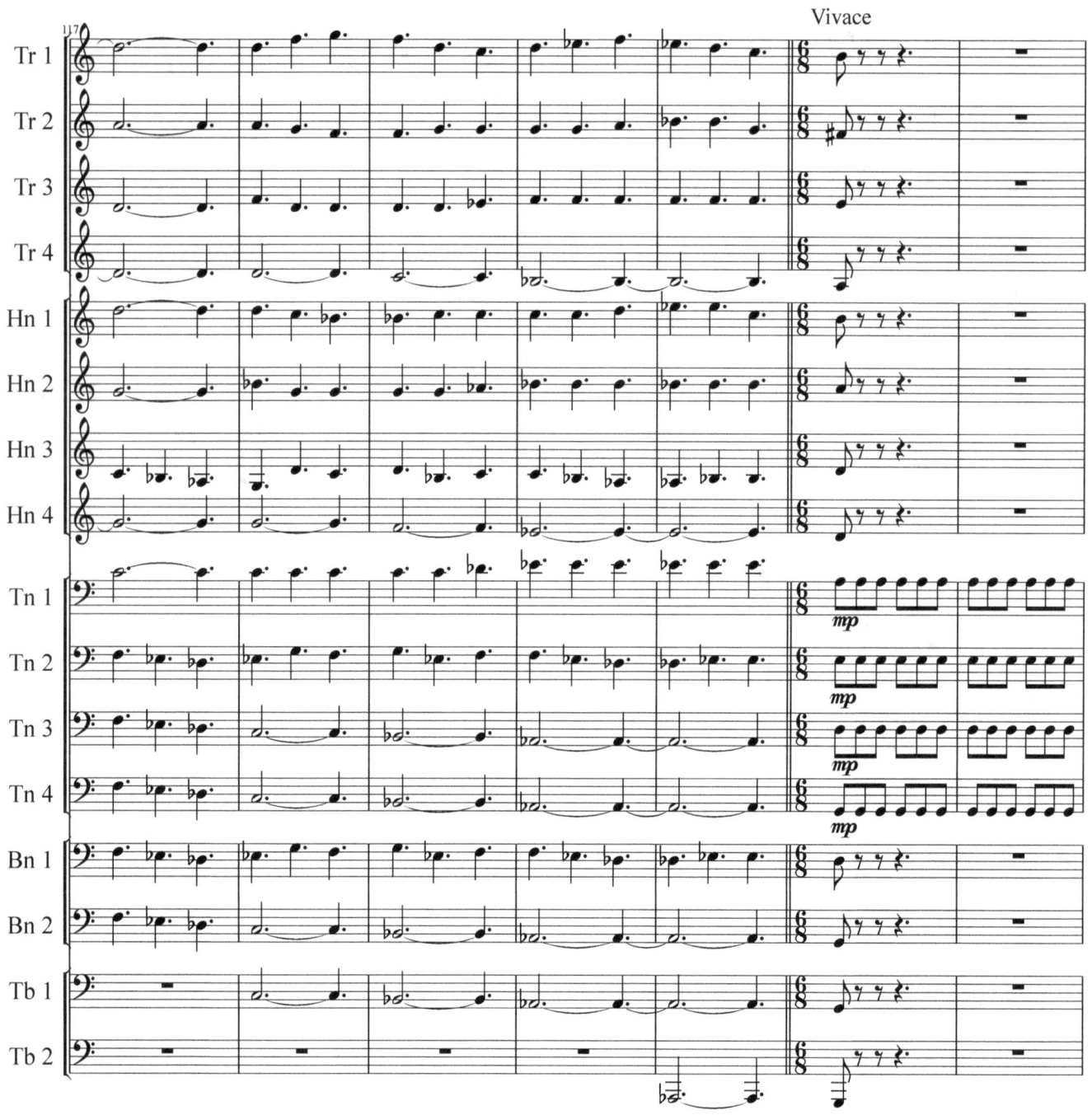

55

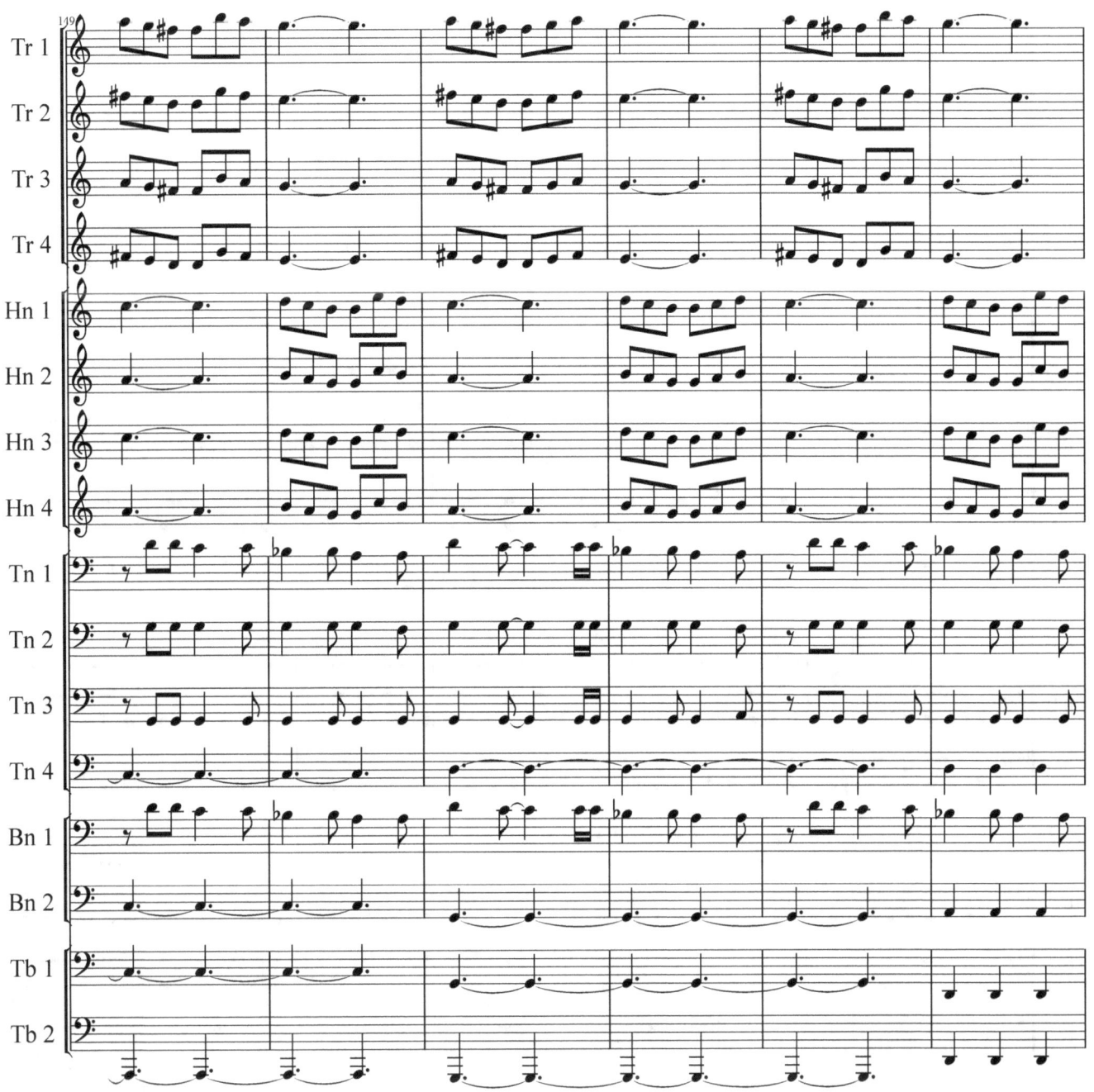

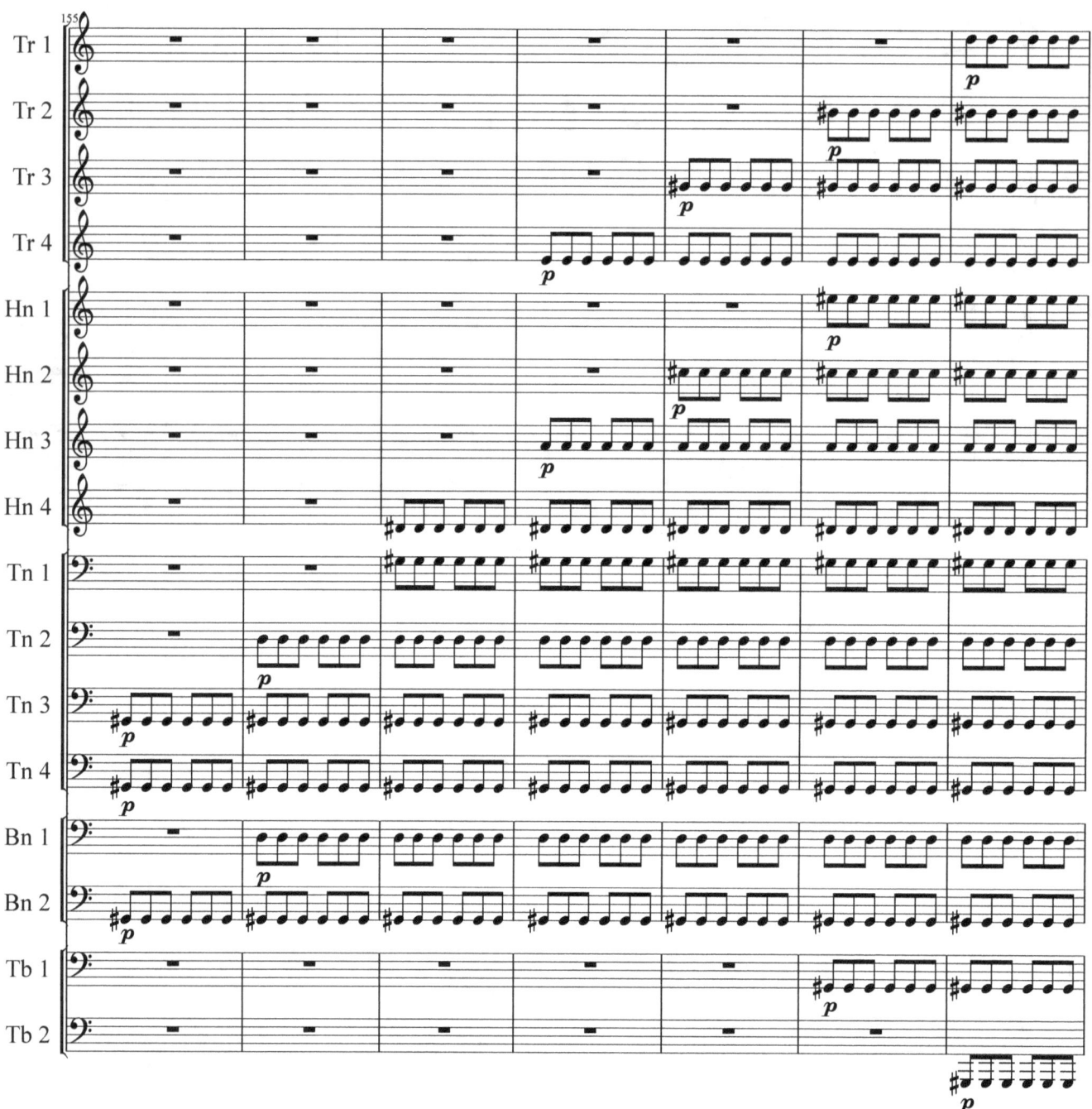

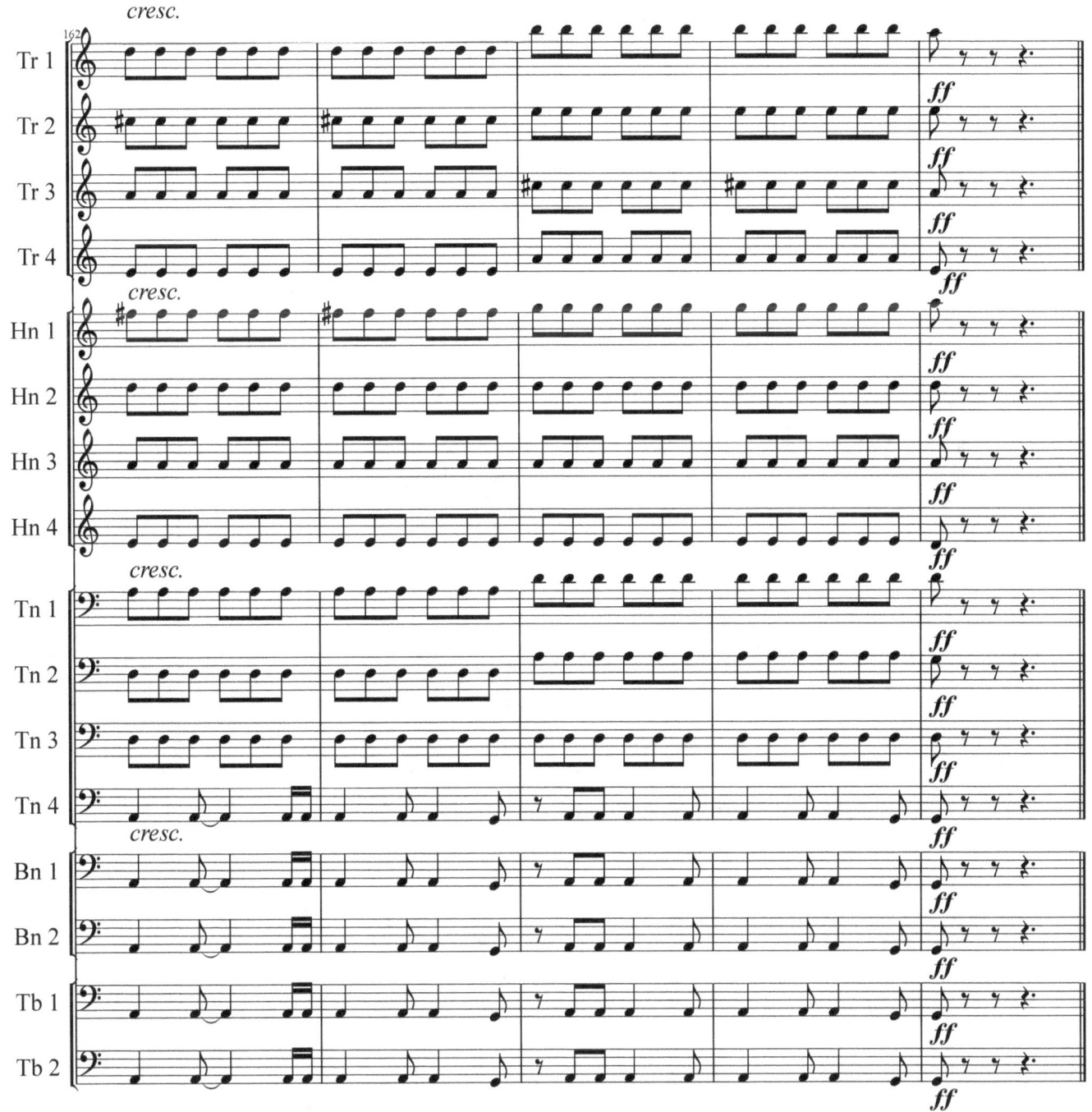

Missa Unitas
Gloria Response

Ken Langer

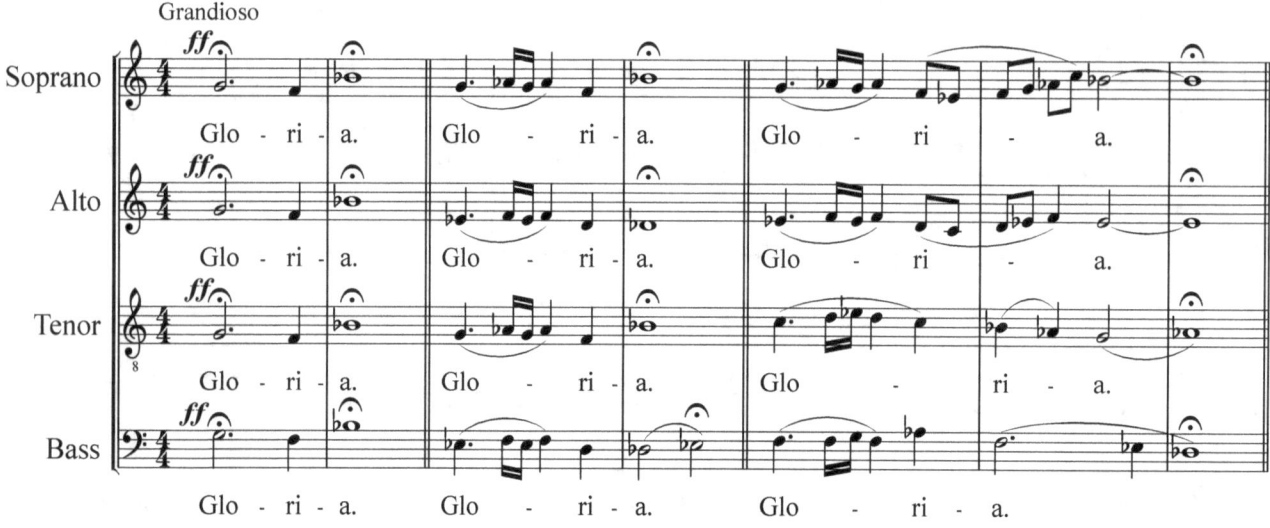
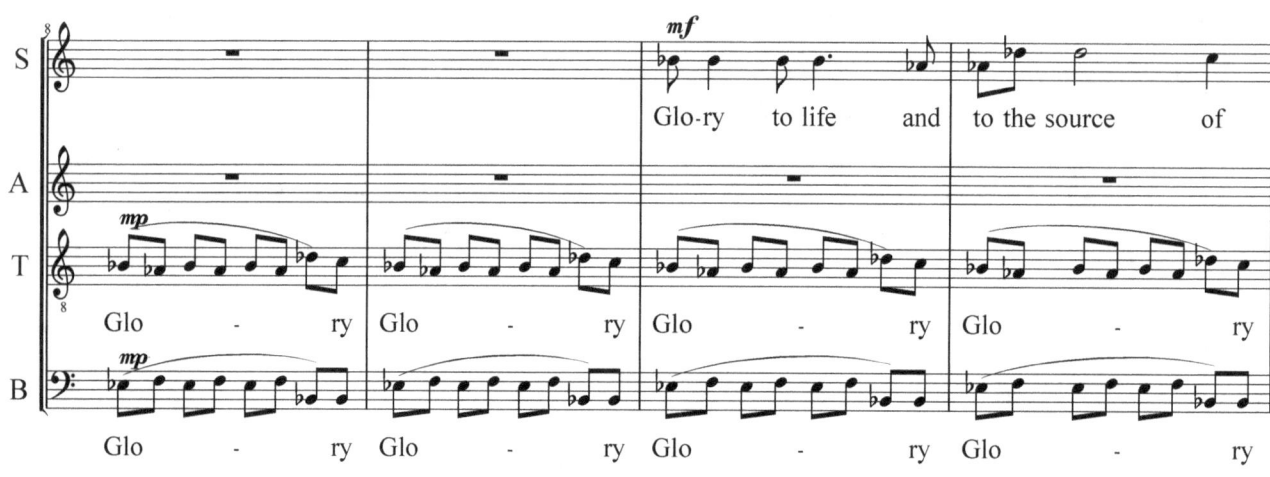
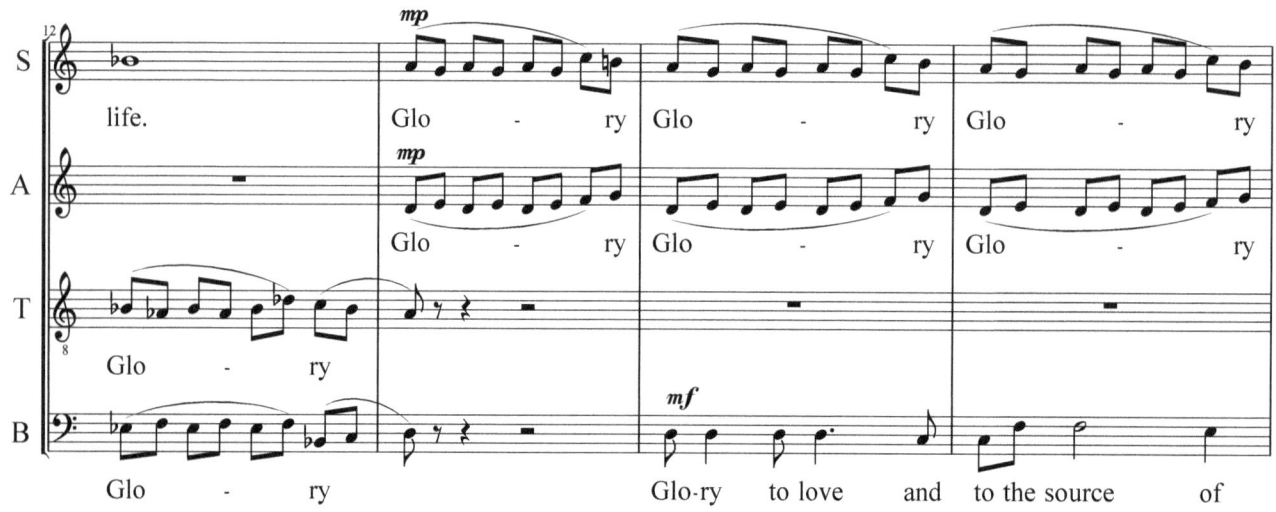

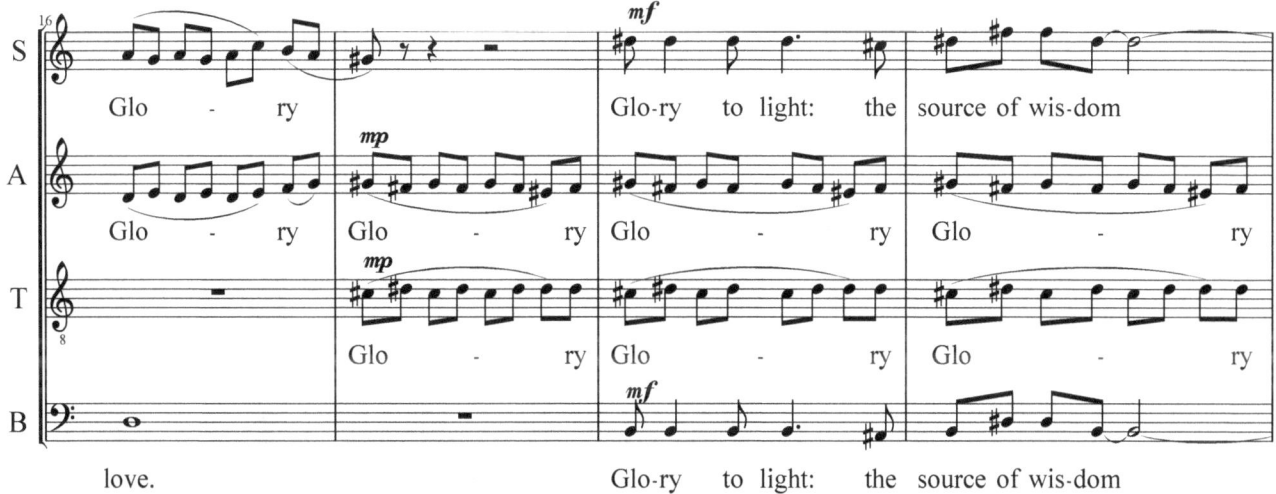
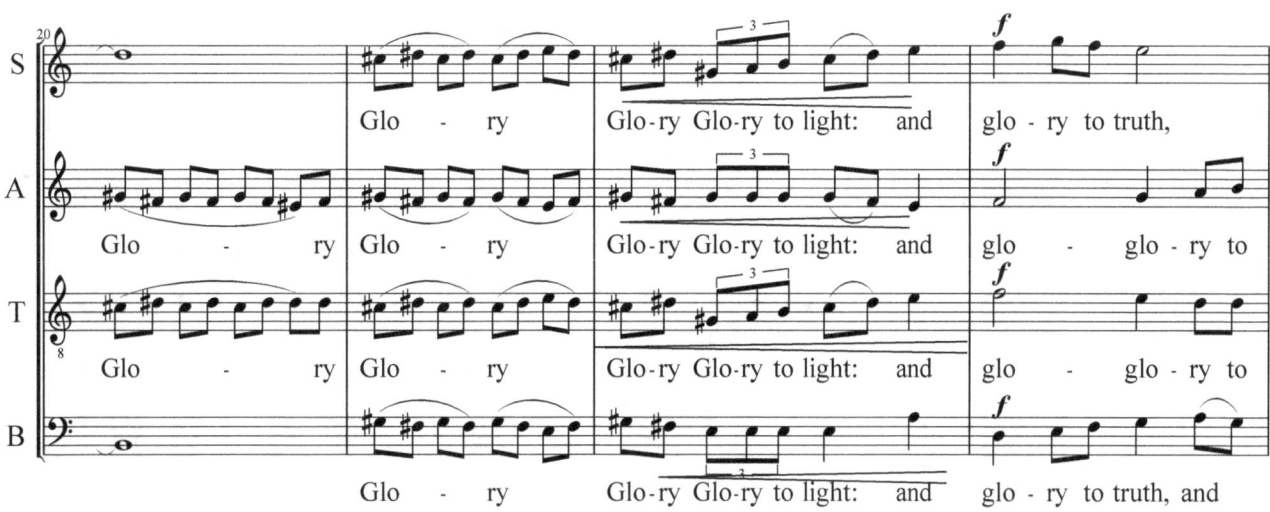
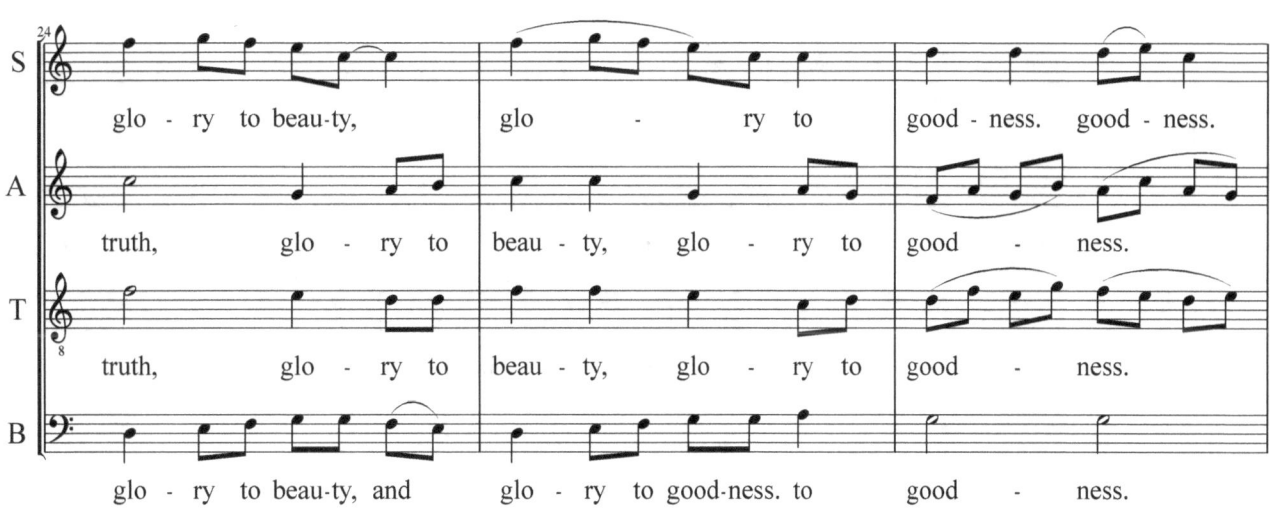

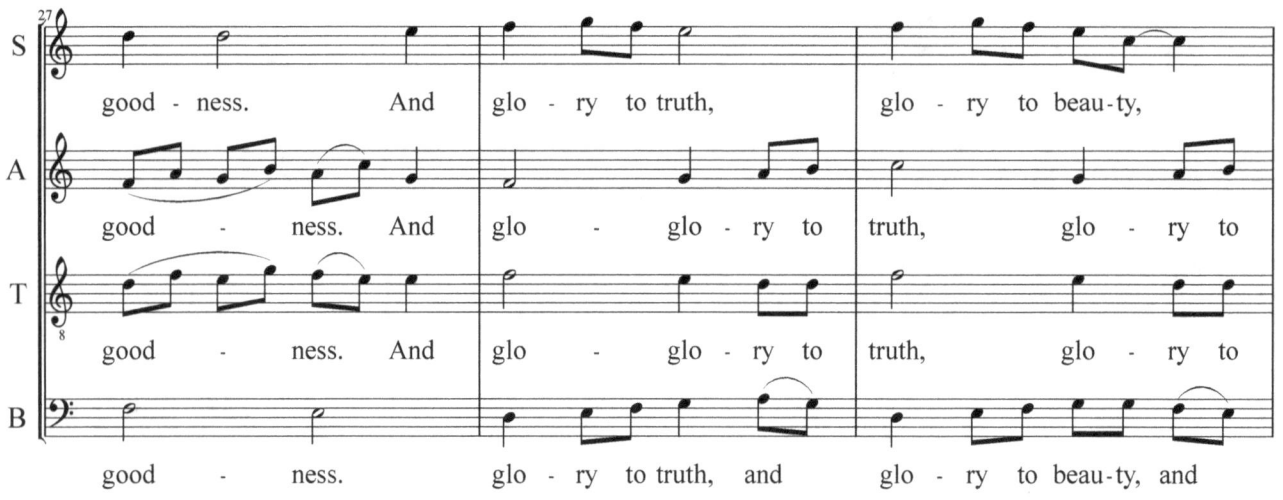
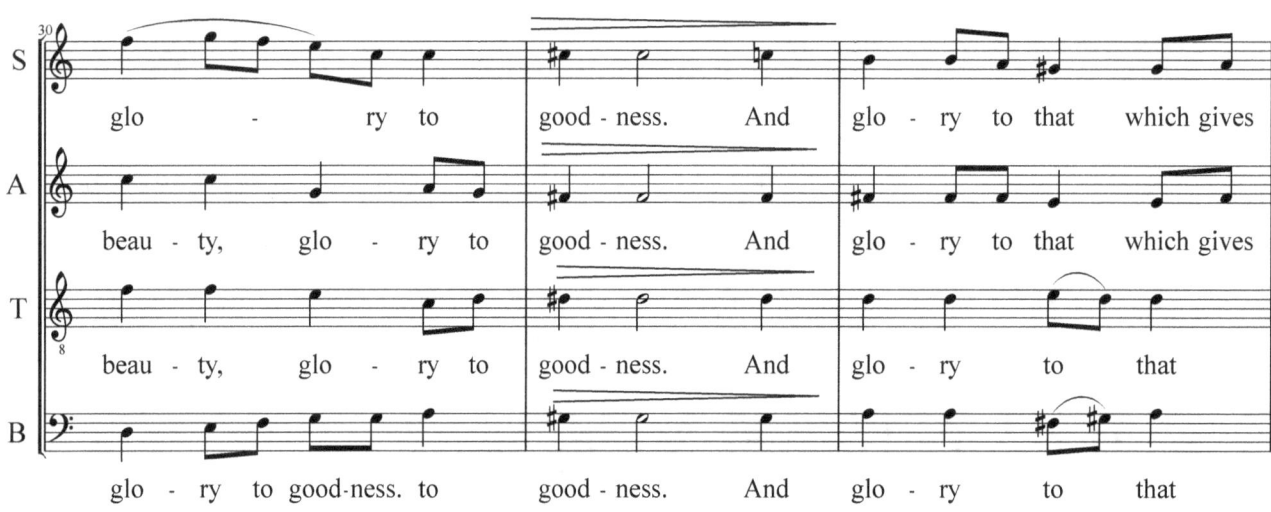
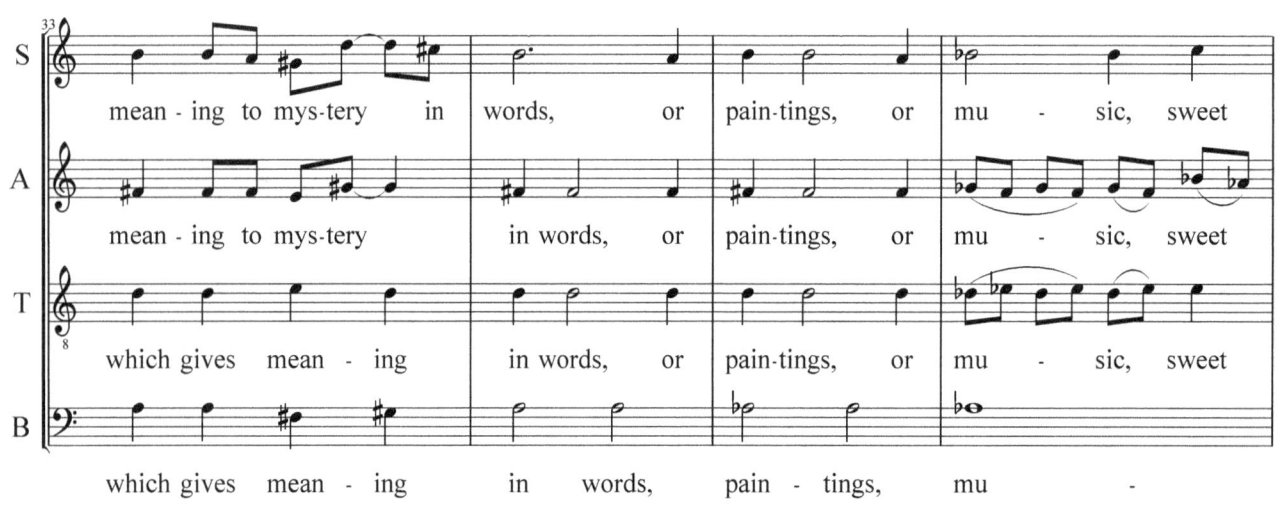

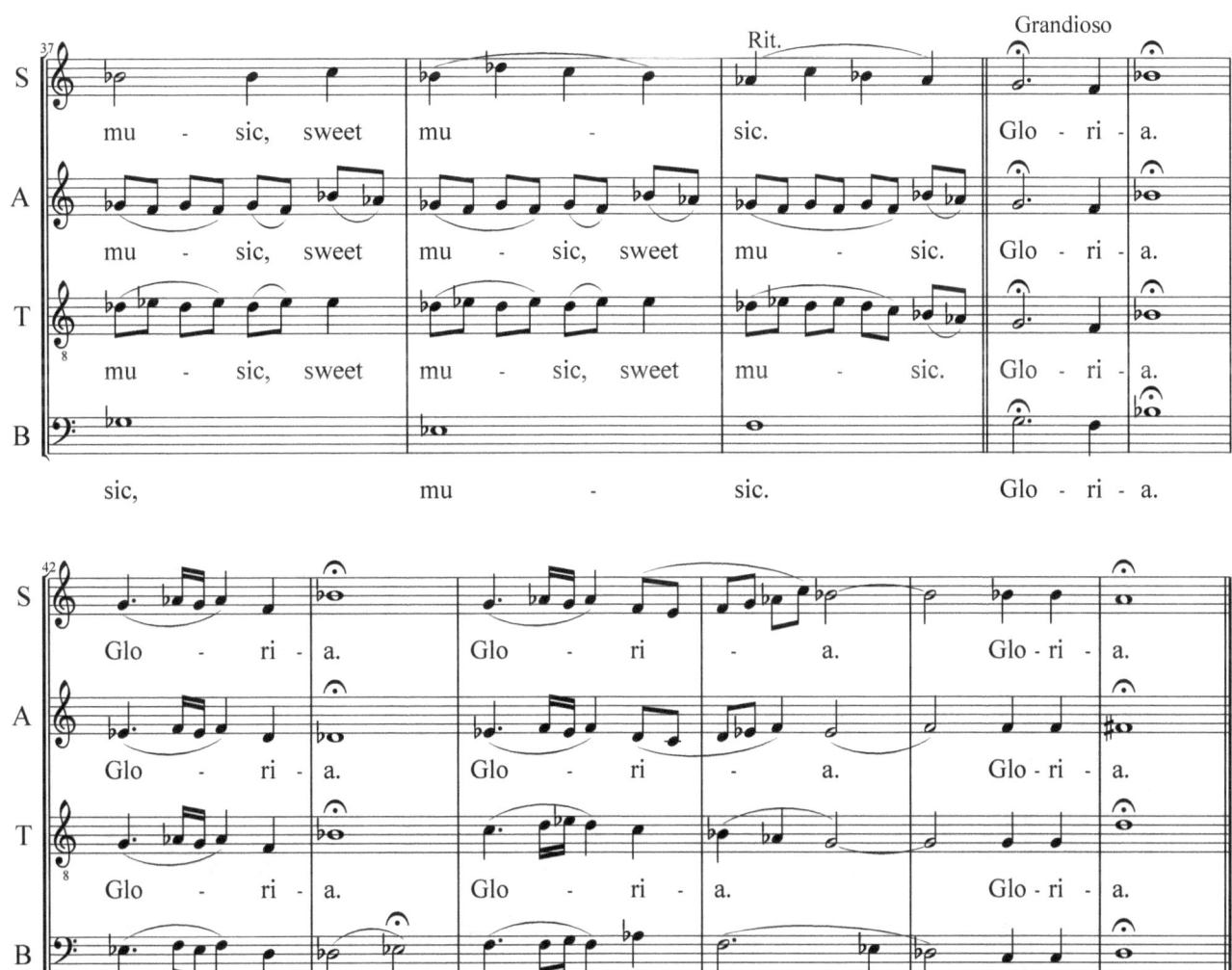

Missa Unitas
Alleluia

Ken Langer

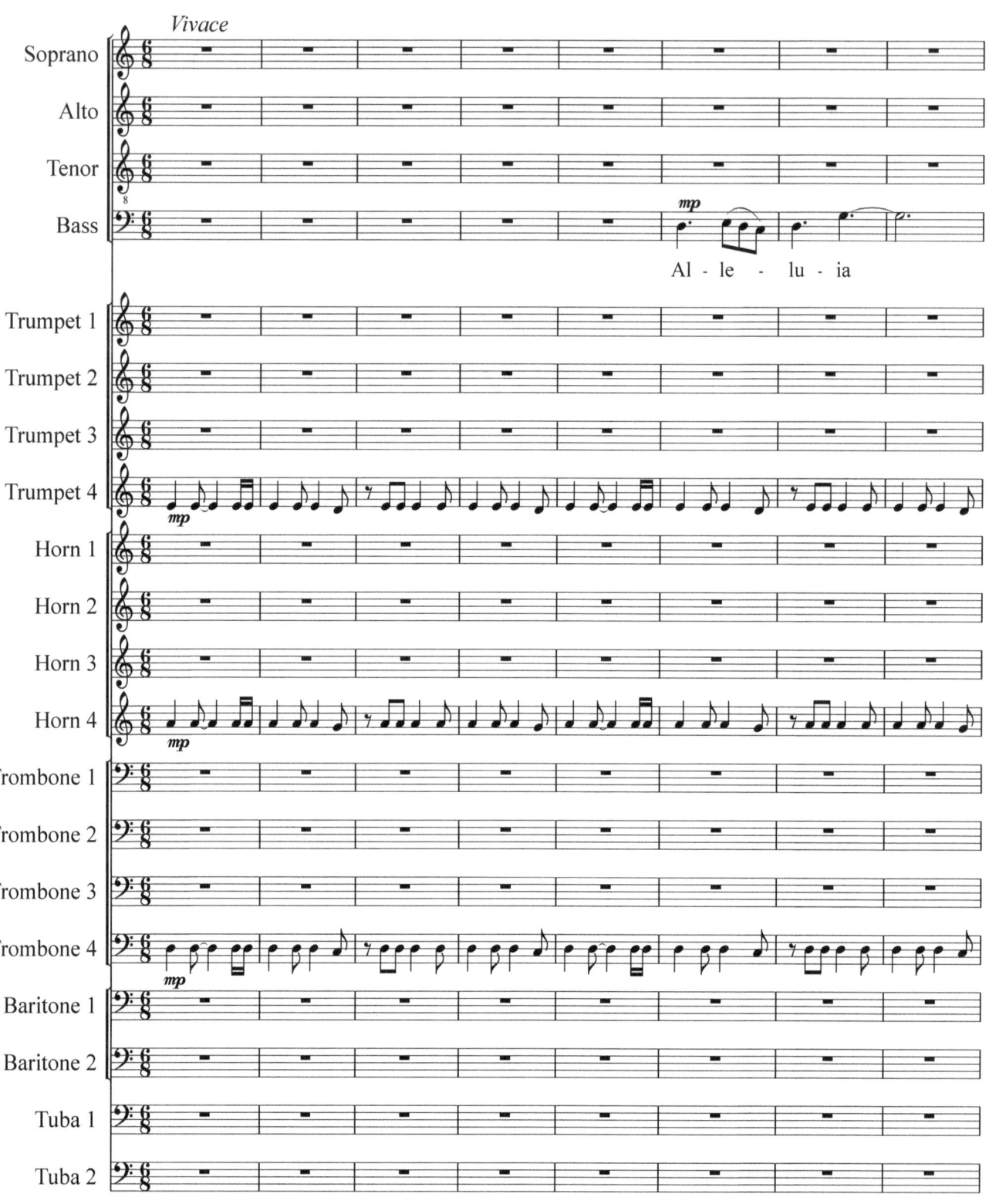

64

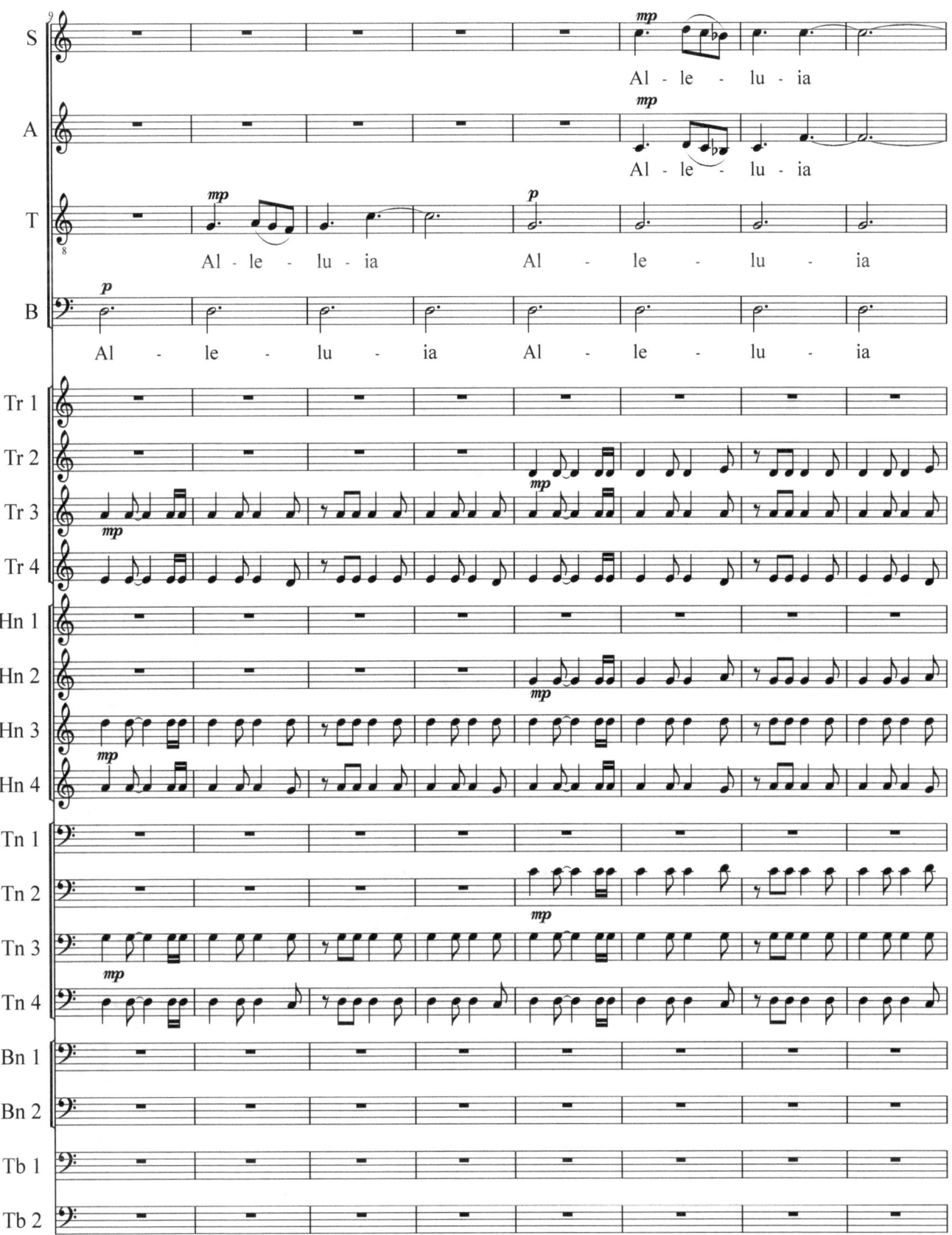

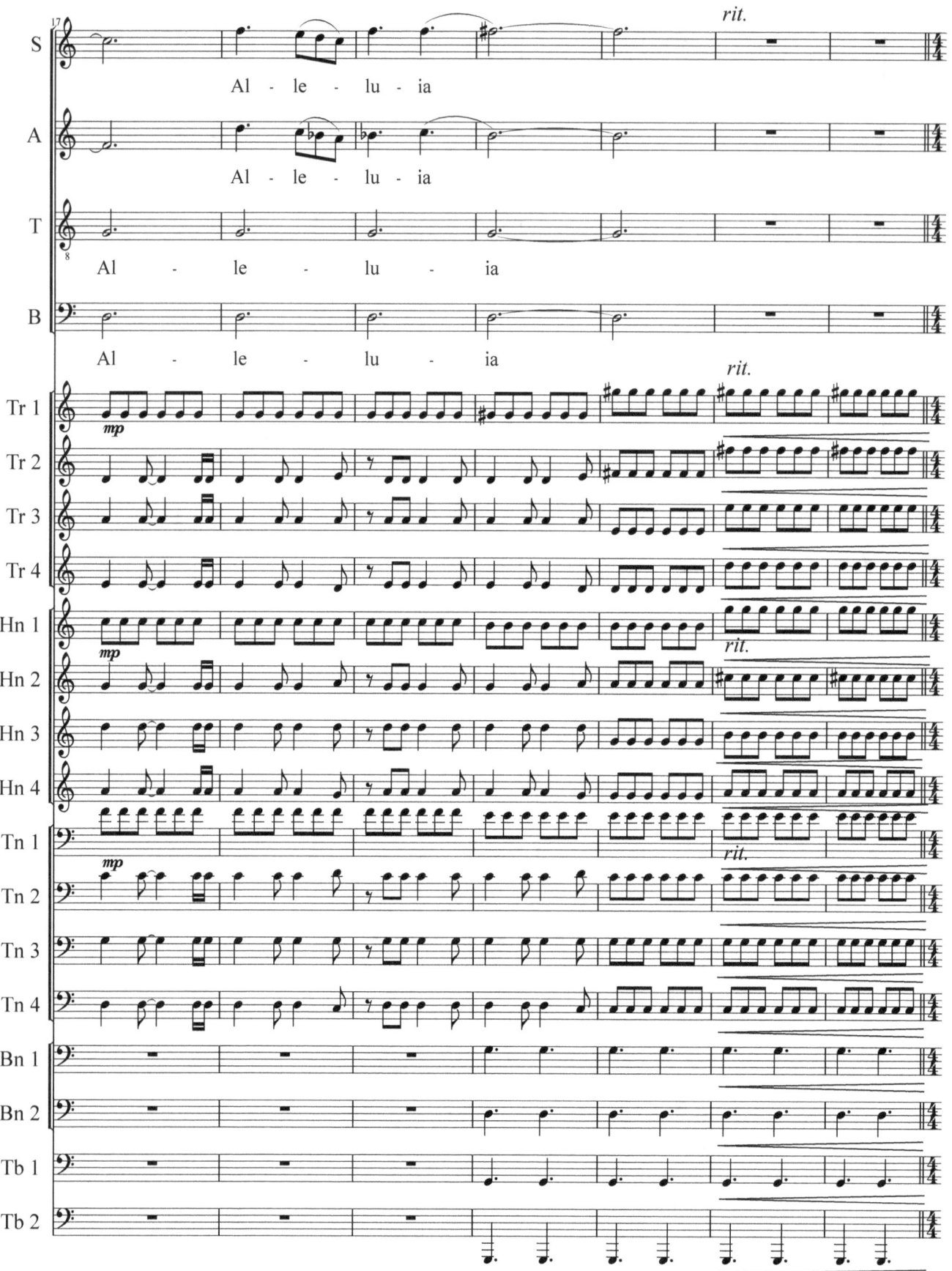

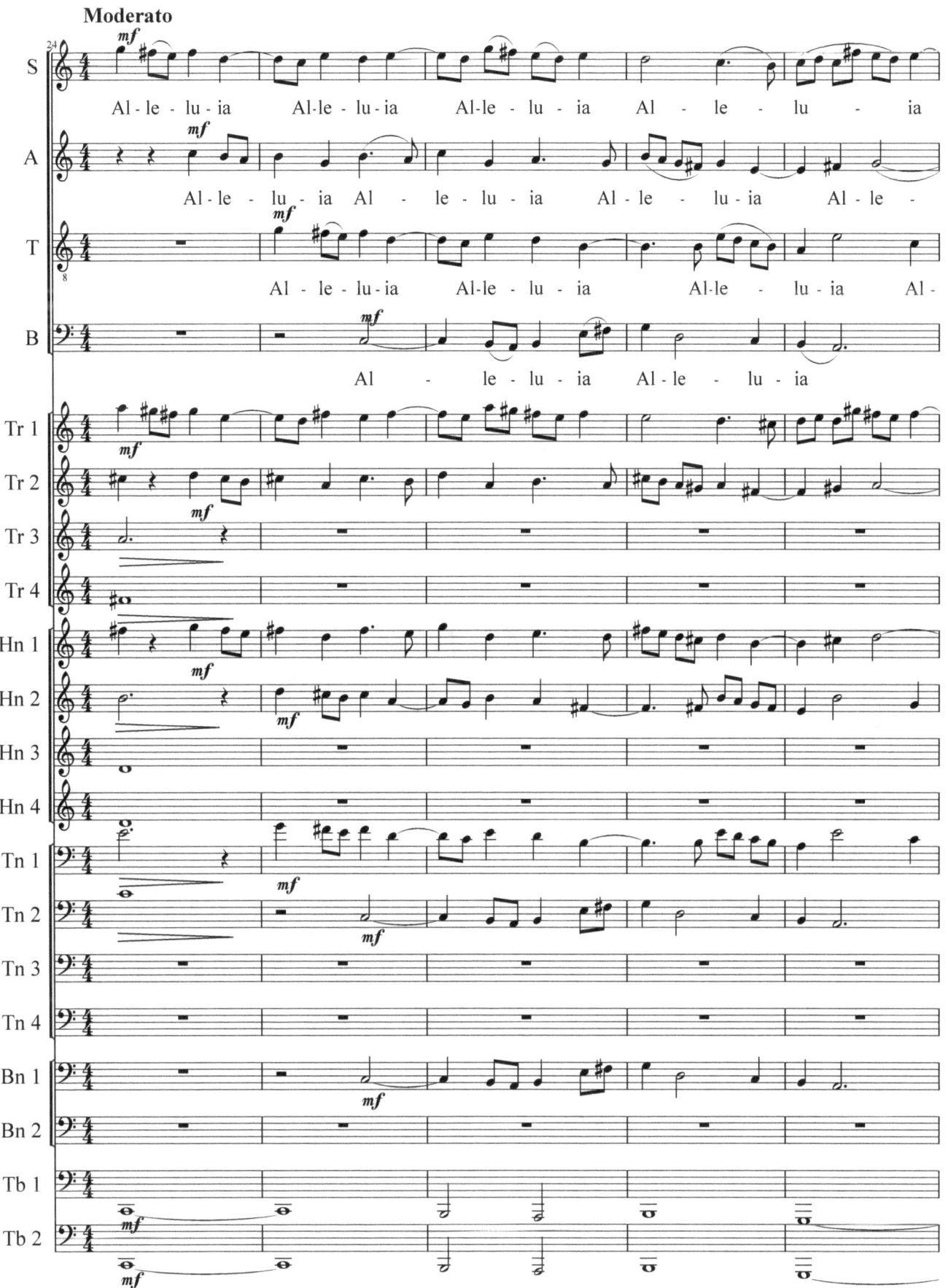

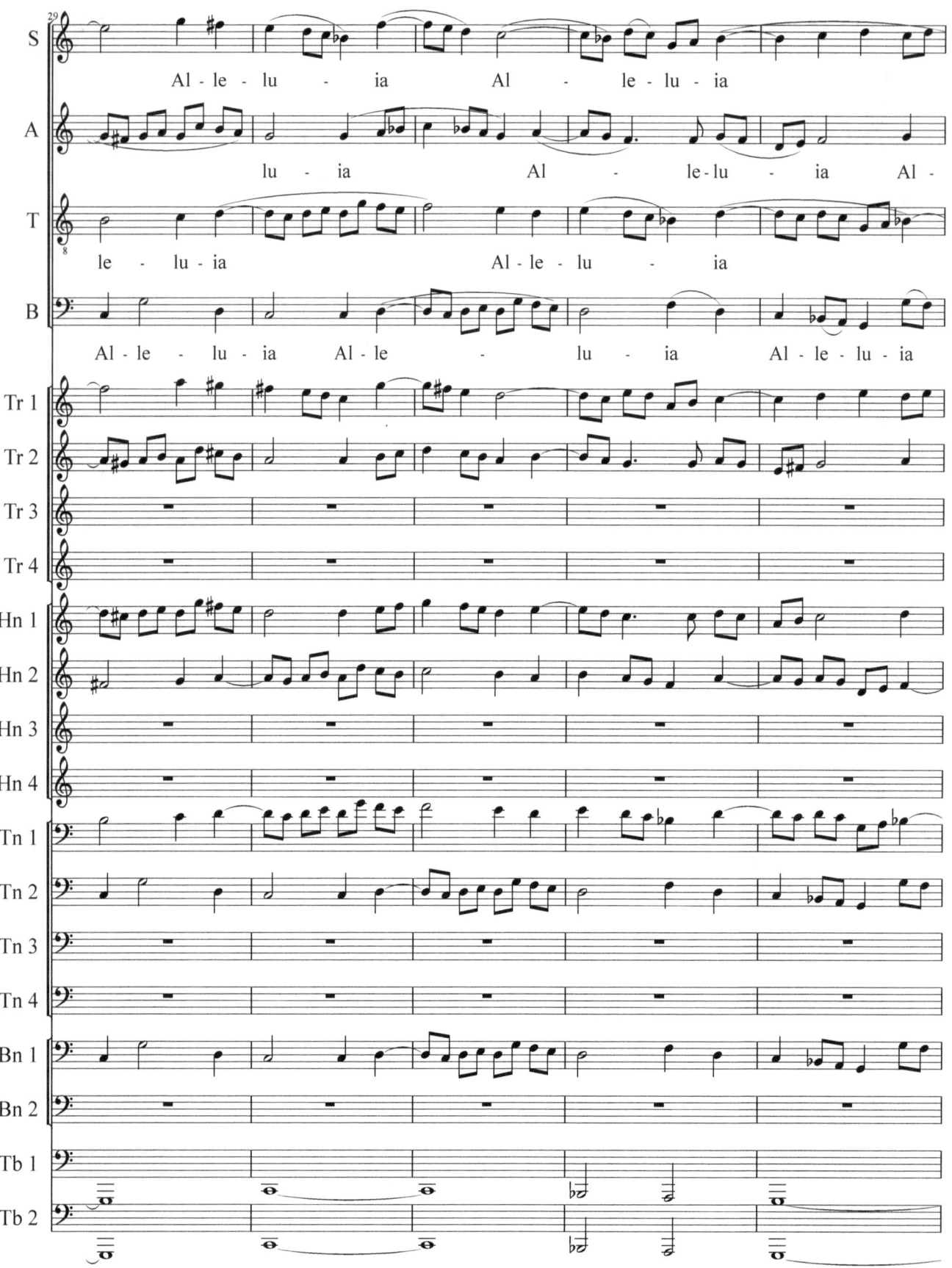

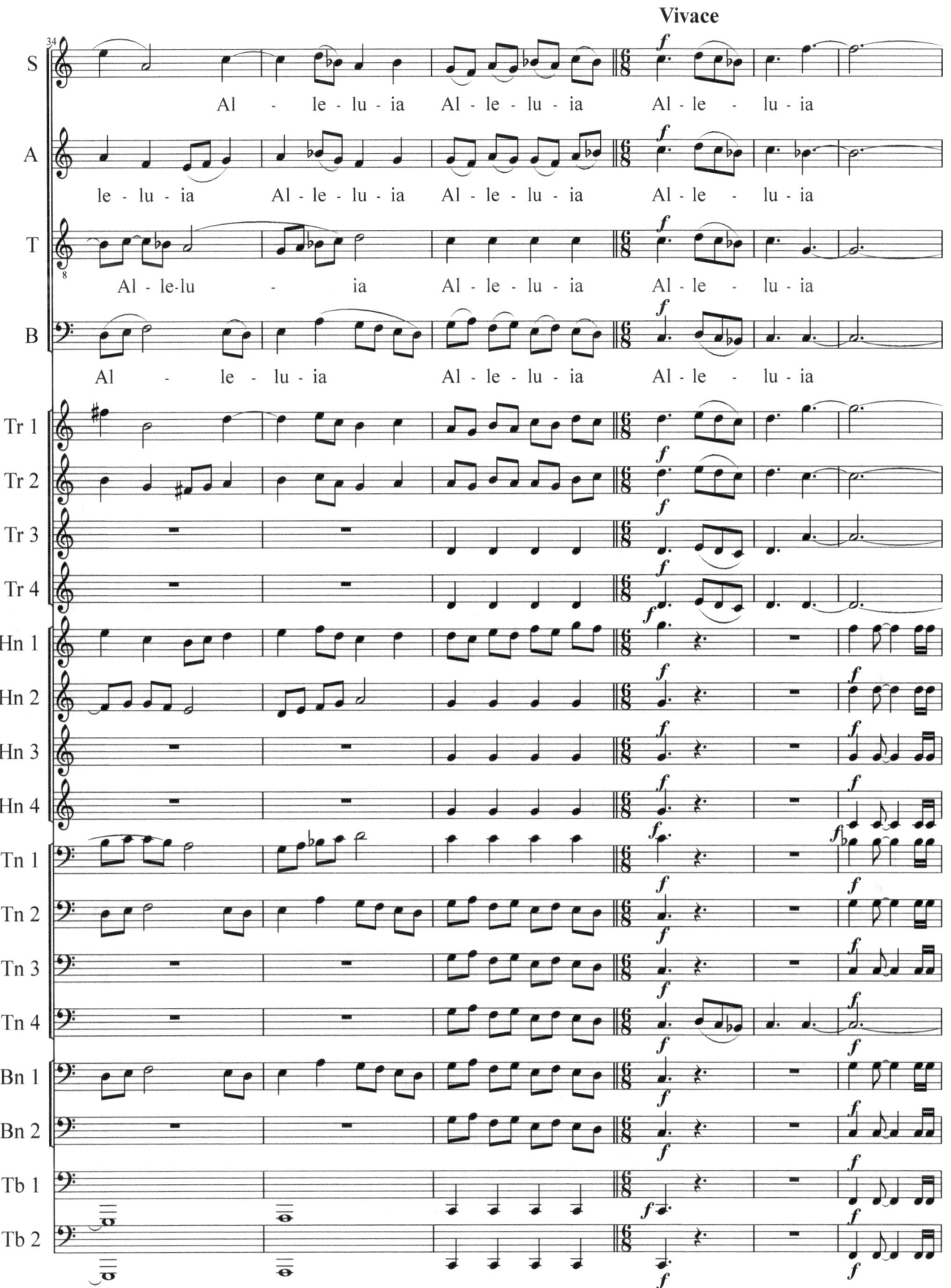

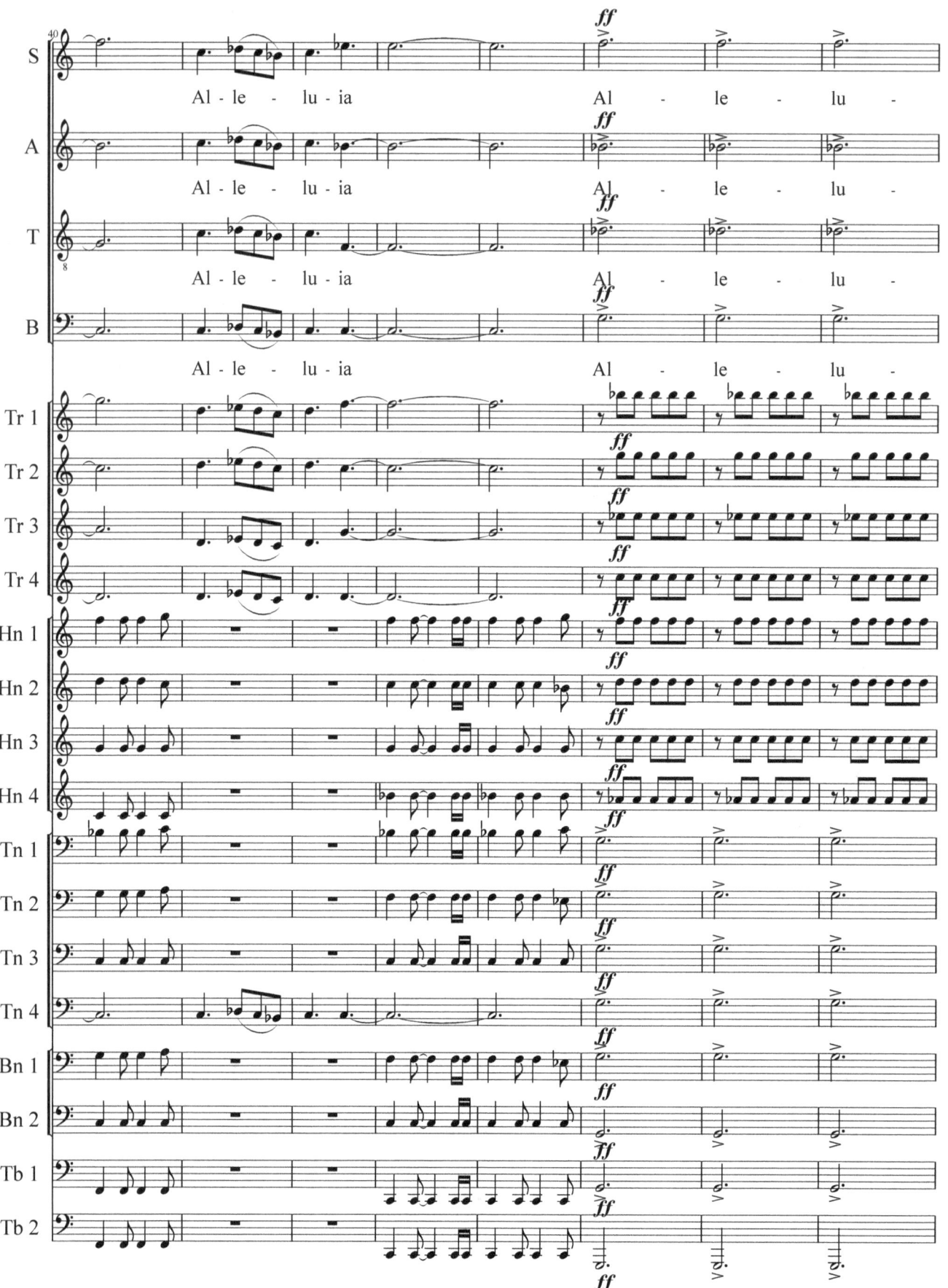

70

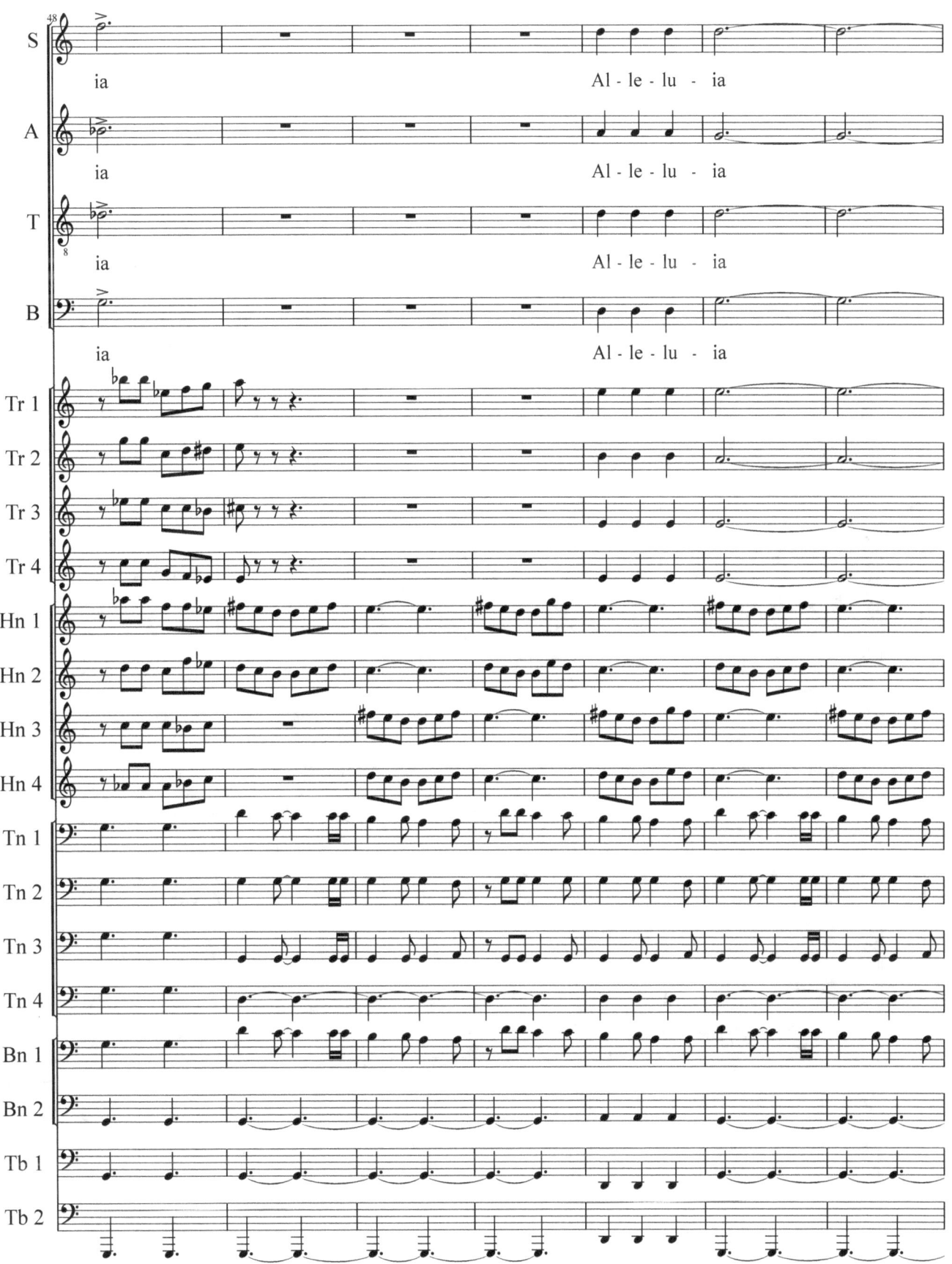

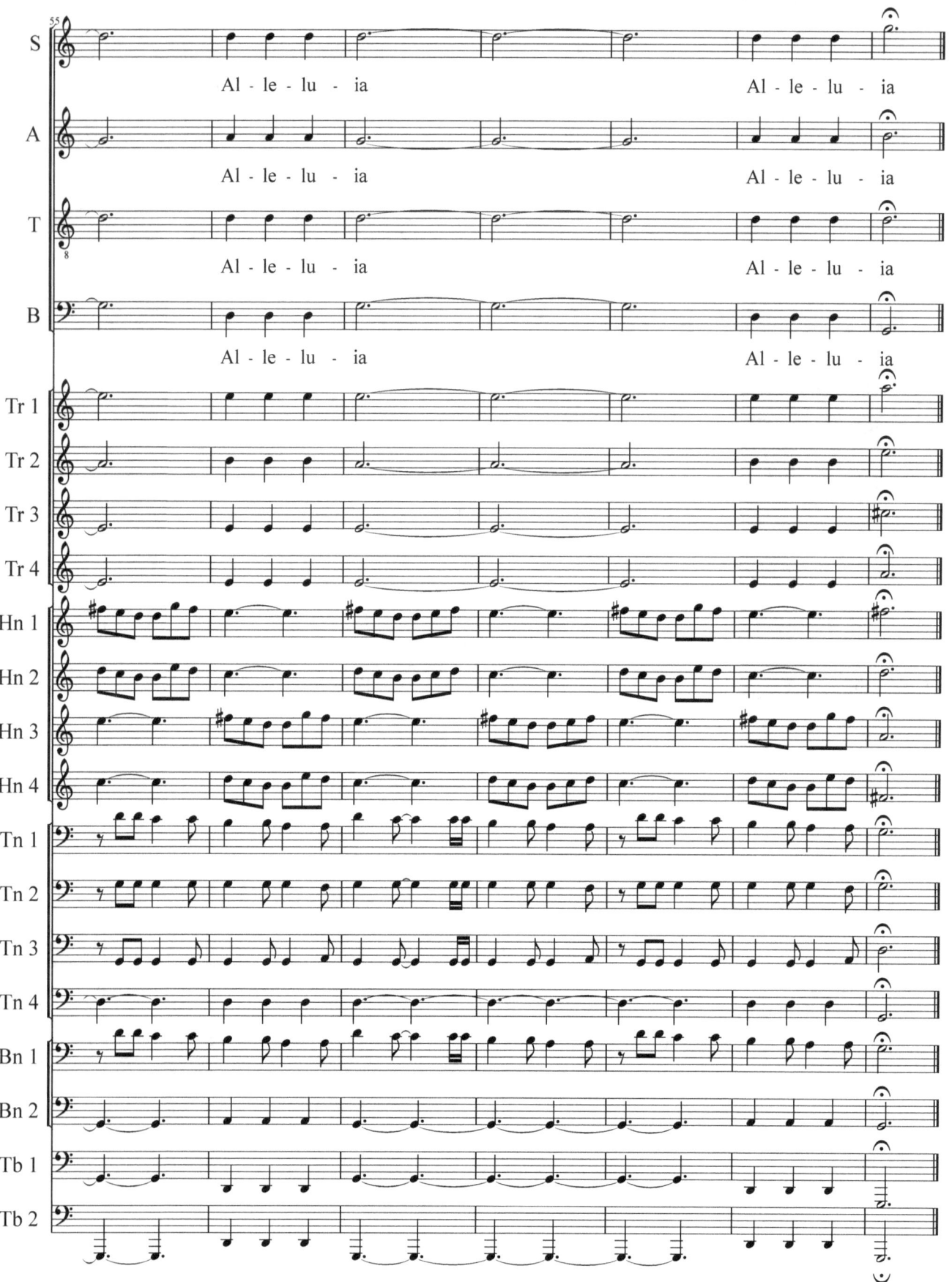

Missa Unitas
Reading No. 2

Ken Langer

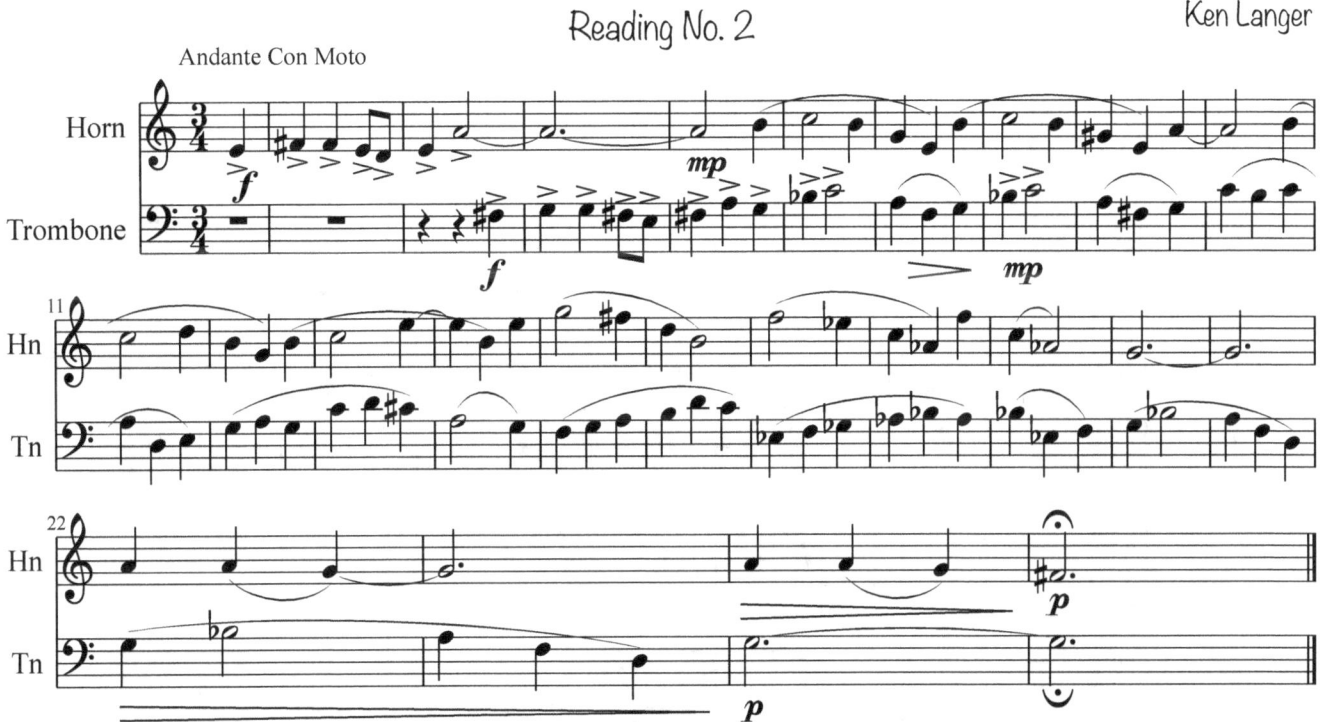

Narrator: This meaning, this secret plan of Creation, flares out, had we eyes to see, from every department of existence. Its exultant declarations come to us in all great music; its magic is the life of all romance. Its law - the law of love - is the substance of the beautiful, the energizing cause of the heroic. It lights the altar of every creed. All (our) dreams and diagrams concerning a transcendent Perfection...
a transcendent vitality to which (we) can attain - whether (we) call these objects of desire God, grace, being spirit, beauty, "pure idea" - are but translations of (our) deeper self's intuition of its destiny;
clumsy fragmentary hints at the all-inclusive, living Absolute which that deeper self knows to be real.

Evelyn Underhill
Mysticism

Missa Unitas

Credo Call

Ken Langer

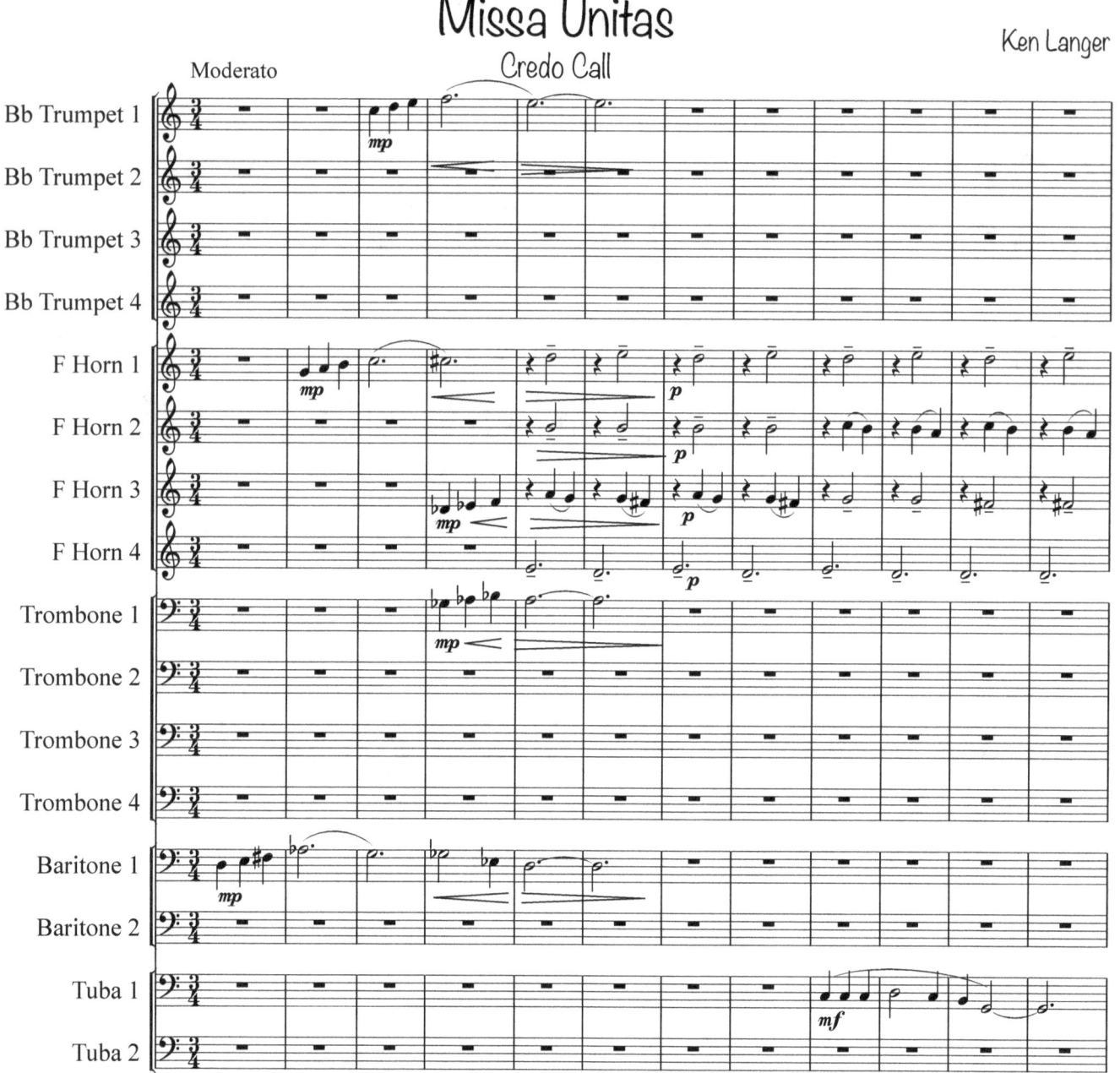

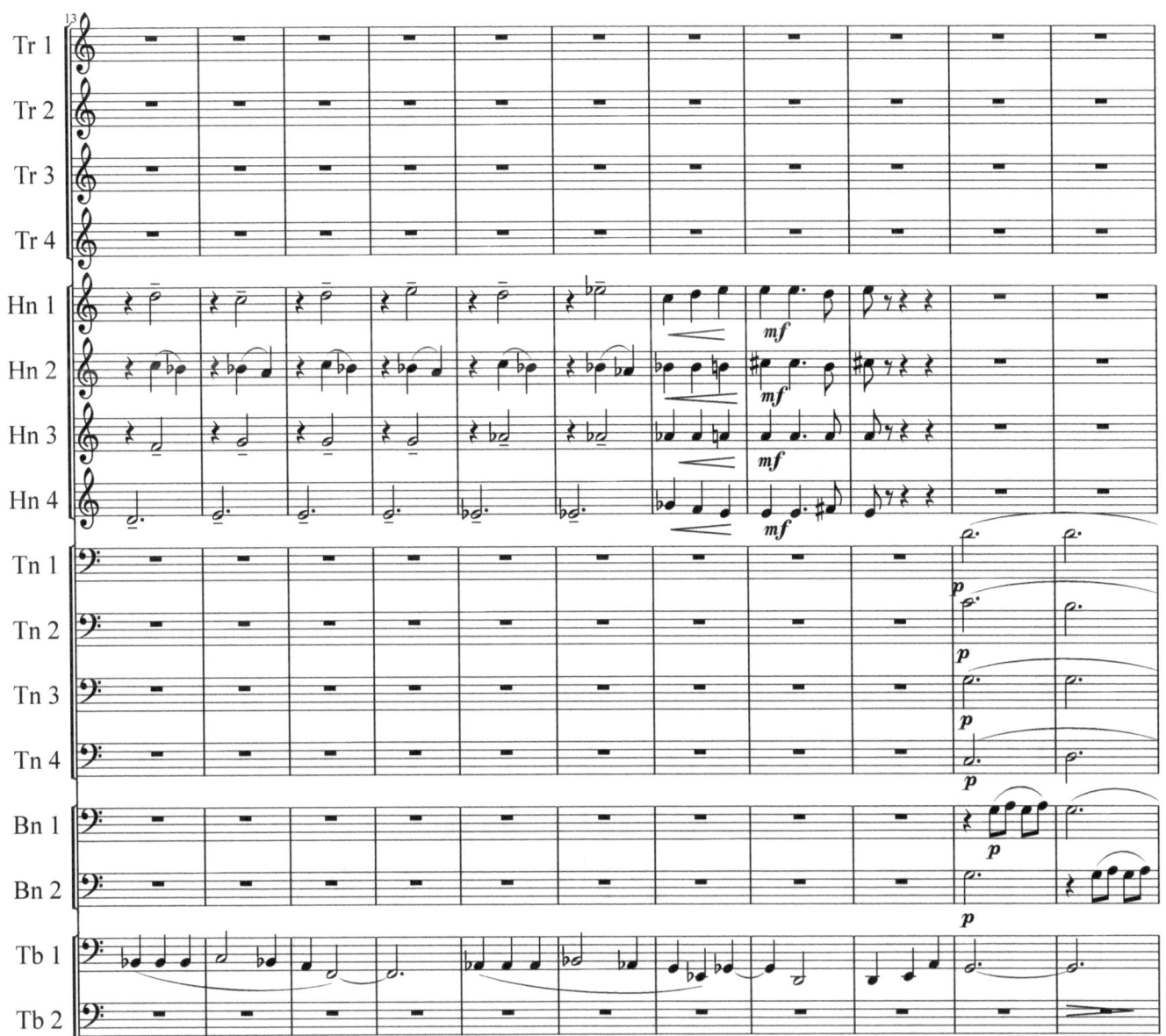

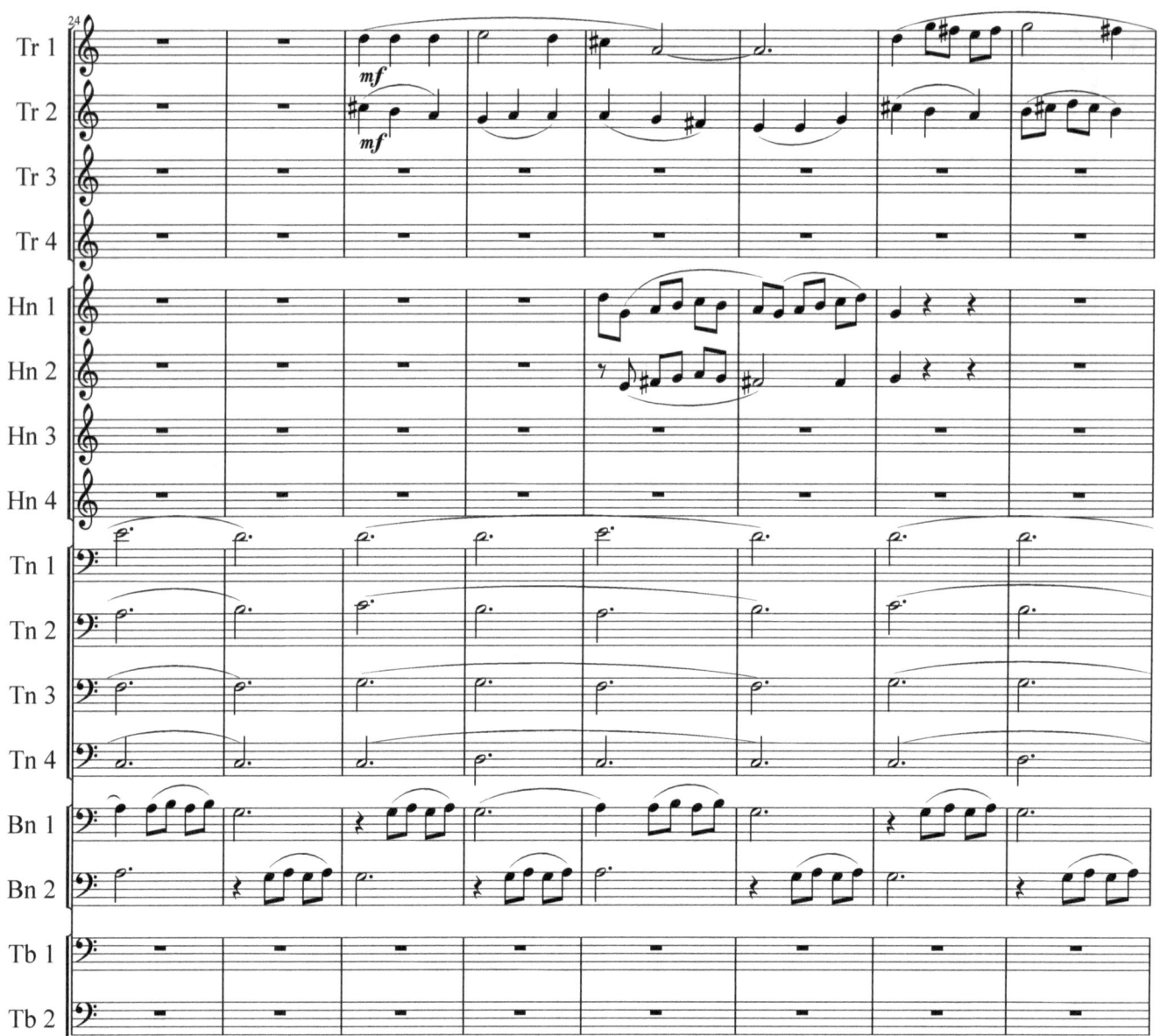

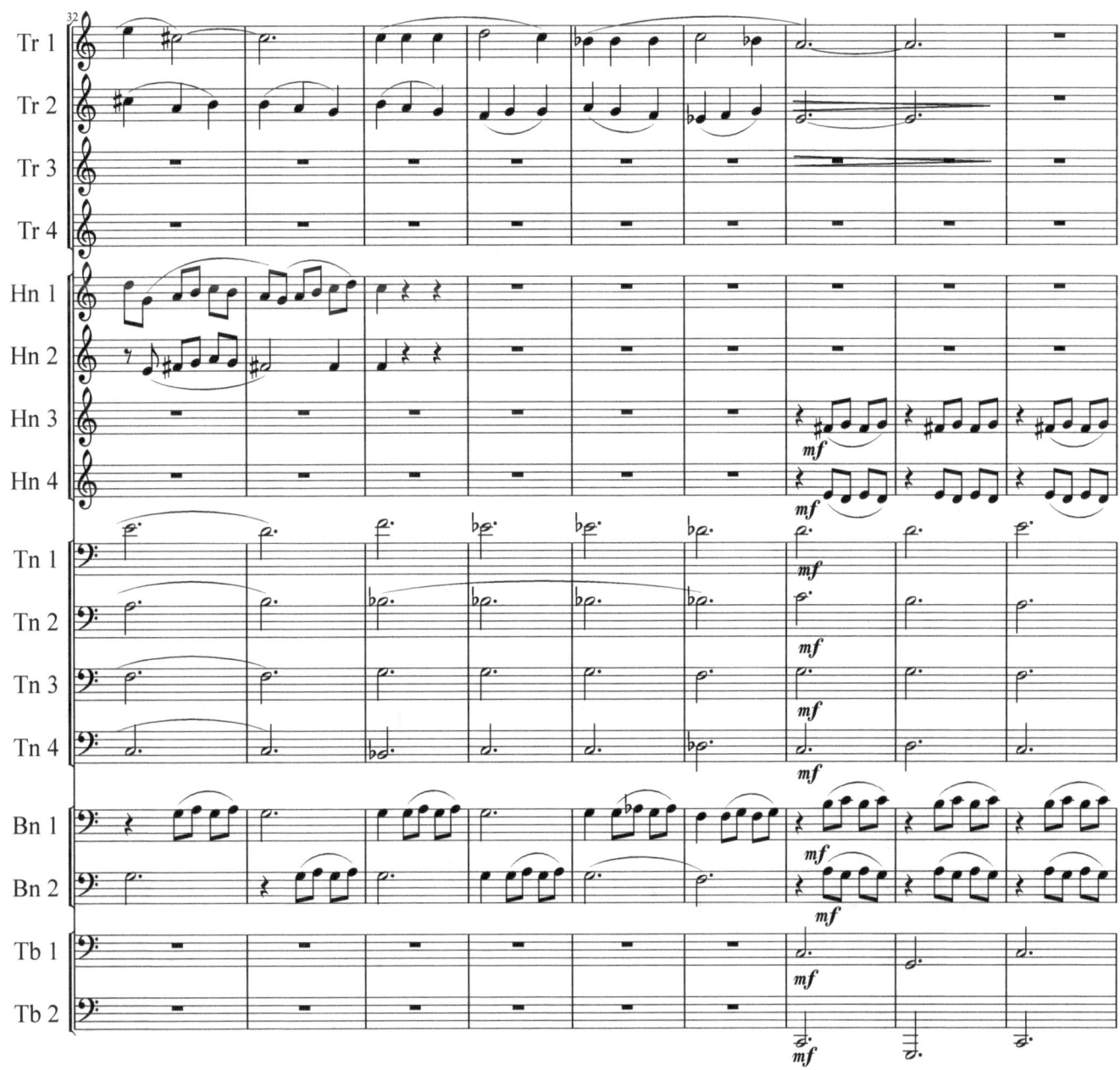

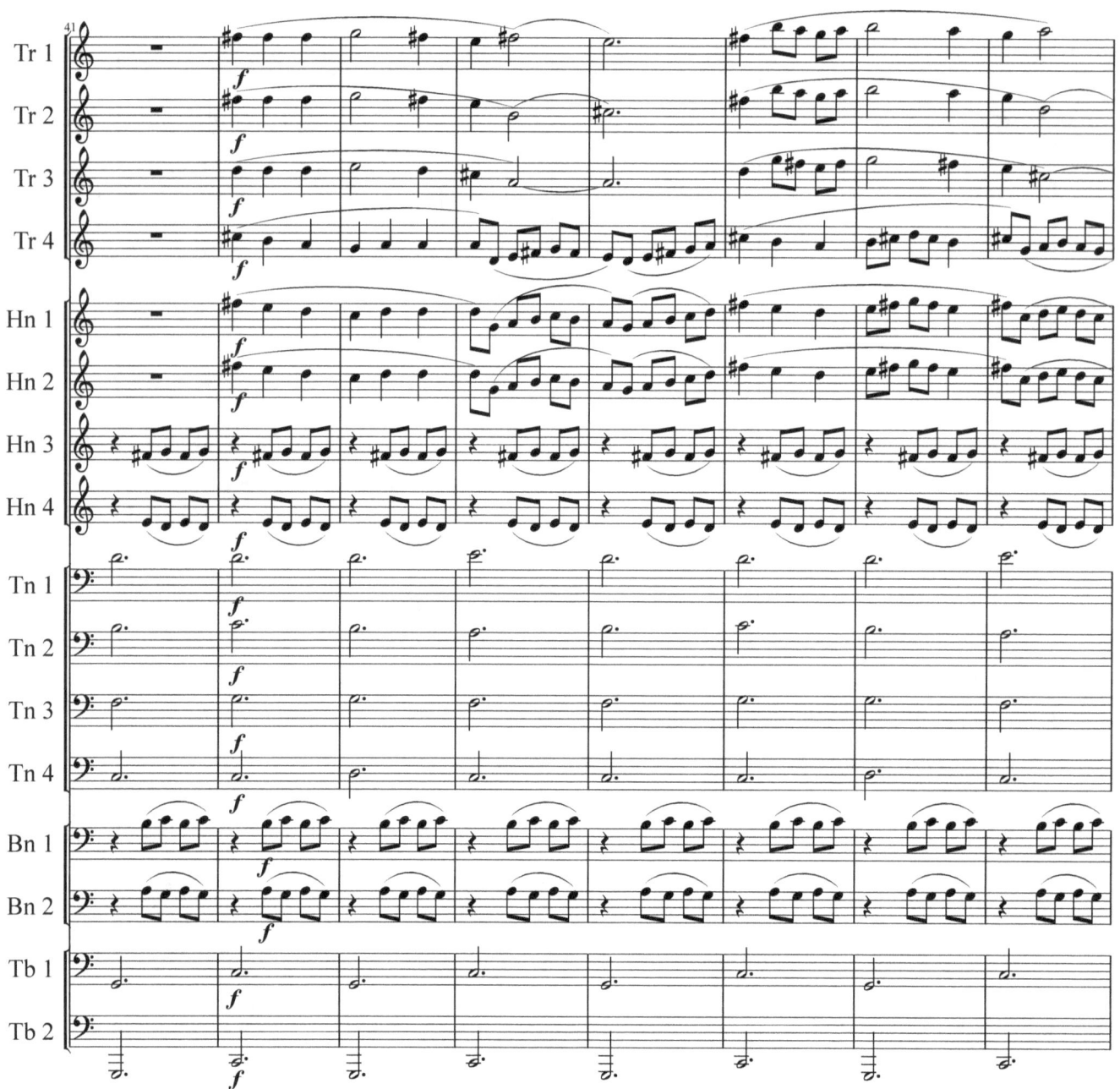

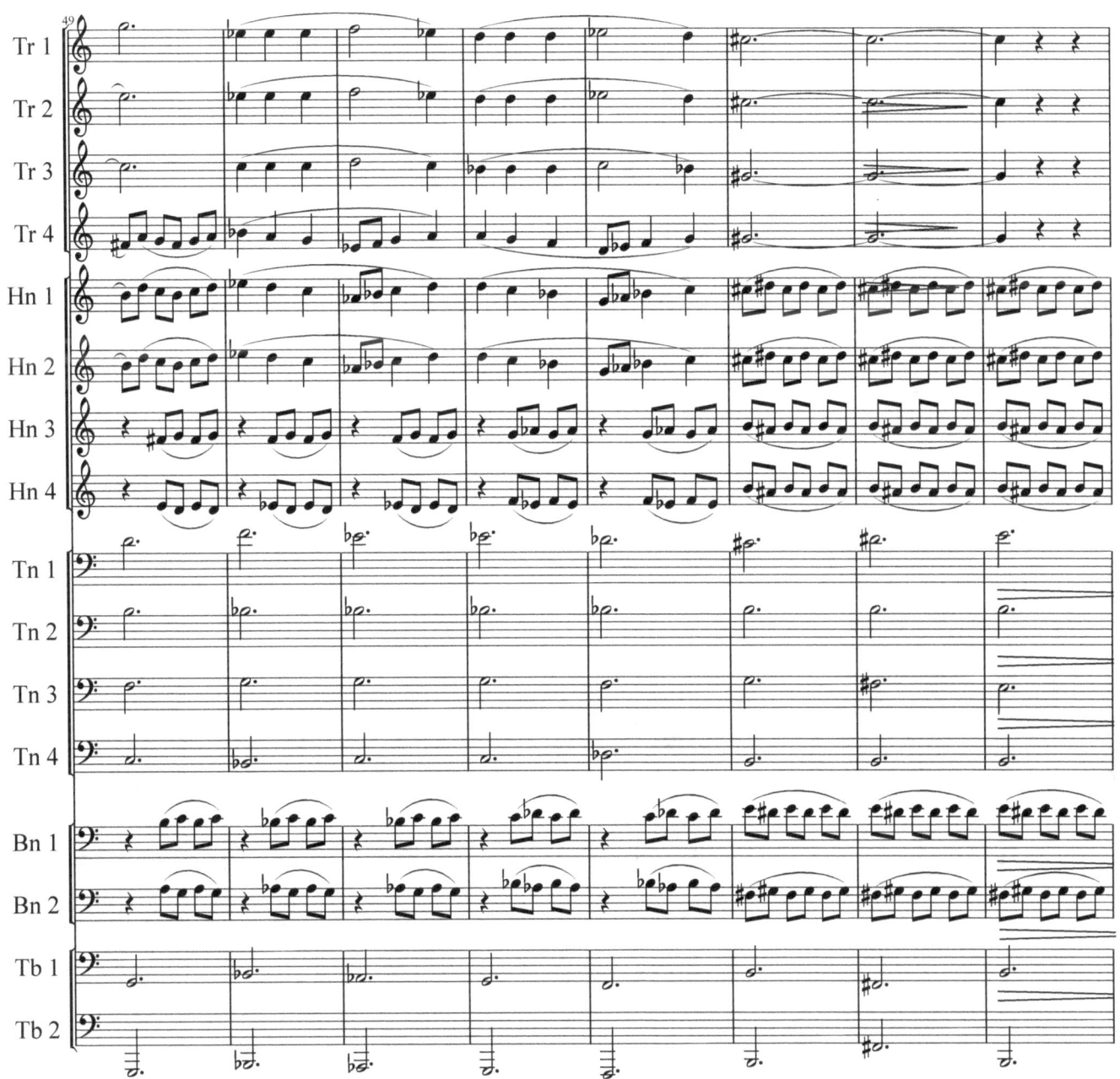

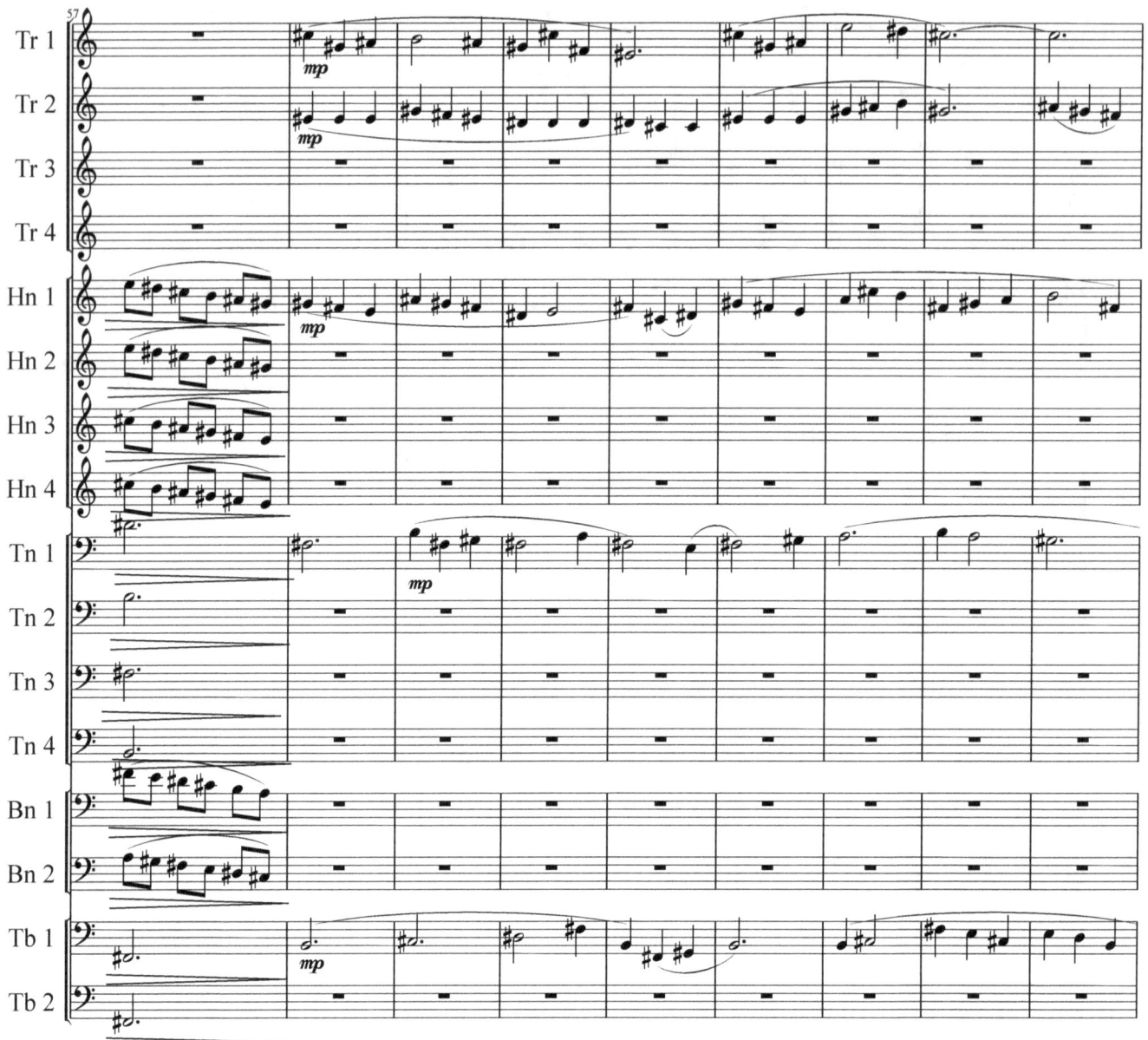

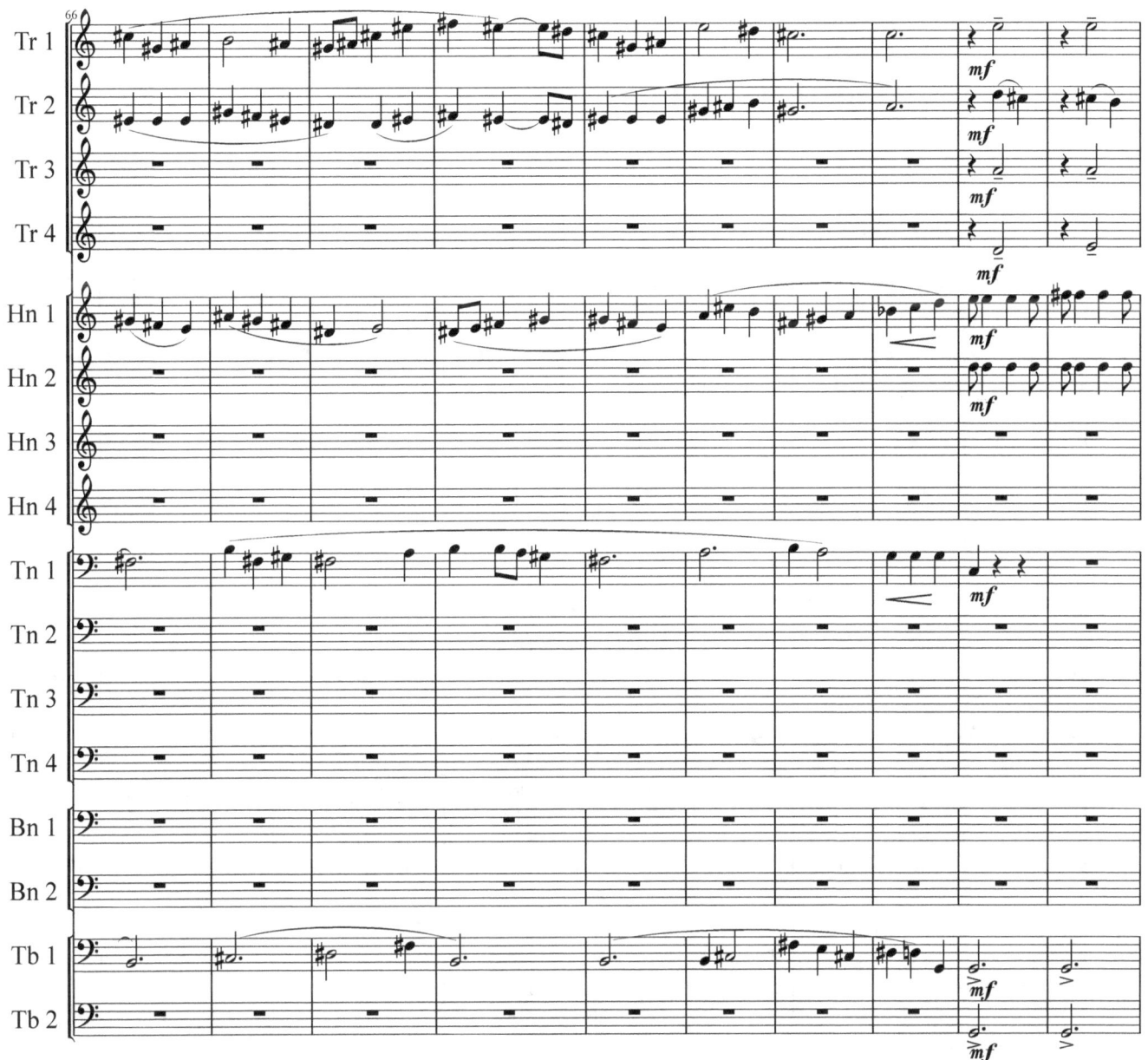

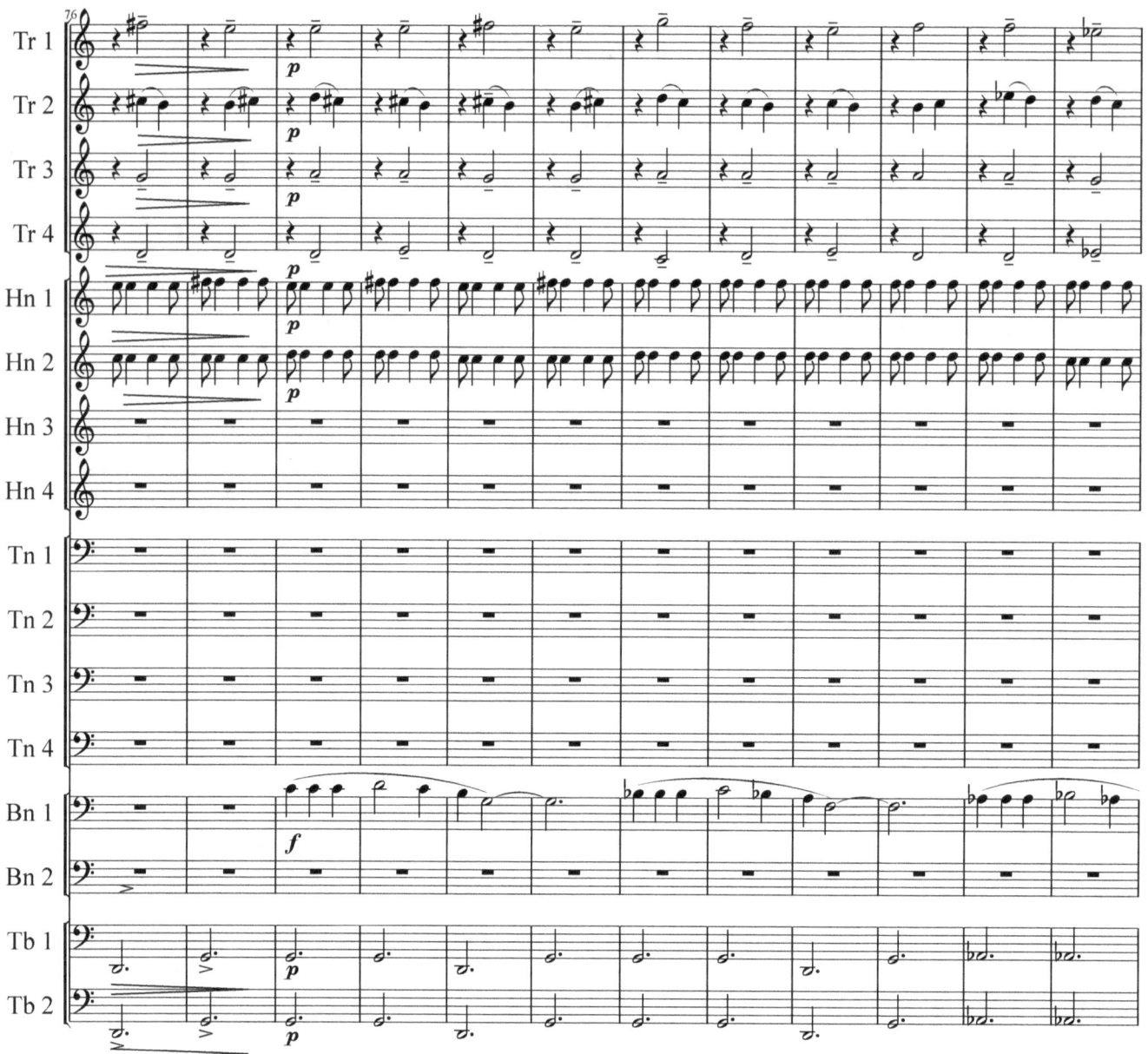

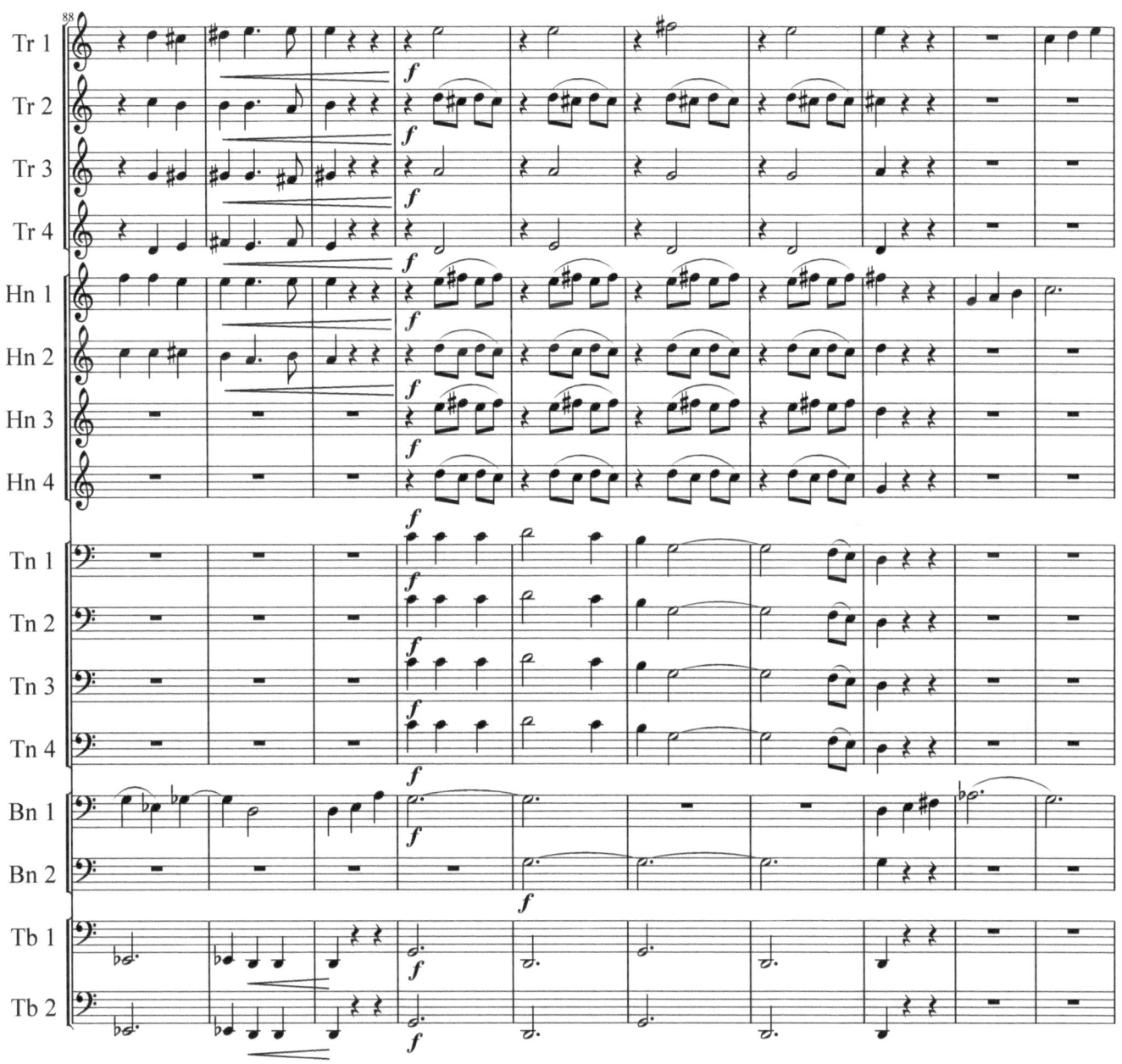

83

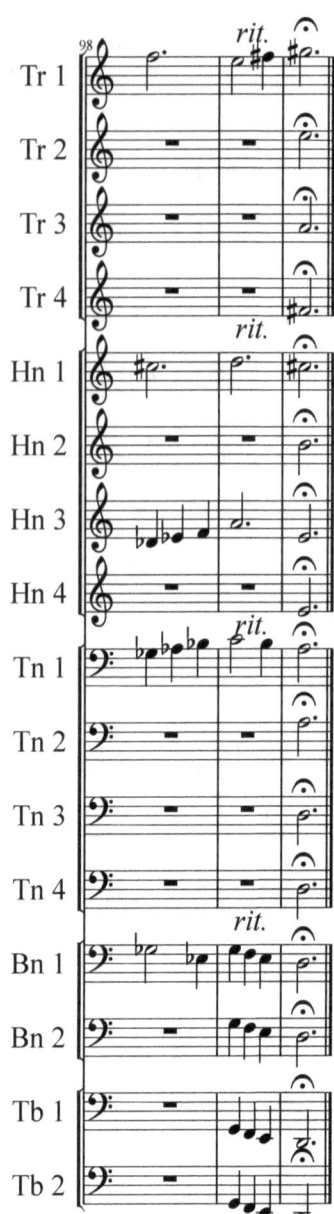

84

Missa Unitas
Credo Response

Ken Langer

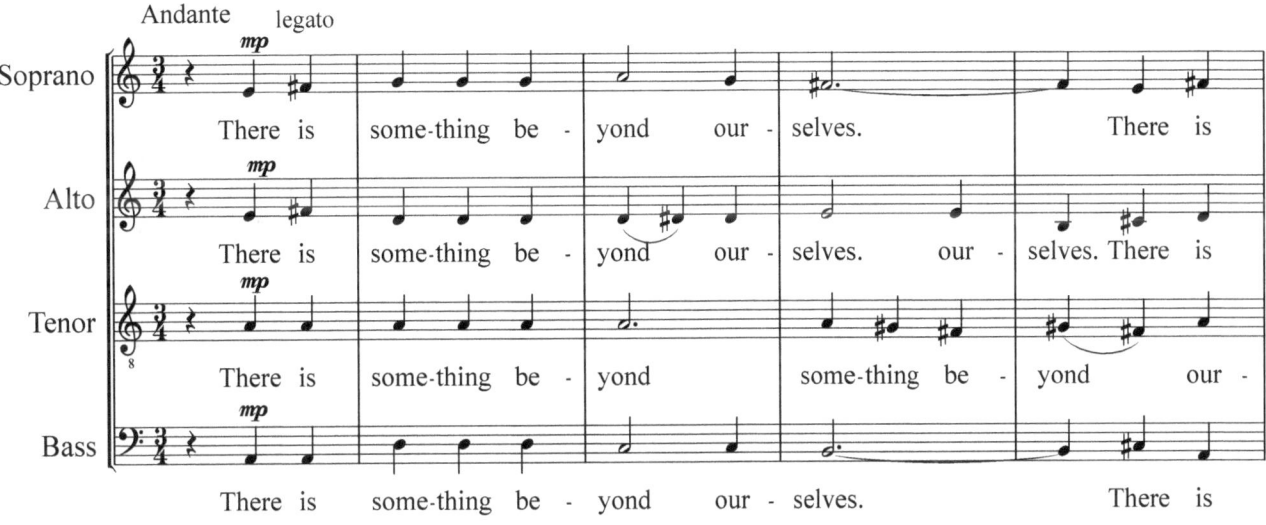
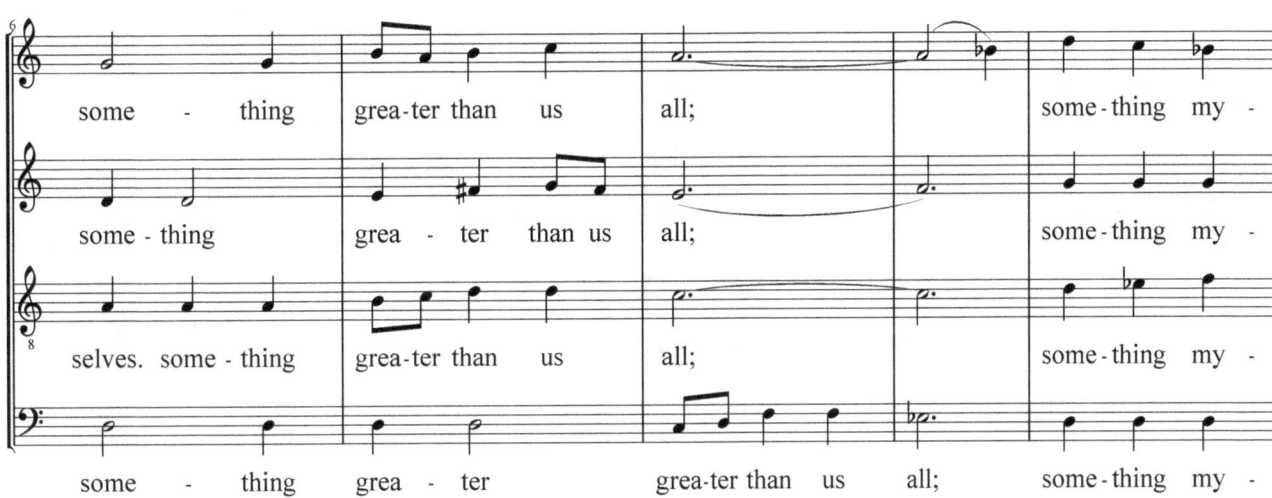

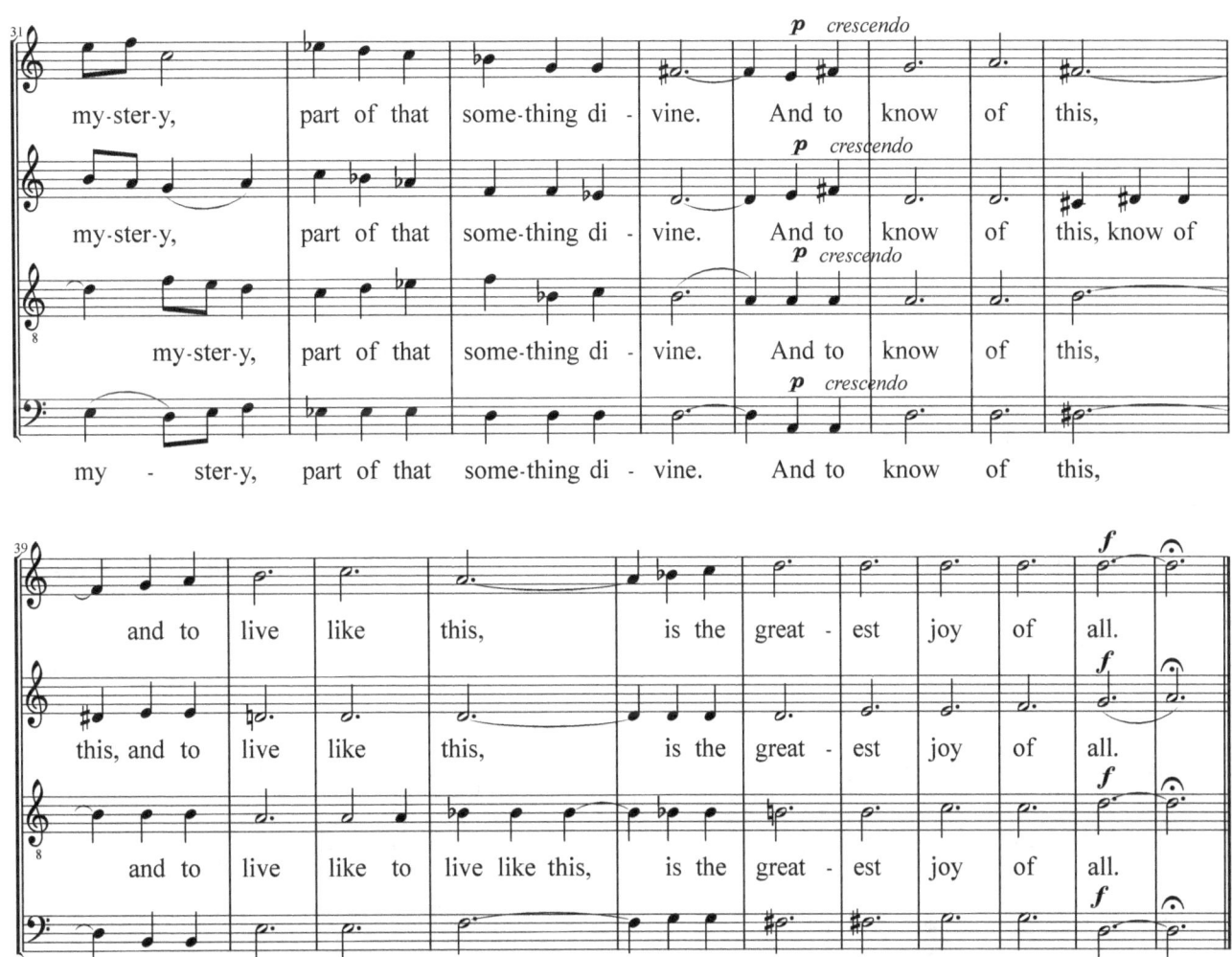

Missa Unitas
Canticle To Love

Ken Langer

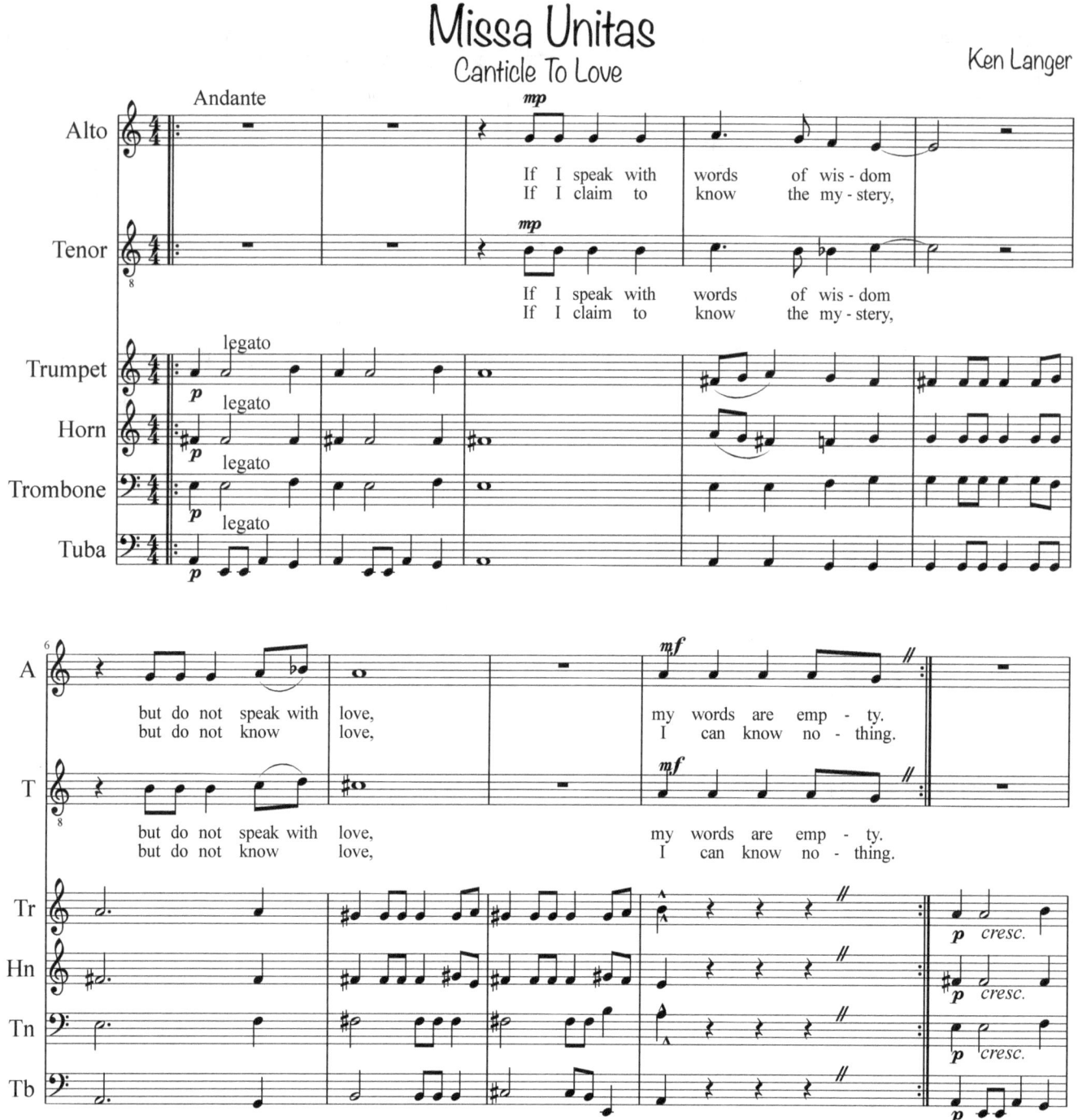

88

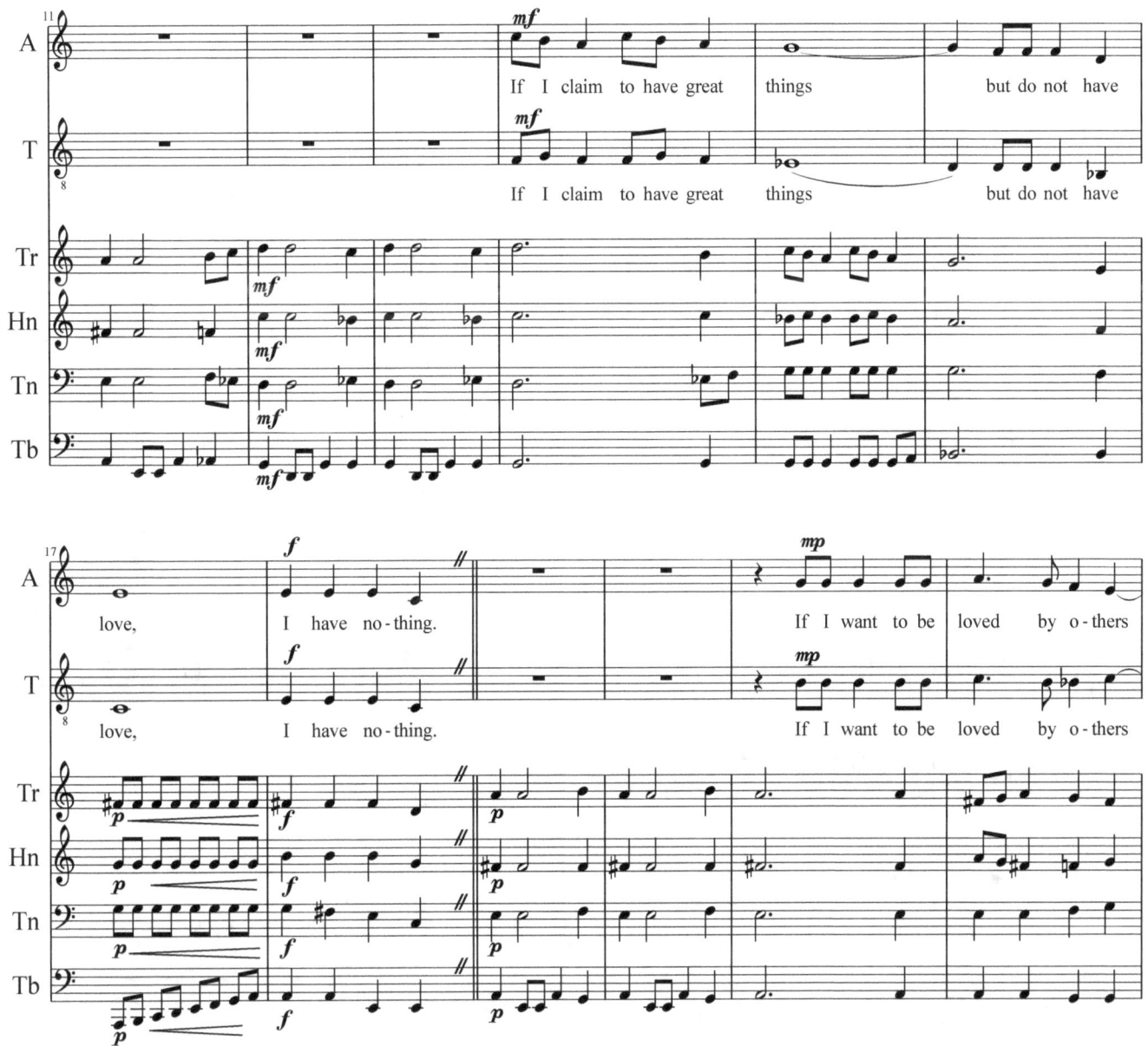

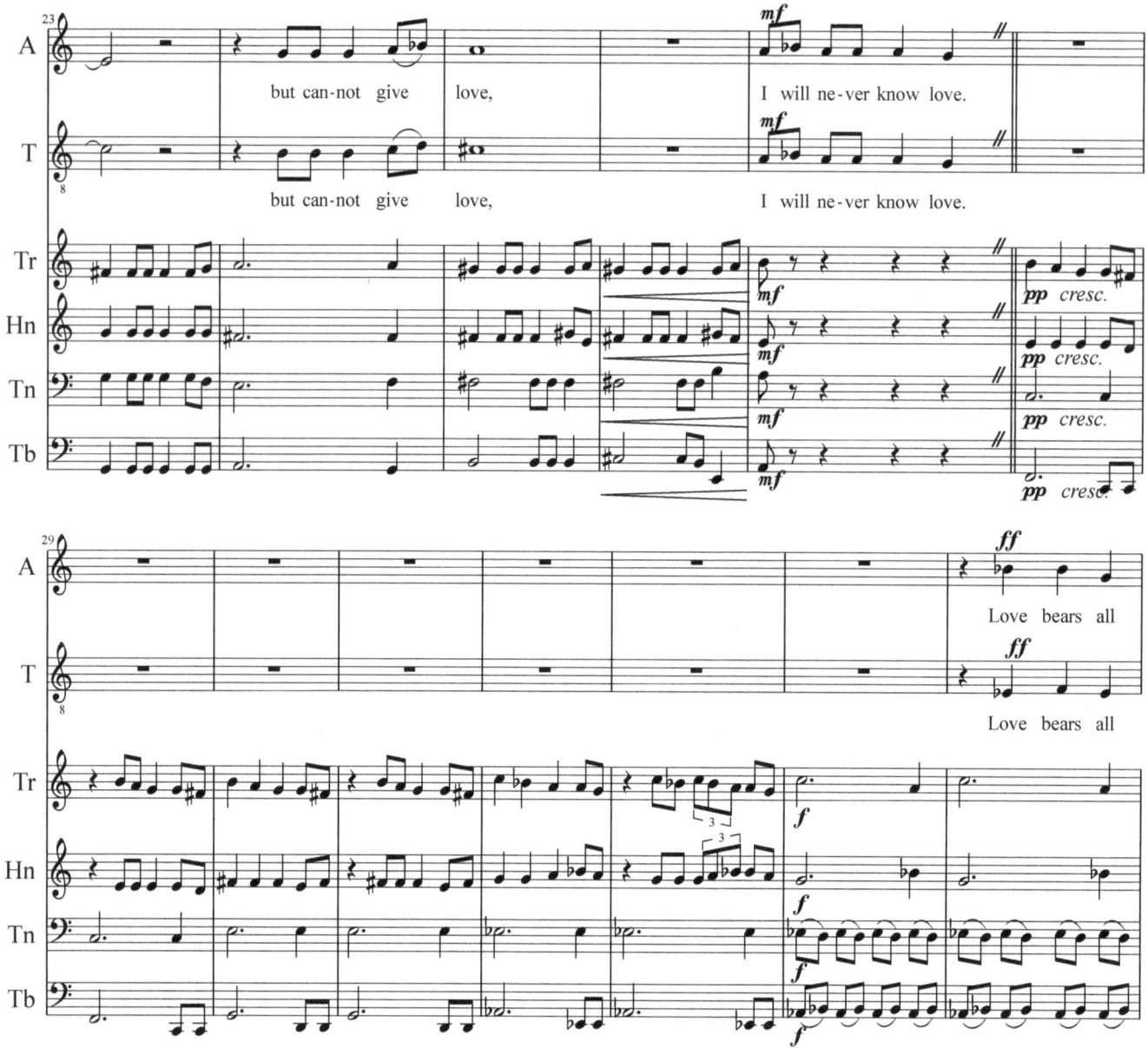

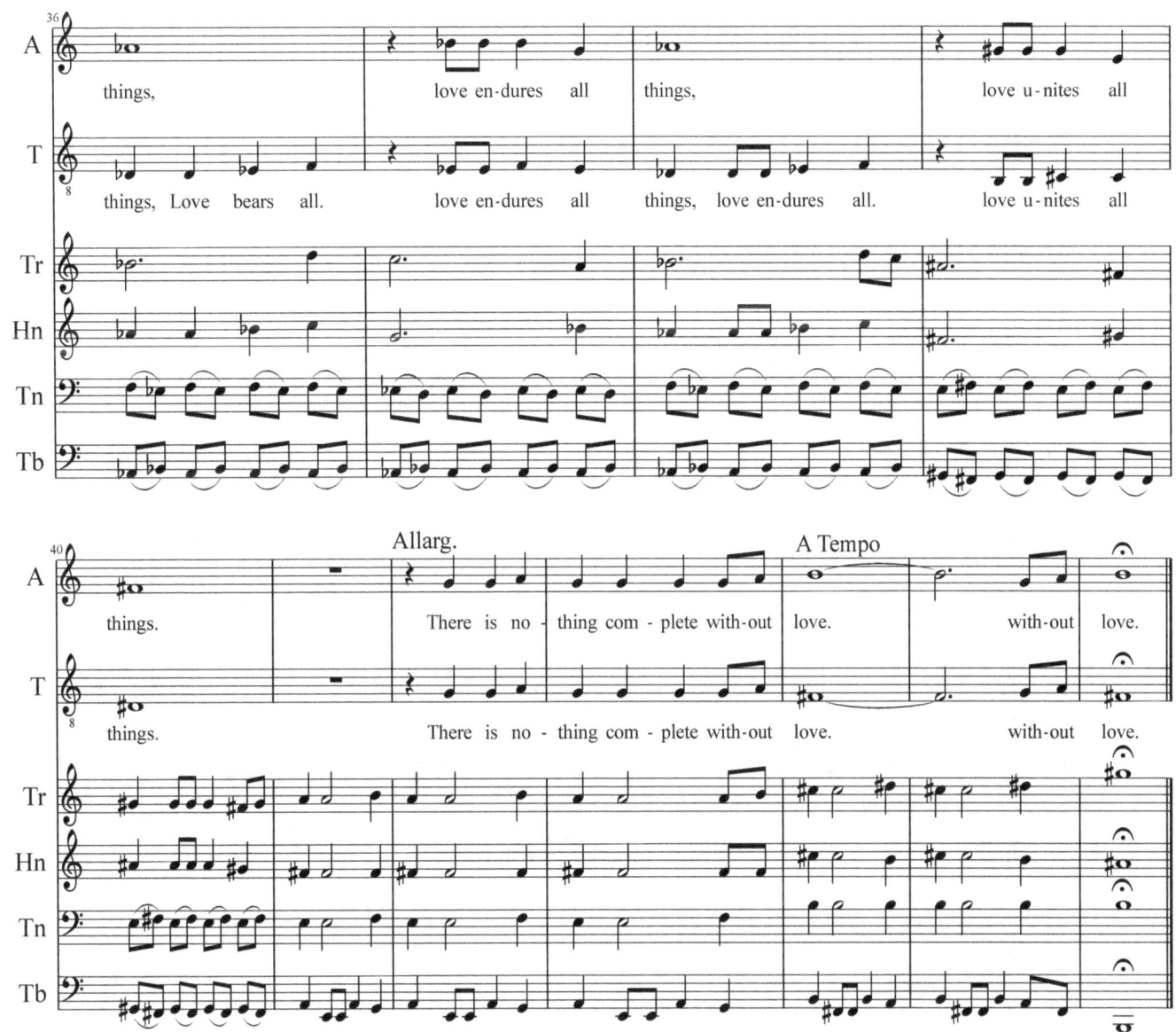

Missa Unitas
Sanctus Call

Ken Langer

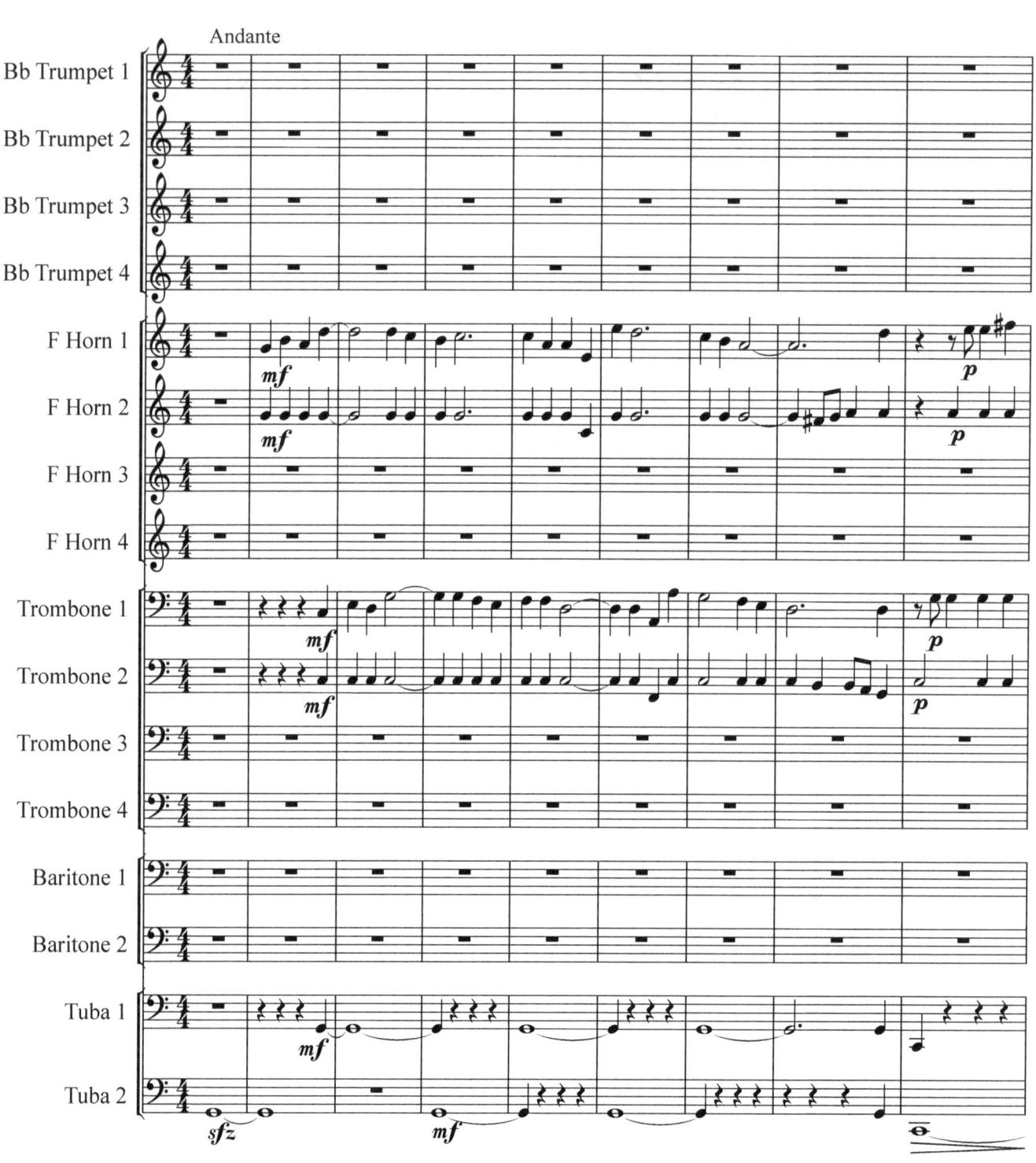

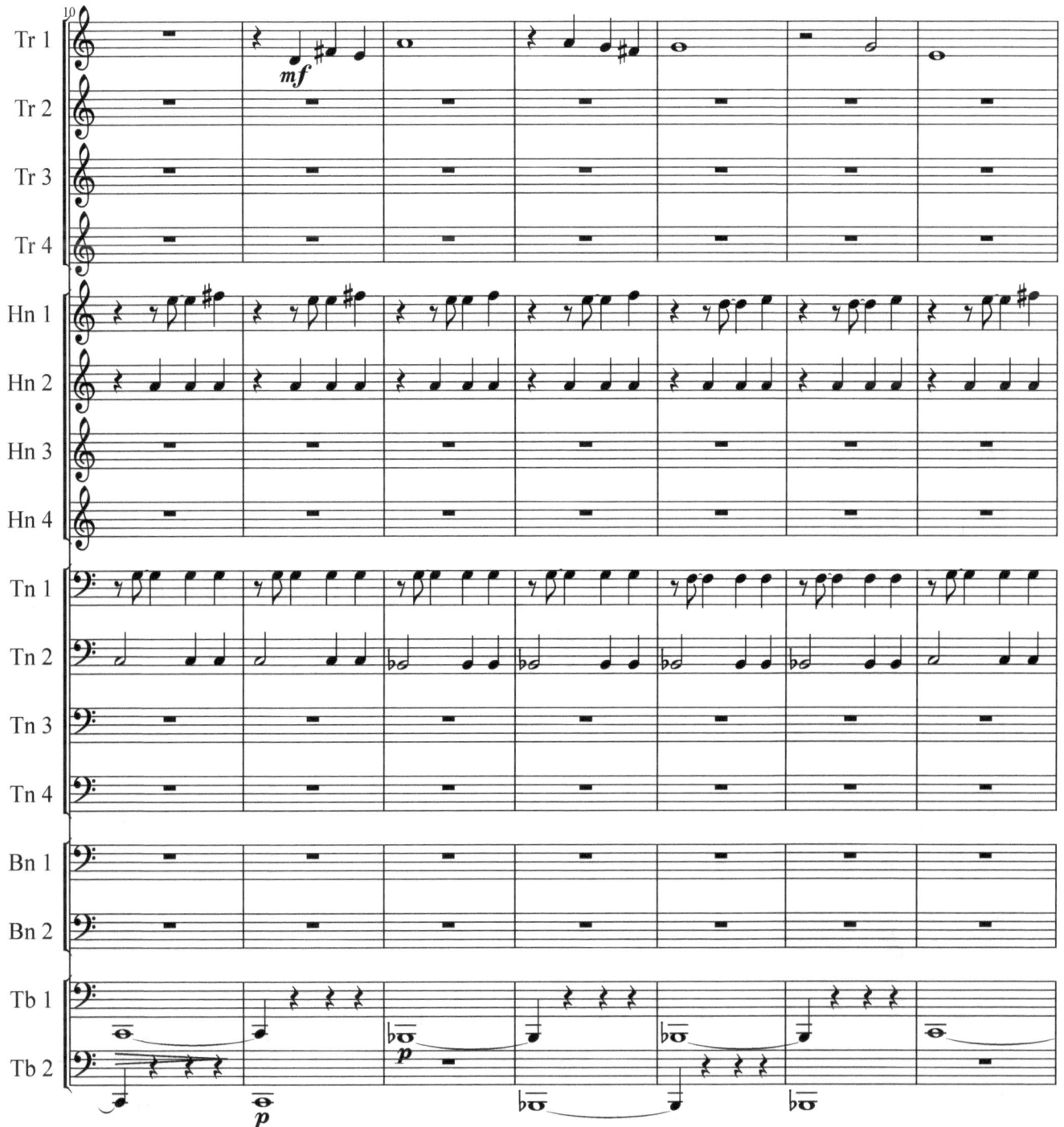

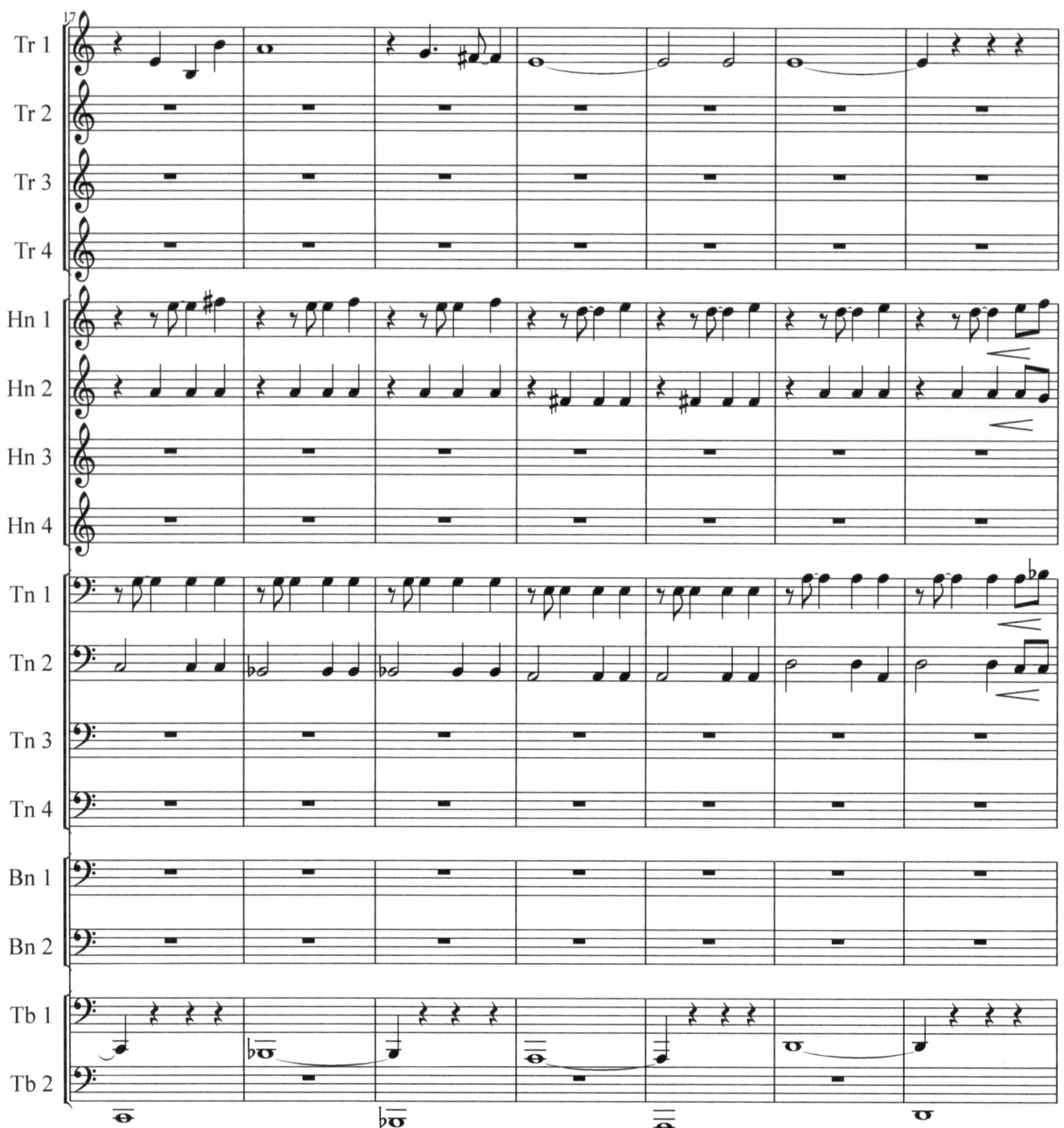

95

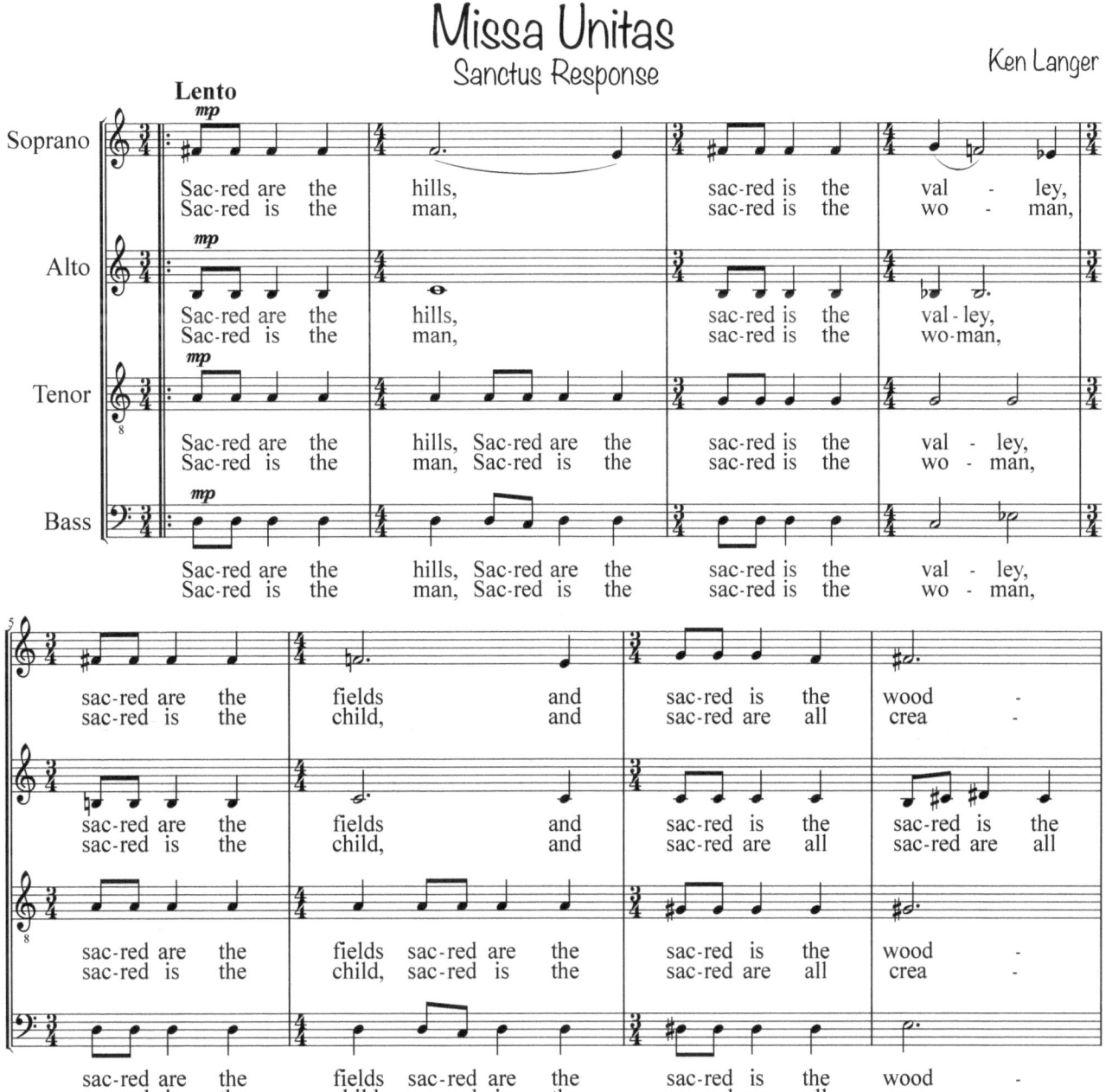

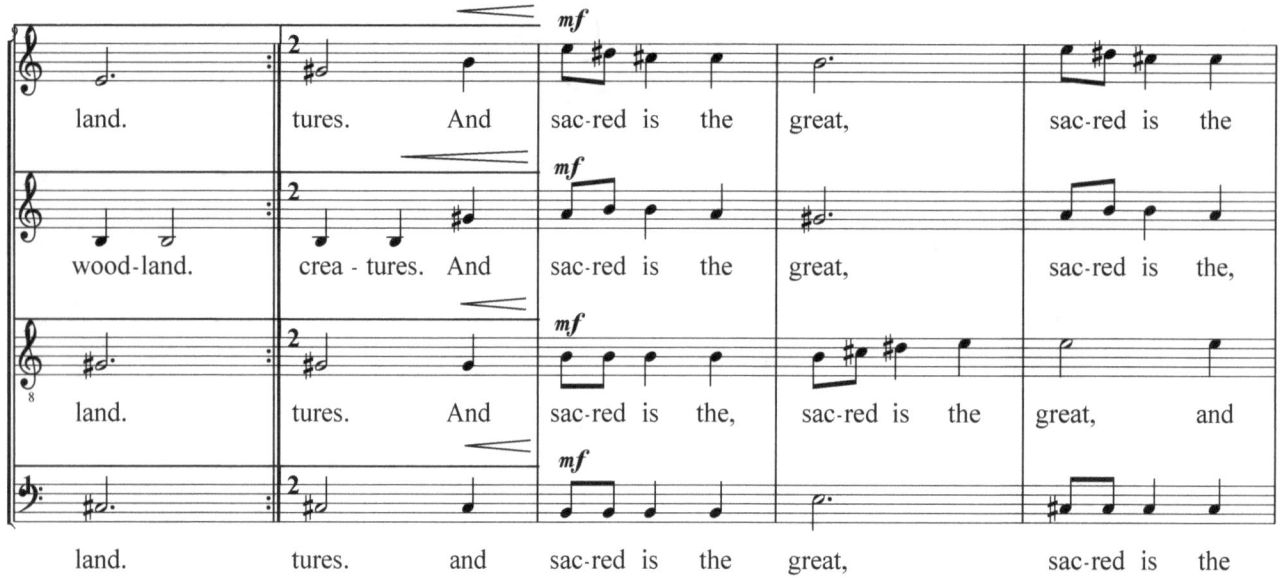
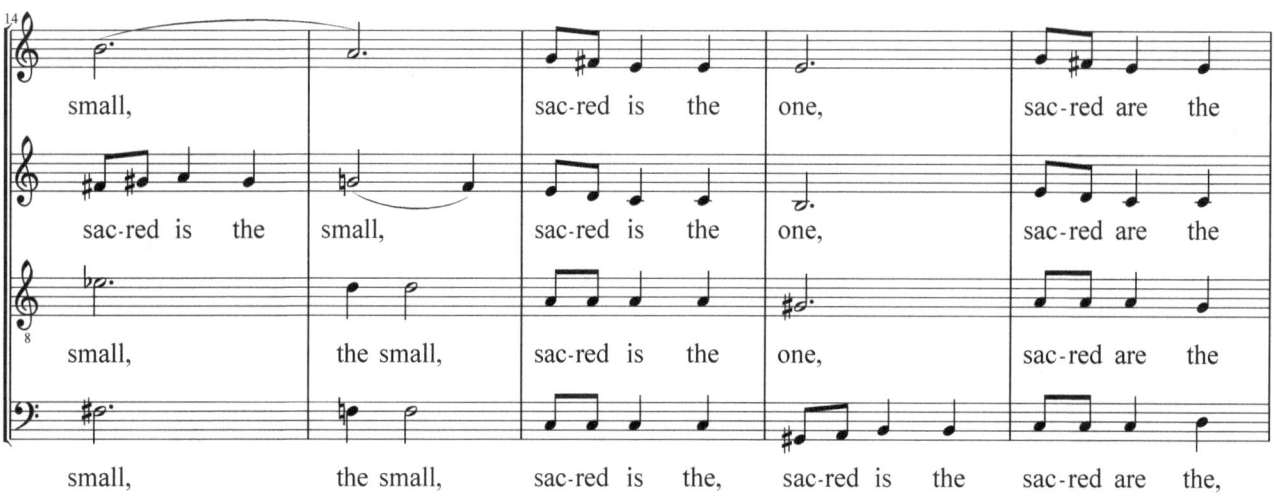
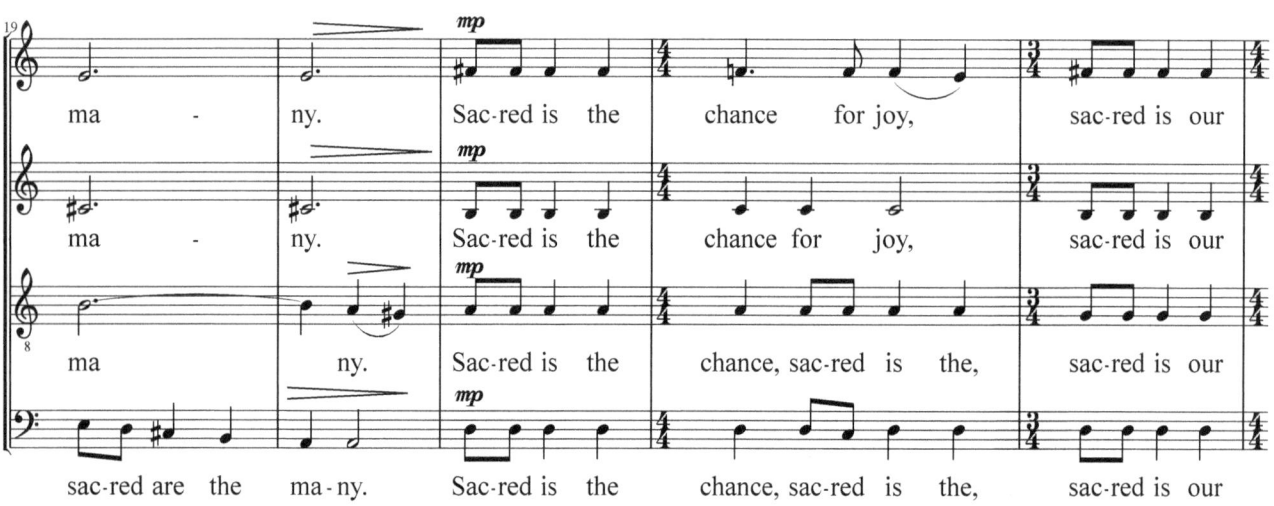

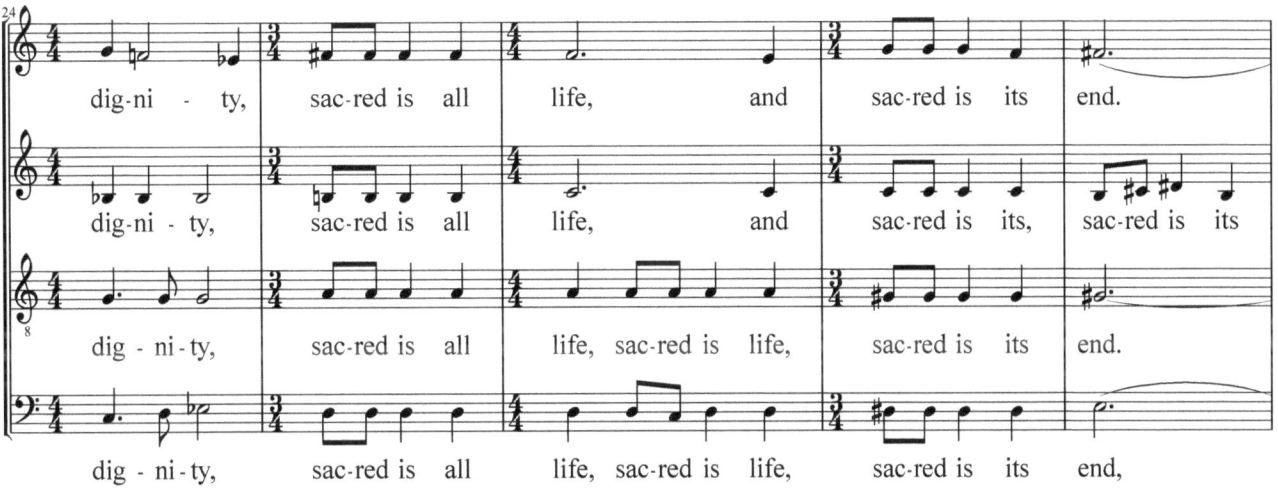
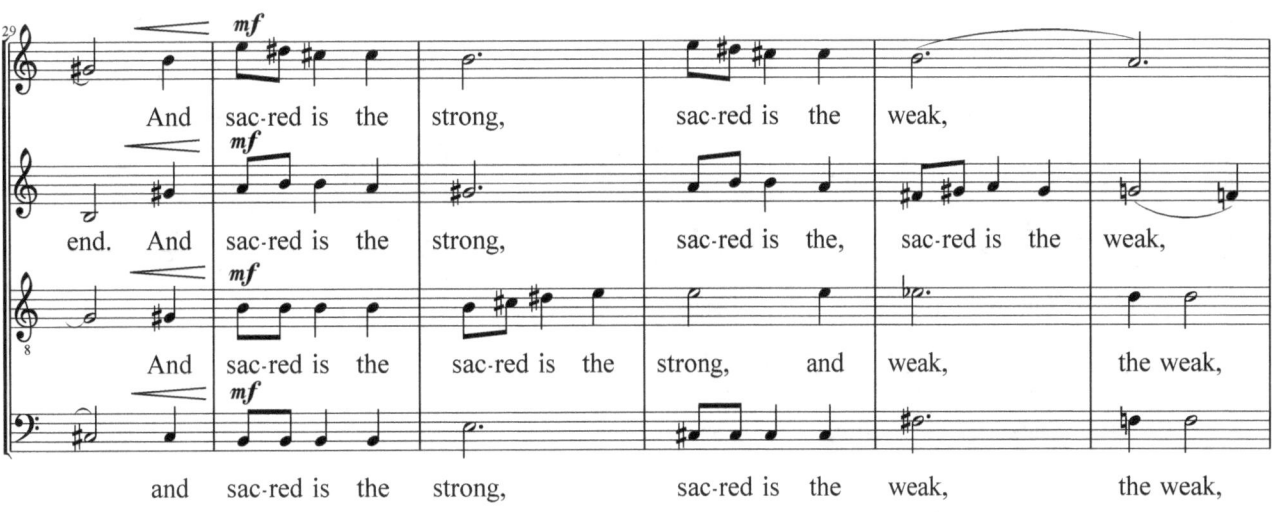
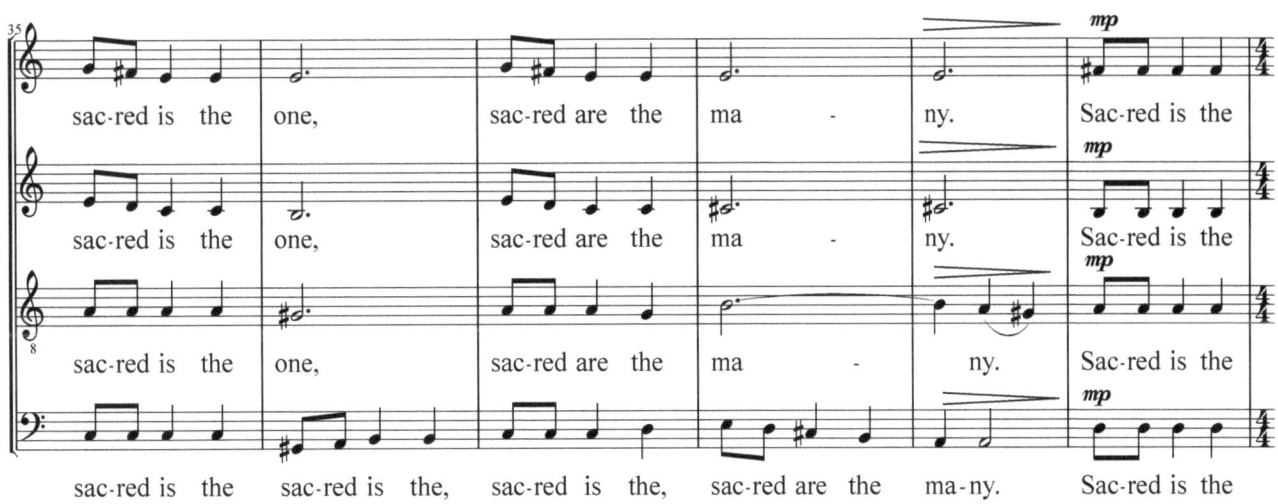

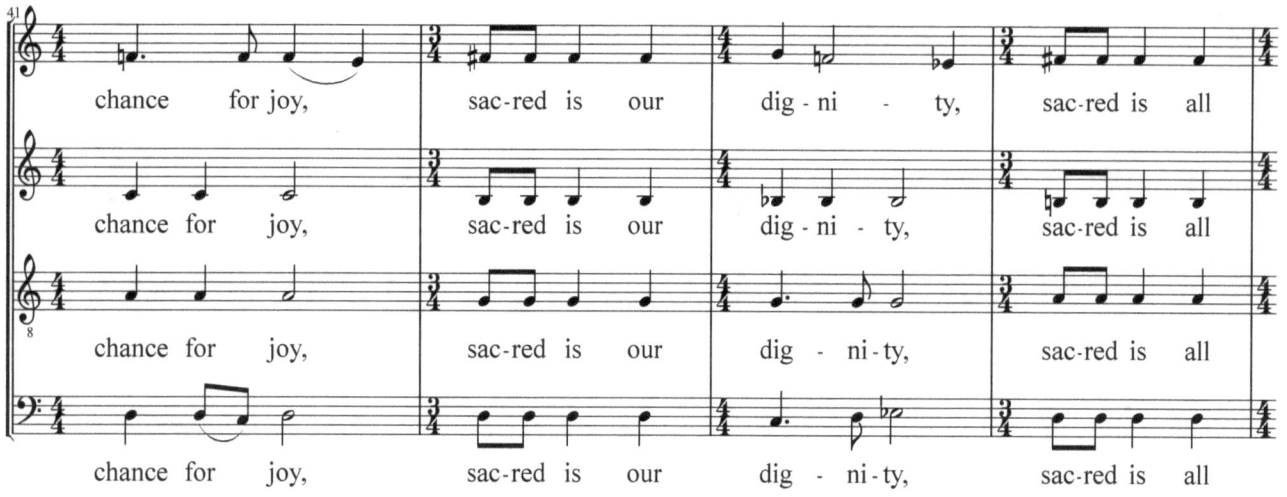
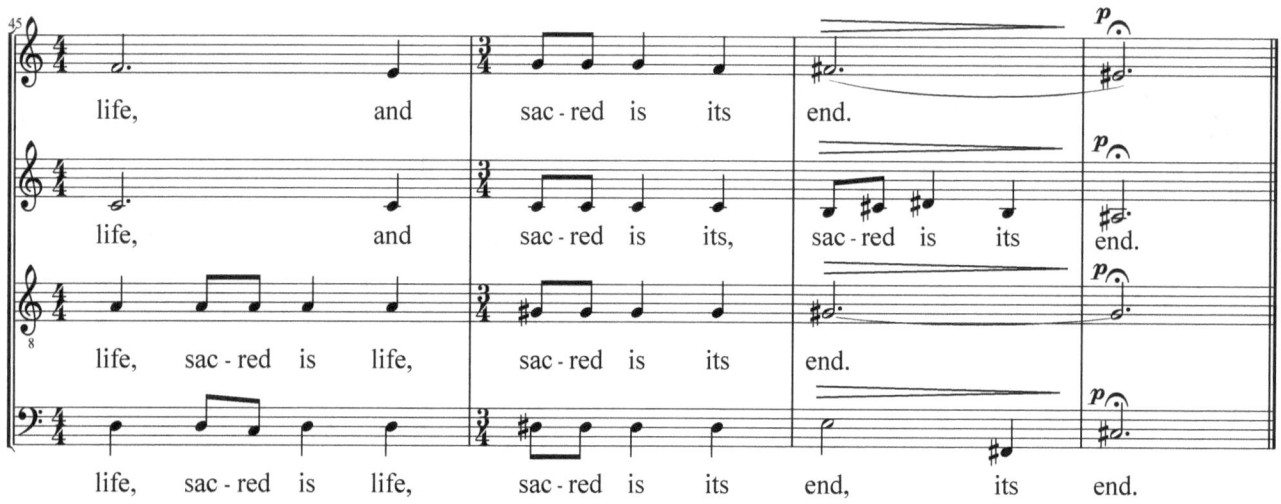

Missa Unitas
Benedictus

Ken Langer

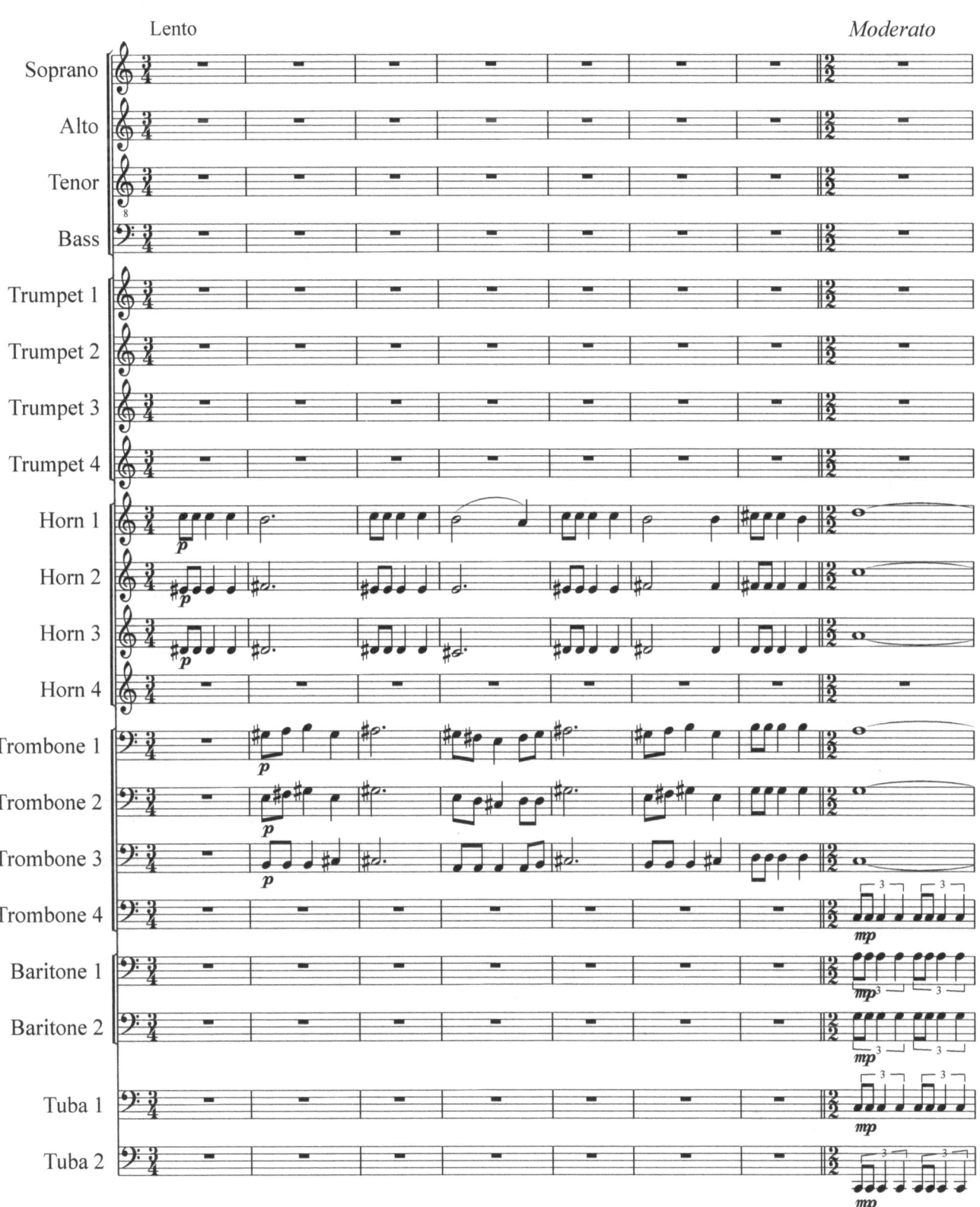

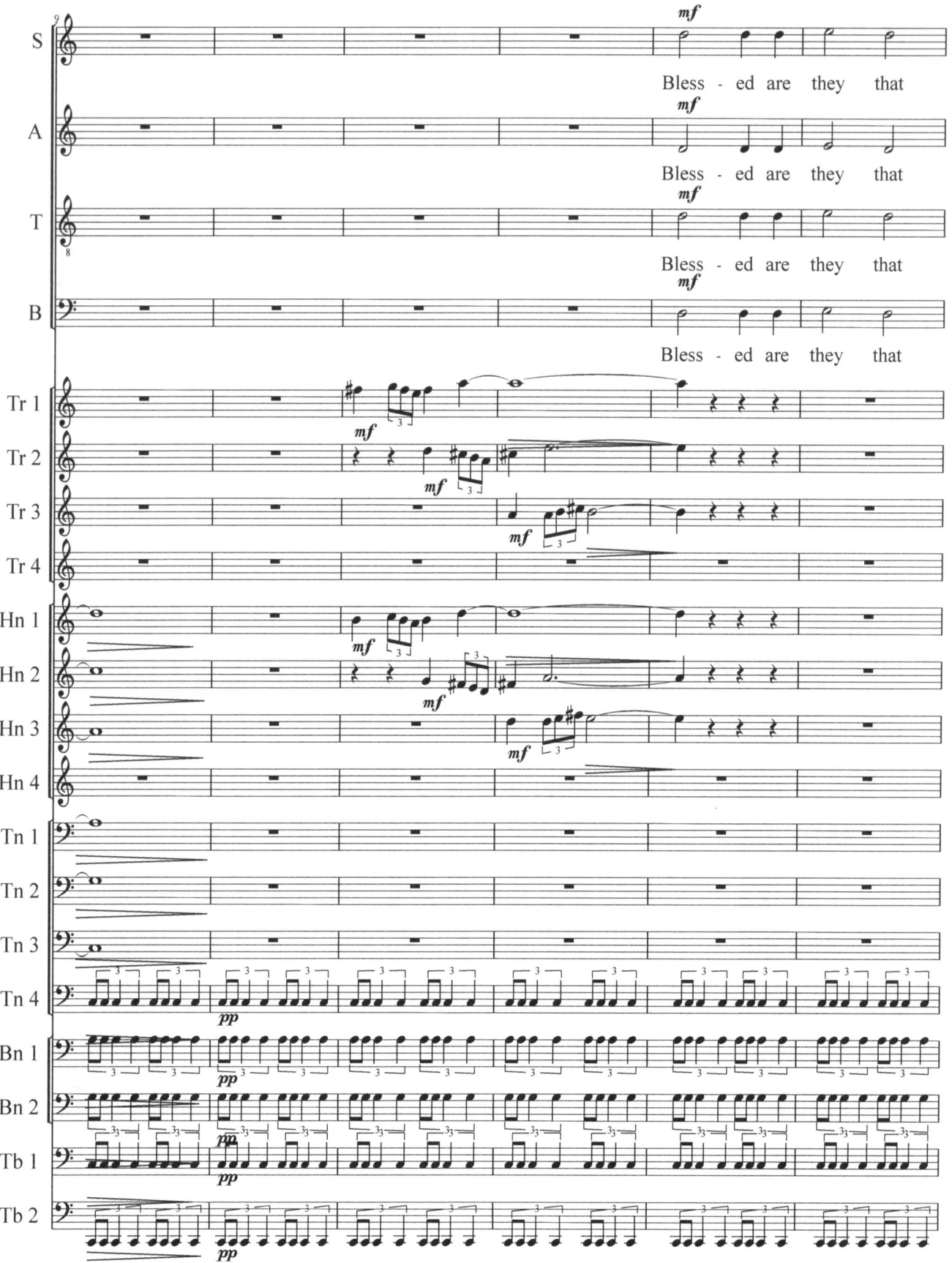

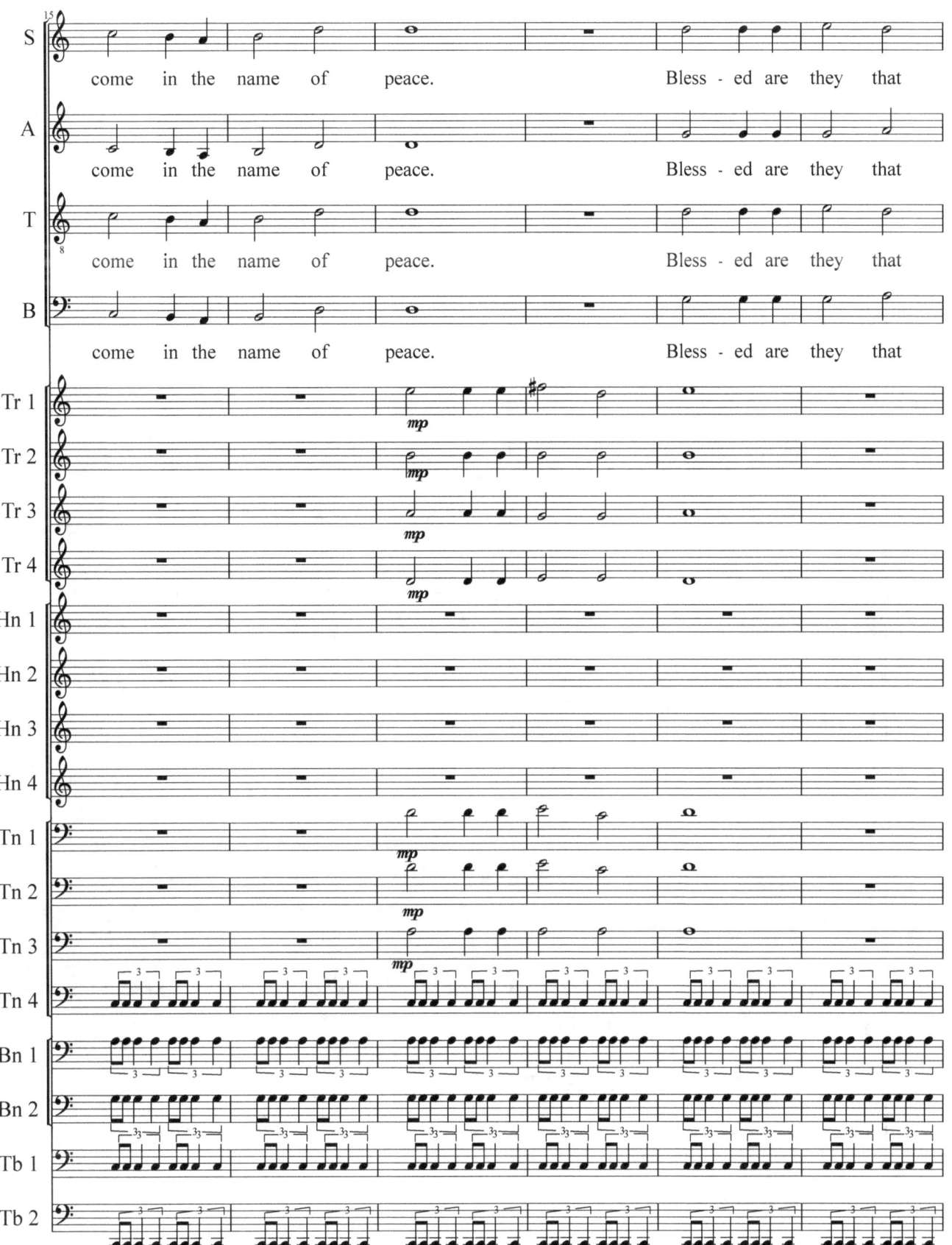

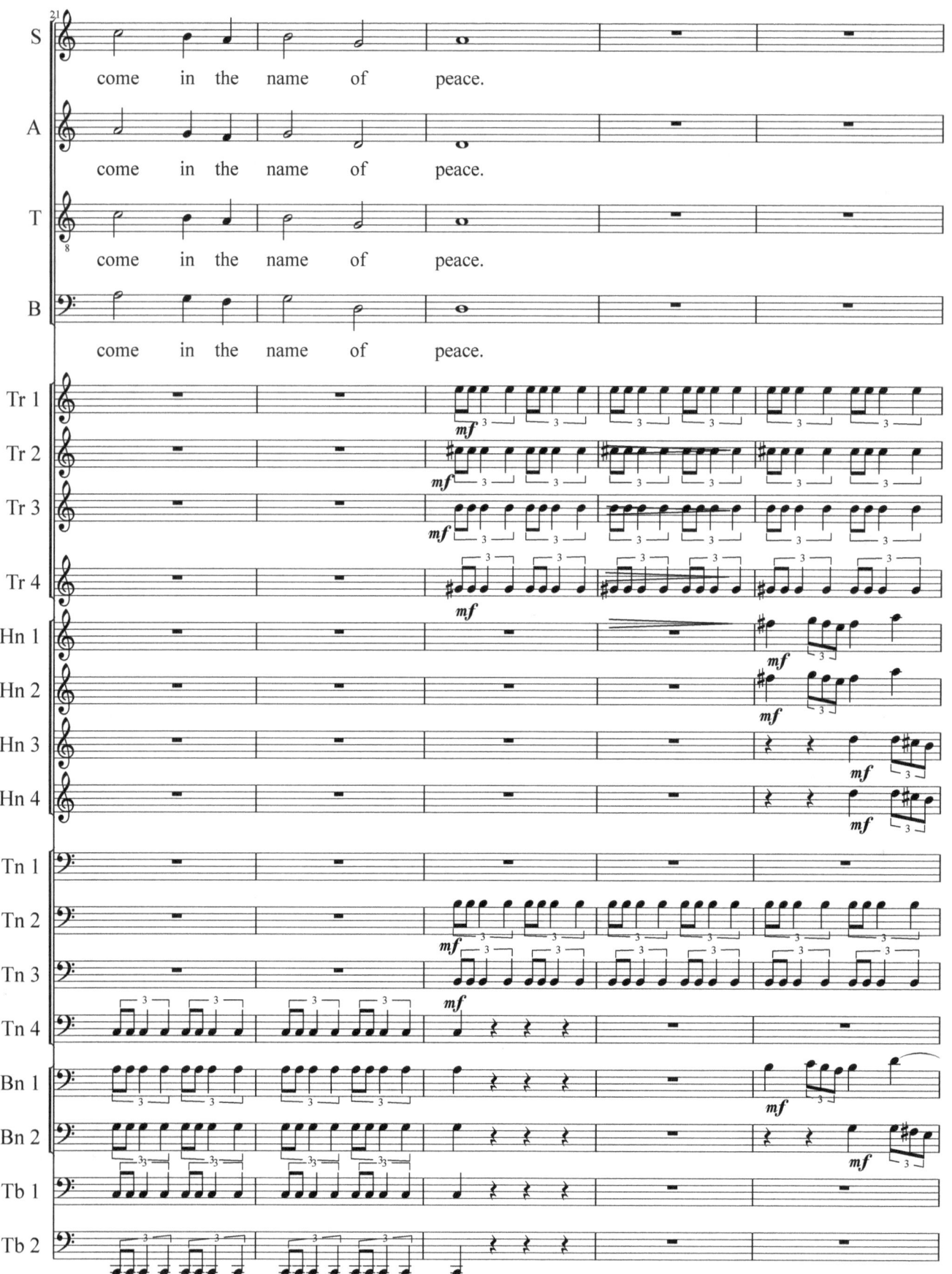

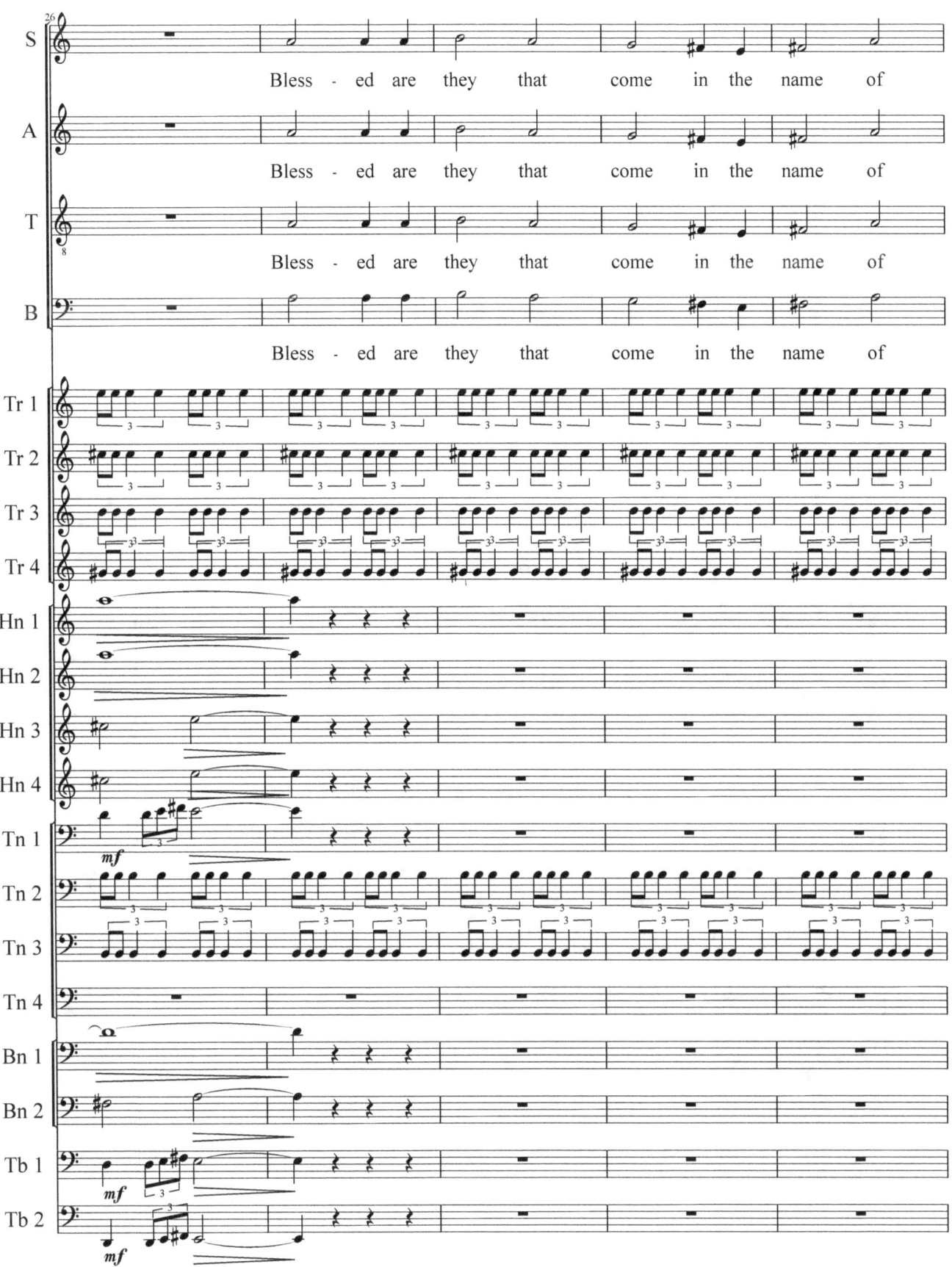

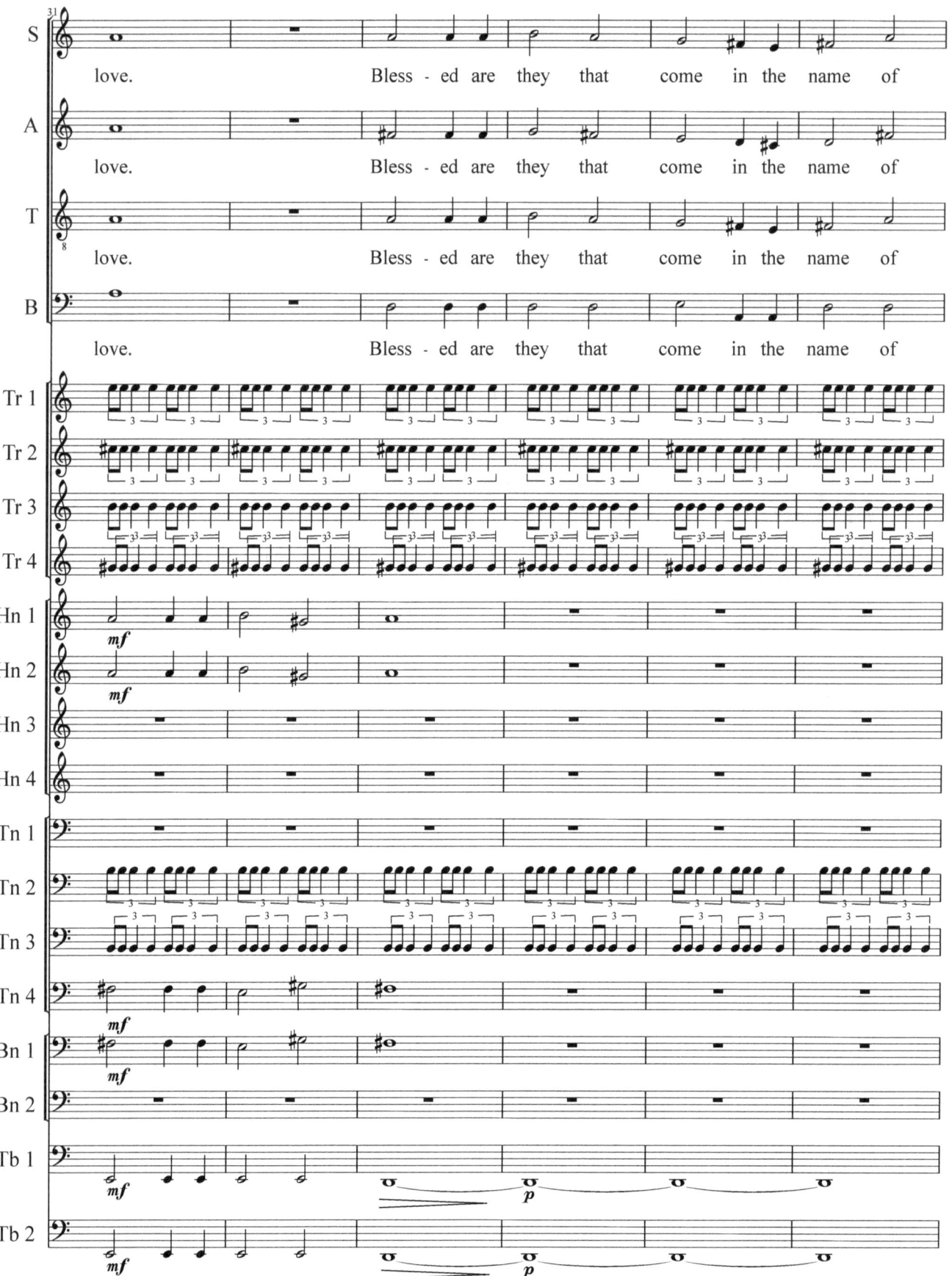

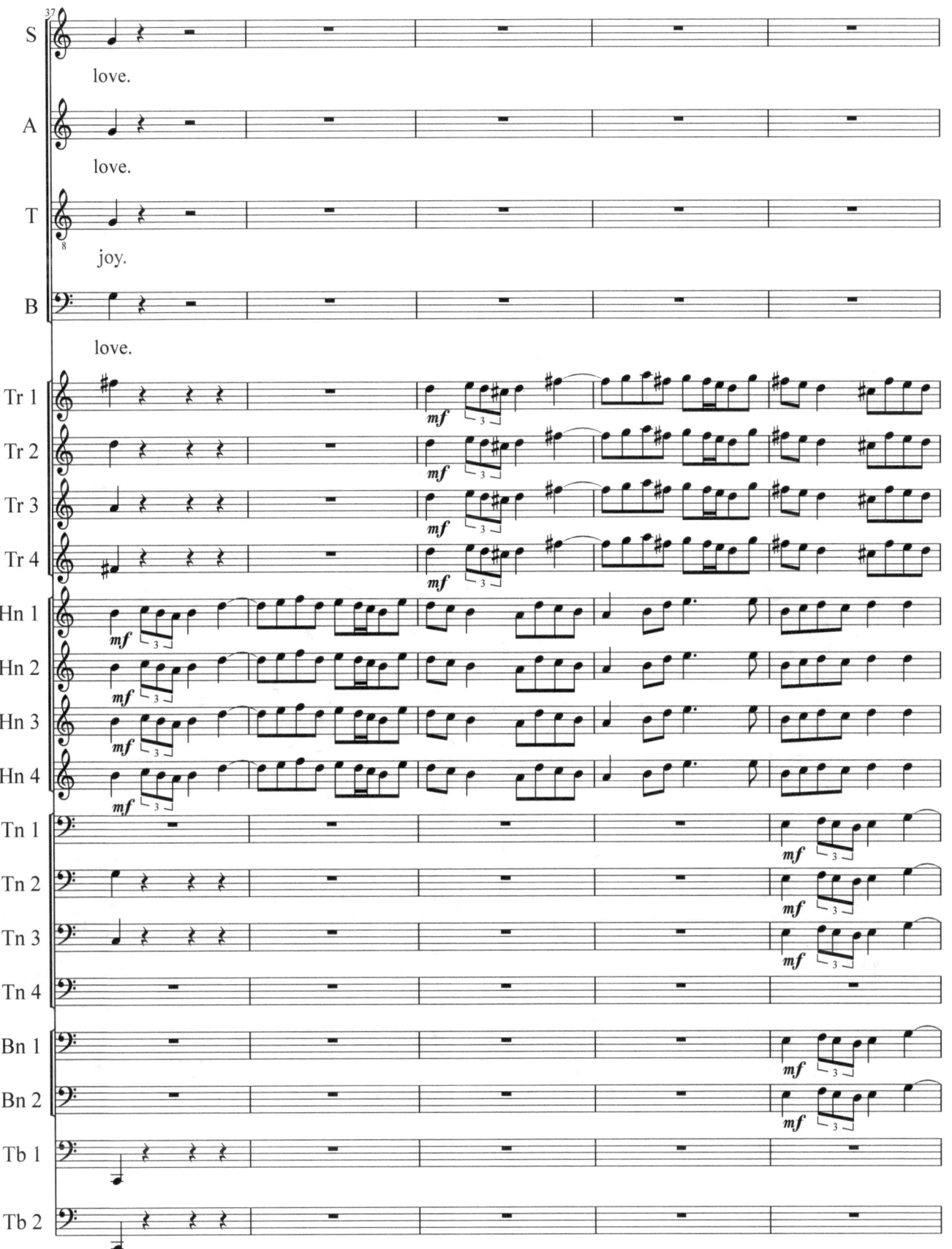

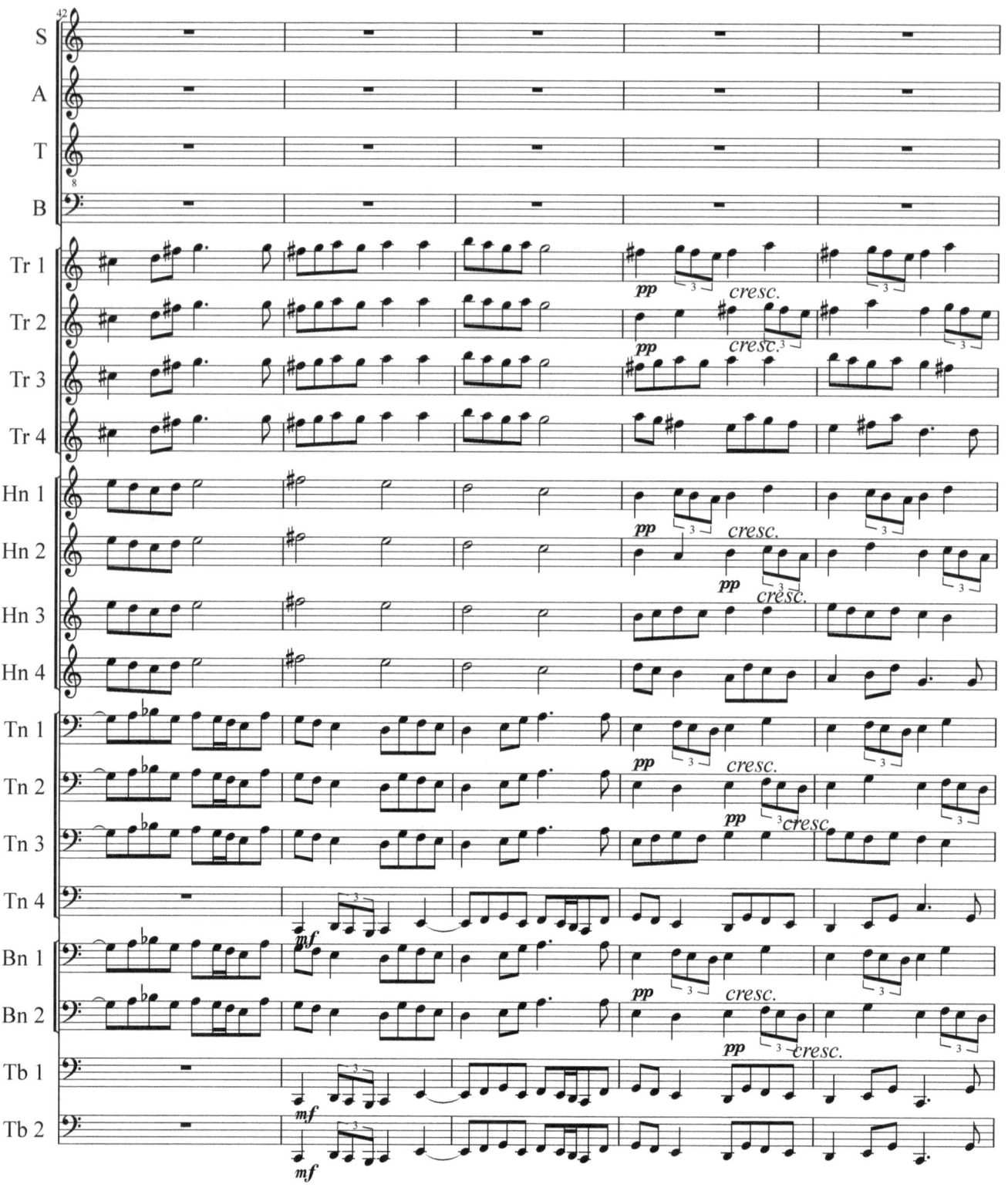

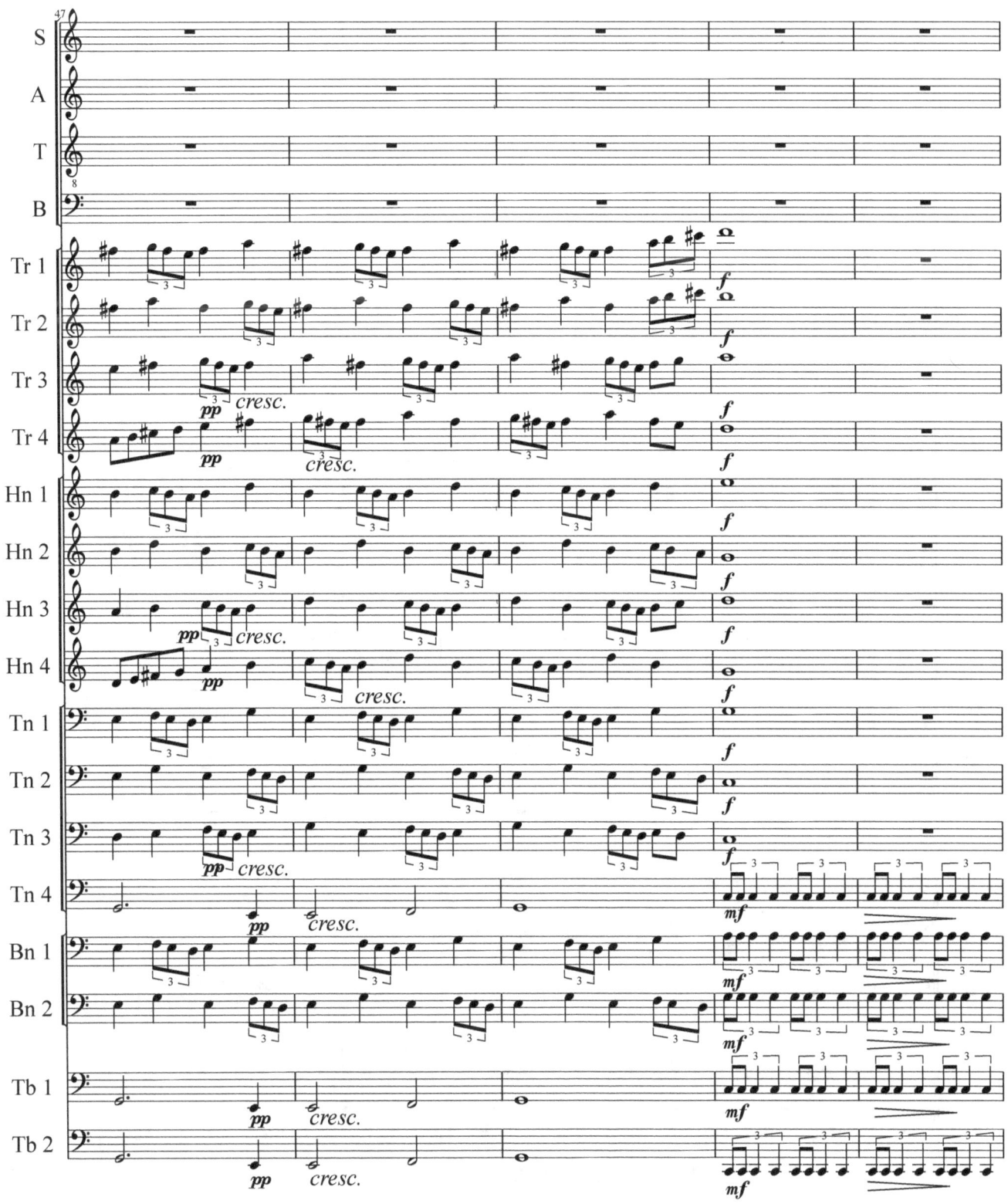

111

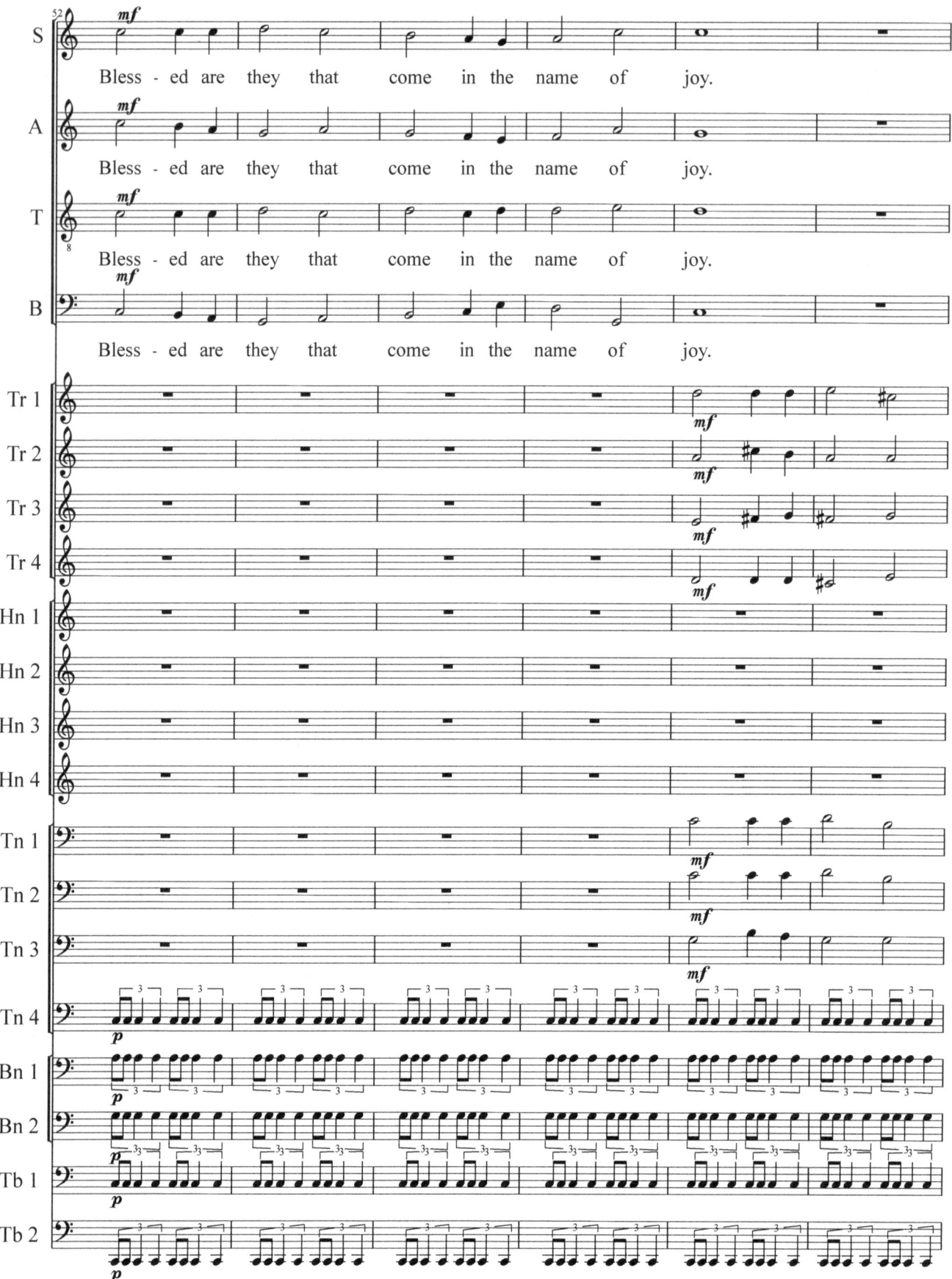

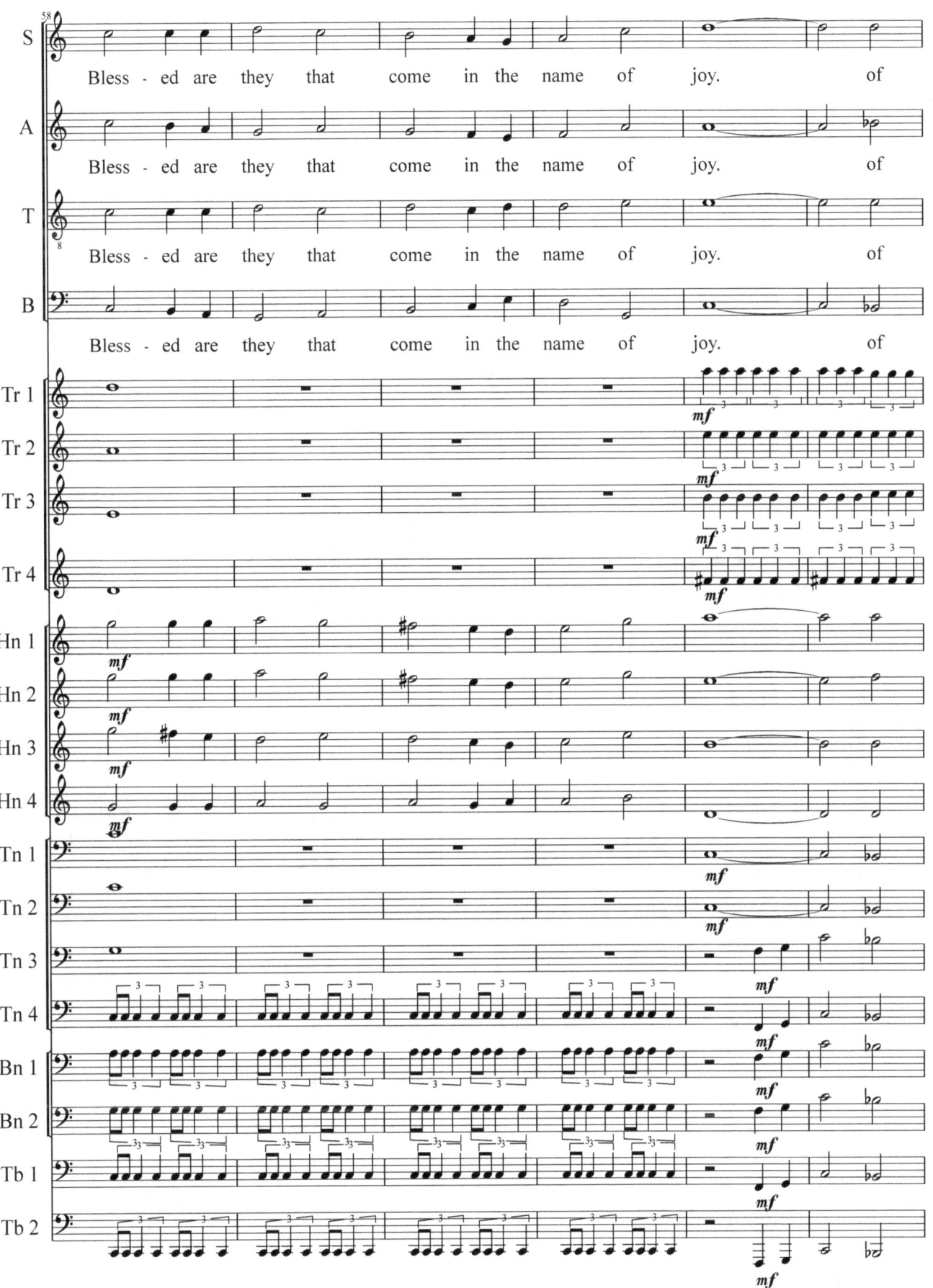

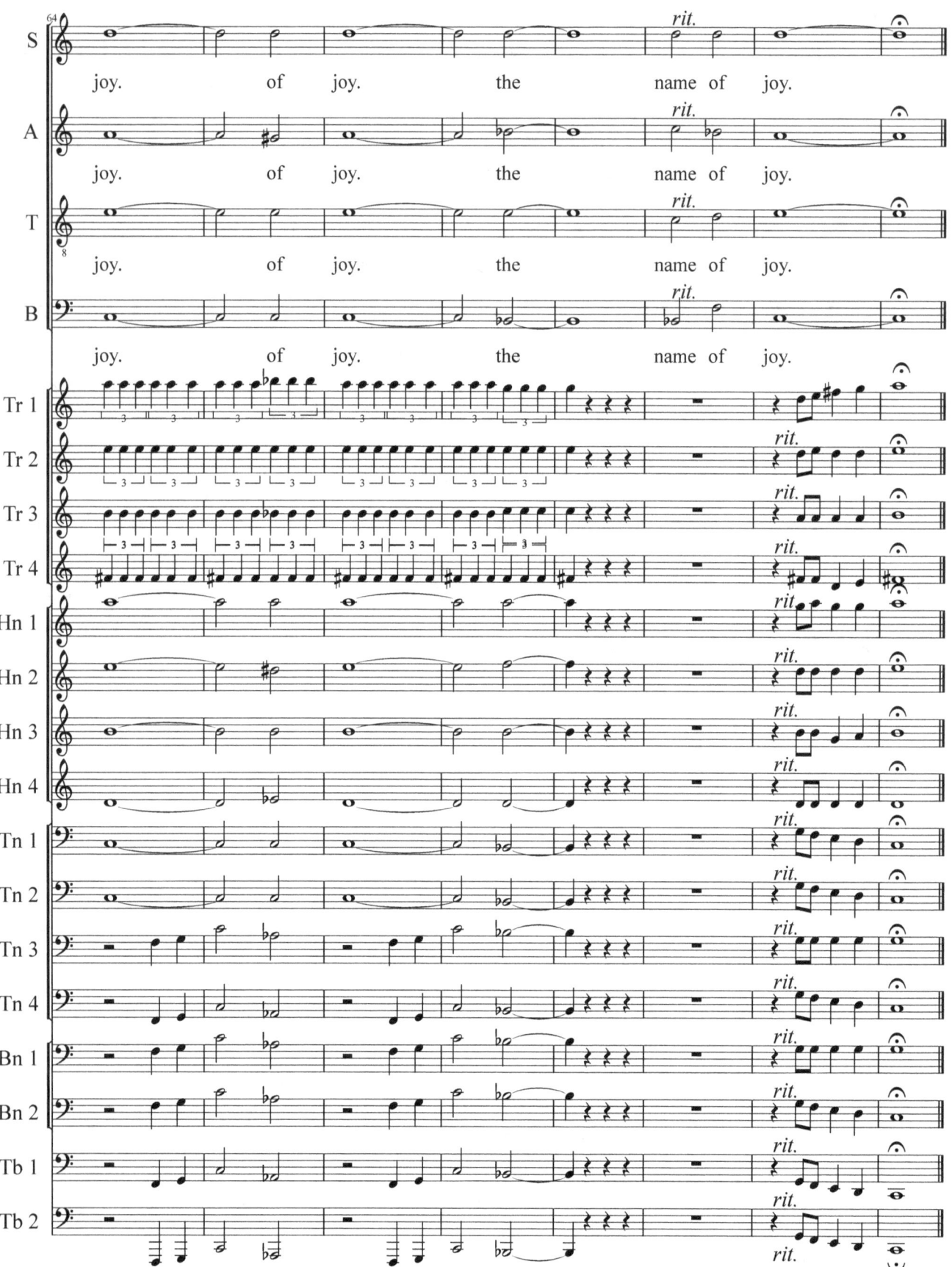

Misa Unitas
Reading No. 3

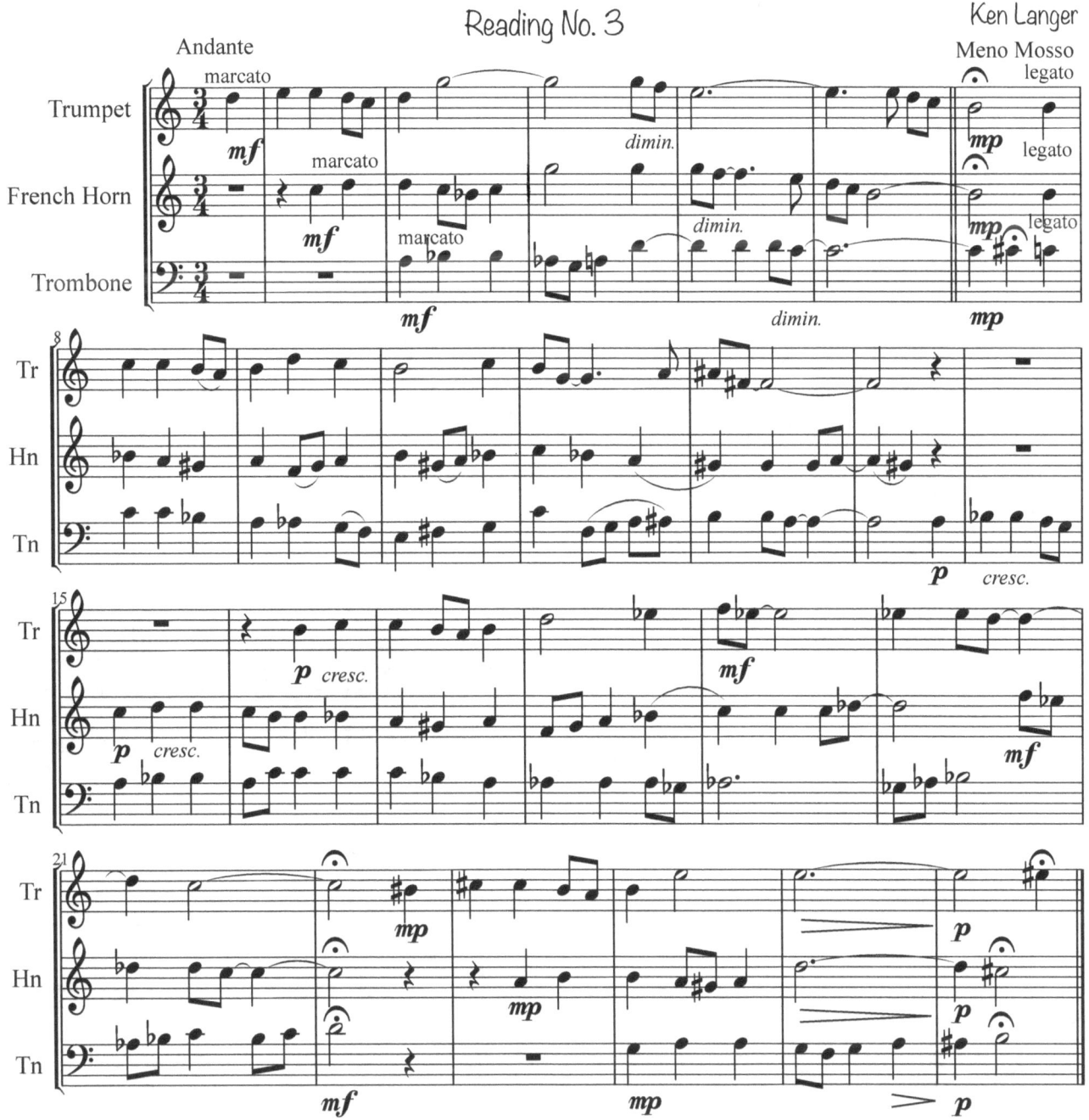

Narrator: I have given each being a separate and unique way of seeing and knowing and saying that knowledge. What seems wrong to you is right for [another]. What is poison to one is honey to someone else. Purity and impurity, sloth and diligence in worship, these mean nothing to me. I am apart from all that. Ways of worshiping are not to be ranked as better or worse than another... I look inside at the humility. That broken-open lowliness is the reality not the language! Forget phraseology. I want burning, burning. Be friends with your burning. Burn up your thinking and your forms of expression! Those who pay attention to ways of behaving and speaking are one sort. Lovers who burn are another.

Rumi (Islamic mystic)
The Essential Rumi
(translated by Coleman Barks)

Missa Unitas
Agnus Dei Call

Ken Langer

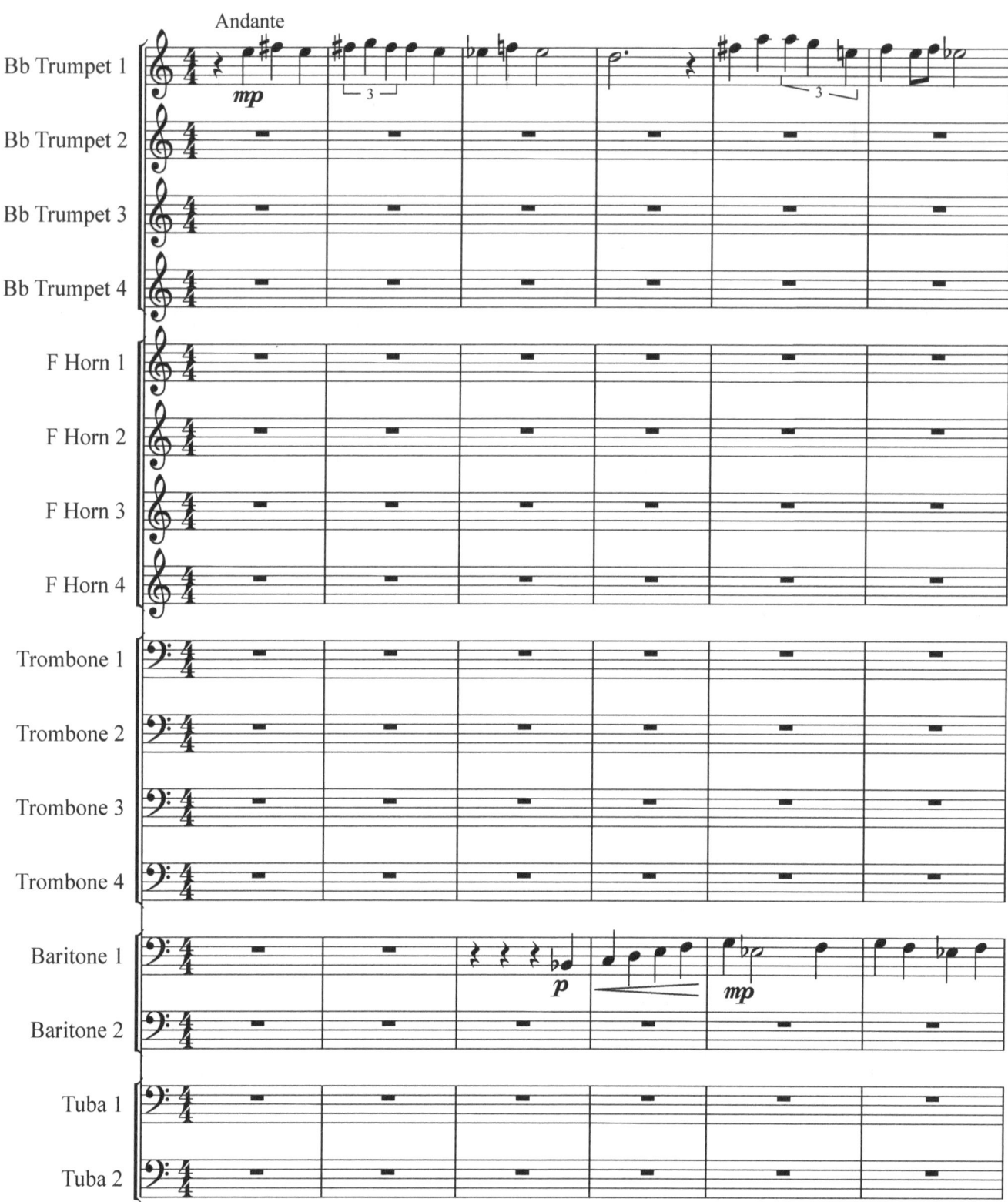

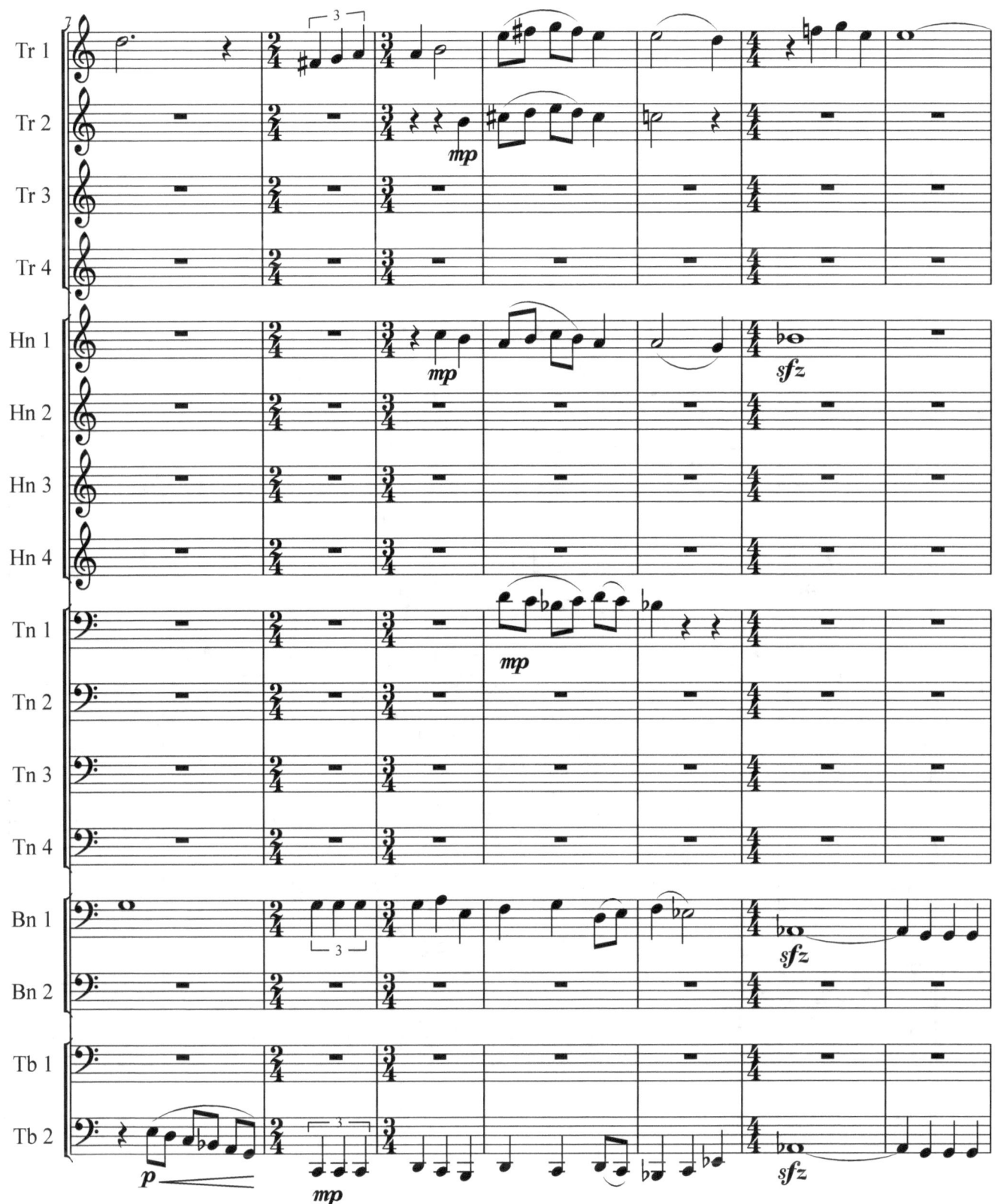

117

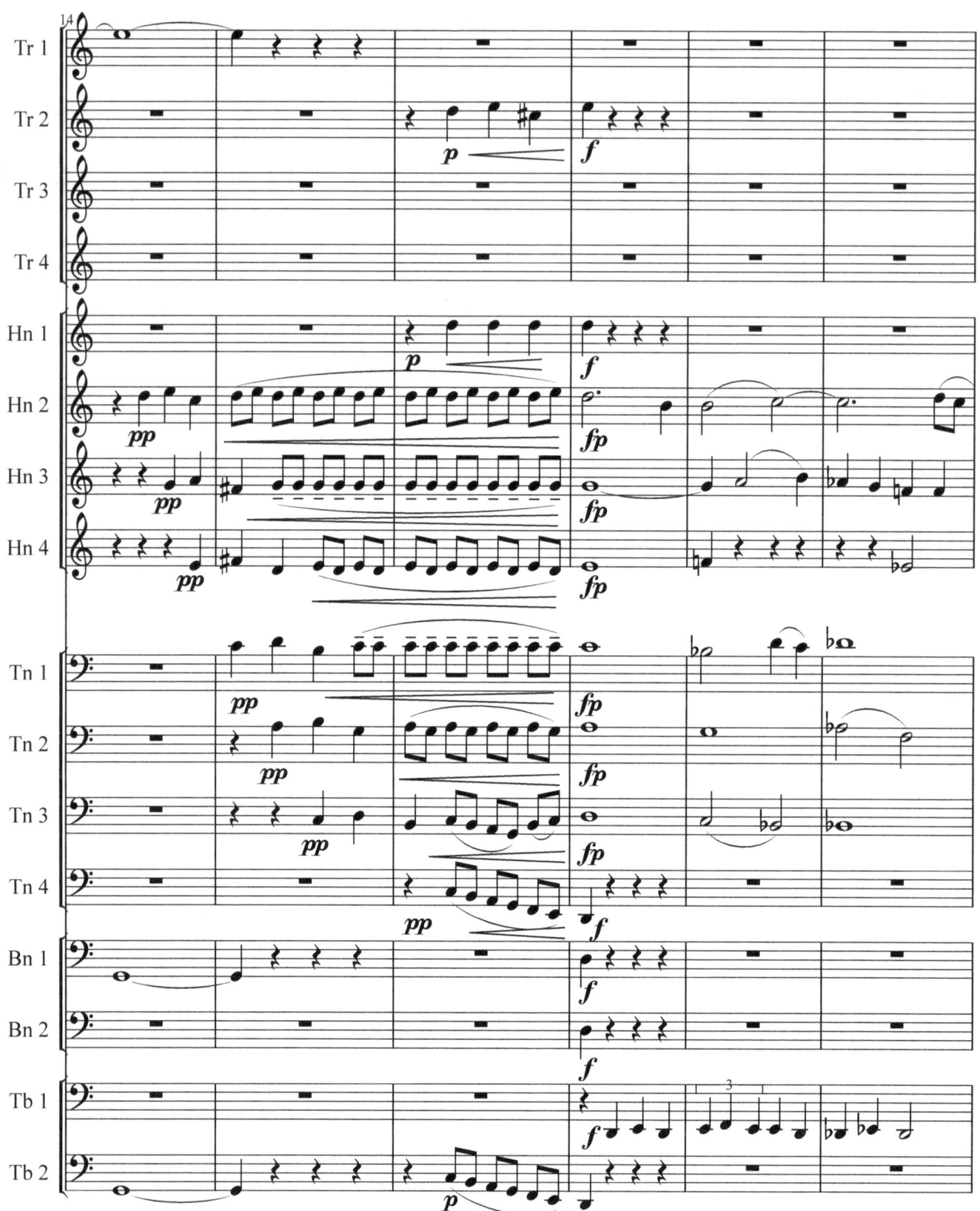

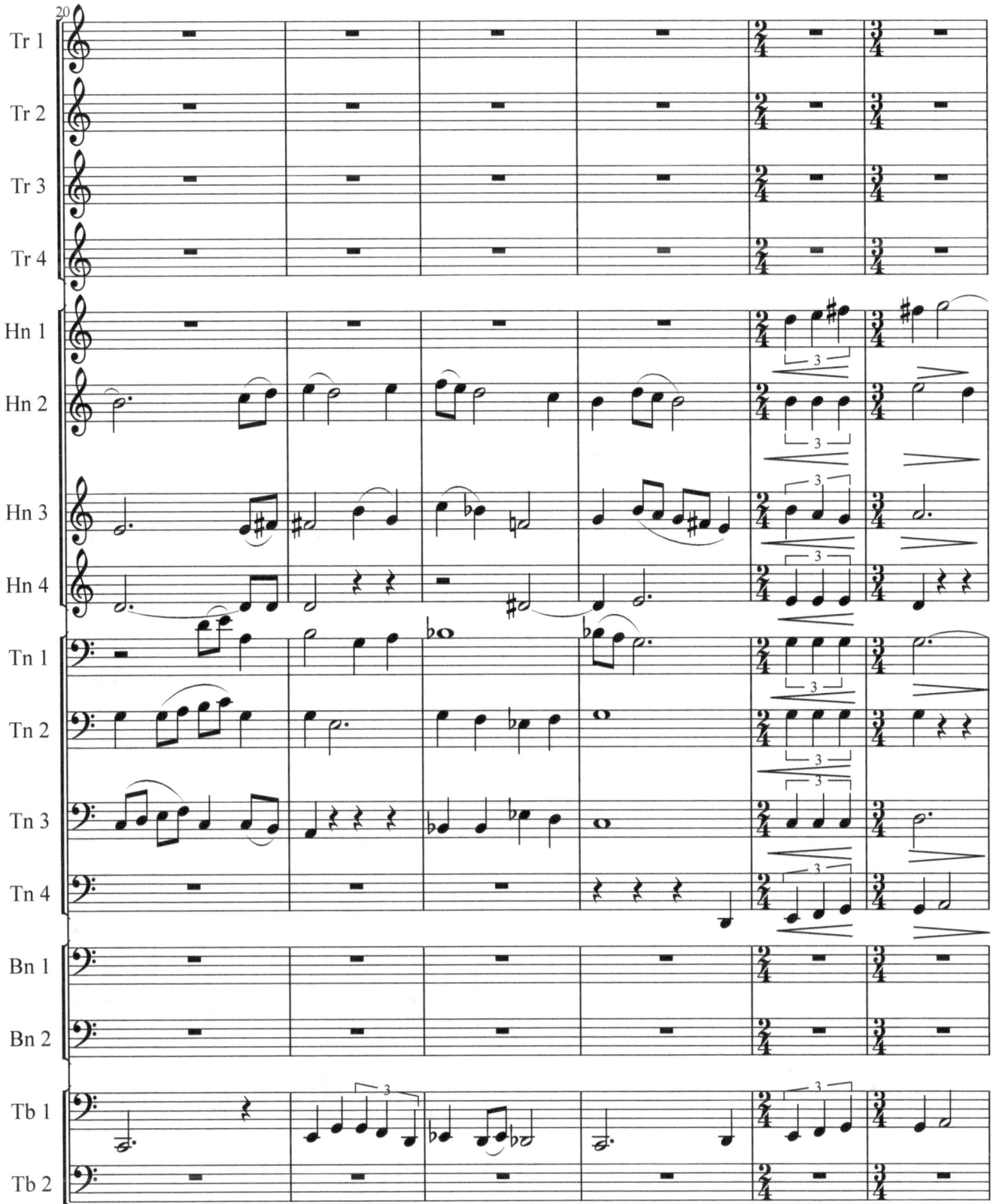

119

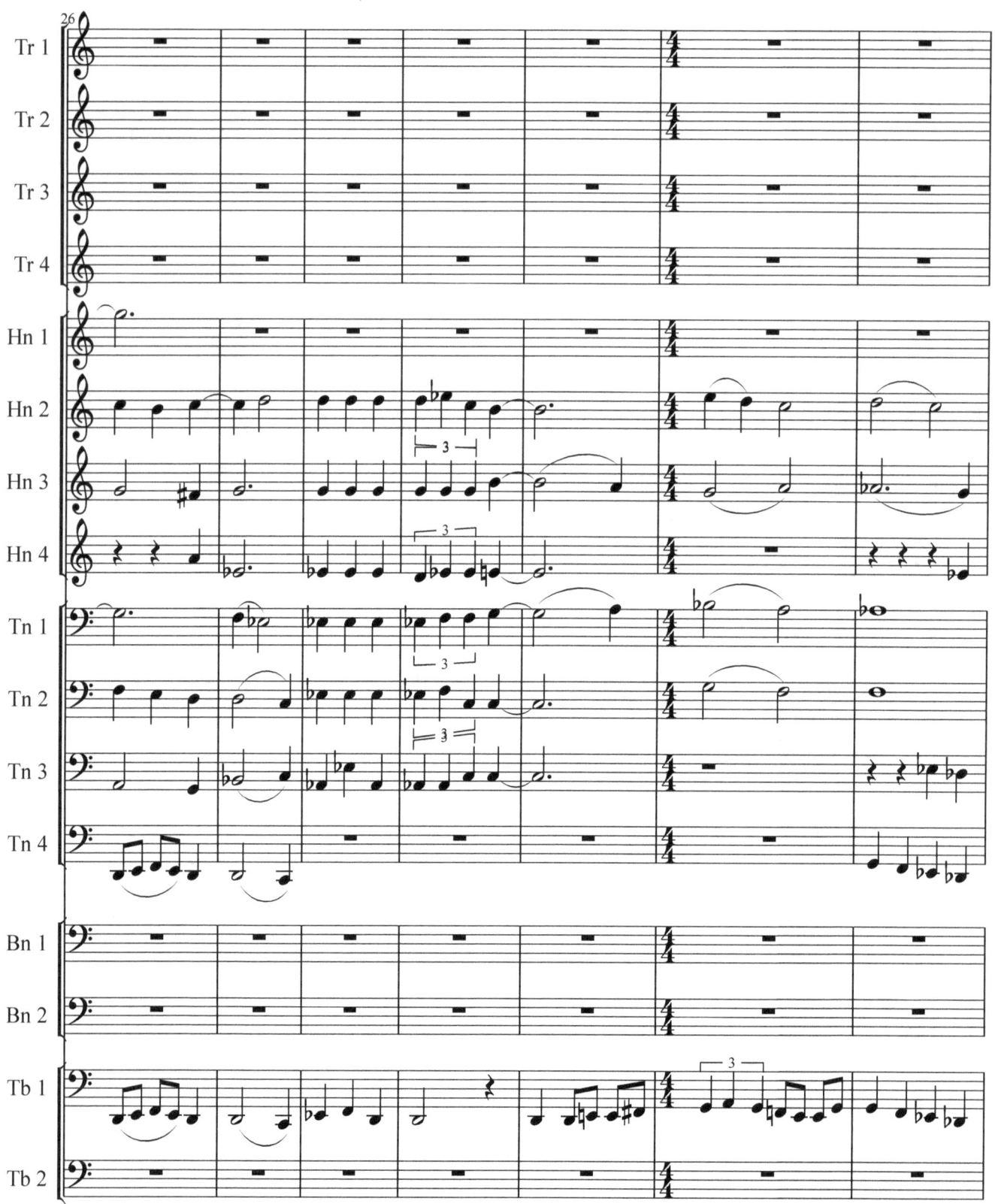

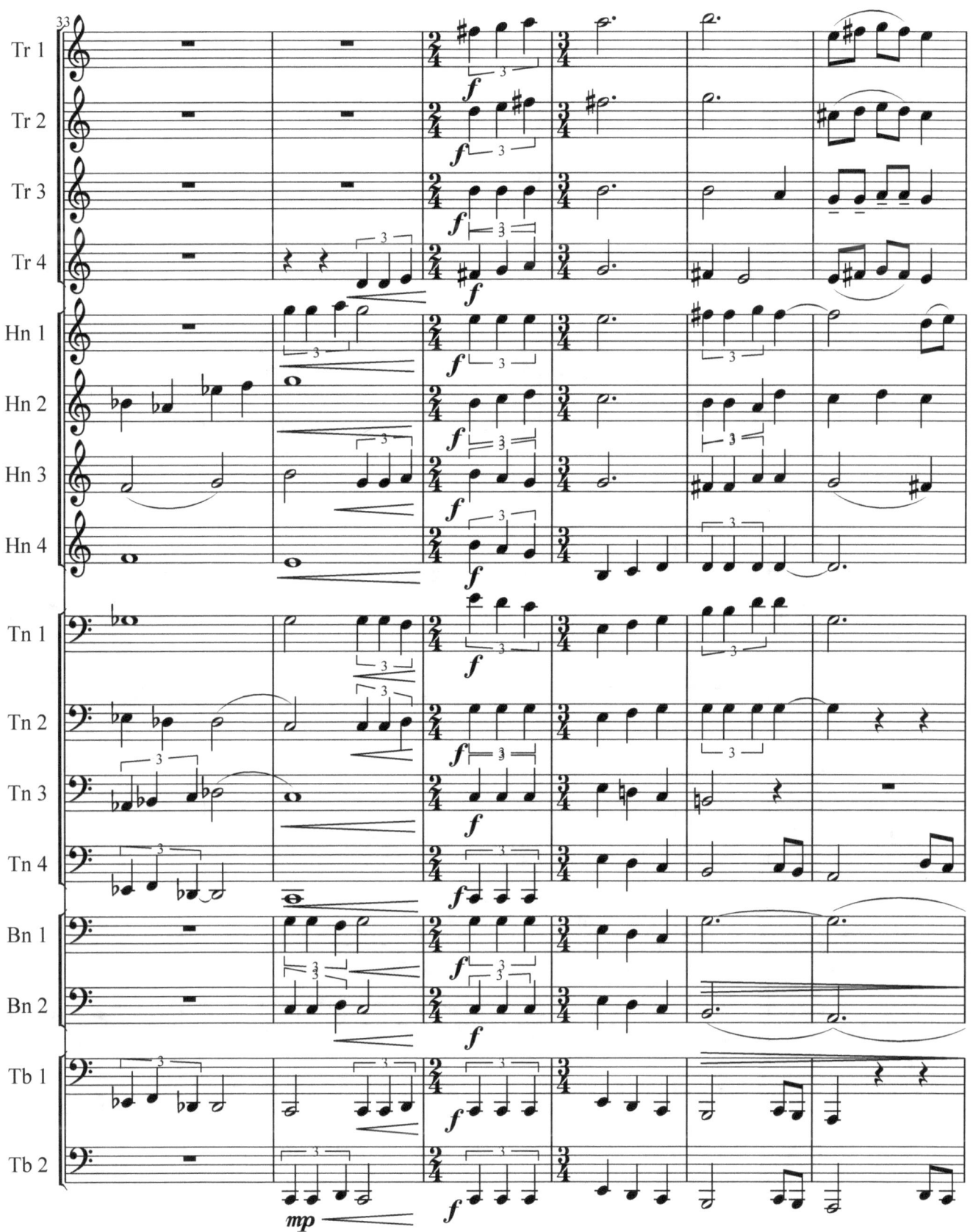

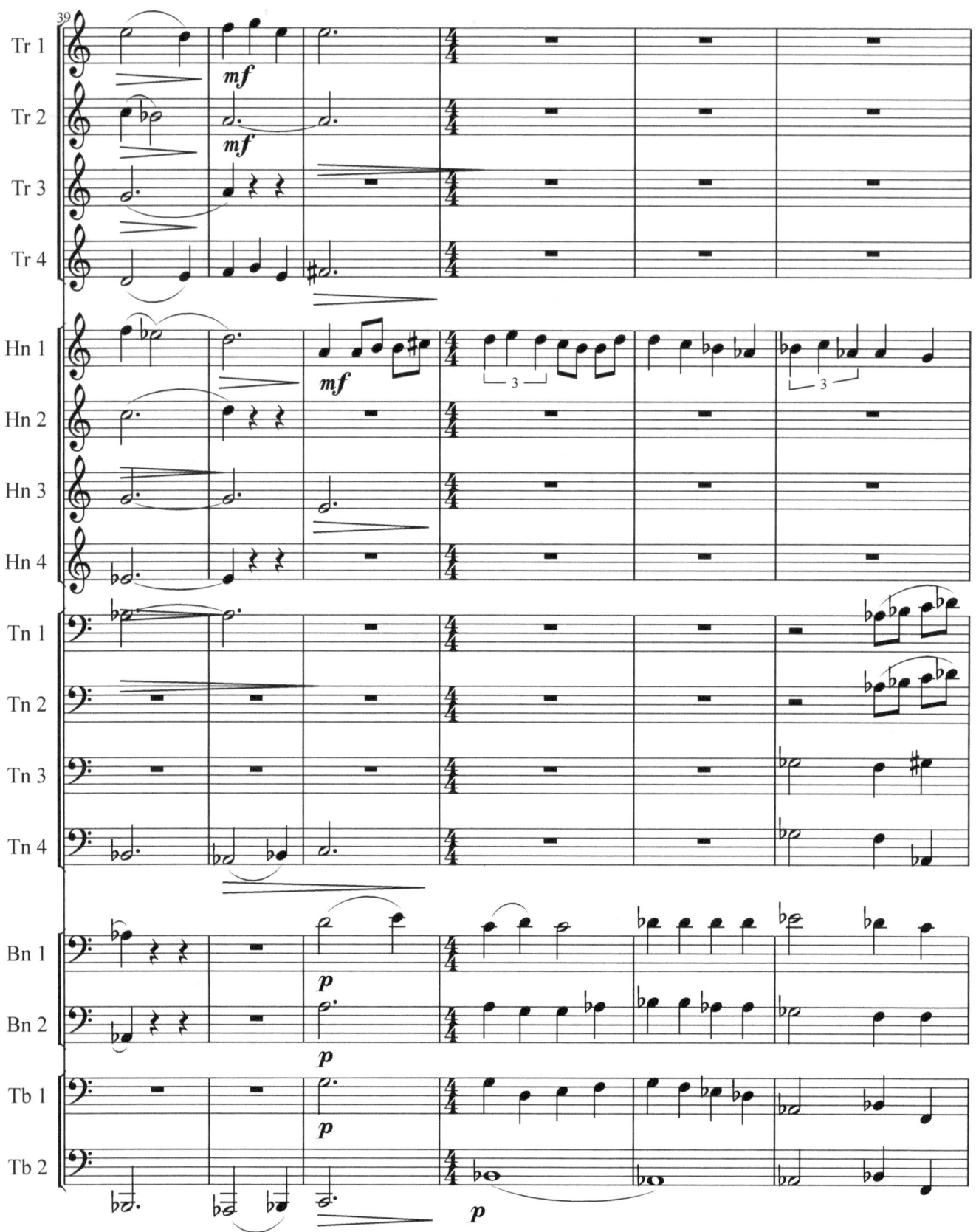

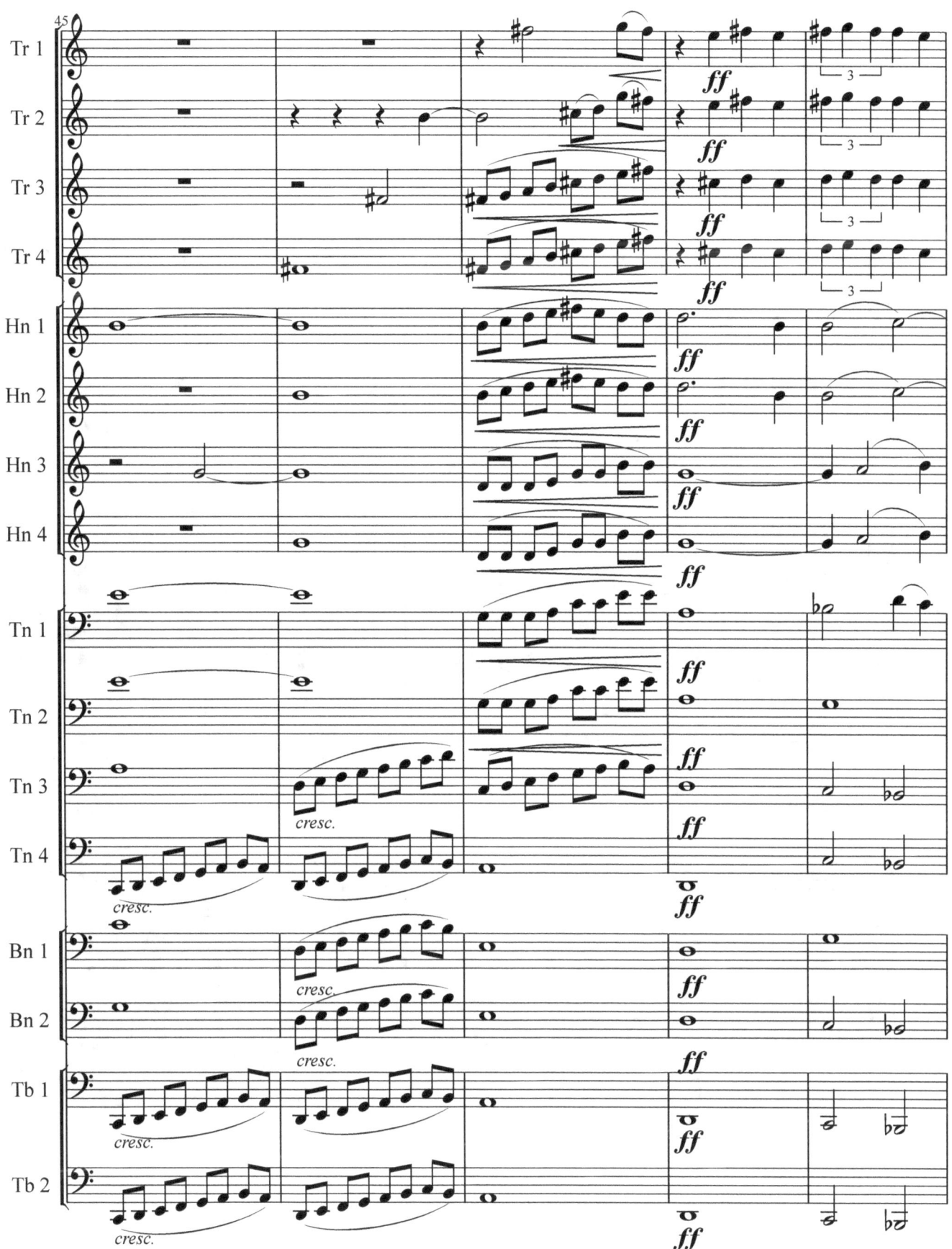

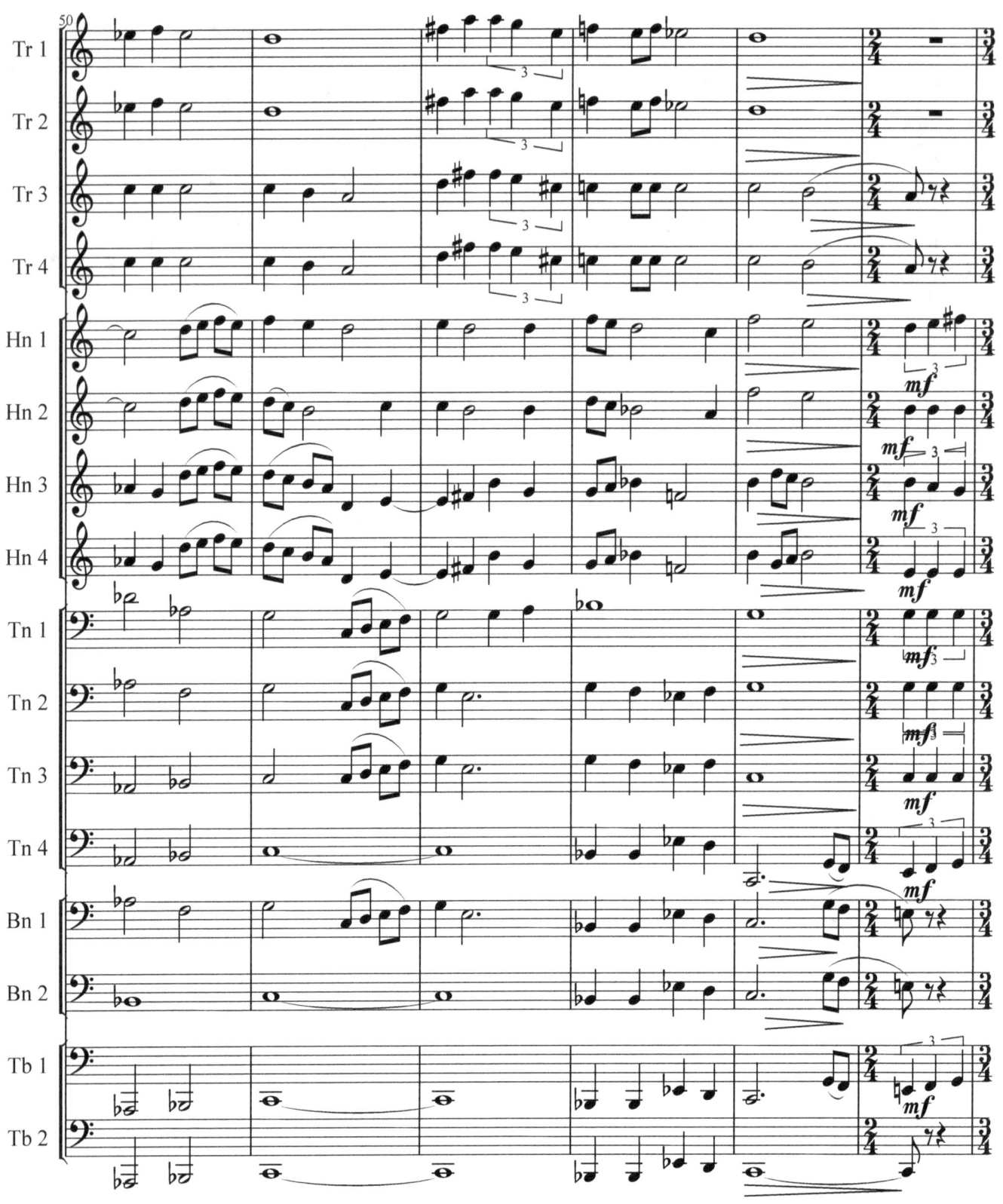

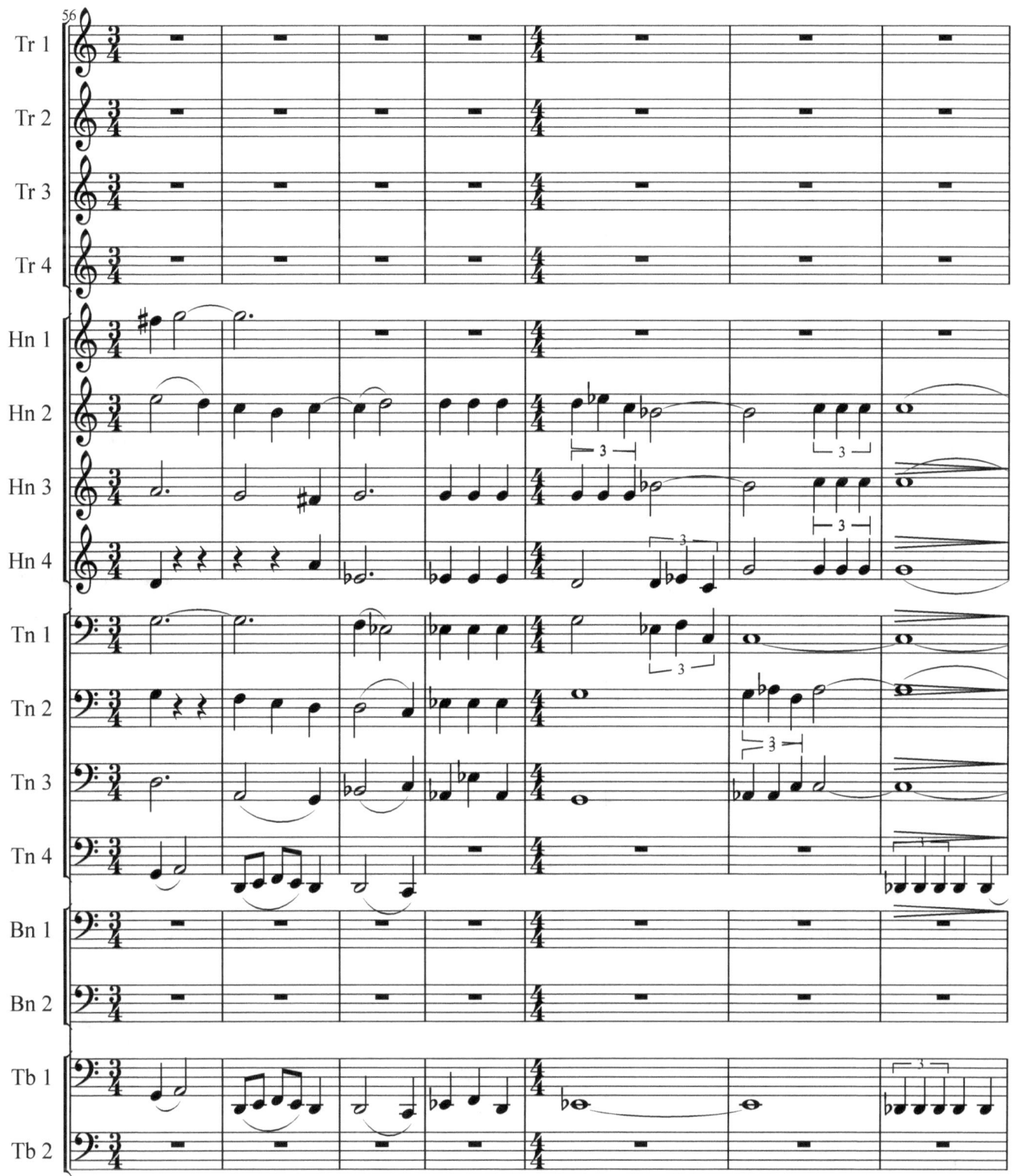

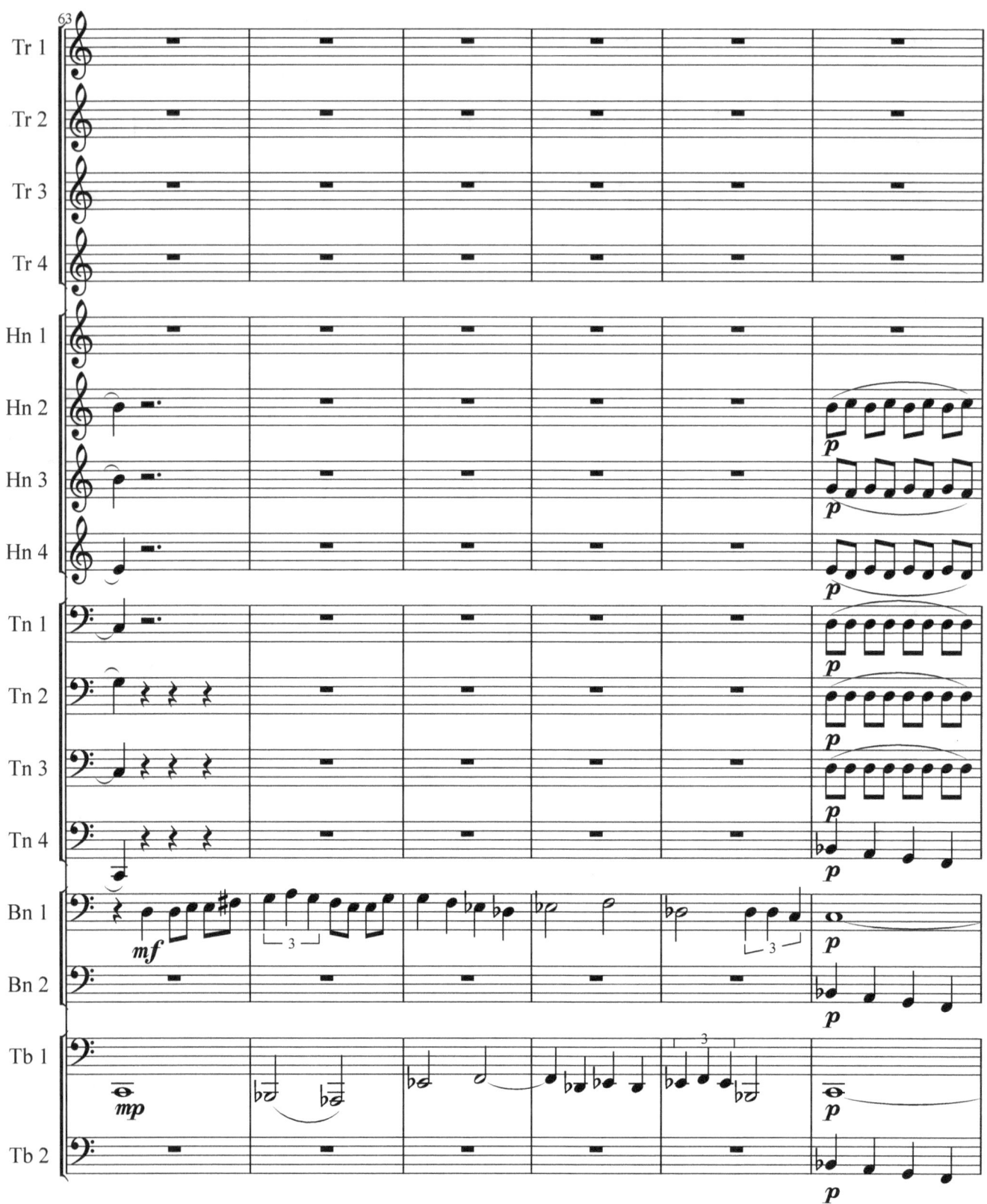

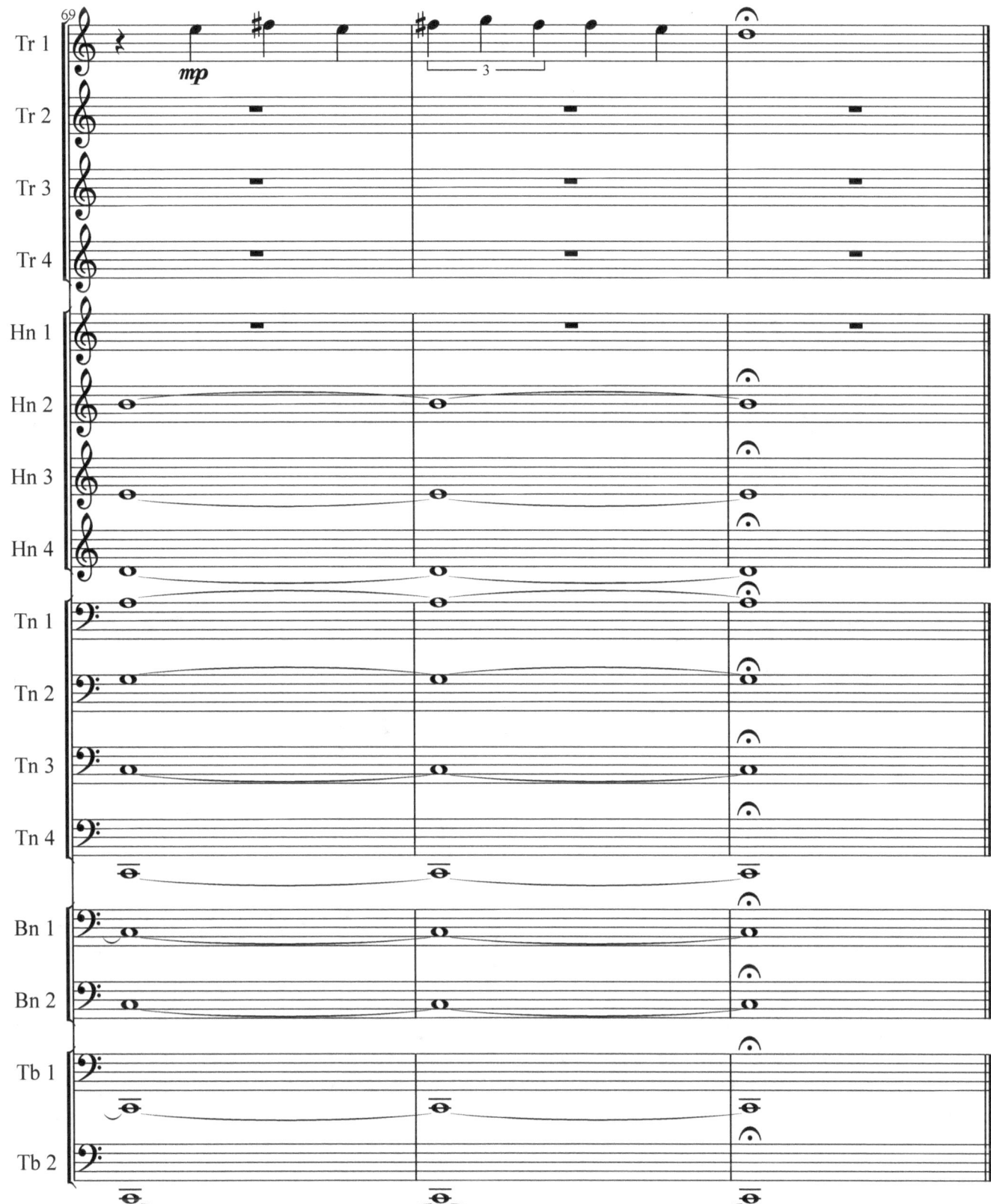

127

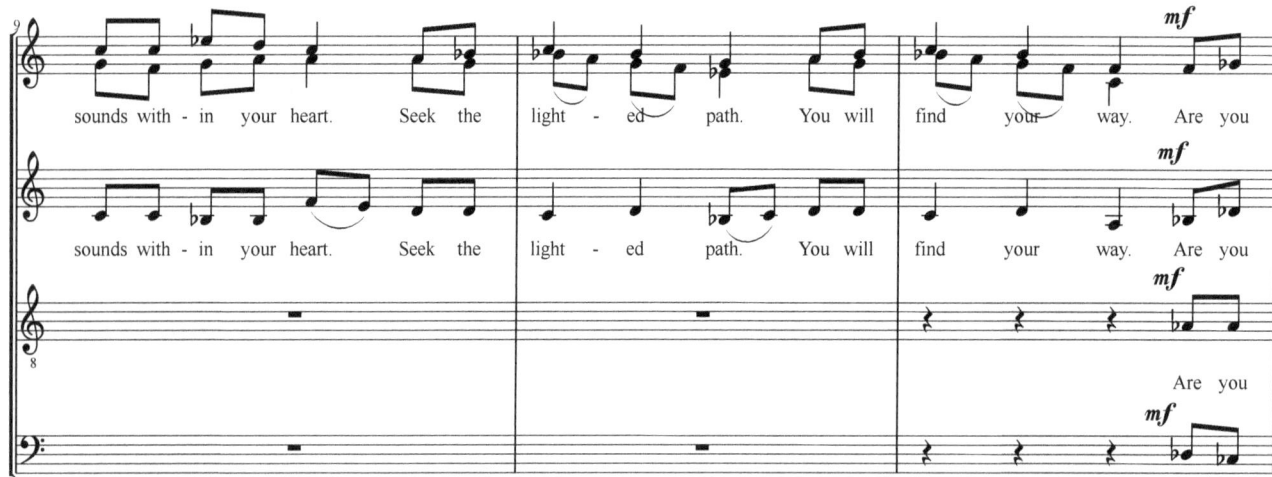

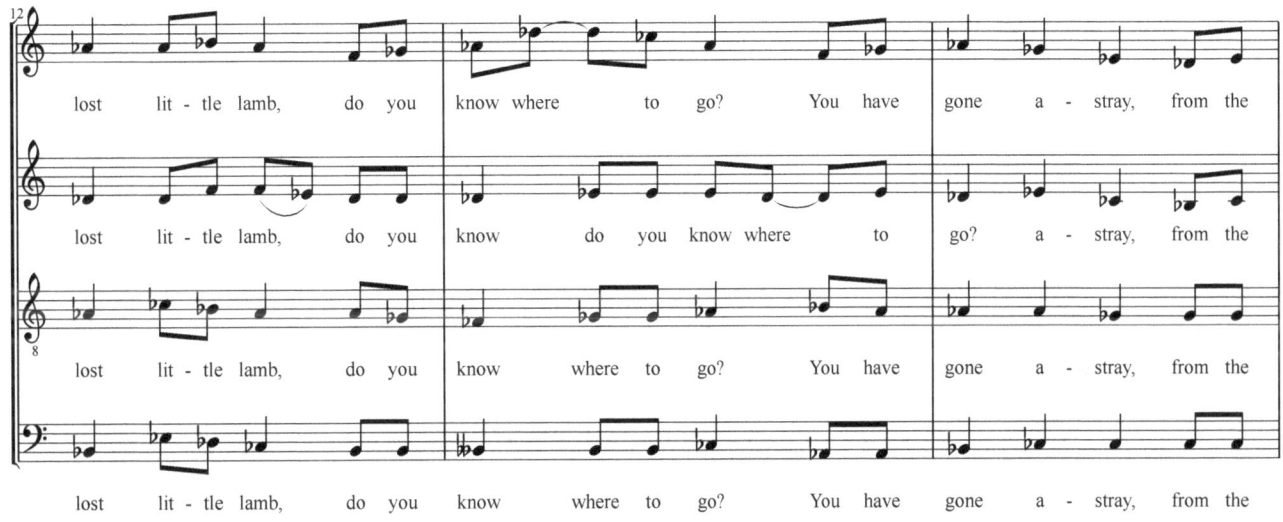
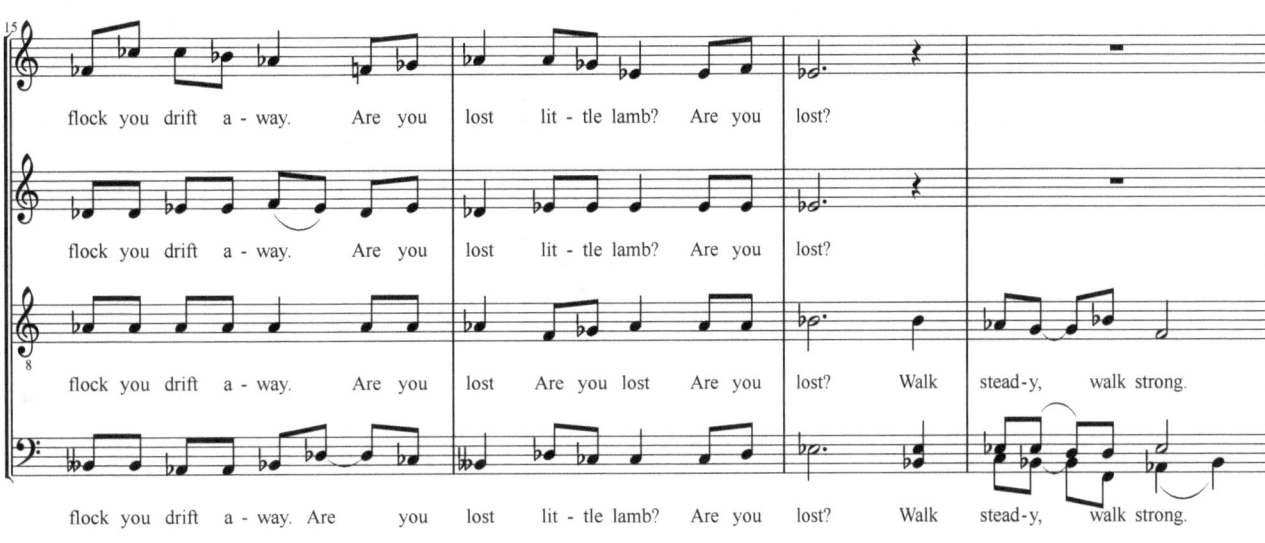
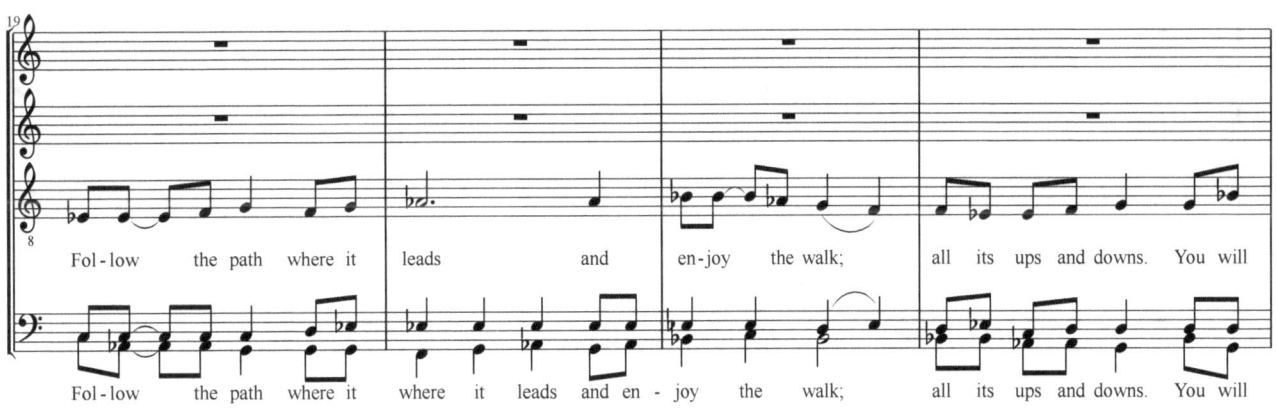

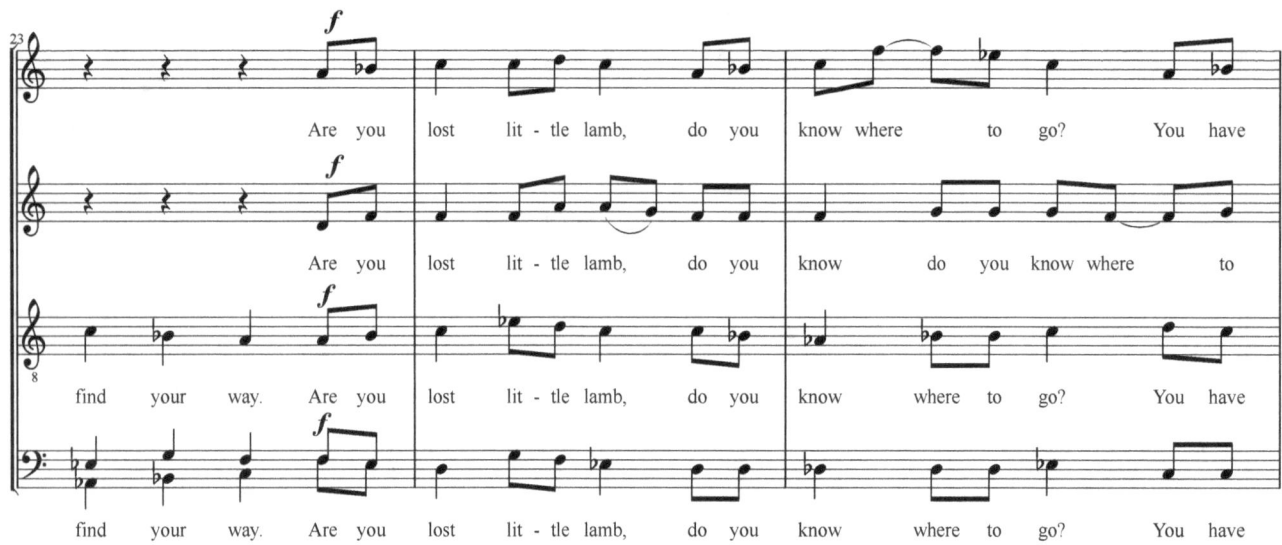
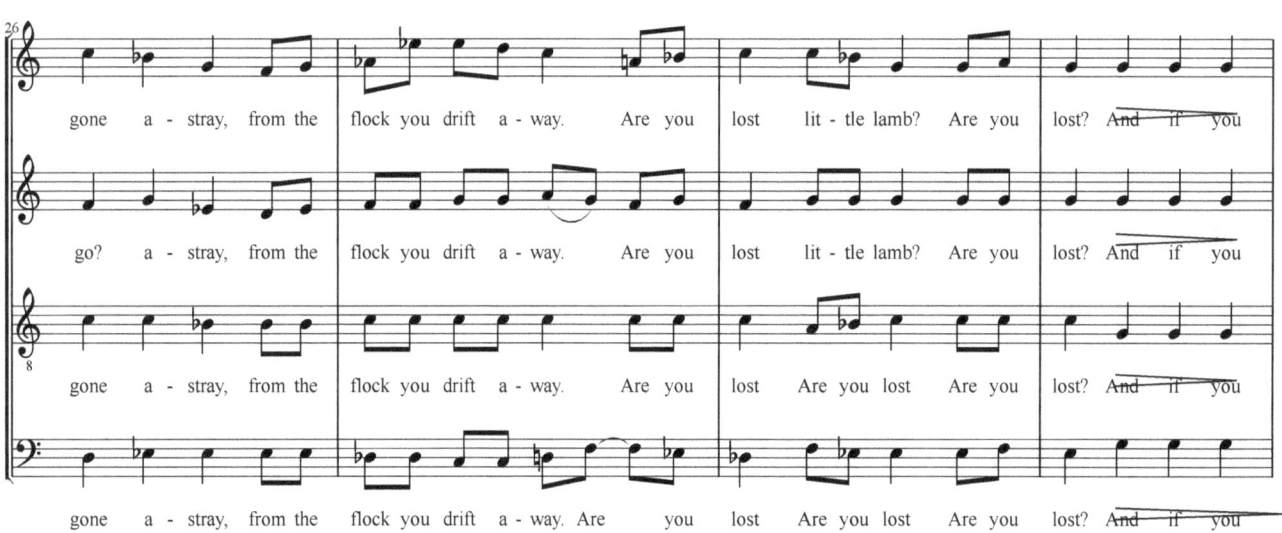
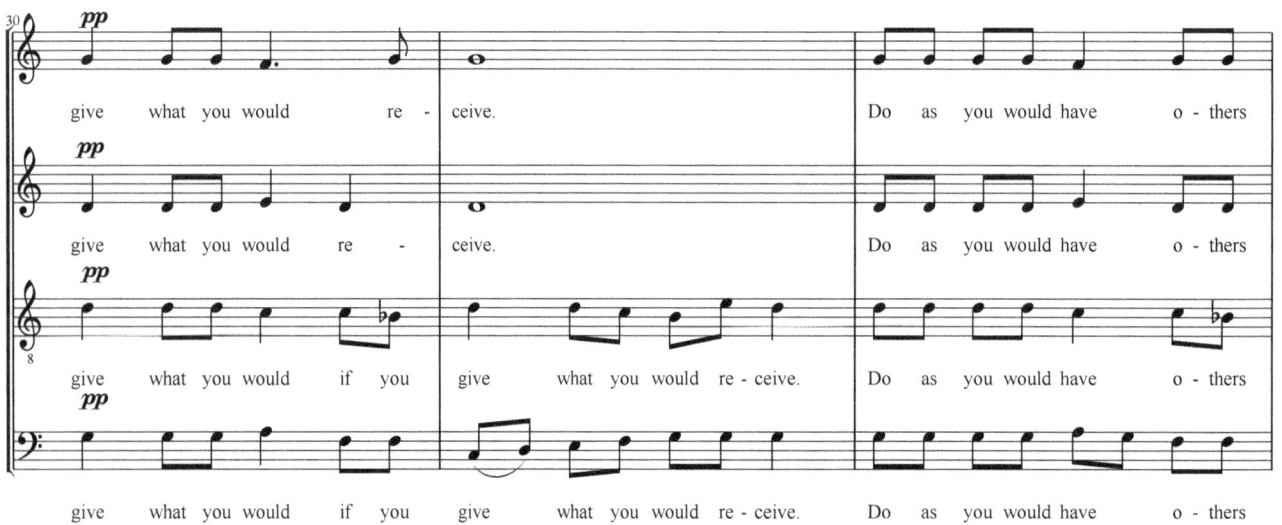

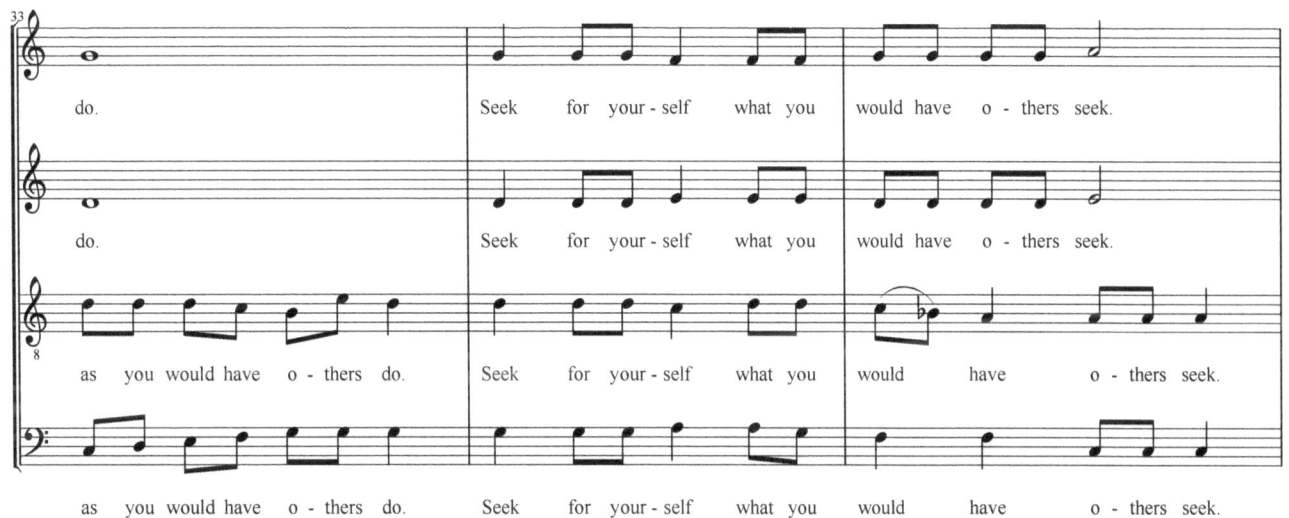
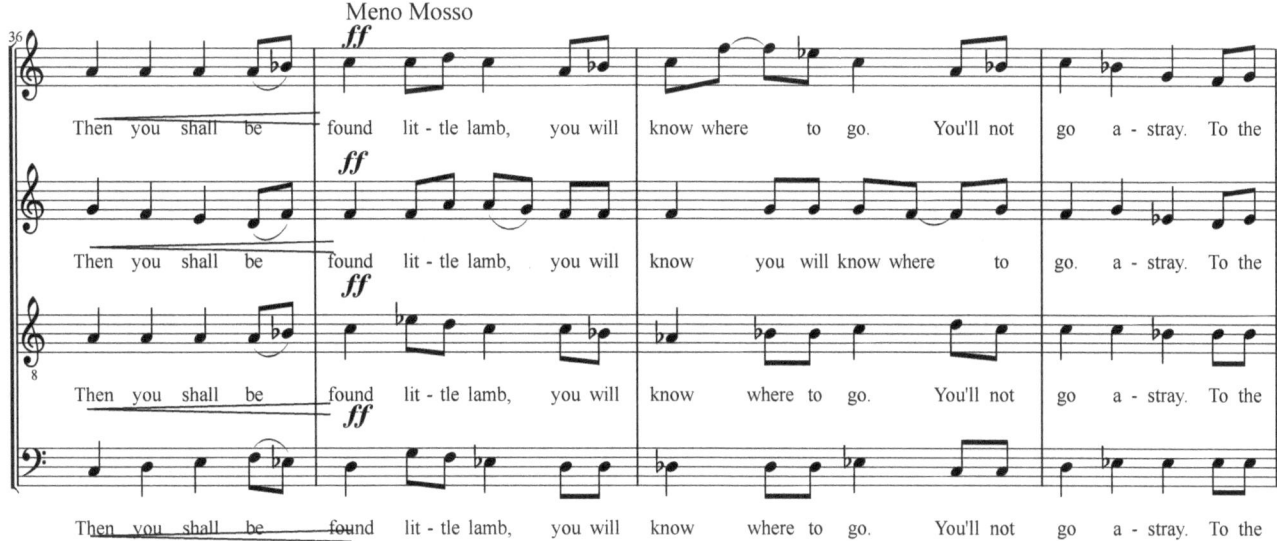
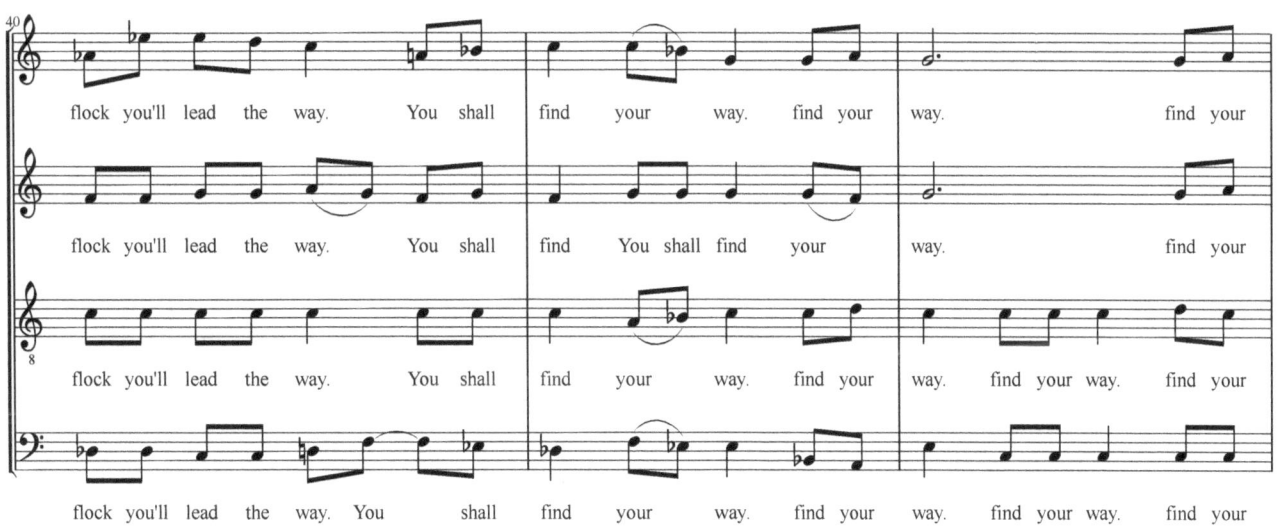

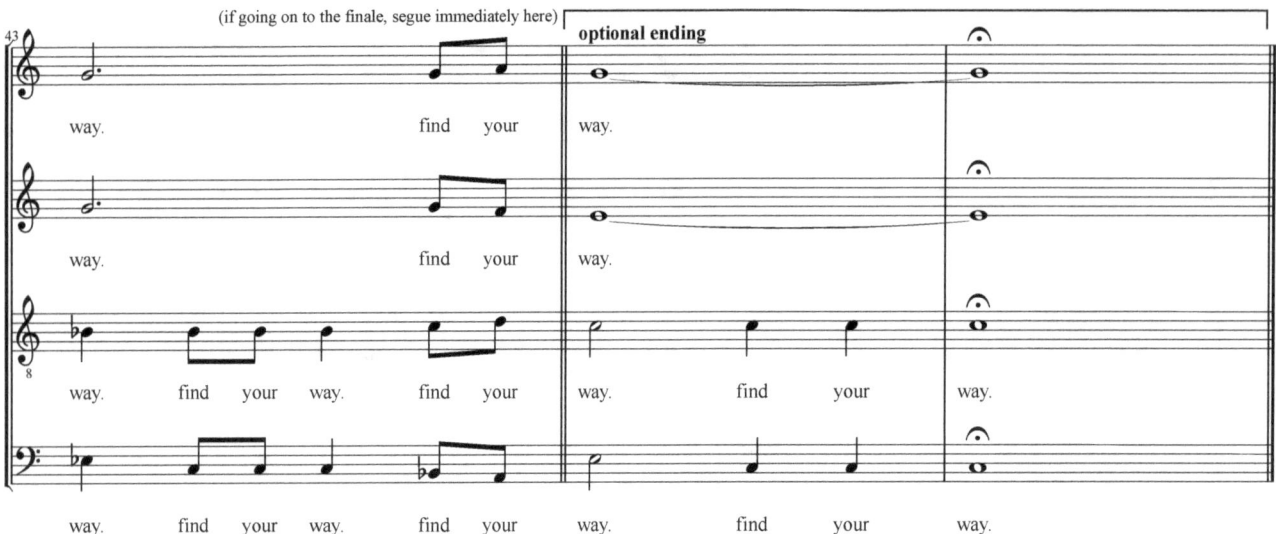

Missa Unitas
Finale

Ken Langer

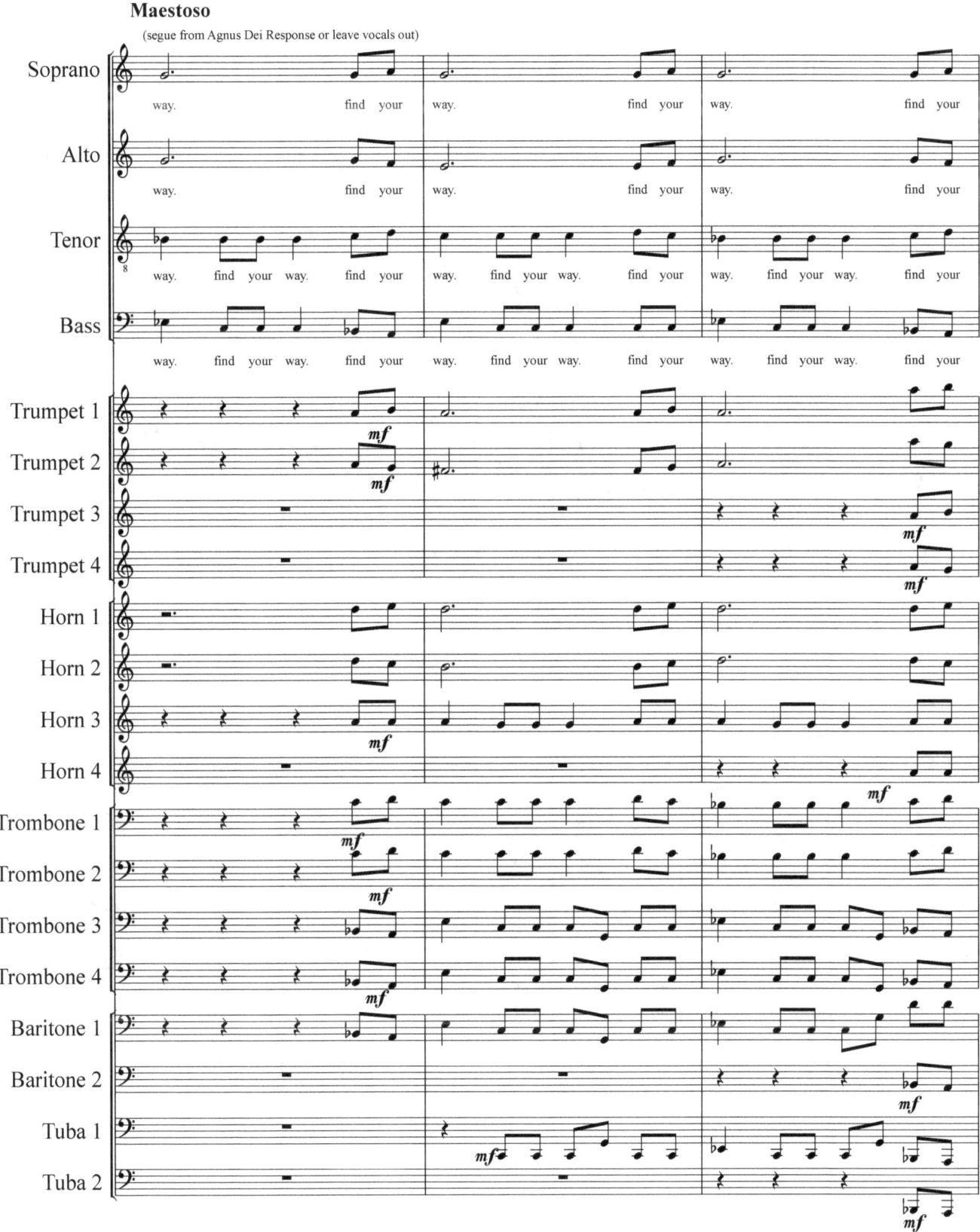

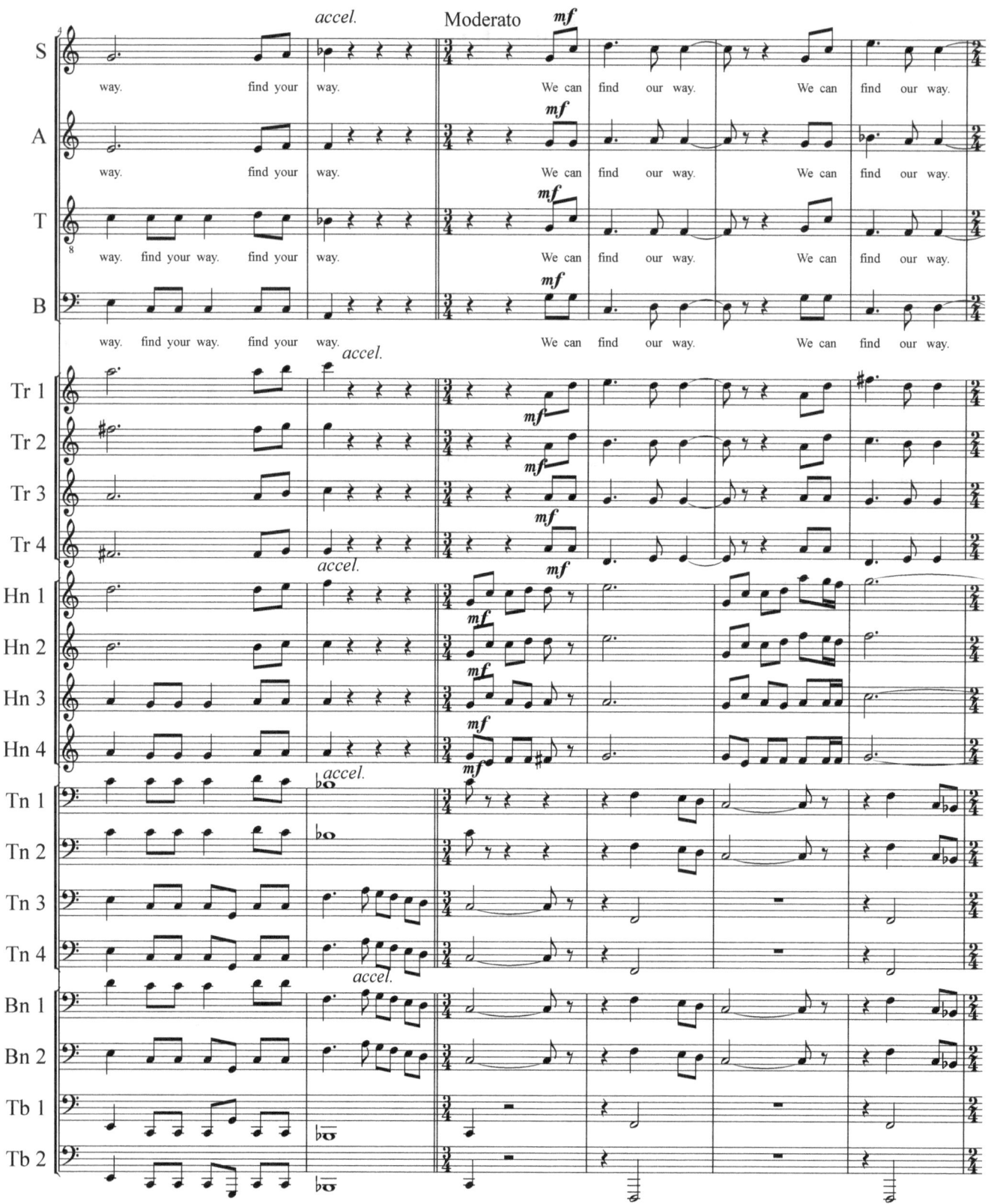

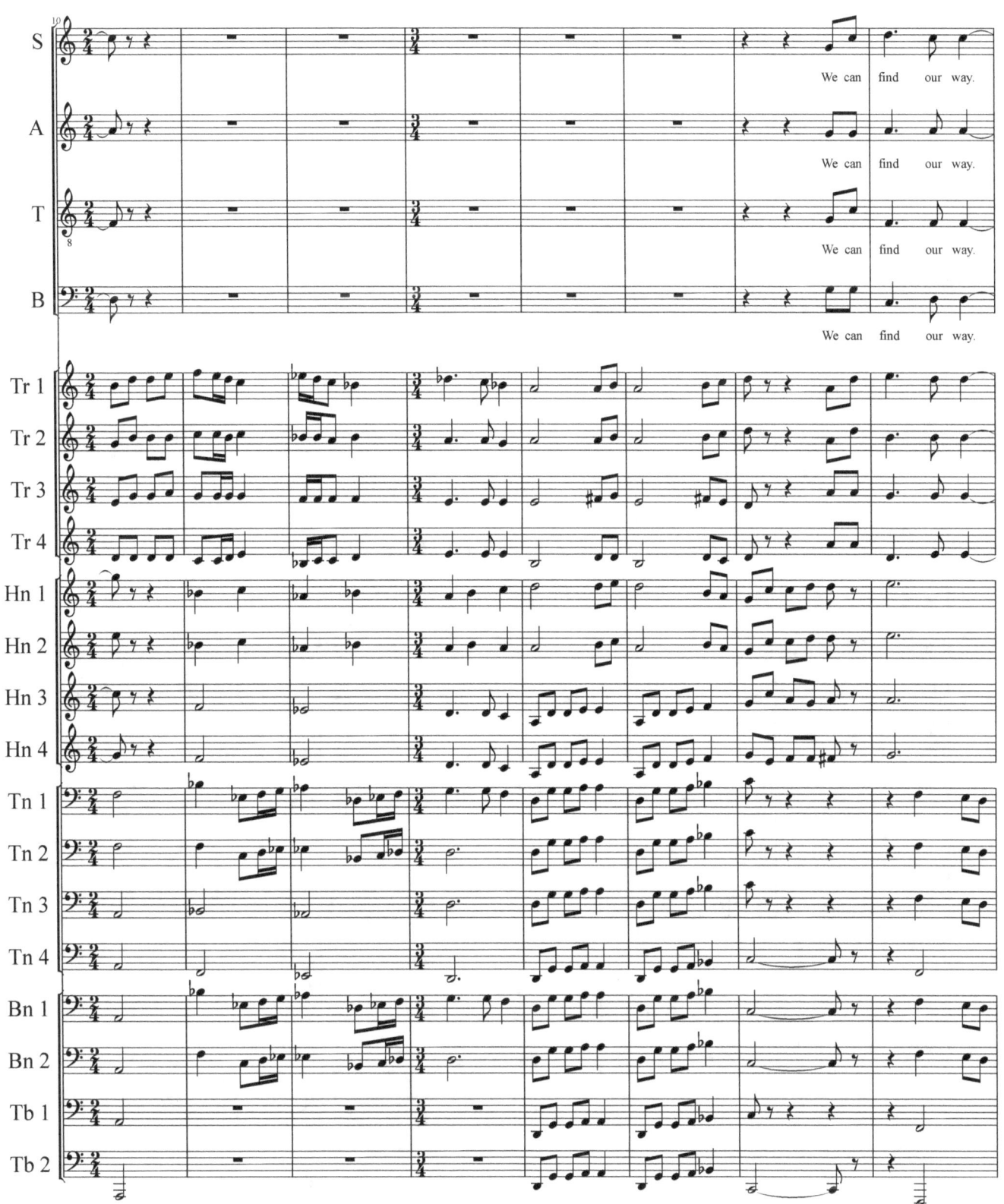

135

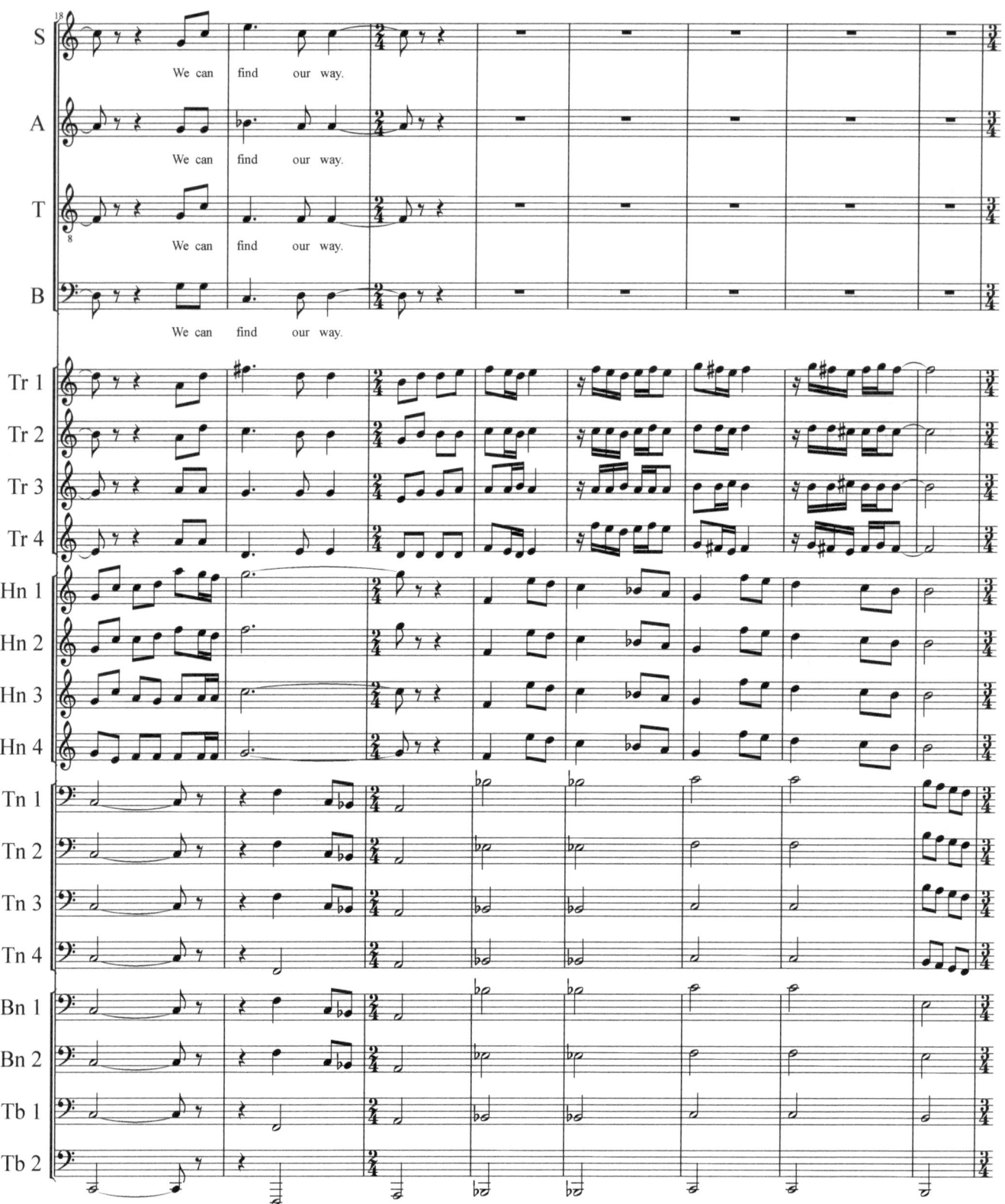

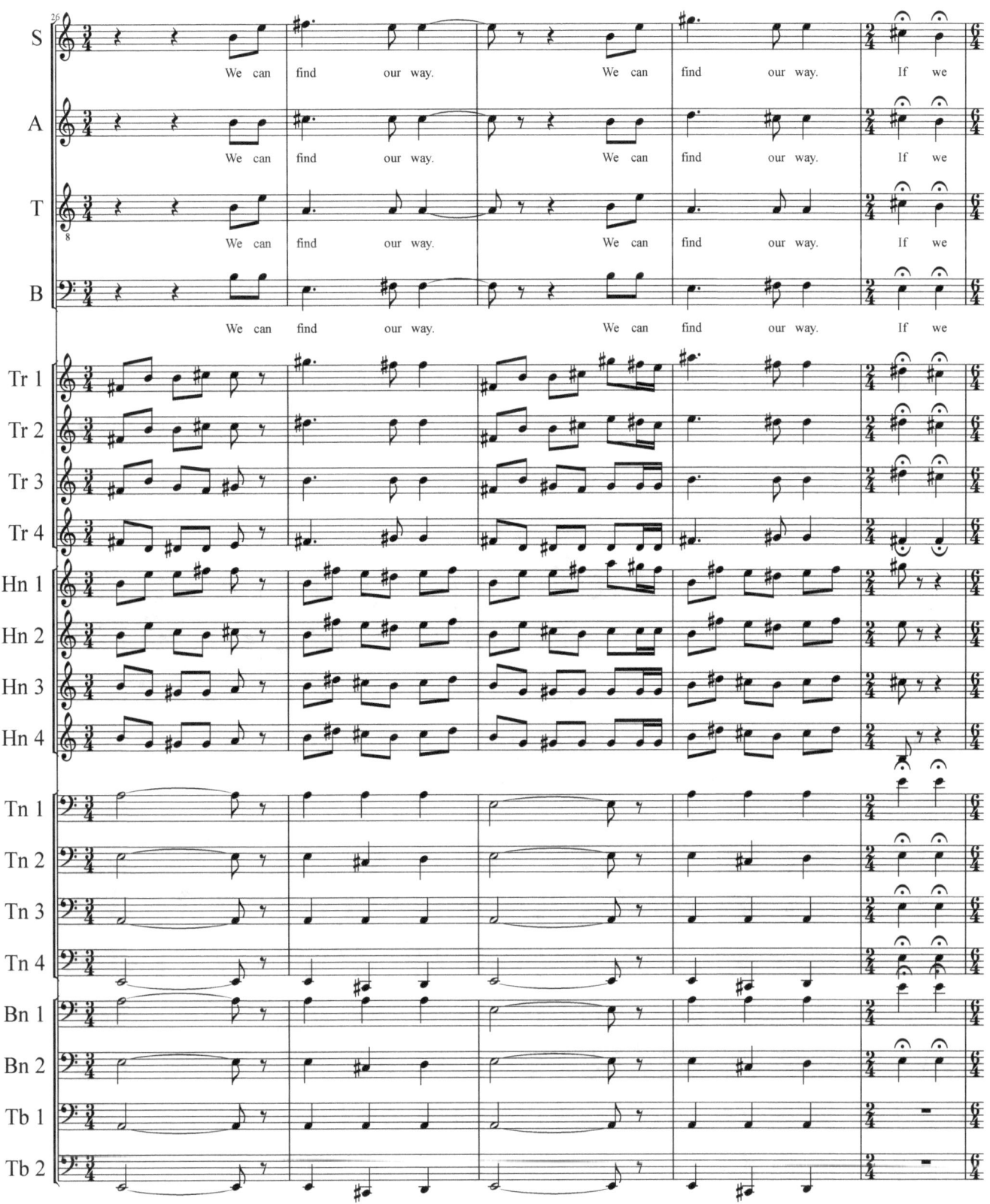

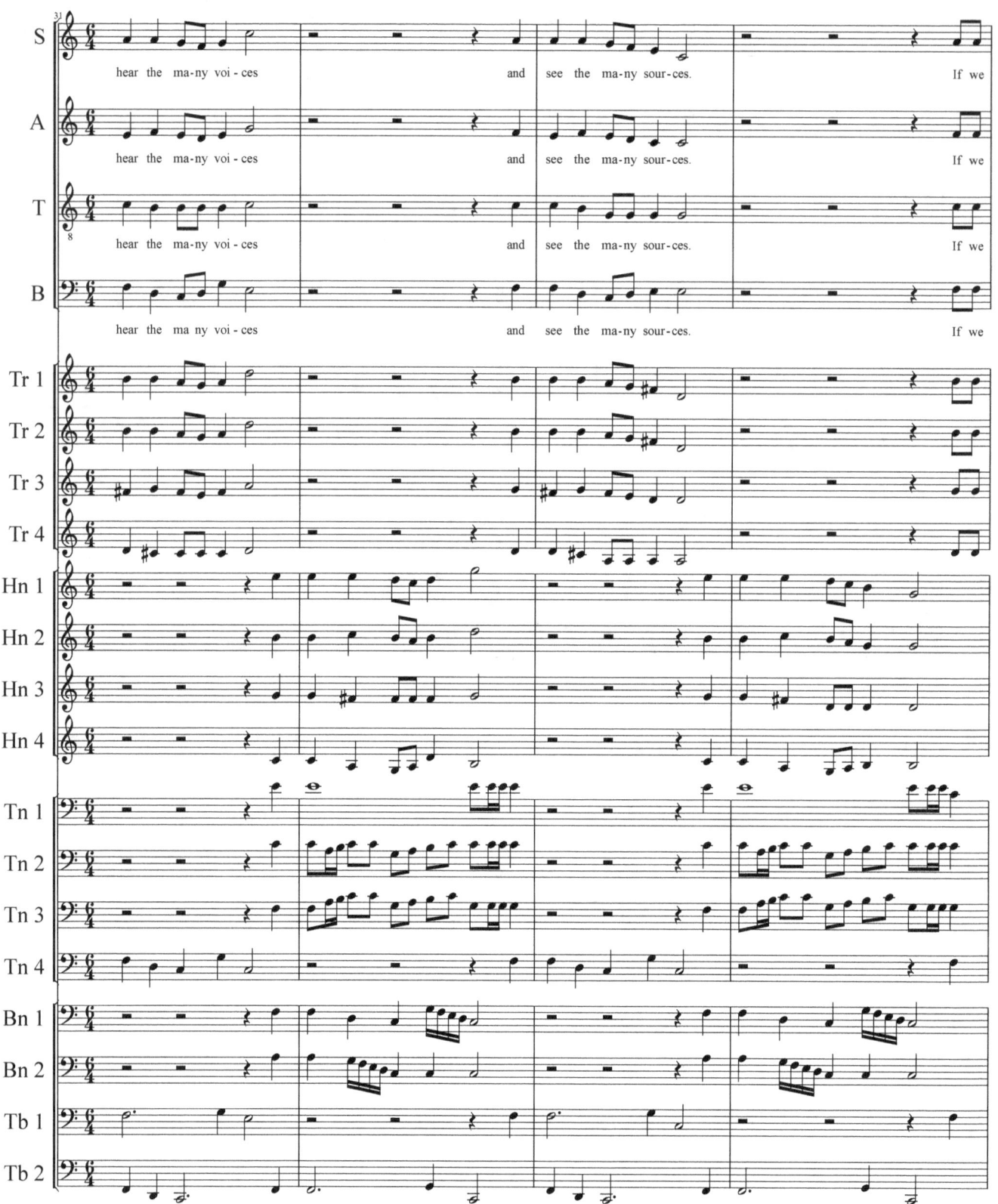

138

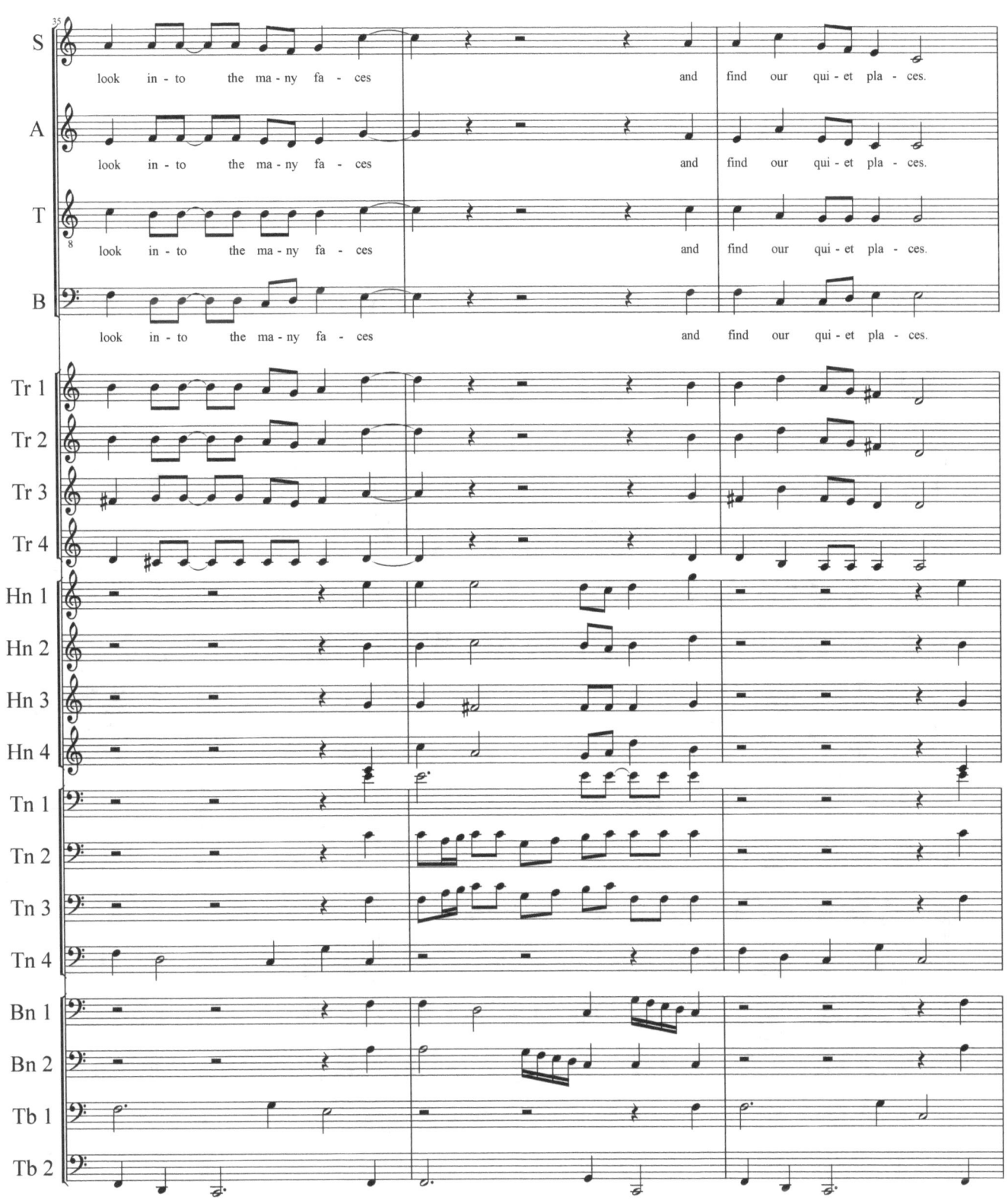

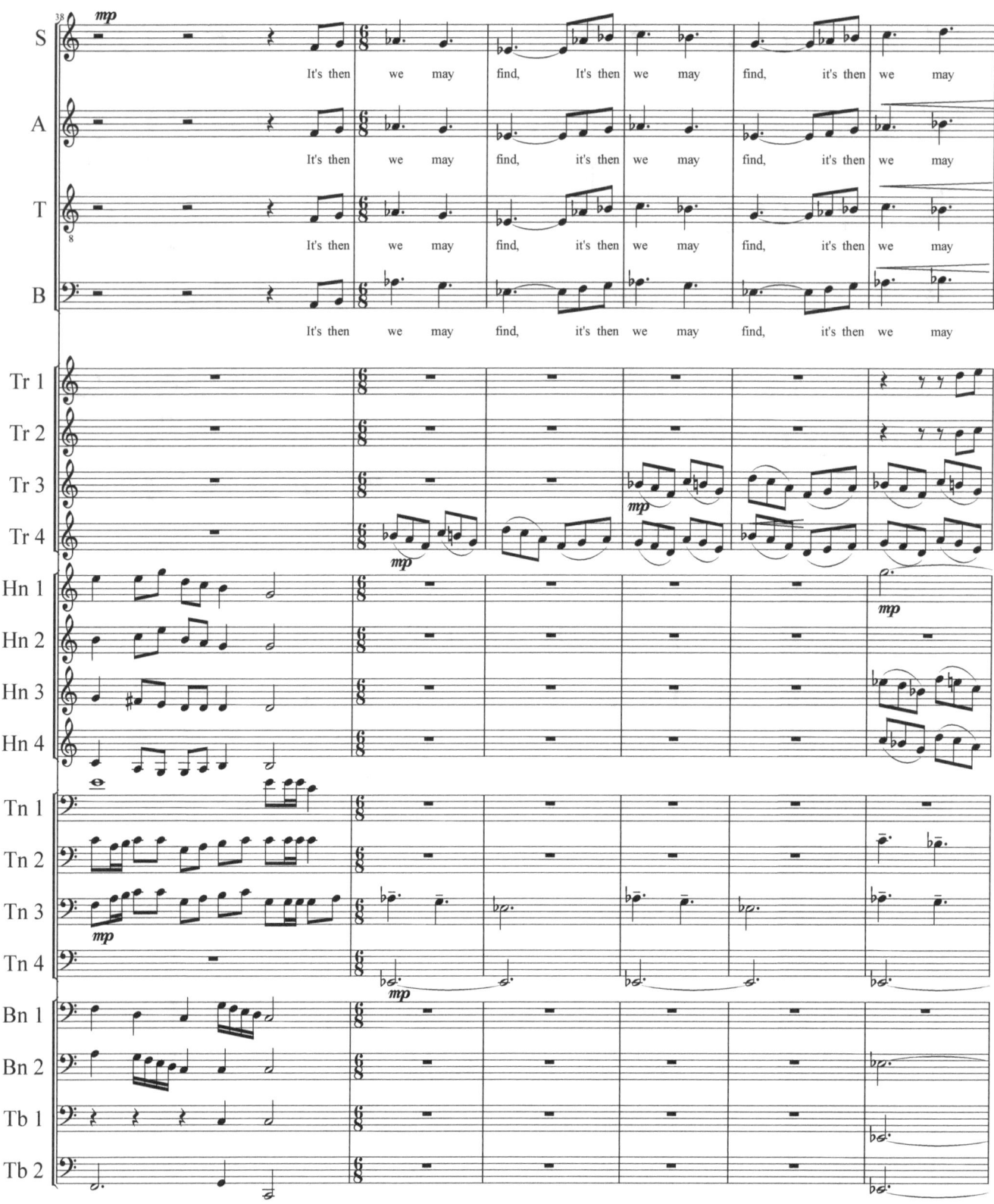

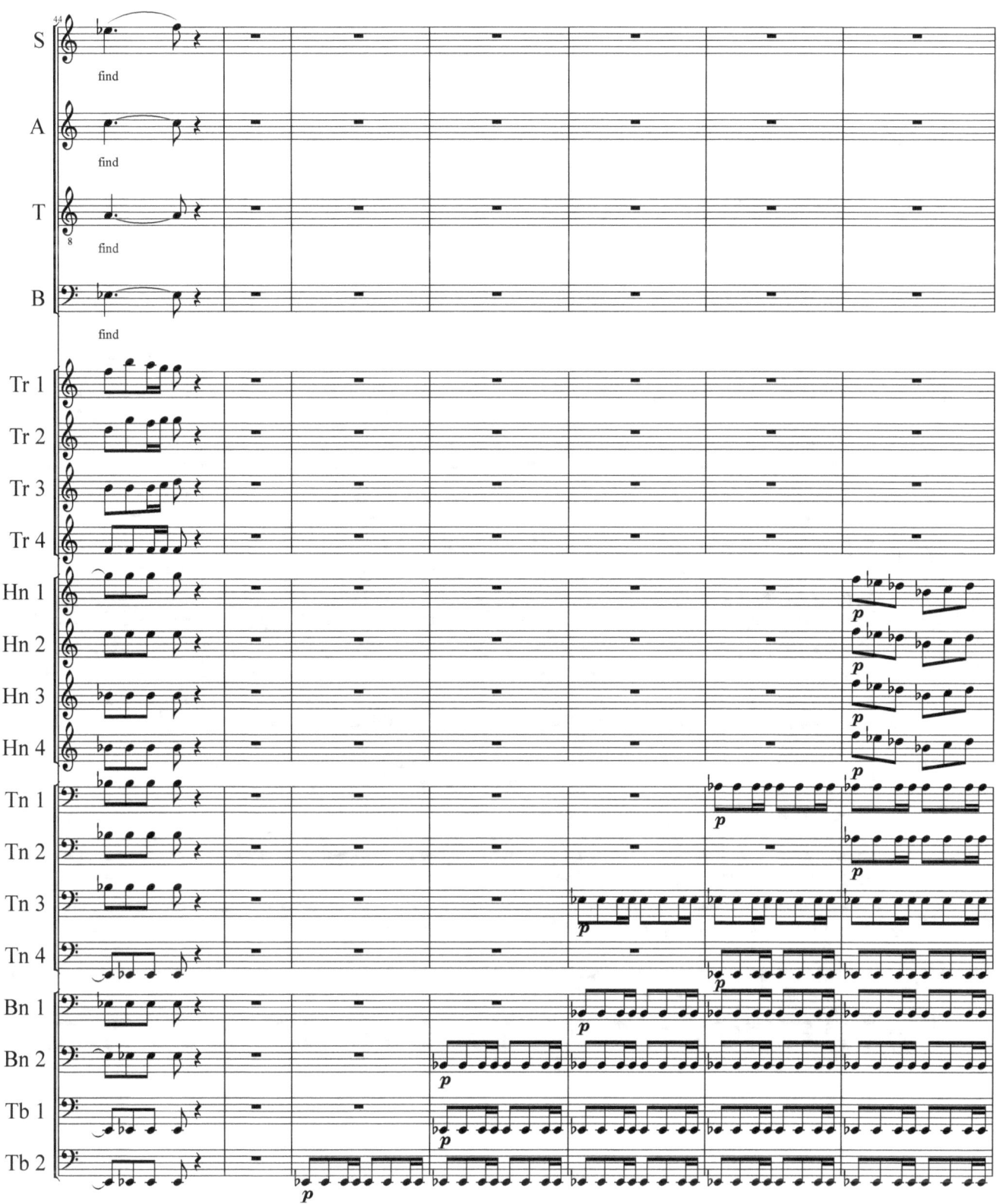

141

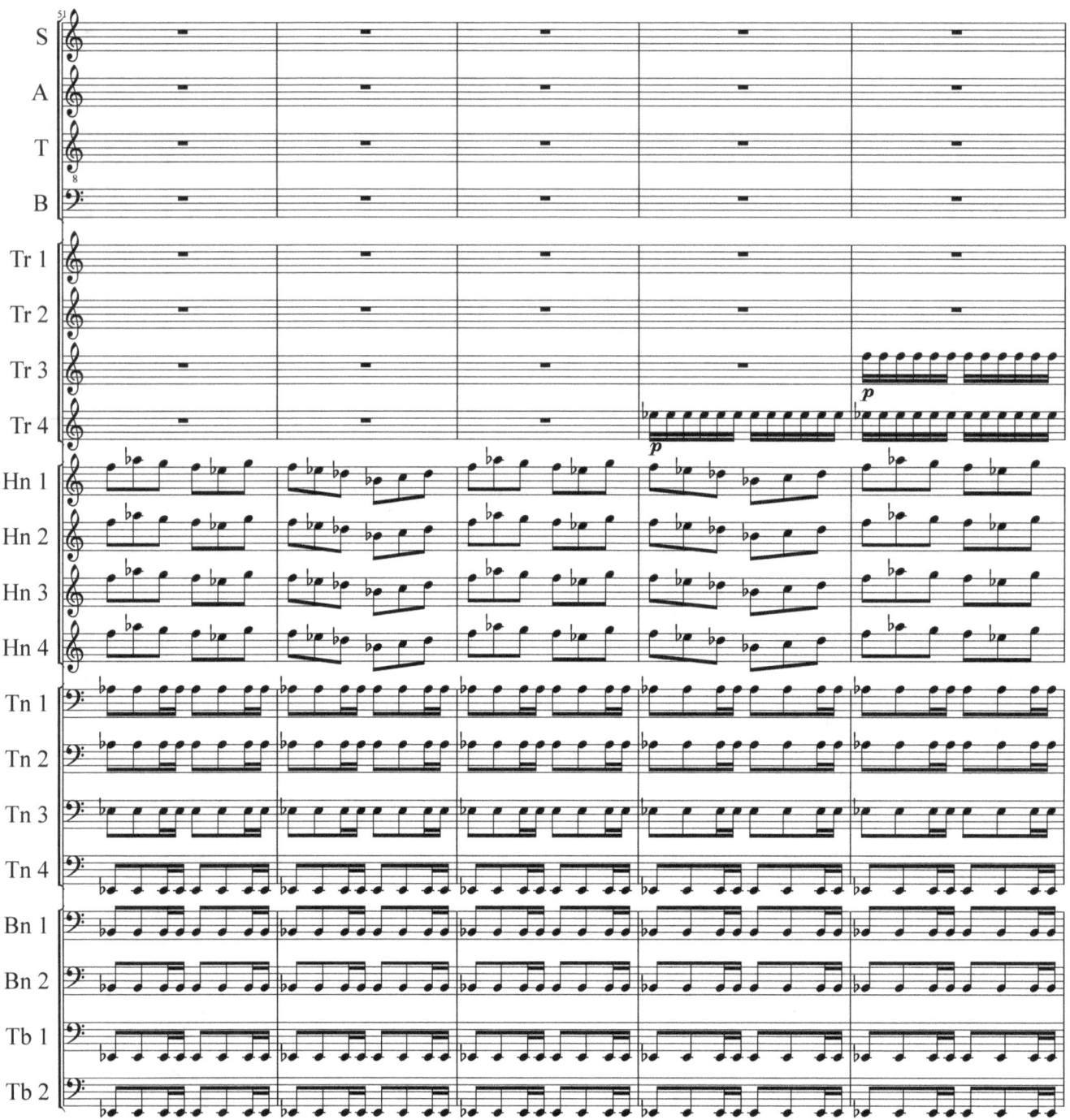

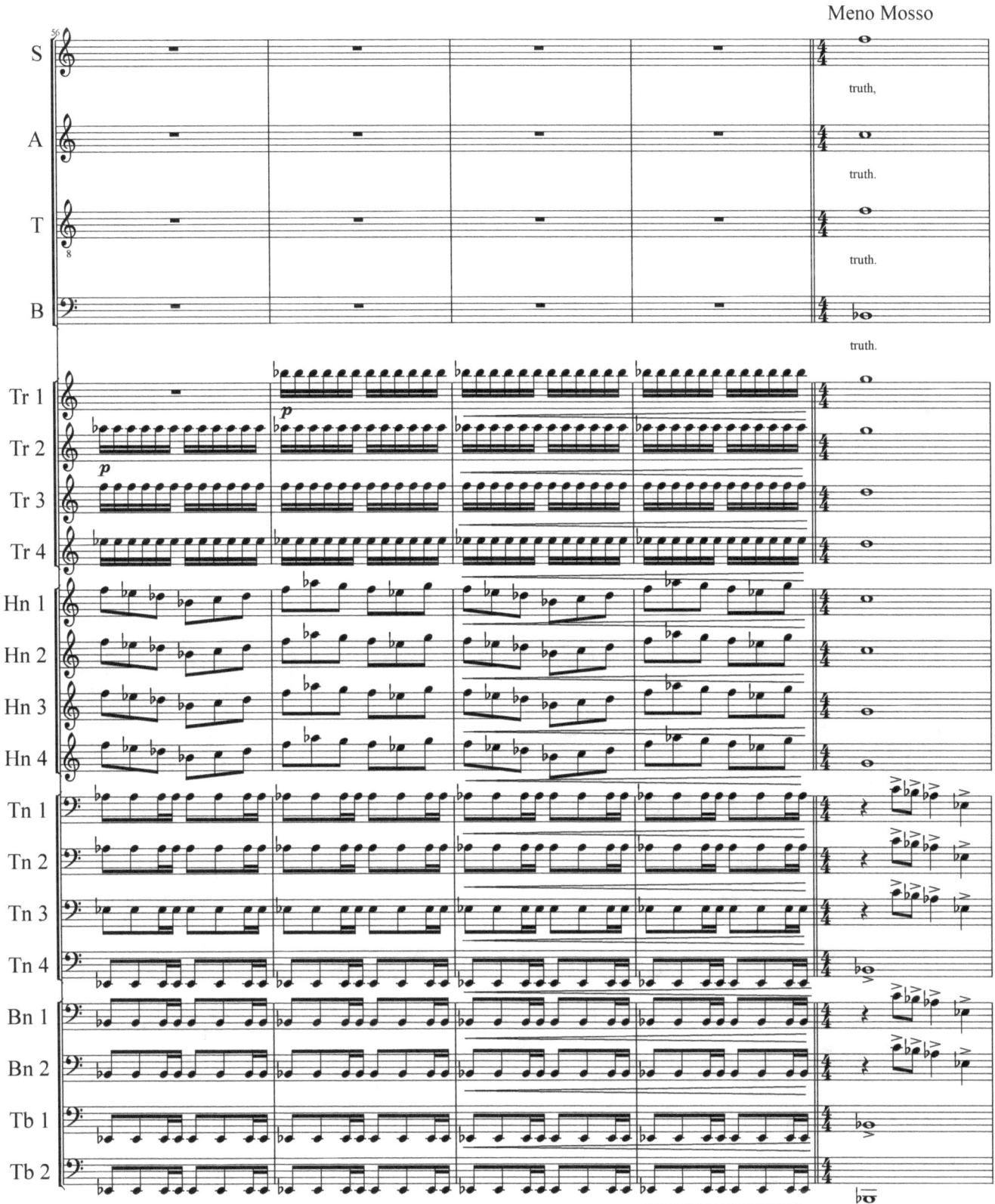

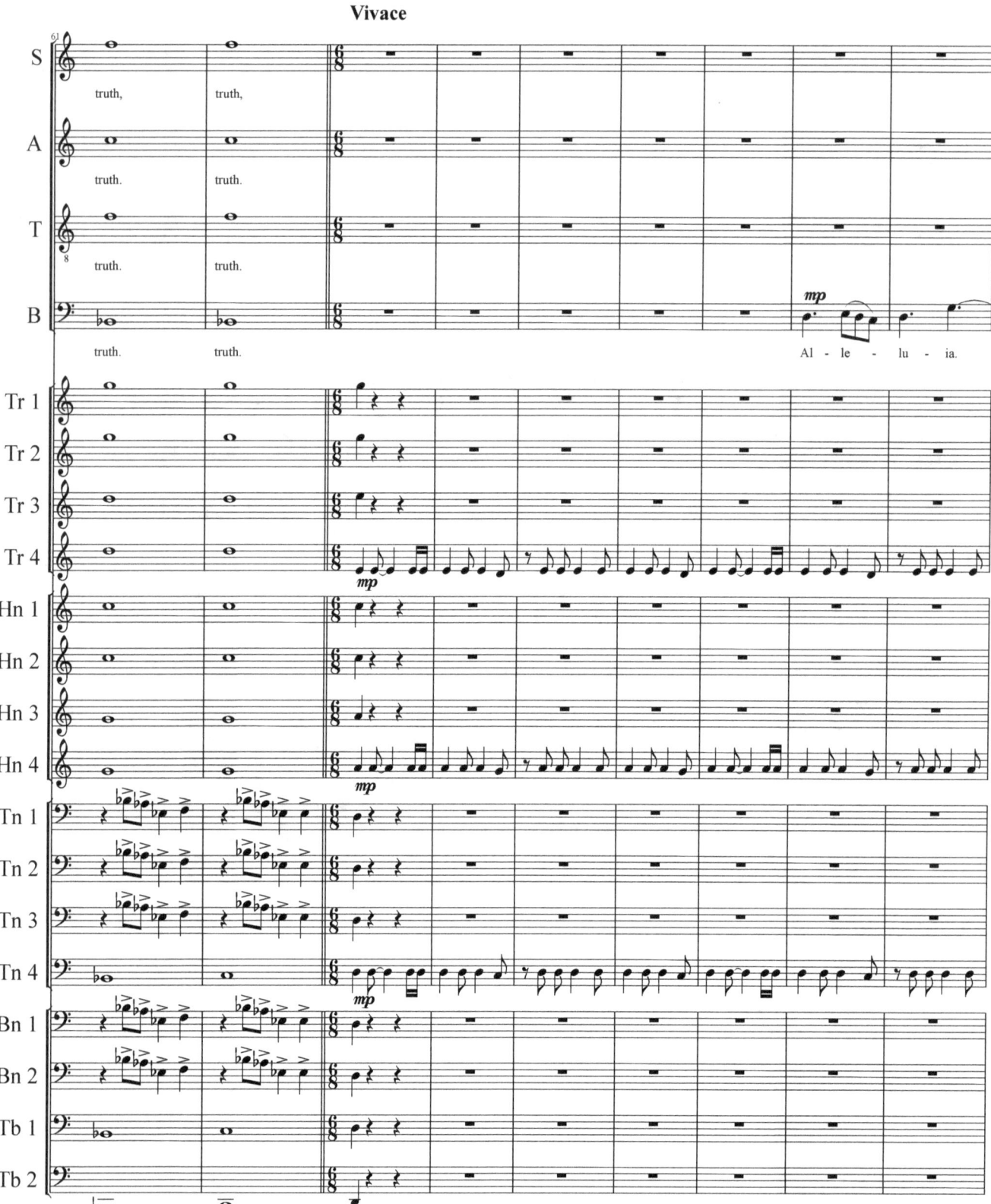

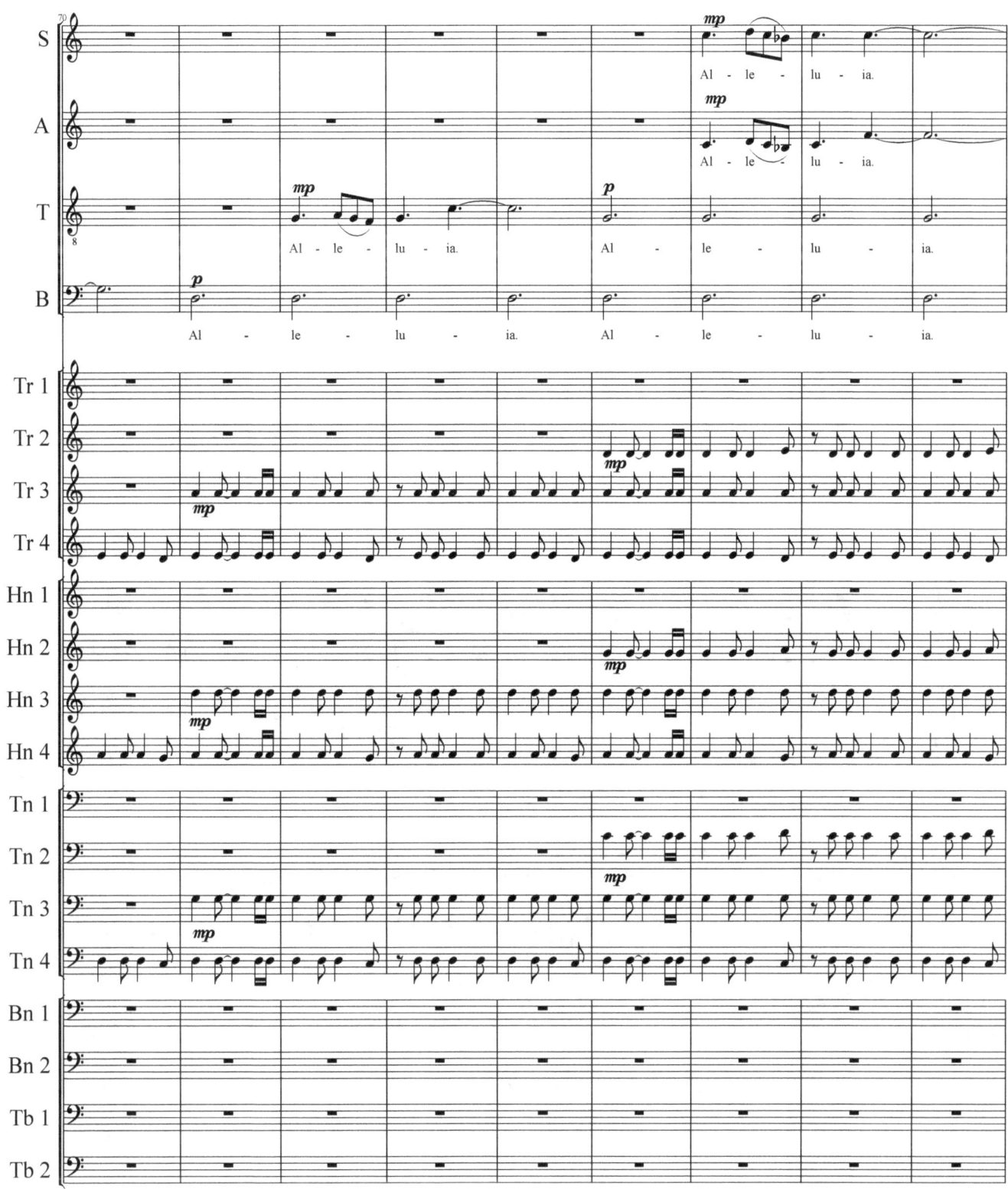

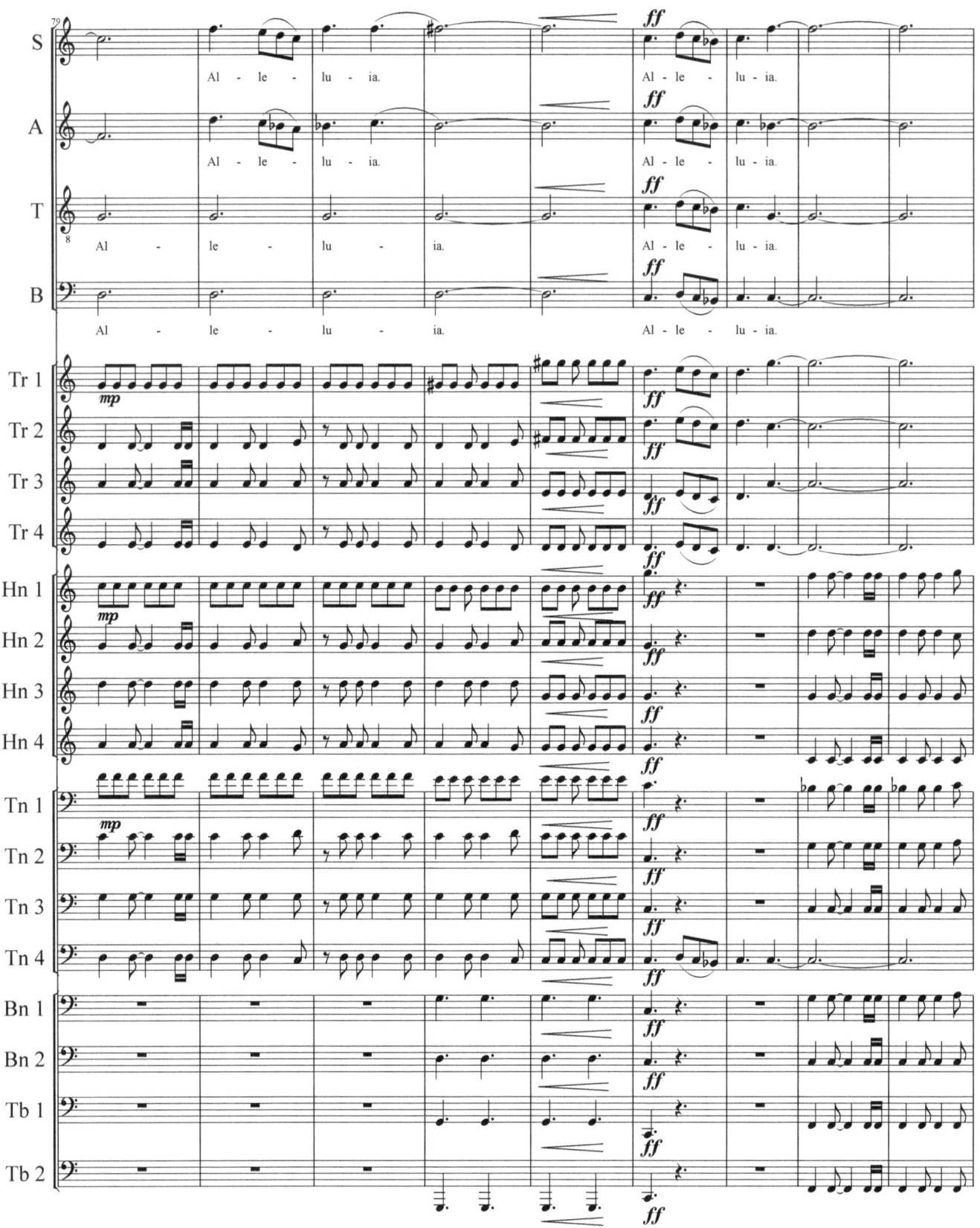

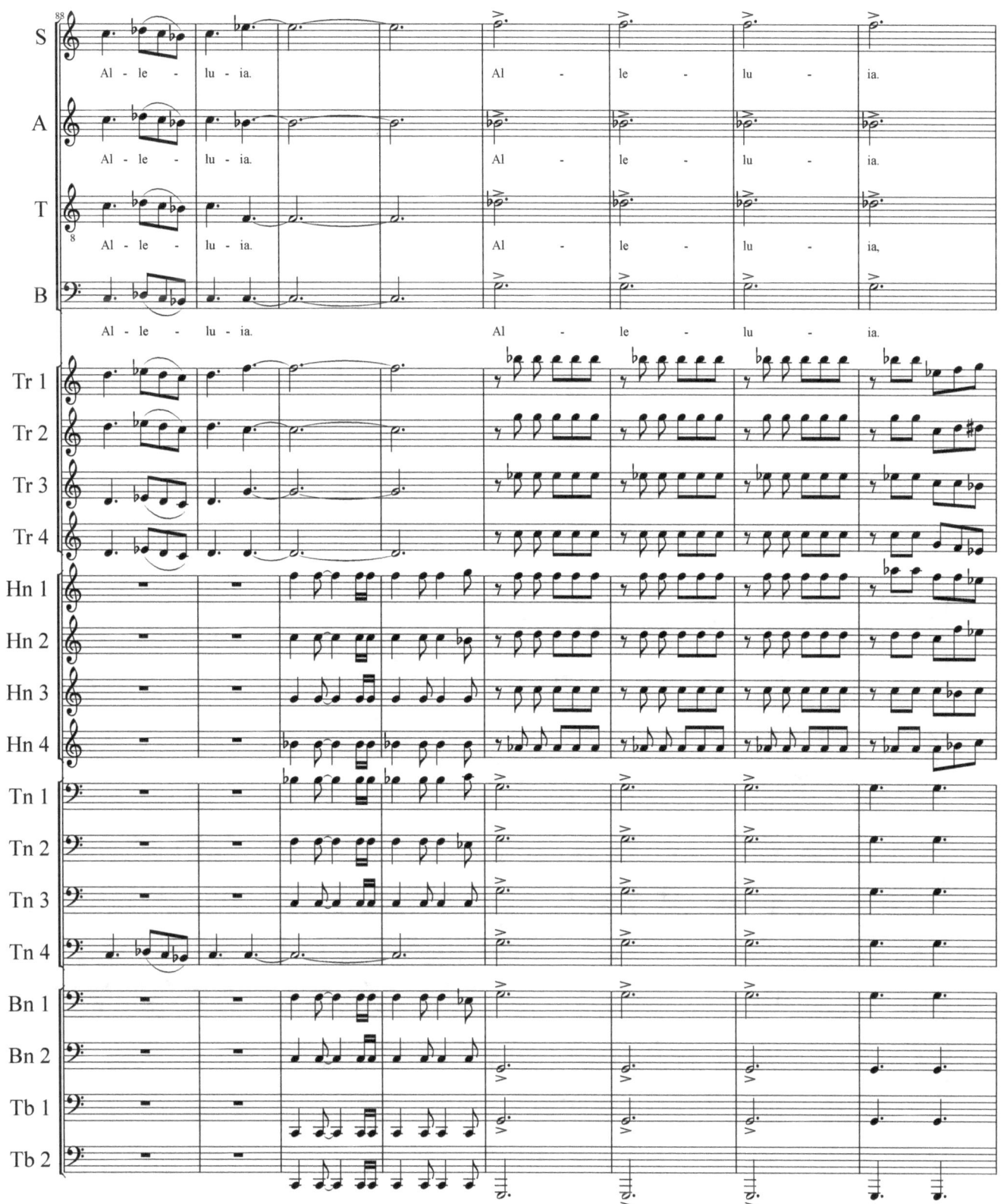

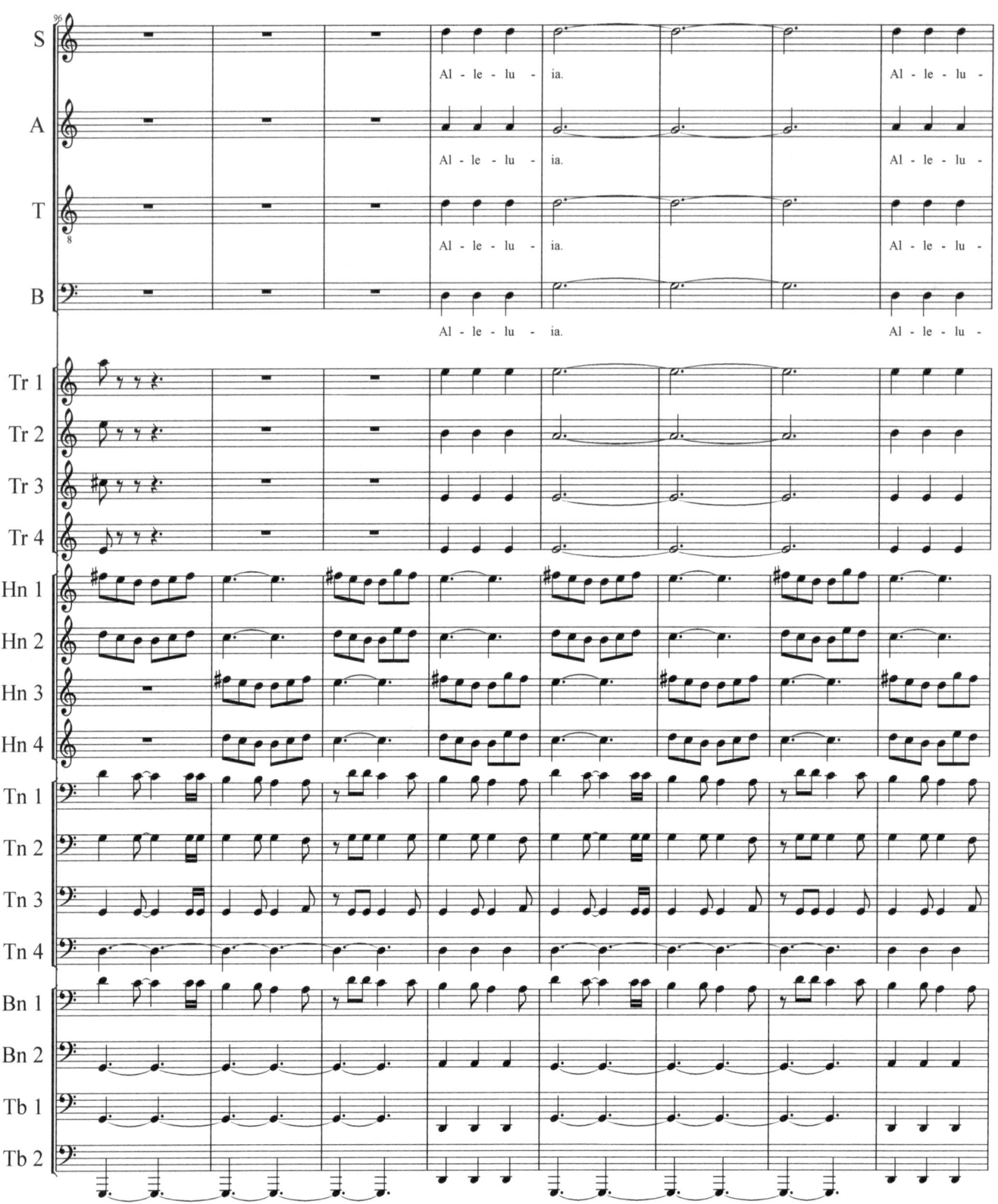

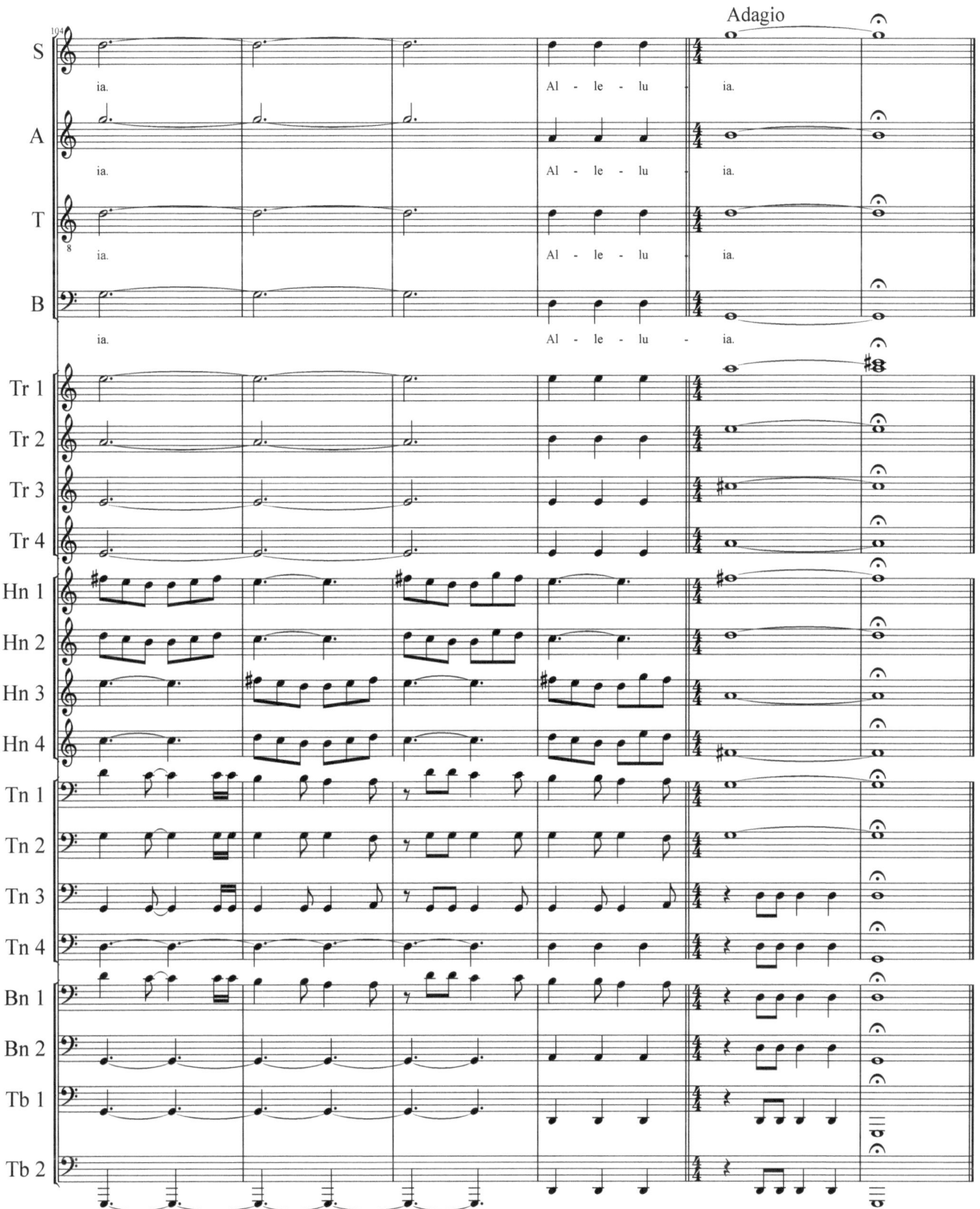

About The Composer

Dr. Kenneth Langer was born in the Pittsburgh area in 1959. He began playing trumpet in the 5th grade and decided in high school to make music his career.

Dr. Langer earned a Bachelor's Degree in Music Education at James Madison University in Harrisonburg, Virginia; a Master's of Music Degree at Radford University in Radford, Virginia; and a Ph.D. In Music Theory and Composition at Kent State University in Kent, Ohio. Since that time, he has taught music at several small colleges.

He has also been the full-time Director of Music and Arts at the Eno River Unitarian-Universalist Fellowship in Durham, North Carolina and the Assistant Conductor and Resident Composer at the Montpelier Unitarian-Universalist Church in Montpelier, Vermont.

During his twenty years of writing over 150 original works of music for various genres including brass, chorus, strings, orchestra, wind ensemble, and woodwinds; he has received numerous awards for his compositions including being named Vermont's Composer of the Year in the year 2000 and winning placement in several international composition contests. He has commercially published well over 30 compositions.

Dr. Langer currently lives in the Boston area with his family where he works as the Head of the Music Program at Northern Essex Community College in Haverhill, Massachusetts.

Publishers

Music For Brass

Nichols Music Company (Ensemble Publications)
P.O. Box 32 Ithaca, NY 14851-0032
www.enspub.com

Solid Brass Music
P.O. Box 2277 Rome GA, 30164
www.solidbrassmusic.com

Cimarron Music Press
15 Corrina Lane Salem CT 06420s
www.cimarronmusic.com

Wehr's Music House
www.wehrs-music-house.com

Music For Chorus

Yelton Rhodes Music
1236 N. Sweetzer Avenue #5 West Hollywood CA 90069
www.yrmusic.com

www.ingramcontent.com/pod-product-compliance
Lightning Source LLC
Chambersburg PA
CBHW080915170526
45158CB00008B/2122